D0404386

TATTOOING THE WORLD

TATTOOING THE WORLD

PACIFIC DESIGNS IN PRINT & SKIN

Juniper Ellis

COLUMBIA UNIVERSITY PRESS

{ *new york* }

COLUMBIA UNIVERSITY PRESS
Publishers Since 1893
New York Chichester, West Sussex

Copyright © 2008 Columbia University Press
All rights reserved

Any views, findings, conclusions, or recommendations expressed in this book do not necessarily
reflect those of the National Endowment for the Humanities or any of the other institutions and
people who helped make this book possible.

Library of Congress Cataloging-in-Publication Data

Ellis, Juniper.
　　Tattooing the world : Pacific designs in print and skin / Juniper Ellis.
　　　p. cm.
　　Includes bibliographical references and index.
　　ISBN 978-0-231-14368-4 (alk. paper)—ISBN 978-0-231-14369-1 (pbk. : alk. paper)
　　1. Tattooing—Social aspects. 2. Identity (Psychology) 3. Ethnicity.　I. Title.

GT2345.E55 2008
391.6'5—DC22

2007040948

♾ Columbia University Press books are printed on permanent and durable acid-free paper.

Printed in the United States of America | BOOK DESIGN BY VIN DANG

c 10 9 8 7 6 5 4 3 2

Contents

List of Illustrations

Acknowledgments

Sincere thanks to the people and institutions that helped make this book possible. An earlier version of chapter 1 appeared in *PMLA*. The National Endowment for the Humanities provided summer research support. Loyola College gave sabbatical and research grants. Libraries, archives, and museums made sources and images available; thanks to the Loyola Notre Dame Library, the Johns Hopkins Milton Eisenhower Library, the Smithsonian Institution, the Huntington Library, the University of Arizona Library, the Honolulu Academy of Arts, the Auckland Museum, the Auckland Art Gallery, the British Library, the Museum für Völkerkunde Hamburg, and the Bibliothèque nationale de France. Thank you to all the people there who helped make my research both possible and pleasurable. A special thanks to the *iwi* and descendants of Pare Watene who granted permission to include her portrait.

Thanks to my colleagues at Loyola College for their generosity and collegiality; those who helped make this book happen include Mark Osteen, Bob Miola, Joe Walsh, Gayla McGlamery, and Mary Skeen. Thanks to Peggy Feild, Linda Tanton, and Nick Triggs for particular help with library resources. Thanks to colleagues at other institutions, including Fr. Fran Hezel for consulting about Pohnpeian terms; Ken Arvidson for sending me good books and good cheer; Michael Neill for helping me locate "Taowiriwiri te tangata," the "tattoo'd Shakespere"; and Suzanne Bost and Phil Nel for support and inspiration. Love and thanks to my family and friends, especially Tim Durkin, for constant good humor and generosity of spirit.

Thanks to the people who make tattoo a living art, awe-inspiring for its beauty and its significance. Many writers and artists are named and acknowledged in this book. Thanks to Albert Wendt, Sia Figiel, Epeli Hauʻofa, Cushla Parekowhai, Henriata Nicholas, Greg Semu, Lisa Taouma, and ʻImaikalani Kalāhele, among others, for discussing their work and giving permission to include it here.

Some of the great artists are not named; their work appears throughout the book, but in many cases their names were not recorded along with their designs. A special tribute to all who helped create the tattoo we see today.

A Note About Pacific Languages

This book makes reference to several Pacific languages that use macrons and other special characters to indicate vowel length and sound. The macrons in the words *Māori* and *tātatau* for instance, indicate a sound in Māori and Tongan languages that is close to a U.S. English pronunciation of *a* in "water" or *o* in "cot."

When quoting other writers, I have preserved their spelling of Pacific words; orthographic conventions vary from one writer to another and one time to another. This book generally follows the current conventions adopted by Pacific presses, using macrons where appropriate to bring the written language closer to the spoken.

Pacific languages are living languages, which means that the way people use them is always changing. Moreover, for some languages used in this book, such as Pohnpeian, orthographic standards coexist with quite variable daily usage even on official things such as street signs and city names. In part that is because the languages are lively, and the written versions point toward robust oral cultures. Throughout, I have included references to dictionaries of the languages that help express some of tattoo's deep meanings. Except in a few cases where predominant usage is clearly different, I have followed the spelling conventions set forth by these dictionaries.

TATTOOING THE WORLD

Introduction

LIVING SCRIPTS, TEXTS,
STRATEGIES

The 1830s castaway James F. O'Connell sported a full-body tattoo. In the Pacific's Caroline Islands, the traditional patterns gave him his life and made him fully human. In the streets of New York, on the other hand, women and children ran screaming from his presence, while ministers warned from the pulpit that viewing O'Connell's tattoos would transfer the marks to any woman's unborn baby. O'Connell identified himself as an Irishman and gained fame as the first man to display his tattoos in the United States. In an important way, he exemplifies the story this book tells: how tattoo moved from the Pacific into the rest of the world.

Modern tattoo begins in the Pacific. The Tahitian word *tātau* was first imported into English in 1769 by Captain James Cook, whose traveling companions incorporated the designs into their skin. Traditional Pacific tattoo patterns are formed using an array of well-defined motifs; they place the individual in a particular community and often convey genealogy and ideas of the sacred. Outside the Pacific, meaning is created by tattoo bearers and viewers who interpret the designs in new ways. The same marks that initiated O'Connell in Pohnpei made him an outcast in New York.

In his autobiography, O'Connell offers an exemplary (if not completely accurate) attempt to decipher the designs he wears on his body. Like many observers, he believed that the tattoo formed a text that could be read if only he could learn a new language. O'Connell, who acquired Pohnpeian tattoos but

not the art of interpreting them, presents the tantalizing idea that patterns in skin may be equated with pictograms or logograms.

He compares his own attempts to read tattoo with Pohnpeian attempts to read a book he brought with him, *Scottish Chiefs*, written by Jane Porter:

> I never learned to read their marks, but imagine they must be something like the system of the Chinese, from this circumstance: before Miss Jane Porter was washed away in a rain-storm, many of the natives had learned the alphabet; that is to say, they "knew the letters by sight," but, counting large letters and small, figures, points of reference, points of punctuation, and every other printer's character, they gave us many more than twenty-four letters. When they saw these repeated, they signified that it was superfluous; they had no clear idea of the combinations, but said there was too much of the same thing, evidently imagining that each letter conveyed in each place one and the same idea.[1]

The passage at first appears to authorize O'Connell's narrative by presenting parallel cross-cultural readings: O'Connell's encounter with the tattoo, the Pohnpeians' encounter with the book.

But instead, the passage relies upon parallel forestalled readings. O'Connell, whose body has been marked by women tattoo artists, remains imprinted with patterns whose meanings he cannot understand and that he assumes may be deciphered by a viewer literate in that language. Similarly, it is the Pohnpeians' inability to read the English letters—which they apparently perceive as pictograms or logograms—that he invokes to support his claim that Pohnpeian tattoo motifs are similar to "the system of the Chinese." Rather than use one reading to support another, he offers one unreadable text to support another.[2]

That the texts go undeciphered in his scene, of course, does not make them indecipherable. O'Connell's readers are able to interpret the same English letters whose meaning the Pohnpeians cannot comprehend, much as a reader of Chinese interprets that mostly phonetic system of writing; so, too, the promise is that a reader literate in Pacific tattoo design could read O'Connell's tattooed body as if it were a book. This extended metaphor underwrites his own narrative; the Pohnpeian women who tattoo O'Connell appear in his account as "savage printers" (*Residence*, 115). They make of his body a book, and the tattoo patterns they imprint upon him propel the protoethnographic narrative he subsequently creates.

James O'Connell was a showman who displayed his thoroughly marked skin to all paying comers across the United States. Imagine him sitting before a mirror in a dressing room somewhere in Buffalo or New Orleans, preparing

for an exhibition. There he sits, the tattooed man, contemplating the patterns a group of tattoo artists have placed on him, wondering what the marks say, what claims they make. As "the tattooed Irishman," O'Connell finds in the motifs an identity, not just a job, and creates his own account of life in Pohnpei as a result of the apparent script the women have impressed upon him.

Of course, now that he is in the United States, no one within three thousand miles can tell him what his tattooers meant by the highly patterned lines that adorn his hands, arms, legs, and thighs. But the tattoos still speak, even in North America. They mean what O'Connell says they mean. They also mean what his audience and other North Americans think they mean. So O'Connell's story offers at least three interpretations of tattoo, which can overlap: the Pacific, the personal or performative, and the social. The Pacific interpretations remain inaccessible to him; he determines the personal or performative interpretations by choosing how to reveal and define his tattoos; and first Pohnpeians and then North Americans assign to him the social interpretations of tattoo. These structures of interpretation apply to many other tattoos on many other bodies.

Through his narrative and his two decades onstage in the United States, he proposes that tattoo patterns form a legible Pacific language, but one that neither he nor his audiences can interpret. In his account, the would-be Pohnpeian readers remain similarly frustrated by printed English. Even the warrant for their attempted reading washes away: Pohnpeian women take apart the book by Jane Porter and weave its pages into a cloak that dissolves when it rains.

The tattoo designs, like the print characters, appear to be the stuff on which meaning is made. But just what do the patterns signify? O'Connell's story represents a vibrant example of the way one individual may encounter Pacific tattoo and its meanings, and his book in turn brings the designs beyond the Pacific for wider audiences to consider. O'Connell exemplifies tattoo's travels, from the time artists apply the patterns in the Pacific to the time audiences read them on skin and in books, in Pohnpei and New York. His story thus serves to introduce further this book's approach to tattoo.

O'CONNELL: SIGNS AND PERFORMANCES

The tattoo served as a form of social registry. Thus, O'Connell had to receive the Pohnpeian tattoo, the *pelipel*, before he could enter into the life of the community. When his hosts try to explain tattooing, specifically announcing that he will undergo the ritual, O'Connell does not at first understand: "We had

been about three days at our new residence, when some of the natives began showing us their tattooed arms and legs, and making signs, not entirely intelligible to us at first, though their meaning became afterward too painfully marked" (*Residence*, 112–13). In O'Connell's account, the unintelligible signs his hosts make become meaningful only when his own arms and legs receive more permanent signs. O'Connell's pun on the word "marked" conveys both an emphatic sense of the meaning he is soon to understand and the physical endurance required of the body as it acquires its own social script.

As in other accounts of visitors who received ostensibly involuntary tattooing, O'Connell repeats his own lack of awareness of what occurs. He and his shipmate are led to an isolated hut, where "there was nothing in the building to give us a clue to the purpose for which it was erected" (*Residence*, 113). There they are left alone, until they are joined by "five or six women, bearing implements, the purpose of which we were soon taught" (*Residence*, 113). Thus presenting himself as thrice ignorant about his impending tattoo and why he would have been brought to the structure, O'Connell emphasizes that he is not responsible for the patterns he bears. Those patterns make him a fully adult man in Pohnpei; they make him a marked man after he leaves the island. O'Connell's narrative holds in tension the at least doubled meaning of his tattoos.

Three women work to create O'Connell's tattoo, beginning with his left hand. One provides the ink, a second holds the skin taut, and "the third beauty" (*Residence*, 113) drives the pigment-laden thorns into his skin to create the design. The women are exacting in their art: after the initial hand design is created, "she commenced again, jagging the thorns into places where she thought the mark was imperfect." Moreover, "the correction of the work was infinitely worse than the first infliction" (*Residence*, 114). The women's demanding standards in correcting the design cause "infinitely" more pain than does the initial application. The point is not just that O'Connell suffers, although he is keen to convey his physical courage; the point is also that the women demand perfection in the *pelipel* they create. They are experts, as his painfully marked body proves.

O'Connell emphasizes that his body is the material with which this female artist works. The woman wielding the thorn assesses the clean quality of the lines she is creating, O'Connell says, "as a carpenter would true a board" (*Residence*, 114). In this simile, his body is the wood that the women are building into something new. This theme recurs: his skin is the blank page on which the women work. The next day, he notes, "Another squad of these savage printers followed our breakfast" (*Residence*, 115). He provides the material; the women

provide the craft. As a result of this (on his part apparently unchosen) collaboration, his body becomes a trued building, a printed page or book. He acknowledges the tattoo artists as members of "a profession, confided to a few women" (*Residence*, 146).

O'Connell's only choice in the matter is how to respond to being made the stuff with which women experts work. He suggests that his fortitude allows him to bear the trial without complaint, while his shipmate displays cowardice and weakness—screaming, cursing, and uttering imprecations until the "squad" of women printers desists. As a result, his shipmate George does not attain full status as an adult male, and is granted a much lower social standing than O'Connell claims for himself. O'Connell was adopted by a chief, Ahoundel-a-Nutt (Oundol en Net, or "watchman of the mountains of Net," *Residence*, 118), a fact verified by subsequent Pohnpeians and scholars.

The patterns O'Connell carries place him in his adopted genealogy. He reports that when he later travels to other communities, "My tattooing, speaking my relationship to Ahoundel-a-Nutt, was better than letters of introduction" (*Residence*, 182). O'Connell suggests that even in neighboring islands, his tattoos declared his connection with a particular chief. Historically, *pelipel* may have indicated his association with a lineage or a clan, but how far tattooing goes in conveying specific names is disputed.[3] The consensus is that the traditional designs can convey lineage and clan history without recording the names of individuals.

One of the major insights O'Connell's narrative affords is the respect achieved by women tattooists. As David Hanlon notes, "O'Connell had described tattooing on the island as a highly refined art form entrusted almost exclusively to women and used for purposes of recording individual lineages and clan histories. As with most other aspects of Pohnpeian culture, however, the importance of women went unnoticed by outsiders, whose understanding of others was limited by their own particular notions of propriety."[4] In other words, even while conveying the exacting artistry practiced by the tattooing professionals, O'Connell missed the matrilineal nature of the political and social system that he was tattooed into.

Similarly, O'Connell muddles a few additional details of his descriptions of gender. He suggests correctly that tattooing marks him as able to marry. This fact is attested to by the Pohnpeians who wrote *Some Things of Value*: "In the past, the time for marriage, or the attainment of adulthood, was symbolized by tattooing of both men and women."[5] Embellishing this fact, O'Connell invents a ceremony in which the chief's daughter who will become his wife

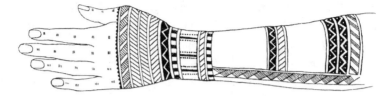

FIGURE 1. A Pohnpeian man's arm tattoo. Illustration by Paul Hambruch. Reprinted from
Paul Hambruch and Anneliese Eilers, *Ponape: Gesellschaft und Geistige Kultur, Wirtschaft und
Stoffliche Kultur* (Hamburg: Friederichsen, De Gruyter, 1936), 2:272.

tattoos rings on his breast, shoulder, and arm. Again, the tattooing—and
even the marriage—occurs without his awareness: "At night I learned that the
young lady who imprinted the last-mentioned marks upon my arm and breast
was my wife!" (*Residence*, 117). Presumably his latest revelation occurs when
his wife initiates sexual contact with O'Connell—a passage that denies his
own responsibility for his marriage, but also places him in a strangely passive
role. Penetrated by first one and then another woman's tattooing implements,
O'Connell is first made a man and then espoused. But by his own account, he
remains unaware of the social transformations he has experienced; he is simple
material for the women to shape.

Finally, one of the most peculiar aspects of the tattooing that he reports is
its placement on his body. He presents the individual order in which his limbs
were tattooed, and then sums up, "I came from the tattoo hospital a bird of
much more diversified plumage than when I entered, being tattooed on my
left hand, on both arms, legs, thighs, back, and abdomen" (*Residence*, 116).
The difficulty is that men were traditionally tattooed on arms, legs, and thighs,
while women were additionally tattooed on the abdomen and buttocks. (For
examples of male patterns, please see figures 1 and 2.) Neither sex was tat-
tooed on the back. As Riesenberg notes, if O'Connell (or his coauthor, H. H.
W., probably Horatio Hastings Weld) is being delicate, and using "back" as a
euphemism for buttocks, then O'Connell received part of a woman's tattoo de-
sign. The same point holds if he received an abdominal tattoo. Riesenberg sug-
gests that O'Connell may have received a variant style of tattooing, or that the
style may have passed out of use soon after O'Connell's visit (*Residence*, 116 n.
13). O'Connell could also have acquired additional tattoo designs after leaving

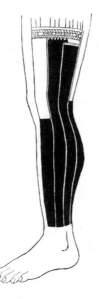

FIGURE 2. A Pohnpeian man's leg tattoo. Illustration by Paul Hambruch. Reprinted from Paul Hambruch and Anneliese Eilers, *Ponape: Gesellschaft und Geistige Kultur, Wirtschaft und Stoffliche Kultur* (Hamburg: Friederichsen, De Gruyter, 1936), 2:273.

Pohnpei. (It is also worth noting that a man from the "Low Caroline Islands" is depicted with elaborate back tattoos in *Voyage Autour du Monde Atlas*.)

However, it is similarly possible that the abdominal and back or buttocks tattoo indicates O'Connell's anomalous position in Pohnpei. Hanlon identifies O'Connell (and his shipmates) as property of the chiefs, distributed by the paramount chief as would be "any other form of wealth" (*Stone*, 40). In other words, O'Connell's tattoos mark him as belonging to Oundol en Net. Recall that power was determined by matrilineal descent lines, and a man's most important relationships politically were through his mother and sister. His position as an adoptive member of Oundol en Net's clan may not have granted O'Connell these relationships, and he may have even been seen as a chattel, a form of property.

As we will see in other contexts, marking a woman with a man's tattoo designs may show her political and social position to be both powerful and anomalous.[6] It is not inconceivable that O'Connell received a woman's tattoo patterns in order to mark his similar position. In this reading, the *pelipel* would

both allow him to belong to Pohnpeian society and still show that he could never quite fit in.

It is thus perhaps appropriate that O'Connell presents himself as a performer from the day he arrives in Pohnpei. Having just arrived on the beach, he claims that he saves his life by dancing an Irish jig, throwing himself into *Garryowen* "to the best of my ability and agility" (*Residence*, 106). After his tattoo is complete, he is "paraded and examined at each fresh arrival" (*Residence*, 117) to the public feast held after his tattooing is completed. As in Fiji, after a period of isolation, the tattoos are viewed publicly.[7] Indeed, the place of the performer is the most stable place O'Connell ever reaches.

When he left Pohnpei, O'Connell arrived in the United States and moved around the country presenting his tattoos in melodramas, circuses, and P. T. Barnum's American Museum. In the United States, he continued dancing on stages up and down the eastern seaboard. An image from a pamphlet sold at his circus performances (please see figure 3) reveals his arm tattoos, which are not visible in great detail but do correspond to the male Pohnpeian patterns shown in figure 1.

As for the gender role he performs in his narrative, he shows himself to be a man penetrated by women. That position was familiar to men in Pohnpei, but not to men in the United States. At least in American terms, it is clear that O'Connell was an anomaly, marked as such by the tattoo. Onstage, however, he may not have emphasized that his body was pierced by women artists. The playbill for his appearance in Buffalo, New York, suggests that the tattooing scene itself happens offstage. As advertised, the opening scene depicts the shipwreck and O'Connell's dancing the Irish jig. The drawing on the playbill depicts O'Connell being tattooed, but part two of the show opens after six years have elapsed, when "O'Connell is now a chief and has been Tattooed."[8] In other words, only the marks (and not the tattooing itself) are presented onstage. O'Connell's "conjugal felicity" is advertised as part of the show, but not the scenes in which tattooing women make him their material.

Even so, O'Connell's performances were considered threatening to gender roles and standard forms of reproduction. And here, perhaps, we see a dramatized beginning of a tradition outside of the Pacific that will read tattoo as a sign of depravity, and of a particularly sexual disorder. A diagnostic tradition that correlates tattoo with the individual psyche and with a sexuality run rampant is anticipated in the streets of New York, where women and children ran away from O'Connell, screaming. Ministers inveighed from the pulpit,

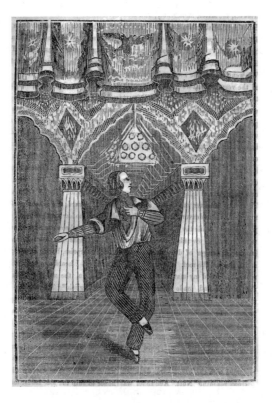

FIGURE 3. James O'Connell. Reprinted from James O'Connell, *Life of Ja's. F. O'Connell,*
The Pacific Adventurer (New York: J. Merone, 1853), facing page 37.

counseling pregnant women to avoid viewing the tattooed Irishman. Failure to
do so, they warned women, would transmit the tattoo marks to their unborn
children (*Residence*, 43). O'Connell becomes a template that reproduces the
Pohnpeian women's designs, a fantastic version of the way the tattoo travels
into the world. The fully developed diagnostic tradition suggests that viewing
tattoo is tantamount to penetration and incites sexual action; here, the wild
transmission of the designs does not even require penetration. The report of
the screaming women shows what an astonishing power was already assigned
to tattoo. In a strange modification of immaculate conception, the women flee
a virginal tattoo birth.

As a testament to the spirit of O'Connell's exuberant performances, a bar
on contemporary Pohnpei is named "The Tattooed Irishman." Moreover, the

tattooing practices he described continue. The writers of *Some Things of Value* declare, "Although tattoos are no longer a required symbol of adulthood on Pohnpei, they are still very much in evidence among the people today" (99).

O'Connell's tattoos make explicit several key elements of this book. His story features two forms of inscription: pigment placed on human skin, ink imprinted on a book's page. His story emphasizes that tattoo circulates in the Pacific and throughout the world, inscribed and reinscribed on skin and in print. Although he does not mention this fact, O'Connell's desire to see his tattooed body as published by women artists has a corollary in the language of Pohnpei. The term that Hambruch records for one of the patterns in the male tattoo, *lăp en pā'n ŭot*, means taro leaf stalk; the term leaf invokes both a plant's foliage and a book's page.[9] (In figure 2, this pattern is the horizontal zigzag line.) And the same word, *nting*, means "to tattoo" and "to write."[10]

Tattoo and print, of course, carry distinct traditions. Tattoo testifies to Pacific forms of genealogy and history, while the written pages created by visitors very often bear a different understanding of human beings and time. Along these lines, Hanlon sees in O'Connell's tattoos a call for a history based on orality and Pacific ways of knowing.[11] Keeping in mind the way tattoo is imprinted both on skin and in books and the way those inscriptions are carried into the world by both Pacific peoples and visitors, let us take a look at the way several contemporary Pacific writer-scholars employ both traditions.

As we examine the contemporary forms taken by those living traditions, this introductory chapter will continue to examine some of the key features of tattoo's histories and presence in the Pacific and in the rest of the world. That means telling more about the way modern tattoo traveled and, as a consequence, presenting some of the key points covered in this book.

WORLDS OF TATTOO

Tattoo encompasses history, genealogy, and cosmology, the distant past and the immediate present, and embodies the sacred and the physical. Albert Wendt's essay "Tatauing the Post-Colonial Body"[12] moves among all of these features. Moreover, the essay establishes Samoan tattoo as an analogue for postcolonial literature, one that helps proclaim the indigenous Pacific and achieve a decolonization. Wendt defines tattoo as "scripts/texts/testimonies to do with relationships, order, form, and so on" ("Tatauing," 19). The language that describes tattoo and the natural world whose patterns shape tattoo attest to the practice's collective meanings and its specific adaptations. Wendt's essay

ranges from tattoo's origins and transmission to its practice today in Samoa and in the world as an art and way of life embraced by Samoans and those who deeply love Samoan culture.

Analogous work on Māori *moko* has been pursued by Ngahuia Te Awekotuku, Linda Waimarie Nikora, and their colleagues in an extensive research project titled "Ta Moko: Culture, Body Modification and the Psychology of Identity."[13] Te Awekotuku, Nikora, and other investigators, including Ngarino Ellis, document the roots and reach of *moko* from its origins to the present, encompassing aspects of the practice ranging from identity, gender, and aesthetics to resistance and appropriation. Their work has been key to revising major assumptions about *moko* (for example, that the practice stopped when publicly suppressed by missionaries or outlawed).

Facing down attempts to outlaw or denigrate *moko*, the designs survive and testify to living histories. Te Awekotuku declares that *moko* "was worn to fascinate, terrify, seduce, overcome, beguile, by the skin; it was carried to record, imprint, acknowledge, remember, honour, immortalise, in the flesh, in the skin; it was also affected to beautify, enhance, mutate, extend the flesh, the skin, the soul itself."[14] These uses of *moko* continue, not as inauthentic replica, but as a continually growing genealogy of life and art in Māori communities: "It was, and still is, about metamorphosis, about change, about crisis, and about coping too; and for many contemporary wearers, the descendants of those first illustrated chieftains encountered by Cook, painted by Parkinson, Ta moko is a strategy too, a means of encounter, an expression of self" ("Ta Moko," 123). Tattoo as strategy, as encounter, as expression: the patterns spiral among these registers and speak the meanings given to them by the bearer, the creator, and the sacred lines of design, descent, and ascent that place recipient and artist in community.

In the Pacific, much as O'Connell asserts, traditional motifs give the tattoo bearer a social standing place. Distinct but related patterns, practices, and significations feature in tattoo across the Pacific, forming some of the most refined artistic traditions in the world. Tattoo practices discussed here include those developed in such places as Pohnpei, Samoa, Māori New Zealand, the Marquesas, Tahiti, Hawai'i, Tonga, and Fiji. Pacific tattoo, which is today experiencing a renaissance, has roots going back three thousand years.

The Pacific patterns convey that the individual is a member of a particular family, tribe, or community, and may depict everything from a person's birthplace to authority inherited and achieved. In many cases, distinct patterns are reserved for men and for women, and thus coincide with (though they do not

determine or restrict the form taken by) the bearer's mature practice of gender and sexuality. The patterns are fitted to the contours of the body and, famously in the case of Māori *moko*, similarly follow the shape of the face or, in Marquesas Islands *tiki*, cut across the shape of the face. With such a bold presentation, the designs are inseparable from conceptions of beauty and adornment. But tattoo involves more than an aesthetic. The practice also conveys an ethic—of responsibility to one's family and community—and is thus related to conceptions of the sacred and the profane and, even more broadly, to ways of recognizing the place of human beings in the cosmos.

Despite these rich meanings, tattoo may not be assimilated into any language, whether pictographic, logographic, or script. Tattoo is an analogue to language and forms a vital means of signification; but it is not reducible to writing, and the patterns exceed any lexicon. O'Connell's attempt to present tattoo as a language, and his continuing speculation about how that language works and what it expresses, represents a recurring feature in observers' presentations of Pacific tattoo. At least as far back as 1769, when Cook and his traveling companions import the Tahitian word *tātau* into English as "tattoo," observers attempt to read the designs, to make the patterns speak.

As tattoo traveled from the Pacific to the rest of the world, the art encountered many places in which tattoo traditions had once flourished. In attempting to read the tattoo patterns, observers tap into an age-old desire to create a clearly *legible* connection between tattoo and social status. In the Hebrew Bible, Cain's murder of his brother Abel results in his being outcast, forced to wander in exile; at Cain's request, God gives him a mark on his forehead to show that he is one of God's people. The sign of protection, however, is inseparable from shame and becomes "the mark of Cain." In Greece from the fifth century on, and in the Roman Empire, we find other examples of tattoo interpreted as degradation and punishment. Slaveholders and civil authorities used *stigma*, permanent skin markings, to designate disobedient slaves and criminals.[15] When the Emperor Constantine converted to Christianity, he allowed the practice to continue on the hands and legs, stipulating in the year 316 that slaves and convicts should no longer have their faces emblazoned.[16]

Outside the Pacific, hints of other social interpretations of tattoo survive. In fact, Britain may take its name from tattoo. Such insular Celtic tribes as the Picts may have inspired the name, derived from the word *Priteni* or "the people of the designs."[17] On the other hand, tribal tattoo was condemned in the Catholic Church.[18] In 786, papal legates to Britain declared, "For God

made man fair in beauty and outward appearance, but the pagans by devilish prompting have superimposed most hideous cicatrices."

The legates, who were sent on their mission by Pope Hadrian I, leave ambiguous room for Christian tattoo: "For he clearly does injury to the Lord who defiles and disfigures his creature. Certainly, if anyone were to undergo this injury of staining for the sake of God, he would receive a great reward for it. But if anyone does it from the superstition of the pagans, it will not contribute to his salvation." While this passage is usually read as approving Christian tattoo,[19] the canon's opening proclamation makes that reading unlikely: "if anything from the rites of the pagans remains, it should be ripped away, despised, abandoned."[20] It is more likely that the legates instead support Christians who are subjected to tattoo, forced to undergo such injury as a result of their faith.

This latter sense is the one Paul invokes in his letter to the Christians at Galatia, when he declares, "I carry the *stigmata* of Jesus on my body" (6:17). (The word *stigmata*, which appears only once in the New Testament, is often translated as "marks" or "brands," but as Jones and Gustafson demonstrate, it was used at the time to indicate tattoo. In fact, *stigmata* is a plural form of *stigma*, which means "tattoo.")[21] In other words, while he probably refers literally to scars he had received from a stoning, Paul makes punitive Roman practices, such as tattoo, a sign of his Christian devotion; he transforms a mark of subjugation into a badge of honor ("Roman," 29). Such is the rich instability of the tattoo, whose meanings may be imposed in one frame of reference but transposed within another.

After the practice was discouraged in the Catholic Church, tattoo seems to have survived in Europe, primarily on "the fringes of Christian Europe,"[22] and among pilgrims to Jerusalem. Such travelers, especially in the fifteenth and sixteenth centuries, often obtained "Jerusalem crosses" to commemorate their journeys. In addition to conveying information about the bearer's religion, the Jerusalem cross tattoo creates a further legible social status acquired by sacred travel.

Any extant European traditions of tattoo, however, were apparently unknown to Cook, Joseph Banks, and others who traveled in the Pacific and marveled at the profusion of designs.[23] The sailors who adopted the designs helped import tattoo from the Pacific to the rest of the world, with the patterns traveling both on skin and in narrative and other representations. Banks and other Europeans of aristocratic background also acquired Pacific designs. Outside the region, the patterns very often acquired different meanings

depending upon the social standing of the bearer. So, as we will see, it is not just that tattoo may be read as a class marker,[24] but also that the bearer's social standing inflects tattoo's meanings both within and beyond the Pacific.

What meaning is expressed by or assigned to tattoo, of course, takes quite differing forms. As the various chapters of the book examine in detail, tattoo shapes language, identity and property, beauty, ethics, culture, and sexuality and gender.

LANGUAGE

Thanks to what they learned from people in the Pacific, travelers from diverse social perspectives also helped document some of the oldest and most vital tattoo traditions in the world. The Pacific practice of *tatau* traveled into the rest of the world, forming the English *tattoo* as well as the French *tatouage*, German *Tätowierung*, and Spanish *tatuaje*, to note a few of the other languages that borrowed the word from the Tahitian, Samoan, and Tongan languages. Before Captain James Cook's 1769 use of the Tahitian word (which he spelled *tattow*), the English words used to describe marking the skin with indelible pigment included *puncturing*, *punctuating*, and *rasing*.[25] The English word *tattoo* that refers to beating a rhythm on a drum existed before Cook's introduction of *tattow* but did not refer to bodily marks. Tattoo shapes language itself. The next chapter examines Samoan tattoo and (according to Wendt, Figiel, and Lacan) the way the tattoo creates the subject and the signifier.

In psychoanalytic theory by Jacques Lacan and works of contemporary Samoan fiction by Albert Wendt and by Sia Figiel, the tattoo has been conceived of as fundamental to forming the subject and the signifier. Wendt presents a young boy who becomes a man when he is tattooed by a prisoner just before the prisoner is executed. Figiel depicts a young woman who is prevented from receiving designs that help produce a full personal and social identity, and the uncompleted marks thus create a disgrace, leading her mother to disown her and ban her from their village. In psychoanalytic theory, tattoo also inaugurates the subject: Lacan declares that tattoo is the first signifier, which makes the subject aware of herself or himself as separate from the line notched into skin. In all of these works, tattoo is an analogue for language and transforms those who bear the signifier.

As tattoo traveled through the world, people saw in the patterns a wealth of different meanings. O'Connell's presentation of Chinese as parallel to a tattoo script anticipates contemporary debate about the way nonalphabetic

scripts may be used to create new meanings. Rey Chow, for example, suggests that Jacques Derrida uses "inscrutable Chinese" as a silent, graphic language to authorize his own readings. She notes the key place held by the ostensibly ideographic Chinese language in Derrida's deconstruction of "Western" phonocentrism:

> Strictly speaking, therefore, the silent graphicity of Chinese writing is both inscrutable and very scrutable: though Westerners such as Derrida may not be able to read it, they nonetheless proceed to do so by inscribing it in a new kind of theorizing (speculation), a new kind of intelligibility. The inscrutable Chinese ideogram has led to a new scrutability, a new insight that remains Western and that becomes, thereafter, global.[26]

Of course, Derrida also critiques the ethnocentrism that both elevates speech over writing and refuses to grant the dignity of writing to nonalphabetic signs.[27] By extension, people who practice tattoo create writing in a general sense (*Grammatology*, 109)—but a form of writing that may not always correspond to words in the direct way the viewer wishes. (Of course, words are not necessarily direct, either.) Much as they underwrite deconstruction in Chow's discussion, Chinese characters underwrite O'Connell's speculation about tattoo motifs, serving as a silent placeholder, a guarantee of intelligibility *because* the present viewer cannot sound or read them.

Tattoo, like the Chinese language for Chow's Derrida, indicates the edge beyond which the observer may not move, the edge that guarantees the speculative meaning the observer assigns to that beyond. O'Connell is not alone in using such silent figures to speak his own concerns. The tattoo forms a similar grand gesture in the writings of the philosopher Immanuel Kant, the anthropologist Claude Lévi-Strauss, and the psychoanalyst Jacques Lacan, who use the body art to help create their theories of aesthetic judgment, culture, and the individual human subject. Specific tattoo signs are presented as universal, and as speaking in the voice of the outside observer. In these theories and in its homelands, Pacific tattoo does not articulate a single perspective. Rereading these theories through the lens of Pacific tattoo reveals that what is viewed as the extreme form of signification reverberates throughout the world.

One of the givens of this study is that the process by which the patterns move beyond the Pacific makes visible the way cultures travel. As tattoo travels, the same patterns are interpreted and used in disparate ways, depending upon whose bodies or faces they adorn and in what situations those bodies or faces are viewed. The same patterns that make one fully human in a Pa-

cific community have been viewed as inhuman in a European or United States context. Another given of this study is that as tattoo travels, people modify important aspects of the living art, from the tools used to create the patterns to the meanings the patterns express. In other words, tattoo also makes visible the cultural adaptation that occurs in both travelers and hosts, regardless of whether the European or Pacific visitors' arrival is voluntary or compulsory and whether the tattoo moves on bodies willing or forced to acquire the designs. Given these premises, this study examines in detail the varying ways people use tattoo to signify and to mark their own and others' belonging or lack thereof.

IDENTITY AND PROPERTY

This study explains one way people create meaning and identity. Tattoo provides a fresh view on questions that have been central to debates about decolonization, indigeneity, sovereignty—and about the ongoing appropriation of land, language, and tradition that continues under globalization. In 1921, Māori warrior Netana Whakaari Rakuraku of Waimana, who had fought against government soldiers in the nineteenth-century colonial New Zealand wars, emphasized that *moko* resists the expropriation that he had battled. He declared, "You may lose your most valuable property through misfortune in various ways. You may lose your house, your *patupounamu* [weaponry], your wife and other treasures. You may be robbed of all that you cherish. But of your *moko* you cannot be deprived, except by death. It will be your ornament and your companion until your last day."[28] Carved into the face, *moko* forms one of the most visible and spectacular traditions of Pacific tattoo. As such, it plays a significant role in many travelers' accounts and presents questions key to this study. Chapter 2 investigates the way Māori *moko* moves into the world, borne by books including Melville's *Moby-Dick* and Lévi-Strauss's *Structural Anthropology*.

As Netana Whakaari asserts, *moko* forms something of a last belonging, both a final possession that may not be confiscated and a testament to one's place in a world defined by intact genealogies rather than by alienation. In a precontact world, *moko* may signal one's affiliation vis-à-vis tribal alliances or rivalries. In a postcontact world, after the practice is banned in New Zealand via the Tohunga Suppression Act of 1907, *moko* also proclaims the bearer's allegiance to an outlawed way of life. The Tohunga Suppression Act outlawed traditional Māori cultural and healing practices, targeting those *Tohunga* (ex-

perts or priests) who practiced ways of life such as *moko*. The Act was repealed by the 1962 Māori Welfare Act. In any of these contexts, the patterns may at once reinforce and disrupt hierarchies internal and external to a particular community.

In these living contexts, the designs convey an inalienable and sacrosanct identity. Beginning with initial contact with outsiders, however, an almost voracious market for *moko* transports the designs far outside of their homelands. Herman Melville depicts such transactions in *Moby-Dick*, when Queequeg sells a string of "'balmed New Zealand heads"[29] in the streets of New Bedford, Massachusetts. These heads, part of sacred Māori mortuary practices, are *toi moko*, tattooed ancestral heads.[30] Melville uses the heads to convey many things: Queequeg's facility in the marketplace, his generosity to Ishmael (to whom he presents the one remaining head when they become friends), Ishmael's comic ignorance and inability to read the signs the landlord Peter Coffin uses to describe his prospective roommate's activities. In the opening chapters, many of the jokes Melville makes about Ishmael and about his American audience rely upon Māori tattoo.

More soberly, Melville depicts the worldwide market for Māori and Pacific tattoo, part of what Linda Tuhiwai Smith describes as "the first truly global commercial enterprise: *trading the Other.*"[31] Like O'Connell, Melville emphasizes that he cannot explicate the same tattoo signs that make his narrative possible. (Of course, Melville takes it one step further by portraying the tattooed Pacific Islands character as similarly incapable of interpreting the patterns.) Queequeg recovers from a life-threatening illness and carves a copy of his tattoos into his coffin, proceeding to use it as a sea chest. That wooden vessel becomes the lifebuoy that carries Ishmael—and thus the novel's narrative—to safety.

The *toi moko* that Melville depicts remove the heads from the body of Māori culture; the tattoo-copy separates the patterns from the tradition that creates them. Rather than conveying a particular identity, both the heads and the tattoo-copy signify the possibility of meaning. Both also indicate the way the marketplace treats such signs as reproducible. So it is perhaps not surprising that the self-portrait of his full facial *moko* created in 1826 by Te Pehi Kupe, Ngāti Toa paramount chief, is used today as the cover image for the sesquicentennial Norton Critical Edition of *Moby-Dick*. The same design features on the cover of the Basic Books edition of Claude Lévi-Strauss's *Structural Anthropology*. The Norton edition misspells Te Pehi Kupe's name and nowhere identifies him as Māori; the Basic Books edition notes that the design is by a

Māori chief but fails to give his name. These cover images continue the process Melville dramatizes, separating *moko* from their cultural origins and appealing to a proliferating market for tattoo. The novel's content calls attention to the alienation of the apparently inalienable pattern, while the novel's packaging heightens that alienation. In the narrative, the tattoo-sign cannot speak; in the marketplace, its value is spoken for.

This dynamic renders the tattoo as surface rather than depth, treating the cultural inside of the tattoo as inaccessible. Restoring such voices as Te Pehi Kupe's and contemporary scholar Ngahuia Te Awekotuku's to the conversation reminds us that tattoo involves both surface and depth, makes visible the simultaneous intensification and joining of the interior and the exterior. This point defines the material tattoo and helps explain its simultaneous expressions of individuality and sociality, choice and coercion, the native and the foreign. Identity, power, and place are among the most important forms of belonging indicated by tattoo. Such prominent signals of belonging serve to include— and just as surely to exclude, depending upon which communities the marked or the unmarked person encounters.

When tattoo is used to indicate a casting out, as when it is punitive, the marks invert the patterns' home contexts, creating shame, subjugation, and exile. Tattoo as punishment confirms the identity, power, and place of those who impose such a penalty. Echoing the biblical instances of Cain and of Paul, such is the case for Sia Figiel's character in *They Who Do Not Grieve*. The incomplete tattoo casts her and her descendants out, and it is completed only in the narrative that Figiel creates. Others may of course interpret the marks outside of their intended registers (as with the white film star who loves the incomplete Samoan tattoo in Figiel's novel, or with the New York women who fear O'Connell's tattoo). Outside of its home contexts, tattoo may create a similar casting out, removing the bearer from the accepted bounds of a differing community. So O'Connell finds that in the United States the designs' meaning is inverted—until he redefines them in his narrative and stage performances.

When tattoo—sacred in its home contexts—is bought, borrowed, or stolen, the designs' meaning comes unmoored. That process may heighten artistic freedom for the writers, artists, and designers who use the patterns; it may be highly meaningful to the individuals who bear the design and to the societies through which they move. But it is also true that in this process, the patterns may be treated as pure form. The people, ways of being, and lands that shaped the designs may be removed from consideration, treated as not

present (consigned to the distant past or to an unreachable place) if they are acknowledged at all. Such consequences are often completely unintended by outsiders who admire the designs.

Structures of thought and of law in the outside world support this copying out of sacred patterns from their traditional contexts, in which unique tattoos were and are created according to very specific protocols. This point explains why Māori filmmaker Barry Barclay declares, "'Out of copyright' hangs like a death sentence over the Indigenous image."[32] The indigenous image—whether a portrait, a tattoo, or a filmed or photographed image—remains volatile and sacrosanct in its home contexts long after copyright has lapsed. But once the image moves into the public domain, little prevents it from being removed entirely from its indigenous domains.[33]

The workings of public domain explain why Te Pehi Kupe's *moko* self-portrait, which in a very real sense conveys his personhood, has multiplied in a potentially endless reproduction on book covers. Te Pehi Kupe himself began that reproduction, creating his self-portrait in London, where demand was so high that he was kept busy for two weeks straight making copies of his design. The 1830 narrative that tells his story in *The New Zealanders* does not report whether he wanted to draw these images or received any recompense for them. It is certain that he was without money or provisions in a foreign land, relying on the kindness of an English captain who was extremely poor but still resisted repeated suggestions to display Te Pehi Kupe for money.

Te Pehi Kupe took matters into his own hands, so to speak, using the materials available to him to present his tattoos. His interactions with the Englishman John Sylvester, who drew his portrait, show that he cared that his *moko* was portrayed scrupulously: "he was above all solicitous that the marks upon his face should be accurately copied in the drawing."[34] In other words, Te Pehi Kupe responded to the contingencies he encountered in England by using different media to present himself. In one sense, his presence on so many book covers continues the journey he chose to take into the world. In another sense, however, against the silent workings of the public domain some Māori scholars speak out emphatically. When I gave a talk at the University of Auckland about the *moko*-adorned book covers, an art historian declared, "Permission never would have been given here [in New Zealand] to publish Te Pehi Kupe's image!" Publishing the image on book covers without following Māori protocols means removing the portrait from the cultural frame that gives it integrity. Such representations of *moko* were used historically as signatures on treaties

and deeds; reproducing it without permission is tantamount to forging a signature or misrepresenting an endorsement. Some would say it risks a form of identity theft.

Along these lines, contemporary *tā moko* artist Henriata Nicholas declares, "the *Moko* belongs to the client not only in bodily terms but also in intellectual property terms, and any photographs or visual representation of the particular *Moko* are owned outright by the client."[35] In other words, even the artist who creates the pattern does not own it, because she makes "each *Moko* distinctive and unique to that person" ("Carved in Skin," 158). The design portrays the bearer's "genealogy, specific landmarks, historical events, and *Kaitiaki* (spiritual guides)" ("Carved in Skin," 158). The design places the bearer in relationship to her or his family and community, and refers to physical and spiritual landscapes; viewed in this light, borrowing the pattern would be something like borrowing another person's skin.

A related matter concerns the holding of tattooed ancestral heads in museum collections around the world. The largest such collection appears to reside in New York, in the American Museum of Natural History. (Ancestral heads remain in museums worldwide, though institutions in Scotland, Australia, and Argentina have set an example in repatriating them, and in 2005 twelve *toi moko* were returned from institutions in Britain and Denmark.) To show respect for these individuals and their cultural and genealogical descendants, this book does not reproduce any images of human remains.

Scholars and artists have an important opportunity to work with institutions including museums and publishers to return indigenous treasures to their home countries. That effort could take the form of repatriating ancestral heads to Te Papa Tongarewa, Museum of New Zealand, which has a facility consecrated to guard ancestral remains. That effort could also take the form of being just as careful to document and credit indigenous creations as we are to cite works of individual scholarship. Such awareness helps restore a rich cultural depth to discussions that have important implications for understanding individual authors, academic disciplines and, more broadly, the way subjects are constituted inside the academy and out.

Historically, such forces as the marketplace and academic and protoacademic study combined to threaten the survival of the very images that are now featured in museums and on book covers. The hunger for tattoo led to the violent removal of heads from living bodies, the production of heads for purchase or study. Other heads were removed from their ritual mortuary scenes. The first full-length book on *moko* was written by H. G. Robley, based in part

on his extensive collection of such heads. He had fought in the colonial New Zealand wars against warriors like Netana Whakaari and obtained four large portmanteaux of tattooed heads.[36] After he returned to England, he traveled with his portmanteaux and, in a photograph taken at Addlestone Lodge by Henry Stevens of Stevens' Auction Rooms in Covent Garden, sits in front of a garden shed wielding a Māori battle club; arrayed behind him are thirty-three heads.[37] His posing with the Māori battle club makes explicit the violence and appropriation such a display involves.

Those ancestral heads formed the basis of the collection now held in New York, a collection that Margaret Mead used to help create her 1928 monograph on Māori life and art. She declares, "The Museum is fortunate in having the magnificent Robley collection of preserved Maori heads, the finest collection of such heads in the world."[38] Her monograph was created as a visitor's guide to the American Museum of Natural History, displaying for new cultural tourists the spoils captured by a previous era's military travel.[39]

BEAUTY

Placing human heads in glass vitrines in a museum case, or in photographs in academic studies, removes the tattoo from its living human frame. Similarly, narrative and film may represent contemporary *moko* in ways that distance the designs from their vital histories and genealogies. Among the most widely distributed versions of contemporary Māori tattoo are Alan Duff's novel *Once Were Warriors* and Lee Tamahori's film based on the novel. This novel and film provide contemporary counterparts to Melville's portrayal of the way spectacular Māori and Pacific tattoo travels into the world. Chapter 3 analyzes the book and film *Once Were Warriors*, alongside Māori and Kantian theories of beauty.

Both novel and film depict contemporary *moko* as present solely among Māori gangs. The film's invented *moko* patterns reinforce the novel's suggestion that the designs (and gangs) imitate a warrior past. One valid distinction is that these particular gang tattoos are created using electric tattoo guns, while *moko* were historically chiseled into the face, forming deep grooves. On the other hand, the presentation of *moko* as confined to the past except for inauthentic gang copies is challenged by many tattooed faces who wear these genealogies of design in the present. Writer-scholars including Witi Ihimaera and Ngahuia Te Awekotuku underscore the continuity of the *moko* tradition. Ihimaera notes in an interview that the art forms a living archive, a literature that

is a storehouse for Māori strength and survival.[40] Te Awekotuku declares that the Māori world "has never been bereft of the tattooed face" ("Skin Deep," 251).

The novel and film *Once Were Warriors* exhibit the way that tattoo, when entering the world market, may encounter a vastly different standard of beauty. In Tamahori's film, when Nig receives a full Māori facial tattoo, his younger brother admires the pattern but says, "I wear mine on the inside." Immanuel Kant, too, suggested that the designs are beautiful, but only when separated from the human face. By contrast, this book identifies an aesthetic that celebrates *moko* as a living face of Māori genealogy, worn by old and young, women and men: a sovereign design of a people resisting colonization.

ETHICS

The *moko* may display a person's affiliations and ancestry, the lines of descent and ascent that make the individual part of a community and give her or him a standing place in the world. As such, the patterns may declare genealogical connections that have profound political and spiritual implications. Genealogies are powerful and even sacred, connecting the individual to the community and the gods. In part, these deep meanings inhere in tattoo from its beginning. In part, they are intensified when the art is condemned and its practice becomes a defiant assertion of sovereignty. Chapter 4 tells the story of tattoo rebellions and practices in the French Pacific, Hawai'i, and Tonga that occurred long after missionaries proclaimed the practice dead.

From the beginning, tattoo, the practice that may render genealogy visible, is considered *tapu*, or sacred. This concept occurs across the Pacific and recognizes at once the distinction and closeness between people and the divine. *Tapu* indicates something or someone that bears sacred power and is restricted, set apart from *noa*, the profane or ordinary. But *tapu* can indicate prescription as well as proscription, and it protects as well as limits those people or entities on either side of the designation. *Tapu* can shift and move; the same thing or person might be *tapu* in one situation and not another.[41] *Tapu* and *noa* are not strict opposites, but complementary counterparts that indicate the presence of the sacred in everyday life.[42] Because it spills blood, because it makes visible deep energies and allegiances, tattoo embodies the volatile power of the sacred.

Henriata Nicholas suggests that the power *moko* bears creates the need for respect and humility on the part of the artist and the recipient. She declares, "Our culture is based essentially on the connection we have with one another,

the environment, all living things, the universe, our ancestor connections, and the creator of all things" ("Carved in Skin," 158). The designs of *moko* convey these connections and make them visible. Moreover, because the patterns are created in skin, by shedding blood, the vital forces that are at the heart of the culture and the individual are brought to the surface. "Because the process [of *tā moko*] deals with the spilling of blood," Nicholas continues, "the whole experience is enveloped by *tapu*—sacredness. So it becomes my job to make sure that the client, the stretcher (who pulls the client's skin tight), myself, and anyone attending are safe and everything is protected and honored with absolute respect and humility" ("Carved in Skin," 158).

Bearing other messages about the sacred, in many places across the Pacific, Christian missionaries attempted to work against tattoo. Perhaps because they taught the word made flesh, they often did not favor the marks that appeared to be words given flesh. Responses to tattoo of course vary by time, region, denomination, and personal inclination of the missionary. In Samoa, where the practice continued unabated through missionary times and colonial administrations, Christian churches historically may have disapproved of the practice but did not usually attempt to ban it, and now they coexist with *tatau*. Contemporary tattoo-master Petelo Sulu'ape, whose family are hereditary *tufuga ta tatau* or tattoo-priests, declares, "In the Catholic church even priests can get tattooed; I have executed complete pe'as [a *pe'a* is a traditional full-body male tattoo, from navel to knees] on several priests. Methodists and Mormons also allow it. Only the Congregational church is still not clear about allowing tattooing. Today most of the major religions in Samoa allow it as they feel that Christianity and the indigenous culture should be in harmony."[43]

Sulu'ape is the name of the family title, which designates him more formally Alaiva'a Sulu'ape Petelo; his brother was also a famous tattoo-master or tattoo-priest, Su'a Sulu'ape Paulo II. So his title and lineage attest to a religious tradition that predates Christianity in Samoa, and his work expresses the conviction that the two traditions may complement one another.

In other places, missionaries helped forge bans against tattoo and brutal punishments against those who received the patterns. Tattoo bans were included in the written code of laws in the Society Islands. Mrs. Favell L. B. Mortimer, for instance, writing anonymously for the American Tract Society to honor the fortieth anniversary of the Tahitian mission in 1836,[44] notes that missionaries disapproved of the practice because it was associated with "many other of their old heathen habits" (*Toil*, 203). But Tahitians did not forfeit *tatau*, and they continued to practice the art. As a result, Mortimer reports, "The only way to

prevent tattooing was at length found to be, having the parts that were marked, disfigured by the skin being taken off, and foul blotches left where beautiful patterns had been pricked in" (*Toil*, 204). In other words, so opposed to the art were they that at least some missionaries supported the flaying or removal of tattooed skin. This celebration of mission history, written to foster financial and other support for continuing efforts in the Society Islands and the Pacific, recounts breathtaking violence within tattoo-suppression efforts.

Why was it necessary to resort to such extremes in fighting the practice? Answering that question reveals a tattoo history in Tahiti that has been suppressed until now. While missionaries announced (and tattoo scholars now repeat) that the ban was so successful that the art ceased quickly and entirely, written records created by other observers (and sometimes by missionaries) contradict that claim. In fact, numerous tattoo rebellions erupted in the Society Islands. Those tattoo rebellions propose a revised history of Tahitian tattoo. Rather than vanish, for decades after it was declared dead Tahitian tattoo continued to be practiced against the new forms of power supported by the written law codes. After its demise was proclaimed, tattoo went underground and under the clothes imported by the missionaries. It is possible to reconstruct similar histories for the distinct traditions of Hawaiian and Tongan tattoo, both of which continued after the datelines drawn for their deaths. In Hawai'i the practice continued in the face of suppression by the American Board of Commissioners for Foreign Missions; in Tonga, the practice persisted after it was outlawed in the first written law codes.

The colonial history of Tahiti is now being rewritten, *contra* the official French histories that claim Tahiti was ceded peacefully, to include "the Franco-Tahitian War of 1843–1846, and the Leewards War throughout the 1880s and 1890s when French protectorates were fiercely resisted by island monarchs, dozens of chiefs, and thousands of warriors throughout multiple island groups."[45] So, too, it is time to rewrite tattoo history. Researches in primarily written archives yield evidence that tattoo continued in all of these places decades past the time when the art had been deemed completely suppressed.

In many islands in French Oceania, tattoo formed a fierce resistance to the new laws against long-standing Pacific ways of life. One vivid example occurs in the Marquesas Islands, where the art reached a peak even relative to other flourishing Pacific tattoo traditions. Marquesan men had historically been tattooed on almost every available surface from head to toe. In defiance of a ban against the art, Moa-e-tahi, who lived in Nuku Hiva at the turn of the twentieth century, wore a script tattoo that declared, in Marquesan letters that

adorned his arm, "Kahau hee atua Ioava! Ii kehu, ahi veu; vave te etua!" In English, the tattoo declares, "You are invited to follow the god Jehovah! [His] anger is ash, the flames are wet! Hurry to the gods!"[46] Forty years after the ban had first been promulgated, Moa-e-tahi and others use tattoo to defy the new laws and the missionaries who helped introduce them. And they do so using a written language taught at the mission schools; the new medium of alphabetic writing is used to convey a message about allegiance to Marquesan beliefs and practices.

Once the traditional grammar of tattoo design is outlawed, the Marquesan message takes on new meanings and uses new forms, including the script used to bring the Christian Bible to the Pacific. Tattoo no longer conveys just the way things are, but also the way things were and the way things might be. The prophetic or visionary aspect of the art comes to the fore. Tattoo proclaims loyalty to lines of descent and affiliation that contest the new colonial boundaries drawn across the sea. Tattoo becomes a sign of protest, a banner of a sovereign people of the land.

As an art that continues to travel throughout the Pacific, tattoo marks Oceania as a visible sea of islands. In Epeli Hauʻofa's "sea of islands," the people of Oceania are connected by ongoing traditions of navigation and exchange.[47] Tattoo is one of the longest-standing and most dramatic forms of such culture transfer. Even as it signals one's social and cultural standing places, the practice bears traces of elsewhere. In stories of its origins, for example, Greeks attribute tattoo to the Thracians or Persians and Romans attribute it to the Greeks, while in the Pacific Samoans and Tongans credit the Fijians as the source of tattoo, Fijians credit the Samoans, and Māori credit the underworld.[48]

In these origin stories, tattoo expresses a practice of borrowing from "elsewhere" in order to designate the bearer's home place. Among those who felt most keenly the tattoo's conjoining of the foreign and familiar were white visitors who acquired full Pacific tattoo. Temporary visitors might avoid the ritual, but those who stayed could encounter intense pressure to acquire the marks. If tattoo registered adulthood and participation in social networks, the unmarked visitor was anomalous, standing alone in places where isolation went unrewarded. Melville's protagonist in *Typee* becomes separated from his traveling companion, Toby, and experiences repeated demands that he receive Taipi tattoo or, as he puts it, submit to the "utter ruin of my 'face divine.'"[49]

Entirely apart from subtle or overt coercion to acquire the marks, appreciation of the designs or simple vanity could offer a good motive. Early in the nineteenth century the English missionary George Vason failed to convert a

single Tongan but obtained a full *tātatau*, boasting, "I looked indeed very gay in this new fancy covering."[50] While Vason converted to Tongan ways, he and his colleagues failed so signally in their mission that they did not even manage to communicate their purpose. William Mariner, who lived in Tonga a few years after Vason, reports that Tongans believed the previous English residents had joined them because they preferred the warmer climate. Vason in Tonga, like O'Connell in Pohnpei, bore his tattoo as a member of the community; the marks became notable after he returned to the ship society, where they inspired shame instead of pride. Vason redeemed the marks by rediscovering Christianity, a process he purports to complete in his narrative. On the other hand, the loving descriptions of Tongan life, including *tātatau*, suggest that there is more than one way to find redemption. Though he was unable to articulate the idea explicitly, Vason's counternarratives anticipate Petelo Sulu'ape's suggestion that tattoo and Christianity can coexist.

CULTURE

Perhaps as a result of such receptions outside of Pacific communities, many white men who received traditional tattoo fashioned identities for themselves based on simultaneously avowing and disavowing the knowledge and experiences attested to by the designs. Many of those who displayed the designs in the United States or Europe invented the fiction of the forcible tattoo—which authenticated the patterns they displayed for money but exempted them from responsibility. For people who acquired Pacific marks and then departed the region, tattoo remained a sign of a specific place that came to represent elsewhere, sometimes indicating a desired destination. John Rutherford displayed his facial *moko* in England so he might finance his return to the Pacific. Joseph Kabris and Edward Robarts, who bore *tiki*, left the islands but spent the rest of their lives yearning for the Marquesas. In all of these cases, once the bearer leaves the Pacific the tattoo requires explanation, inspires new narratives. The white men who acquire tattoo make visible the way the patterns designate entire ways of life. In these narratives, tattoo embodies the concept of culture decades before E. B. Tylor introduced the concept in its modern sense in *Primitive Culture* (1870).[51] Chapter 5 examines the way white visitors (tattooed and not, famous and not) bring the practice back to their homelands.

Tattoo's embodiment of culture is tested in a particularly vivid manner in the Marquesan practice of repeating the tattoo until pattern is obliterated. The resulting field of dark pigment, where the entire body is blackened, takes

tattoo's signification to an extreme. Pattern becomes so extensive that it cannot be distinguished; the body is wrapped not in images, not in text, but in a solid second skin. These early depictions of tattoo as culture inspire a series of (apparently untattooed) visitors' comments on these solid fields of pigment. Descriptions of solid tattoo written by Porter, Stewart, and Melville heighten a quality of all tattoo commentary: in speaking of the design, the observer tells not so much the design's stories as his or her own story.

The solid tattoo field, like all patterns seen in skin, deflects attempts to assign to pigment a single story. More than multivocal, tattoo pigment reveals one of the earliest kinds of culture narratives: culture is that which travels, which claims us and which we claim, which incorporates the foreign and the familiar, which we see in other places and in our own faces, reflected in other eyes. The haunting quality that unites these tattooed and untattooed visitors is that they create the forcible tattoo and the concept of culture to manage the tattoo, to indicate difference rather than belonging. Because they will not allow tattoo to designate home, they cannot be at home with tattoo, and the tattoo becomes a sign of the foreign, while the tattoo wearer becomes a wanderer or an exile. In all cases documented thus far, the tattooed white travelers are men, and their marks register differing forms of masculinity inside and outside the Pacific.

Tattooed white men are anomalous outside the Pacific in the nineteenth century, but even after the tattoo became more widely diffused in the United States and Europe in the later nineteenth and the twentieth centuries, the marks often continued to be viewed as aberrations and as indications of deeper marks within the psyche. Along with the social science fields emerged a tradition of using tattoo to present diagnostic readings of the bearer. Cesare Lombroso in Italy and Alexandre Lacassagne in France attempted to divine a correspondence between tattoo and criminality. In Austria, Adolf Loos declared that anyone who receives a tattoo and dies without committing murder dies before fulfilling his destiny.[52]

SEXUALITY AND GENDER

As the study of the human psyche continued, many attempted to define a correlation between tattoo and what they viewed as sexual deviancy. According to this logic, the tattooed man is a latent (if not an overt) homosexual who seeks the tattoo needle's penetration as a "form of homosexual experience."[53] More, the type of tattoo indicates the scale of the bearer's sexuality: "The homosexual

has his form of tattooing. The latent homosexual has his."[54] Correspondingly, the tattooed woman is deemed to be sexually experienced. In one rape case in a 1920s Boston court, the prosecutor declined to continue the trial after learning that the alleged rape victim bore a butterfly tattoo on her ankle: even though she had not experienced sexual intercourse prior to being allegedly raped by several men, he concluded that the tattoo needle's penetration of her skin had already violated her virginity (*Secrets*, 3–4). This logic (which would limit rape victims to non-tattooed virgins) uses tattoo to "diagnose" a sexuality and psyche viewed as aberrant. Chapter 6 gathers materials on Pacific women's tattoo, which have not been previously examined together, and complicates the (non-Pacific) medical tradition that sees tattoo as pathology.

The assumption that tattoo indicates an aberration from an assumed norm informs even recent anthropological discussions of tattoo. Alfred Gell's study of Pacific tattoo, *Wrapping in Images*, claims that tattoo features in this region because "these are societies which are dominated by criminals, soldiers, and prostitutes" (19). Gell also creates an epidemiology of tattoo, treating the designs as an epidemic, a "somatic illness" (19) or "cultural 'disease'" (163) that transfers from skin to skin. These images of a contagion, along with the claim that the designs thrive among "criminals, common soldiers and sailors, lunatics, prostitutes, and so on" (19), pathologize tattoo.

None of the societies that create Pacific tattoo, on the other hand, treat the designs as aberrant, much less pathological; instead, the patterns designate maturity, which includes but does not fetishize gender and sexuality. Pacific tattoo worn by women make this point clear, especially in the cases of Vitian Fiji and Pohnpei, where women were the traditional tattoo artists. The patterns point toward a woman's beauty and desirability, placing her as they do within social and sacred networks. In other words, sexuality is not separated out from any other aspect of a full human life. This point has important corollaries for conceptions of identity. Not only does Pacific tattoo uncouple the putative link between body art and sexual deviancy, but it also points toward conceptions of gender and sexuality that do not necessarily predict behavior or identity. Thus, in the Pacific, the "discrete analytical categories of 'homosexuality' and more fundamentally 'sexuality' itself, are a colonial imposition";[55] and the distance between sexual acts and gender identity allows for constellations beyond the strict homosexual-heterosexual axis.[56]

Because Pacific women's tattoo patterns and practices have received much less extensive study than have Pacific men's, the book's final chapter collects for the first time material on women's tattoo in many different Pacific cultures.

What we classify as sexuality is an integral part of a whole Pacific life. As a result, this chapter integrates and extends analysis presented throughout the book, and thus forms a capstone to the study.

Recognizing that tattoo does not correspond to a single meaning or even a single category of identity creates much richer and more nuanced understandings of tattoo, as of human sexuality and the psyche. Some of the meanings Pacific tattoo expresses today are traditional. "Even today," the tattoo-priest Petelo Sulu'ape declares, "in any place that Samoans live, it is very hard for a *matai* or chief without a tattoo to speak up at a meeting or other occasion" ("History," 106). The tattoo may delineate sacred genealogies of descent, indicating authority and making possible speech and language itself. Meanings may also both continue and adapt: *moko* now appear most prominently on young men and older women, where they signal respectively physical strength and cultural authority. Or meanings may be both sustained and inverted to create serious comedy. In *Kisses in the Nederends*,[57] Epeli Hau'ofa uses the traditional anal tattoo of Tonga to serve as the logo of the Third Millennium movement, which merges globalization and salvation: he thus both honors and upends the idea that either tradition or marketing is sacred.

A NOTE ON METHOD AND ORGANIZATION

This book seeks out Pacific perspectives on tattoo. That means the book considers contemporary tattoo as presented by practitioners, artists, writers, filmmakers, and scholars whose work promotes and is informed by deep cultural and linguistic awareness. That also means that the book reconsiders past descriptions of the practice and teases out meanings that do not fit the frame in which they are placed. Historically, visitors often did not promote Pacific understandings of tattoo, and they sometimes distorted them. For example, beyond the Pacific, many believed that tattoo placed the bearer outside the bounds of the human, a view drastically disparate from one in which the patterns designate the bearer as fully human. Nonetheless, sometimes the same accounts that proclaim the practice dead or attempt to denigrate it convey strong evidence to the contrary; rich Pacific views, uses, and interpretations of tattoo emerge in every chapter.

Pacific perspectives are emphasized by the book's structure. The book is organized by theme in order to investigate in depth several of tattoo's important aspects: language, identity and property, beauty, ethics, culture, and sexuality and gender. The book's thematic organization has a further benefit. It

also challenges some of the assumptions about time and culture that have pre-
vented fuller understandings of tattoo. These assumptions, which are explored
in detail in later chapters, place the Pacific in the past and the United States
and Europe in the present, or suggest that indigenous cultures are static and
unchanging.

This book's methodology examines the presence of the Pacific in modern
tattoo. The first chapter begins with contemporary Pacific presentations of tat-
too. Wendt and Figiel establish that tattoo is the first signifier, the mark that
inaugurates language and a full social standing. So, though the writers are con-
temporary, they allow us to begin at the beginning, and to encounter tattoo
first through some of its Pacific frames, present and past.

These Pacific frames continue to be emphasized, even as we examine how
tattoo moves into the world, borne in part by travelers, writers, artists, and phi-
losophers. The book attends with corresponding care to the ways tattoo gath-
ers new meanings outside the Pacific. Writers, scholars, and thinkers whose
works are famous and familiar appear in a vivid new light. Given tattoo's sur-
plus of meanings, it is not surprising that some of the most significant think-
ers in the Pacific, the United States, and Europe have considered the practice.
Immanuel Kant, Herman Melville, and Jacques Lacan are among those who
provoke new insights into tattoo, even as tattoo's Pacific meanings make pos-
sible new insights into their works.

All of the chapters are informed by historical research and by attention to
language and culture; in fact, the book focuses largely on tattoo from the east-
ern Pacific, or culture areas often designated "Polynesian" by anthropologists.
That is not an attempt to overlook other important areas of the region, but
to allow the study to benefit as much as possible from deep readings of these
specific cultural traditions. For example, my work with languages from the
eastern Pacific reveals some lively evidence of tattoo rebellions that has appar-
ently not been discussed in English until now. It is also the case that modern
tattoo traveled from the eastern Pacific through the world, so tracing the pat-
terns' spectacular movements on bodies and in books requires attention to this
part of the region.

The first four chapters focus on tattoo on Pacific bodies and faces; the fifth
examines tattoo on white visitors. Much of the tattoo discussed in the first five
chapters is shaped by gender: historically, most Pacific travelers who bore tat-
too beyond the region were men; similarly, most visitors who acquired tattoo
and wrote about it were men. Perhaps as a result, traditions of male tattoo have
been documented more exhaustively than have traditions of female tattoo. Tat-

too is of course itself a practice inflected by gender, so all of the chapters are attentive to gender, and chapter 6 focuses on Pacific women's tattoo. Women's tattoo is part of the whole fabric of Pacific life that each chapter documents; but given the imbalances in the written records, it is worth considering what we know and do not know about women's tattoo in particular. Each of the chapters in this study may be read on its own, and the chapters combine to portray an even fuller picture of the way modern tattoo emerges from the Pacific.

Tattoo is a primary form of signification that indicates who does and does not belong. The belonging indicated by permanent tattoo is, counterintuitively, not a fixed but a shifting designation. Depending upon who bears the tattoo and where that person stands in social, geographical, and cultural realms, the meaning of the marks may change. Those meanings may be claimed by the individual or assigned by the community, and in either case may be assented to or overturned by the viewer. In their implications the marks may be playful or deadly serious; they may wrap the bearer in a sacred second skin or cast the bearer out of human society; they may create erotic enticement or painful ignominy. And these apparently contrary meanings may exist at the same time and in the same place. Because of these rich extremes, as it travels in the Pacific and the rest of the world, tattoo defines and redefines the reach and the limits of human existence.

Tatau and Malu

VITAL SIGNS IN CONTEMPORARY SAMOAN LITERATURE

In two works by contemporary Samoan writers, tattooing produces and proclaims the psychological and social place of the tattoo bearer. Albert Wendt's short story "The Cross of Soot"[1] depicts a young boy whose partially completed tattoo, begun by a condemned prisoner just before the man leaves to be executed, represents the way the boy "crossed from one world to another, from one age to the next." The tattoo, as the boy's mother recognizes, stands as a mark of that passage: "For the first time her son was no longer afraid to stare straight at her when she was angry with him. He had changed, grown up" ("Cross," 20). In Sia Figiel's novel *They Who Do Not Grieve*,[2] a young woman is torn away from receiving a full-body female tattoo when it is only half completed. The character is prevented from receiving designs that help produce a full personal and social identity, and the uncompleted marks thus create a disgrace, leading her mother to disown her and ban her from their village.[3]

In both works, tattoo helps constitute Samoan subjects, and in both works the process is interrupted.[4] The tattoo serves as a sign of the traditional subject, but, in these depictions, because it cannot be completed, it also serves as a sign of a new subject. The forestalled pattern makes visible a process inherent in even completed tattoo: these marks on skin signal the splitting or doubling of subjectivity, a mechanism by which the individual human subject is produced continually and repeatedly.

The continuing production of the subject corresponds to the continuing movement of the tattoo. Even traditional tattoos embody the cross-cultural

traveling of signs, making visible and material the process by which culture moves both within and beyond the Pacific. That is, in Samoan stories (as in Tongan ones), the tattoo comes from Fiji; in Fijian stories, from Samoa; in Māori stories, from the underworld.[5] Even in its Pacific homelands, where tattooing has been practiced for three thousand years, in places that developed their own distinctive designs and techniques,[6] the tattoo is a sign of elsewhere. The patterns at once promise that the bearer will be at home—by bearing marks of belonging, meaning, and identity—and inaugurate a redoubled journey toward creating here from elsewhere. This apparently most fixed sign proclaims that the subject is as much an itinerary as an identity, that location is as much a passage as a place.

The Samoan word *tatau* helps create the English word *tattoo*.[7] In part because of the way the word and practice have traveled, in English and around the world, Wendt's and Figiel's portrayals of *tatau* offer several important implications for models of reading, in fields including Pacific, postcolonial, and psychoanalytic studies. The portrayals and practices of tattooing insist on the materiality and the local production of sign and word, of image and text, even as they make explicit the ways tattoos travel, not least the exporting of the practice of *tatau* to the world as *tattoo*, its Pacific origins often obfuscated.

The process by which the Pacific and the rest of the world meet and shape one another has sparked debate in Pacific literature studies. Often scholars trace the interactions between the Pacific and the rest of the world by using paired opposites: literature and theory, for example, or insiders and outsiders.[8] These formulations capture the oppositional impulses of much Pacific writing, which is often propelled by a powerful decolonizing impulse. On the other hand, writers and artists often achieve profoundly transformative work by creating a balance between and among these pairs and by challenging the very categories that create such polarities. Such an impulse is not surprising, since these classifications may limit political, artistic, and human expression.

To take a look at what these paired opposites might look like, Paul Sharrad, for instance, proposes that "the 'inside' of Pacific Literature, if it is broad and flexible enough, can appropriate a central position in literary debate not because it is essentially oppositional to a notional Western hegemony but because it can actually stand as a working model of much of the theory commonly labeled and used as Western."[9] Sharrad makes this statement in the context of proposing how important it is to work against treating Pacific literature as innocent of theory, a point that is very valid. But Pacific literature, more than standing as model of so-called Western theory, also challenges many of its

terms and assumptions. In other words, Pacific literature does not exemplify so-called Western theory, but questions how such categories are produced.

Examining tattoo extends this discussion by focusing on material and textual production that reveals the constitutive relation of the inside and outside, literature and theory, the Pacific and the West. It is not necessarily that Pacific literature serves as a working model of Western theory—or even that the two concepts have a fixed, much less binary, relation, much as current versions of "the local" and "the global" help constitute one another. Nor does so-called Western theory validate and complete Pacific literature.

Instead, as Selina Tusitala Marsh suggests, theory is not foreign to the Pacific. In her essay "Theory 'versus' Pacific Islands Writing," she begins with a poem and a defiant "refusal to see theory and art as incompatible entities, and second, to view theory solely as something foreign and outside myself."[10] The poem presents her own telling of Pacific stories as containing collective significance for herself and for Pacific Islands women. The poem begins with a lower-case "i" and closes with "we," using oppositions to move toward unity for poetry and theory and for "tama'ita'i," or Pacific Islands women.

By extension, the tattoo bears its own theories. The tattoo also offers an invitation to retextualize the well-rehearsed postcolonial text, to retheorize familiar psychoanalytic theories. As Epeli Hau'ofa declares, contrary to the widely accepted view that the Pacific consists of isolated islands adrift in a vast sea or is outside the major world movements of capital and culture, "Oceania is vast, Oceania is expanding."[11] Oceania has already traveled into high French theory, including Jacques Lacan's. Much as Wendt and Figiel portray the tattoo's production of the doubled or split subject, in the lectures collected as *Four Fundamental Concepts of Psycho-analysis*,[12] Lacan uses the tattoo to consider what he terms the split or barred subject and identifies the tattoo as part of a universal process: the creation of the subject. As this chapter investigates in detail, whereas Lacan presents the tattoo as a general, nonlocalized figure, Wendt's and Figiel's portrayals account for the tattoo's material and corporeal effects, its origins in Oceania, and its function in inaugurating the specifically Samoan subject. The Samoan works treat the production and movement of the tattoo, reshaping the English language and narrative conventions to create a written version of *tatau*. They also make possible a critique of particular theories, such as Lacan's, that have been viewed as universal, but that both contrast and coexist with Pacific considerations of tattoo and subjectivity. Restoring portrayals of Pacific tattoos to the conversation does more than reverse the typical vec-

tor of using European theory to read works from "other" literatures; it makes plain some of the ways the subject is produced in literature and theory.

Tatau ushers the bearer into language. The patterns signal the bearer's status as clothed for life: "Clothed not to cover your nakedness but to show you are ready for life, for adulthood and service to your community, that you have triumphed over physical pain and are now ready to face the demands of life, and ultimately to master the most demanding of activities—language/oratory."[13] The pain of *tatau* not only helps create the subject, but it also readies the subject for the intricate demands of speaking (oratory in Samoan, for instance, includes a formal or respect language that has as many as five registers, some reserved for specific persons of higher status). Tattooing is part of a process that is more than individual. Having a tattoo, Wendt declares, is a "way of life" ("Tatauing," 19).

The word *tatau* in Samoan refers generally to the practice of marking the skin, and specifically to designs worn by men from their navel to their knees. These designs form a full-body male tattoo—termed colloquially the *pe'a*. Figure 4, "Self-portrait with side of pe'a," by Greg Semu, presents an example of this type of tattoo. The *malu*, made with distinct motifs and patterns on a woman's thighs, is the female counterpart. Figure 5, a still from the film *Measina Samoa: Stories of the Malu* by Lisa Taouma, depicts the *malu* pattern, named for the distinctive triangular motif that adorns the area just above the back of a woman's knees. These stunning images at once present a living art and comment ironically on the tradition of representing such art in anthropological displays.

Historically, tattoos could be used to reinforce an existing order. In his study *The Samoa Islands*,[14] written when colonial powers began consolidating their presence in Samoa, the early anthropologist Augustin Krämer notes that while a chief's son could "choose his time" and be tattooed when he was almost full-grown (so that further growth would not "draw the pattern apart" [*Samoa*, 68]), other young men were obliged to accompany him, even if they were not full-grown. (Carl Marquardt verifies the practice in 1899, as does Margaret Mead in 1930.)[15] Marquardt notes that young women, too, often received tattooing at the same time as the chief's son.[16] Thus, though not all young women took their tattoos at the same time, the creation of *malu* was similarly social

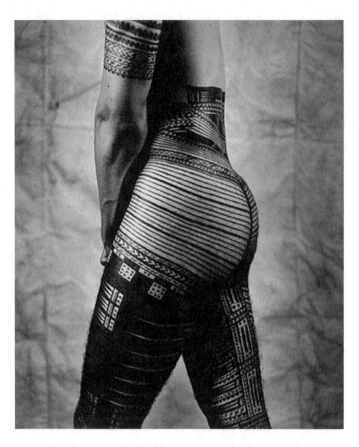

FIGURE 4. Photo by Greg Semu. "Self-portrait with side of peʻa, Basque Road, Newton Gully," 1995. Gelatin silver print, toned with gold and selenium. Published with permission of the artist and Auckland Art Gallery Toi o Tamaki.

and collective. Producing the designs could be one way of ensuring an orderly succession.

On the other hand, tattoo can disrupt the existing order. In colonial times *tatau* represented an overt proclamation of allegiance to Pacific ways rather than to the language, culture, or political hierarchies brought by outsiders.[17] The first Samoan independence movement—the 1908 Mau of Pule, which advocated autonomy from the German administration—like the 1920s Mau movement against the New Zealand administration, embraced tattooing as a marker of Samoan ways.[18] Since the nation achieved political independence in 1962, Wendt notes, there has been a resurgence of tattooing ("Tatauing," 23),

FIGURE 5. Photo by Lisa Taouma. Still from Lisa Taouma, *Measina Samoa: Stories of the Malu, 2005*. Published with permission of the artist.

one that corresponds to Samoan literature in which writers use *tatau* as a structuring principle.

Tattoo can thus serve as both a transmission of and a challenge to differing forms of authority, in a double movement that encompasses the status of the designs; at once more than skin deep and marking the skin as a surface, the patterns remain both inside and outside the body.[19] The figures by extension make visible subjectification, by which subjects claim and are claimed by the processes that reproduce culture. The figures show the simultaneous creation of individual and social standing places, as a person seeks the designs that express the interior and absorbs the patterns that mark the exterior: "The basic schema of tattooing is thus definable as the exteriorization of the interior which is simultaneously the interiorization of the exterior" (*Wrapping*, 39). As they explore this process, Wendt's and Figiel's accounts make possible a critique of Lacanian and finally of Samoan models of subjectivity. The tattoo's interior and exterior fields both emphasize and challenge the Lacanian focus on a discrete, bounded subject and, in turn, the Samoan focus on a collective, corporate subject.

In her introduction to *Written on the Body*,[20] Jane Caplan suggests that Western European tattooing may have been active in 1769, when Captain James Cook helped import *tatau* into English while his traveling companions incorporated Pacific designs into their skin. Responding to this point in his

introduction to *Tattoo*, Nicholas Thomas notes the surprise that Cook and his fellows evinced at the practice, which indicates that any extant European tradition could not have been widely known. By extension, cross-cultural readings of Lacanian theories and Samoan literatures make visible the way Pacific tattoo moves into other parts of the world. From this transit emerges the sign that creates the subject.

THE SUBJECT OF *TATAU* AND *MALU*

Wendt's story, like Figiel's novel, is written after but set before political independence; it traces the way *tatau* serve as a flash point in the circulation of power. Wendt and Figiel show that even when they are incomplete, tattoos signal a radical change in the tattooed character's place in the world and indeed the world itself. Both writers remake the conventions of literature and language in order to portray this newness, emphasizing the materiality of the signifier as they create a written version of the tattoo. For Wendt, a debased realism gives way to a tattoo-based revelation; for Figiel, proleptic and partial translations of the Samoan *tatau* terms she uses create a narrative structure that follows and completes the design of an incomplete *malu* or full-body female tattoo.

The tattoo in Wendt's portrayal, created on the boy's hand by the prisoner, makes the boy aware of himself as a subject and marks him, in his mother's terms, as "grown up" ("Cross," 20). "The Cross of Soot" uses metaphors that render the apparently smooth surface of realism almost diseased, beginning with Wendt's opening sentence: "Behind him the hibiscus hedge was bursting crimson boils of flowers ... a twisted breadfruit tree threw a fungus of shadows over the boy busy clearing the grass with short pecking movements of his hands" ("Cross," 7). The story's extravagant metaphors draw attention to words as signs, emphatically not allowing the reader to experience a realism that occludes the means of representation. Wendt warps the conventions of realism further when the unnamed boy meets the condemned prisoner, Tagi, whose "hair seemed to be growing whiter," and whose "reflection seemed to be disappearing" ("Cross," 18, 19). While tattooing the boy, Tagi is called away to be executed; the intended star tattoo, unfinished, forms a cross on the boy's hand.[21]

Realism begins to take the form of revelation when "like the turning up of the palm of a hand Tagi disappeared around the jail" ("Cross," 20), and the boy crosses the stream that separates his yard from the prison yard. Return-

ing to his own yard, the boy "looked back as if he had forgotten something" ("Cross," 20), having moved from one world and one age to another. In that movement, Tagi becomes in the boy's mind "the Man who died on the cross" ("Cross," 20). When the boy's mother asks who gave him the tattoo, the boy declares that it was Jesus: "And he's never coming back. Never. He left me only this" ("Cross," 20). For the boy, the condemned prisoner is transformed into Jesus, but Wendt modifies the conventions of revelation too: this Jesus will not return. In other words, we do not encounter a transcendental signifier in a Christian sense; the cross of soot is the form that the resurrection or second coming takes. That form creates a self-aware young man who for the first time meets his mother's anger by staring straight at her.[22]

In its incompleteness and materiality, the tattoo thus inscribes both loss and gain, forgetting and recognition. Whether it is finished or not, the subject is inaugurated with the making of the first mark. A question remains about the degree to which the process can be closed or completed.

The story emphasizes the subject's doubleness and incompletion, in everything from narrative patterns to tattoo portrayals. Wendt both uses and undercuts the conventions of realism and revelation, as the boy crosses over the stream to the prison yard and back. The cross tattoo itself, consisting of two lines, registers further forms of the subject's doubleness: the cross on his hand is both animate and inanimate, separate from him and incorporated into his skin. When he first sees the tattoo, "a black cross stared at him from his hand" ("Cross," 19); after Tagi leaves, the boy "clutch[ed] his [now-tattooed] hand as though he was holding something precious" ("Cross," 20). In a show of mimetic desire, he requests the tattoo after he notices an eagle tattoo on another prisoner's arm. The process indicates how people reproduce tattoos and in so doing invokes two traditions: the prison tattooing that has been prominent in many countries (beginning perhaps in response to penal tattooing) and the tattooing sought by Christian pilgrims to the Holy Land (especially from the fourteenth through the sixteenth century).[23] Tagi marks the boy's hand just before his own body is marked in an execution that remains powerfully present but unnamed.

The power exercised in the impending execution is referred to indirectly in this story, unlike that in Franz Kafka's short story "In the Penal Colony,"[24] where the sentence is written on the skin and death administered through the ever-deeper inscription. Kafka offers a parable about a prison officer who becomes troubled by the method of execution and finally substitutes his own body for a convict's, only to have other guards halt the sentence he is having

written on himself—"Be just"—when it is too late to save him. Wendt's story, too, is about the way people work in confined circumstances to form their own sentences. In Tagi's execution, portrayed only through its effect on the other prisoners, the police, and the boy, the law creates its last mark on Tagi's body. Juridical codes are no longer literally written on the bodies of convicts in the way Kafka portrays. Michel Foucault's tracing of the modern disciplinary process suggests that "execution should cease to be a spectacle and remain a strange secret between the law and those it condemns."[25] In Wendt's story, the death sentence is an unspectacular marking of the body as condemned. Through the tattoo and its effect on the boy, Tagi has also left a very different mark, one that pronounces a sentence of transfiguration.[26]

The boy acquires his nontraditional tattoo by traveling physically, making a double move that inaugurates a corresponding psychic and social journey. His tattoo is not the full-body male *tatau*, but Wendt emphasizes that the design is gendered, created in the masculine prison world as one man's last act for a boy who becomes a man. The tattoo serves as a substitute for the dead prisoner, a sign that the artist is still present. In moving into life as an adult, the tattooed boy also substitutes for the artist, standing for him in the ranks of men.

Since political independence, there have been no state executions in Samoa. That Tagi's act of creation survives him means that the tattooist, like the writer, works beyond the ending of colonial power and of narrative conventions in English. Wendt grants Tagi a resurrection in a sense that is not Christian but literary, suggesting that his figure of resistance authorizes the boy, who will become one of the Pacific's major writers.

The story contains autobiographical elements that support this reading of the boy. Wendt notes, "I do have a small modest tattoo, a cross in fact, right here on the back of my hand. The result of a tattoo that was going to be a star but attained only the form of a cross because the prisoner who was tattooing it was called away before he could finish it. I returned home to an angry father, and years later to writing one of my first published stories, *A Cross of Soot*, which is based on that incident" ("Tatauing," 25).

Figiel's novel, too, presents a tattoo that is completed in narrative if not on skin. In her novel about *malu*, the tattoo's mutual expression of individuality and sociality shapes language and the narrative conventions of fiction. Figiel offers partial, contextual, and proleptic translations of the Samoan tattooing terms she uses. In this way, she invites readers to move forward and backward in the text and in narrative time to appreciate her varying glosses on the terms,

and she completes her account of tattooing in the very design and structure of the book.

Folding and enfolding together English, Samoan, and other Oceanian languages, Figiel creates a linguistic and narrative arc that follows and completes the tattoo lines. Gayatri Spivak, analyzing the distinct histories of the Indian subcontinent, terms English "a violation that enables."[27] Figiel's presentation of English, especially in *They Who Do Not Grieve*, suggests that Spivak's phrase applies to the Pacific. But if the character Malu struggles with English, the character Alofa describes herself "chewing the new alphabet [of English]" (*Grieve*, 172). Figiel's depiction of English creates a space between Spivak's formulation and one offered by Vilsoni Hereniko when he declares, "English can be said to be just as much the language of the Pacific as that of the English people."[28] Samoan shapes Figiel's English, but here language itself, whether English or Samoan, becomes a burden that enables.

One of the reasons her award-winning books are both celebrated and controversial in Samoa is that Figiel breaks the rules of a language that intricately recognizes social hierarchies. In her works, which are created for performance, speech and oratory are present, breaking into writing, in all their elaborate and sometimes prescriptive forms.[29] She remakes the conventions of writing Samoan, using the spoken forms of words rather than the written ones. Orthography would dictate writing the insult "*Thighs as thick as a ka'amu*" (*Grieve*, 51; italics in original) as "Thighs as thick as a ta'amū," but she retains the spoken form of the word for the large herb that is related to the starchy root taro but eaten only in times of famine.[30] She thereby underscores the raw insult Malu receives when hearing this phrase. In other words, to convey the subject making that *malu* heralds, Figiel challenges conventions in written English and Samoan. She thus emphasizes how the subjects she portrays reshape given signs.

Book 1 opens with an explanation of the primary narrator's name, but it offers first no translation at all, then literal meanings of the name, and then a description of some of the motifs that compose a *malu*. Finally, the female *tatau* is cited as one of the definitions of the name. Thus, from the outset Figiel exploits the way that words and ideas in Samoan may not find precise equivalents in English and may bend English in new directions. Malu declares, "My name is Malu (chicken-shit girl/dog-girl/rotten pig-girl/rat-child/horse-face/piglet, depending on Grandma Lalolagi's mood), granddaughter of Lalolagi herself (the lower heaven, the world)" (*Grieve*, 11). The opening identification of Malu and her grandmother gives a partial English explanation of the Samoan

names. Figiel translates Lalolagi's name (literally "the lower heaven," figuratively "the world"), but does not translate Malu's name; instead, the narrator substitutes the insults that her grandmother throws at her. From the opening page, Figiel emphasizes translation, not only linguistic but also psychological, as Malu transforms invective into a mock-heroic description of herself as granddaughter of the world.

Malu's next explanation of her name introduces the tortured relation between her identity and her grandmother's incomplete tattoo:

> I carry my grandmother's pain, my family's shame, in the letters that spell my
> name, M-A-L-U. In the commonly known beginning, Malu means "shelter,"
> "protection," like a fa'amalu, an umbrella that protects one from the rain. It also
> means to protect or to shelter from bad spirits. Thus I have protected the stories
> of my grandmother, the pain of shame she carries on her thighs, the one that
> lives in the letters that spell my name. (*Grieve*, 13)

The paragraph opens and closes with chantlike rhythms and a slant rhyming of "pain," "shame," and "name" that emphasizes the ignominy Malu feels in the word and sounds that designate her. The young woman's identity, which derives from and culminates in *tatau*, is inseparable from distress. She lives in the contradictory state that *tatau* inhabit, traversing internal and external worlds, a permanent wound and an elaborate healing art.

This passage offers a contextual translation of *malu*: the pain of shame that Lalolagi carries on her thighs is the unfinished *malu*. Figiel continues to extend the explanation of Malu's name and introduces the first fragment of the *tatau* story: "Besides being midnight-bastard-child of a whore for the children of the village, I am also a fish, a starfish, a spear, a centipede on my grandmother's left thigh" (*Grieve*, 13). The designs that cover her grandmother's leg give Malu her name; that they cover only one leg gives grandmother and granddaughter their shame.

The direct translation of Malu's name is the one Figiel provides last, when Malu states finally, "The female tattoo is my name: I am the fish, the starfish, the spear, the centipede that never was" (*Grieve*, 14). The first part of the statement is a clear assertion. So far, the movement from Samoan to English seems smooth and uninterrupted. But this direct translation becomes quickly complicated. For Malu qualifies her name as the figures in the tattoo "that never was." A statement that begins with a positive correspondence between the name for the female tattoo and the character Malu ends in a proclamation of simultaneous identity and nonidentity. Figiel presents the movement between Samoan

and English and, more, between being and nonbeing, design and lack, motif and word.

In addition to wrapping her English narrative with contextual meanings of Samoan words and identities, Figiel uses *malu* as the structuring principle of her book. The story is told through two granddaughters, each of whom relates her grandmother's stories. The story of *malu*, which Figiel breaks up chronologically and presents fully only in the third and final section of the book, begins when the two grandmothers are young and vow to obtain a *malu* as sign of their friendship. One of the women completes her *malu*; the other does not, and lives with ignominy. The complete story of the unfinished *malu*, introduced in book 1 and presented in short form in book 2, culminates in book 3 in a full confession.

In a further instance of narrative doubling, Figiel uses two first-person narrators and takes the title for *They Who Do Not Grieve* from the Māori writer Witi Ihimaera's use of a phrase from Wordsworth. Figiel notes in an interview that she borrows the idea from *Nights in the Gardens of Spain*.[31] In "Ode: Intimations of Immortality," Wordsworth writes, "We will grieve not, rather find / Strength in what remains behind."

Malu makes the *malu* pattern here by means of narrative: she becomes a subject in telling this story. Figiel's portrayal makes overt the notion that the tattoo artist's work serves as a figure for the writer's art. The designs he makes are "a form of writing," as he tells it: "*Gathering the soot for the ink was a prayer. Every action associated with the tattoo was a prayer. Is a prayer. The gathering of the materials and the act of tattooing itself, which I equate to a form of writing*" (*Grieve*, 228; italics in original). The tattoo, which the *tufuga* sets explicitly outside the Christian church, Figiel sets inside her writing. Once again, though, as is familiar in tattoo, the inside and outside form one another. The photograph of the *malu* that appears on the cover of the book, enclosing the book's narrative, is not just a wrapping or an image but an integral part of the story and its language. Similarly, in this account the *malu* designs form a kind of writing, one that inspires yet exceeds printed words.

The paradoxical doubleness of the tattooed subject returns: Malu, who becomes a subject in fashioning the complete story of the *malu* designs her grandmother bore, is given contradictory advice. Lalolagi enjoins her granddaughter, "*Don't write anything down*" (*Grieve*, 13; italics in original), yet Lalolagi's dying act is to press into Malu's hands a dictionary that is a family treasure: "the alphabet had spilled, running wild through the spaces between my fingers" (*Grieve*, 242).

In the narrative logic that Figiel's book upholds, doubleness is evident in *tatau* from the start. One of the stories that accounts for the origins of tattoo is that two women, conjoined twins, brought the practice to Samoa. Meeting these twins in her dreams, Malu "did not understand whether to call them one or two. . . . They were identical. Everything about them was the same, but they could not see each other" (*Grieve*, 43); stuck back to back, seeing everything that came at them from any direction, "they had no fear" (*Grieve*, 43), Malu concludes, and that was why they swam from Fiji to Samoa, bringing tattooing with them as they traversed the waters. Later in the myth and Figiel's version of that story, the two-in-one tattoo goddesses become separate women. In this way, *tatau* from their attributed origins form a subject that is both doubled and split.

The tattooing pair Malu seeks is similarly broken apart. Shortly before she dies, Lalolagi tells the story: having been alerted by her jealous friend (the same friend who is taking the *malu* with Lalolagi) that Lalolagi and the tattoo artist are having an affair, the women of the village, led by the tattoo artist's wife, tear Lalolagi away from being tattooed, rip her ear off, and throw it to the dogs. The ordered bloodshed of the tattoo gives way to the punitive bloodshed of a public shaming. (In exacting vengeance, the women fulfill the expectation that they will enact a ritual shaming.) The incomplete design makes the humiliation permanent, penalizing the illegitimate daughter Lalolagi bears, and that daughter's daughter. Notably, only Lalolagi is punished; the tattoo artist vanishes from the village and her story. The mother's name, a sign of outcasting like the unfinished *malu*, is the only one that her children bear.

The women who punish Lalolagi use *malu* to confirm social patterns by recording their violation. The tattoo that Figiel portrays, however, is nontraditional from the outset. Even if it were completed, the design would not confirm the order of things, because it testifies to a forbidden expression of sexuality. Once the patterns are interrupted violently, their very incompletion becomes both an attempt to reestablish order and a testament that it has been violated. The women punish the trespassing woman, emblazoning the scandal on her body, while the tattoo artist, who wished to emblazon his love on her body, disappears. As in the Wendt story, the circulation of power removes the tattoo artist from the story and impels the writer to carry on that art.

The marks that remain express both sexuality and its foreclosure. Figiel critiques the process by which women's sexuality becomes forbidden—regulated and displaced by other women. Lalolagi and her unnamed lover share personal

pain in being ripped apart from one another; her pain, unlike his, is also social, one that she passes on to her female descendants as a warning against transgression. The *malu* and the blank space where the remainder of the design would fit are gender-specific. For Figiel's characters, that blank is a sign of dishonor. In her narrative, however, Figiel renders the space one of possibility, using it to write a different ending, in which the marks are completed in narrative if not in skin. She appropriates the power of the tattoo artist to create a form of writing beyond that authorized by the church, the village hierarchies, and the languages she uses.

Wendt's and Figiel's characters recognize themselves as subjects through their encounters with tattoos. As these marked subjects suggest, the tattoo expresses and creates both an individual's externalized claim to identity and a more or less internalized and standardized mark of sociality. In duration, tattoo marks are as mortal as one's skin; at the same time, their patterns persist across and reproduce the life of the culture. The designs are both dependent on and independent of the single subject, who exhibits an intimate and impersonal relation to the marks.

Like the conjoined twins who bring the practice to Samoa, as first one and then two, the Samoan language reflects a nonsingular conception of the subject by allowing for different degrees of closeness between subject and signifier. *Tino* or "body," for instance, is classified as a personal noun, a noun that signifies an intimate connection to a person (also present in this category are the words for "mother," "clothing," and "canoe"). The words for "tattoo," "language," and "culture," however, are classified as nonpersonal or impersonal nouns.[32] It would seem obvious that a tattoo is closer to the subject than is a canoe, but the nonpersonal status of the Samoan noun *tatau* suggests the repeated process of conjoining and splitting that characterizes the tattoo in portrayals of Samoan subjects.

The intimate and impersonal tattoo signals both the interior and the exterior, is created in a process that is both chosen and imposed, and forms marks that are both inalienable and impermanent. In Wendt's and Figiel's accounts, the tattoo is a recursive signifier, referring to and reproducing itself. It at once duplicates and branches off from itself, repeating itself with a difference on each skin, in each narrative. The process helps constitute not only the subject but also the signifier. In Wendt's and Figiel's works, the object of the doubling and splitting is the subject. As it recurs on skin and in narrative, the tattoo signifier that reveals the subject's doubling and splitting also reproduces

itself, indicating thereby the subject's continuing movement. The *tatau* and *malu* portrayals show the correlation between the subject's and the signifier's embodiment in tattoo. The portrayals, moreover, invite a critique of Lacanian and ultimately of Samoan conceptions of the subject as marked.

INALIENABLE AND ALIENABLE SIGNIFIER

Lacan declares that the individual subject is marked as a tattoo: "The subject himself is marked off by a single stroke, and first he marks himself as a tatoo [*sic*], the first of the signifiers."[33] The tattoo, in one move, creates the subject and the first signifier, establishing the subject in relation to the mark he makes on his own body. To extend Lacan's gendered terms, the subject is called into being only in relation to the sign that she or he forms. That first sign is specifically a tattoo.

Creating the tattoo, the subject at the same time becomes the one who marks and is thereby also notched as separate from the mark made: "Thus is marked the first split that makes the subject as such distinguish himself from the sign in relation to which, at first, he has been able to constitute himself as subject" (*Psycho-analysis*, 141). To mark himself as a tattoo on the bones of his prey, making a notch on a bone every time he kills an animal (*Psycho-analysis*, 141, 256)—an image Lacan repeats—creates a separation. The hunter is separate from what is counted and from the notch that marks the count; thus, from the beginning the subject is split, marked as a tattoo. More, the notch is not just a tally of a successful kill; "the reckoning is [not one but] *one* one" (*Psycho-analysis*, 141; italics in original). The lone notch—a line that drawn in the context of the English language would refer to both *one* and *I*—records both the kill and the act of counting. The notch, single but not singular, begins to determine what counts.

The barred or split subject is made visible in the tattoo. The splitting marked by *tatau* is related to what Freud termed *Ichspaltung* (the splitting of the I or ego). In Lacan's writings, which also refer to the divided or barred subject, the splitting is a feature of the subject's entry into the symbolic, or participation in language. It characterizes all subjects, not only those that exhibit the *Spaltung* that appears in classic psychoanalytic definitions of psychosis, hysteria, and schizophrenia.

The French word *tatouage*, like the English *tattoo*, derives from the Pacific word *tatau*. In adopting the sign of the tattoo as universal, however, Lacan

suggests a spontaneous and nonlocalized origin of the tattoo. An attempt to explain his disembodied tattoo could suggest that the subject marks herself or himself as a tattoo on the real and symbolic orders in a metaphoric process.[34] But returning the specific, historical sources and corporeal workings of tattoo to the discussion expands theories of the subjectivity that is produced in tattoo.

Lacan's split subject departs from the conjoined and separated Samoan subject. One emphatic difference in the Samoan accounts is that the tattoo is formed—or disallowed—in an inevitably social situation, applied by other members of the community. The Samoan subject is not composed solely of the individual who marks and is marked. "'I' am 'We,'" is the way Figiel expresses it. "'I' does not exist."[35] In this view, the Samoan subject consists of the marked individual but also of that individual's family and community (to note only two of the collectives that contain the subject). The tattoo produces and proclaims a subject and signifier that are constituted collectively.

"'I' does not exist, Miss Cunningham," a young narrator insists in Figiel's first novel. "'I' is 'we' . . . *always*" (*Where*, 133; ellipses and italics in original). The character responds thus, silently, to her teacher's criticism of the girl's English composition, which avoids the word "I." In the next chapter, Figiel describes the difficulty in comparing conceptions of the individual in English and in Samoan: "my self belongs not to me because 'I' does not exist. 'I' is always 'we'" (*Where*, 135). Figiel provides, in Samoan, a catalog of the forms of "we" that help constitute her speaker as subject.

The point goes beyond linguistics, for in Samoan separate first-person singular and plural forms do exist (in fact, distinct forms of the first-person plural indicate whether the speaker includes or excludes the interlocutor in a given statement). Even when an approximate equivalent exists in English, Samoan subjects carry not only a burden of language (oral, written, Samoan, English) but also a material and collective signifier that makes them more than individual, responsible to shared imperatives. Today, even in countries outside Samoa, *tatau* announce that the bearer has acquired "a passport to service" and assumed increased duties to community and culture ("Tatau-ed," 26). The worldly effects of tattoo, as both a continuing of Samoan authority and a challenge to colonial or imperial authority, persist.

Reading Lacan through the lens of *tatau* suggests a more cumulative and collective—if no less conflictual—formation of subjectivity. The Samoan portrayals of tattoo suggest that Lacan's formulation must be revised to take into

account the recognition that there is no such thing as only one tattoo notch. To extend Figiel's statement, in the doubling that tattoo features, *I* does not exist; nor does *one* exist. Even in Lacan's statement, the one is single but not singular. It indicates the act of counting, a tallying that, revised in accordance with the Samoan portrayals, is grounded in present histories. Separate from the signifier, separate from the doubling and splitting that tattoo makes visible, there is neither *I* nor *one*. And in the Samoan accounts, neither that *I* nor that *one* is single or singular.

Wendt's and Figiel's portrayals of tattoo thus make possible a critique of the ideals of Lacanian and Samoan subject formation. In the Lacanian model, the subject comes into being when she or he creates a spontaneous tattoo that refers to her or his successful kills. The emphasis rests on the discrete, bounded subject. However, the very tattoo that registers the hunter as such, creating at one stroke the subject and the first signifier, records the way the outside world has penetrated the individual. The emphasis is still on the autonomous subject, but she or he is inaugurated only in relation to a notch that reveals the body and the subject to be permeable.

In the Samoan ideal, a completed tattoo is created when the young recipient's body has achieved its full growth. Wendt and Figiel focus on tattoos that do not meet this model, interrupted as they are by violent sanctions. Even so, they emphasize a collective, corporate subject, one that is ineluctably social.[36] The accounts underline the fact that in traditional *tatau*, the ideal was achieved primarily by the fully grown son of the chief; the other young men, and the young women who received designs at the same time, took their place in the hierarchy, bodies ready or not. The portrayals of the interrupted tattoo also reveal that the recipient of the punishment is set aside as a circumscribed individual—in other words, pushed beyond the bounds of sociality—and so marked by sociality. The casting out occurs only in the collective; by expelling the transgressor, the community calls attention to its own status.

The bounded Lacanian subject is shaped by the tattoo that permeates her or his skin, revealing the internal presence of that which is excluded in the creation of the autonomous subject. At the same time, the open Samoan subject (one might reappropriate the term "Oceanic" to describe this subject) is separated from the sociality that constitutes her or him. The tattoo's spectrum of subjectivity, ranging from an ideal Lacanian individuality to an ideal Samoan sociality, suggests that each portrayal discussed here gestures toward its counterpart, one incorporating the outside, the other casting out or closing off the individual.

TRAVELING SIGNIFIER

Tatau is irreducibly material. Narratives and bodies, too, bring the designs into the world. *Tatau* moves from skin to skin, wrapping Pacific Islanders and visitors in similar designs and sometimes disparate meanings. In traveling from the Pacific to the rest of the world, it moves across languages, conceptual structures, bodies. As the reading of model Lacanian and Samoan subjectivities shows, *tatau*'s traversing of bodies reveals both distance between and propinquity of points of origin and arrival.

Pacific tattoo could form a lifelong endeavor. In one extreme that suggests the impossibility of ever completing the subject formation that the tattoo displays, some men in the Marquesas Islands were "entirely black; but this is owing entirely to the practice of tattooing with which they are covered all over."[37] The designs, repeated until they were lost, thus "ended only when there was no part of their body untouched,"[38] although the pigment sometimes needed to be renewed. Without being blacked over, patterns could be elaborated on or added to as an individual's exploits and social standing increased. In some ways, then, the designs could never catch up to the subject, nor could the subject catch up to the designs.

For the visitor to Oceania, on the other hand, tattooing seemed all too able to catch and hold the subject. In Herman Melville's *Typee*,[39] for example, the narrator, Tommo, flees from a Marquesan tattoo artist's ambition to mark his white skin, lest he "be rendered hideous for life" (*Typee*, 218). The tattoo as an "index of inclusion and exclusion" (*Written*, xiv) worked very differently in Oceania and the United States.

Consider the story of James O'Connell, the 1830s beachcomber who suggested that for his well-tattooed Pohnpeian hosts, "printing was the English method of tattooing."[40] After his visit to Pohnpei, where his body was marked by the Pohnpeian method of tattooing, O'Connell "enjoyed the honor of being the first tattooed man ever exhibited in the United States"[41] and for two decades gave performances centered on his tattoos (e.g., portraying himself in a melodrama). In 1842, the same year Melville was in the Marquesas Islands collecting experiences he would use in *Typee*, O'Connell was featured in P. T. Barnum's American Museum.[42]

The marks that made O'Connell ordinary in the Pacific made him extraordinary in the United States; he carried the material sign of his subjectivity with him, a subjectivity produced continually and differentially. Even in the United States, the subject of the signs is created in part by the communal assignation of

the tattoo's meaning. The figures continue to signal the movements of author-ity, as exercised by the Pohnpeian women who assign the patterns to his skin; by the United States audiences who flock to his stage and print performances; by the New York ministers who warn that pregnant women viewing the marks will imprint the patterns on their unborn children;[43] and by the designs that distinguish his body and his book, where he claims status as narrator, tells the way tattoos travel, and produces his textual performance.

O'Connell as marked subject is neither the individual tattooer of Lacan's formulation nor the collective tattooed of Wendt's and Figiel's literary works. His patterns are applied according to the distinct practices of Pohnpei, where the tattoo artists are women. The motifs give him an involuntary place in the Pacific, registering him in a Pohnpeian social order. Before he knows what is occurring, the women hold him down and begin tattooing; he submits to hav-ing his skin penetrated by a "squad of these savage printers" (*Residence*, 115). He accepts but does not choose the sexually charged marks: "I summoned all my fortitude, set my teeth, and bore it like a martyr. Between every blow my beauty dipped her thorns in the ink" (*Residence*, 114). The marks incorporate him into the Pohnpeian community but do not quite fit traditional patterns. While his arm and leg tattoos are similar to male Pohnpeian tattoos, the de-signs he describes on his back are anomalous, worn by neither men nor women in Pohnpei. If O'Connell uses the word "back" as a euphemism for "buttocks," then he bears patterns that are reserved for women (*Residence*, 116). Either way, the devices on his white skin make him anomalous in Pohnpei and later the United States.

In his metaphor, the female "savage printers" make of his body a book, one he cannot read. The Pacific signifier is as close as his skin, yet it escapes him, in part because he attempts to force it into a lexical framework that it does not fit. He speculates that to the trained eye the patterns would yield a narrative: "I never learned to read their marks, but imagine they must be something like the system of the Chinese" (*Residence*, 153). O'Connell's body and biography thus exemplify several of the ways in which the Pacific signifier loses specificity and gains speculative meaning as it moves into other parts of the world. The tattoo here stands neither as Wendt's and Figiel's collective subject nor as Lacan's material of subjectivity; rather, it is a sign of a sign.

The durability of the signifier remains an immediate concern for O'Connell. He portrays an insistently material indigenization of English narrative and Irish skin. Pohnpeian women take the volumes of his book, Jane Porter's *Scot-tish Chiefs*, and weave its pages into their cloaks, only to discover when it rains

that print is impermanent. The women "protested that the white man's tattoo was good for nothing, it would not stand. That the islanders' tattoo will stand," O'Connell continues wryly, "my body is witness" (*Residence*, 110). The apparently permanent book that is his body, nonetheless, does not endure as long as does the tattoo narrative he helps create by dictating his story. More ephemeral, it turns out, than his print accounts of the designs, the visual record of his tattoo is nearly lost (see figure 3). The itineraries of the subject, the articulations of location, are embodied also in tattoo stories and histories.

"The Original Queequeg"?

TE PEHI KUPE, *TOI MOKO*,
AND *MOBY-DICK*

Tattoo is the first signifier and a primary object of exchange. Captain Cook sailed away from his first visit to New Zealand carrying two *toi moko*, tattooed ancestral heads. In Herman Melville's novel *Moby-Dick*,[1] demand is high for the tattooed Māori heads that Queequeg sells in the streets of New Bedford, Massachusetts. Queequeg presents the one unsold head to Ishmael, who donates it to be used as a block, a form around which hats are shaped. Melville shows the way tattooed ancestral heads were removed historically from the body of Māori culture, where the heads are sacred and each tattoo is the individual mark of a communal identity. Viewing the heads outside Māori culture makes the designs both incomprehensible and reproducible in the world market, much like copying a signature without knowing what it says. This chapter examines the same Māori tattoo portrait that features today on the front covers and in the texts of *Moby-Dick* and of Claude Lévi-Strauss's *Structural Anthropology*, investigating how these books move tattoo from Māori domains into the public domain.

TE PEHI KUPE'S *MOKO*: SACRED DOMAINS

To begin, let us examine some of the rich meanings a *moko*, or Māori tattoo, expresses in its home contexts. The *moko* patterns proclaim the identity of the individual; that is to say, the patterns traditionally identify the bearer as

connected to genealogies that link the individual to the extended family and the tribe, and to the land and the divine. Each pattern is so unique that it may serve as the mark of an individual, allowing that person to be identified, especially by the distinctive facial tattoo she or he bears. This mark of an individual, copied onto paper, may serve as the person's signature on documents or deeds.

The mark of the individual conveys more than just that individual's signaling of her or his presence. A signature is formed by a distinctive name, mark, or feature, often one's own name written by oneself. But even the signing of one person's name attests to networks of relationships: the surname that identifies the person's family and also possibly conveys ethnic or national connections, the given name that the individual may answer to or may adapt, and that also bears traces of those who gave her or him that name. The given name may convey qualities witnessed in or wished for the person who bears the name, such as political, religious, personal strength. A *moko* conveys all of these qualities and more.

Let us examine one dramatic *moko* signature, which reveals much about the way a mark of the individual may function in first Māori and then international domains. The stories told by and about this *moko* become representative of the way the meanings assigned to a signature mark may be modified drastically.

A self-portrait created in 1826 by Ngāti Toa paramount chief Te Pehi Kupe is elaborately curvilinear (figure 6). Te Pehi Kupe's self-portrait forms a full spiral facial tattoo, and exemplifies important aspects of the art and practice of *moko*. (The design was published in George Lillie Craik's book *The New Zealanders*[2] and reproduced on the covers of the Norton sesquicentennial edition of *Moby-Dick*[3] and of the HarperCollins/Basic Books edition of Lévi-Strauss's *Structural Anthropology*.[4]) The design elements follow the natural contours of the brow, cheeks, mouth, and chin. This method of design is at once standardized and individualized.[5] The face is divided into several design fields, each of which bears particular patterns and meanings. Four *tīwhana* adorn Te Pehi's forehead, for example, sweeping along his brow line. The term refers literally to lines of tattooing over the eyebrows, but figuratively invokes the power of a bent bow and the god of the rainbow.[6] The four lines that almost encircle the mouth, curving from the bottom of the nose to the point of the chin, are termed *rerepehi* in many accounts, and are associated with the strength of a waterfall.[7] Some design names and meanings vary depending upon the region or time at which the practice is documented, although many design names are identical in the written accounts.

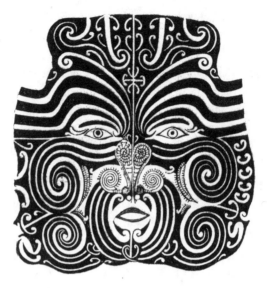

FIGURE 6. Illustration by Te Pehi Kupe. *Moko* self-portrait. Reprinted from George Lillie Craik, *The New Zealanders* (London: Charles Knight, 1830), 332.

Some scholars and *moko* wearers suggest that upper-cheek spirals, for instance, depending upon how many lines they contain, can designate birth order, whether the person's authority is inherited or achieved, and what rank the mother or father possessed. Contemporary wearers state that the lack of an upper-cheek spiral indicates that the person is a younger son. Comparing his own with his older brother's facial designs, Piri Iti declares, "Tame has a design denoting chieftainship whereas my cheeks have been left unmarked in deference to him."[8]

A *moko* includes standardized design elements, yet each tattoo is distinctive, to the point that the tattoo can be used as a signature.[9] Craik prints "Themorangha's" *moko* signature, "as drawn by himself with a pen, which he then handled for the first time in his life" (*New Zealanders*, 146). Historically people signed treaties and deeds by representing their *moko* on paper. As we shall see, Te Pehi himself emphasizes the way his *moko* forms a unique, signature design, comparing elements that distinguish his *moko* from the *moko* of others.

Each design element has a name and meaning. The four already-mentioned *tīwhana* or *rays* that adorn Te Pehi's forehead, for example, sweeping along his brow line, are a feature that recurs in many *moko* designs, though the number and placement of the rays may vary from one *moko* to another. In Te Pehi's

moko, upturned and downturned double *koru*, rolled or looped spirals,[10] appear on either side of the face's center line right where the forehead rays begin to arc across the brow. (To eyes accustomed to reading roman characters such as those of written English, they might look like a "U" shape and an inverted "U" shape.)

Spiral figures occur also in carving and probably derive from the unfurling spiral shape of a fern frond. The same word, *pītau*, designates spiral carving and a circinate fern frond (*Maori Language*, 284). In his book on Māori carving, Hirini Moko Mead writes that the scroll or *pītau* "is the main motif in kowhaiwhai patterns and in the tattoo designs of old" (*Te Toi*, 237).

Carving is a sacred art closely associated with tattooing, since *moko* was carved into the skin with a chisel, forming deep grooves.[11] Because it involves shedding blood, sometimes around the highly sacred human head, *moko* is perhaps the most volatile art. Connected to the body of Māori culture, *moko* has not only powerful beauty but deep meaning. And *moko* is a living tradition. Today these elements and patterns are in use; the *tā moko* artist often applies them by electric tattoo needles, and sometimes by chisel.[12]

Above the rays, Te Pehi's *moko* includes elaborate circinate scroll patterns on the upper portion of the forehead. Books by Ko Te Riria and David Simmons suggest that these elaborate upper forehead patterns proclaim Te Pehi to be descended from two paramount tribes on both his paternal and maternal lines. Specifically, Te Riria and Simmons suggest that the upper forehead designs mark him as an *ahupiri*, or paramount chief, and indicate that he is "protector of the land and giver of life."[13] (Te Riria and Simmons also suggest that patterns along his jaw line on both sides of his face designate Te Pehi a master carver descended from master carvers on both his father's and his mother's sides.) It is important to note that this interpretation is provided only by Te Riria and Simmons; these writers are unique in presenting such clear verbal translations of the *moko* elements. Other scholars and practitioners suggest that the visual grammar does not translate into words, or that the sacred meanings of the patterns may not be divulged to an unrestricted audience.

Without providing specific translations of the patterns' meanings, many commentators agree on the principle that the upper forehead designs are sacred, tying the bearer to the gods from whom he descends directly. As a result, some *moko* wearers today leave the forehead blank. Hemi Te Peeti declares, "The upper part of my face has been left untouched to defer to the realm of the gods, from where I seek knowledge" (Neleman, 127).

To examine a few more of the design elements in Te Pehi Kupe's tattoo, both left and right sides of his tattoo design feature *paepae*, an upper-cheek spiral and a lower-cheek spiral. The mouth is adorned on either side with symmetrical *rerepehi*, the lines associated in one account with a waterfall ("Maori Tatu," 64). The nose is marked by *whakatara*, spirals that include *pākati* or cross-hatching. On both sides of the face, an anchor-shaped *koru* appears on its side between the upper- and lower-cheek spirals, pointing toward the ear. Moving from the upper-cheek spiral toward the ear, five joined double *koru* distinguish the left side of the face. In the corresponding area of the right side of the face, two simple scrolls or *pītau* appear, one moving up and away from the ear toward the upper jaw, and one moving down and away from the ear toward the lower jaw.

Another aspect of Te Pehi's tattoo important to note is that many of the patterns are clear-skinned, that is, formed by darkening the background with tattoo pigment and leaving the pattern "in negative," so to speak—in the clear-skin spirals and rays that are thus formed.[14] Te Pehi drew his tattoo, and Craik reproduced it, in black and white. The Norton Critical Edition presents the design in blue and gold, with the tattoo pigments in blue and the clear-skinned background in gold. The HarperCollins edition presents the design in gold and blue, with the tattoo pigments in gold and the clear-skinned background in blue. Te Pehi Kupe's face in gold or blue has a powerful, unearthly effect. Te Pehi Kupe's face in black and white is tied firmly to the powerful genealogies of his land and people.

In the written accounts that present his *moko*, Te Pehi emphasizes the pattern in the center of his forehead, elsewhere named the *titi* and designated the central brow ornament (*Maori Art*, 313). Te Pehi suggests that this pattern identifies him and places him in relation to his family. The center forehead pattern appears immediately above the four *tīwhana* and consists of upturned and downturned double *koru*, bisected by horizontally opposed anchor-shaped *koru*. The anchor-shaped *koru* are, in this portion of Te Pehi's tattoo, quite stylized.[15] Te Pehi referred to this particular portion of his design as his name, declaring, "'Europee man write with pen his name,—Tupai's name is here,' pointing to his forehead. Still further to illustrate his meaning, he would delineate on paper, with a pen or pencil, the corresponding marks in the amocos of his brother and his son, and point out the difference between these and his own" (*New Zealanders*, 331–32). This signature pattern places him in relation to other members of his family.

Te Pehi traveled from the Kapiti coast, one of the southern areas of New Zealand's North Island, to England. There, he borrowed the technology at hand, pen or pencil and paper, to illustrate the Māori technology of naming and designating the individual. In so doing, he propagated his own distinctive mark, the *moko* which means *tattoo* literally, and *person* figuratively (*Maori Language*, 207). The use of his tattoo on the covers of so many books by Melville and Lévi-Strauss thus reproduces not only the marks but also, in some very real sense, his personal identity, his personhood. As contemporary Māori artist Robert Jahnke and Māori writer Witi Ihimaera declare, such a *moko* signature "is an embodiment of the Maori self transferred to paper."[16] Of course, as long as the designs are considered outside of Māori culture, whether the pattern or the person remains Māori is an open question that depends upon the viewer's knowledge.

Today Te Pehi Kupe and his *moko* continue to embody Māori identity and pride. A song titled "Moko," performed by the Māori band Moana and the Moa Hunters on their album *Rua* (2004), mentions Te Pehi by name, and presents his patterns, drawn by himself without the aid of a mirror, as an example of the deep knowledge, history, and authority conveyed by this living tradition.[17] Moana Maniapoto, the band's lead singer, won a songwriting contest for "Moko." In 2003 the song was awarded the grand prize out of 11,170 entries from sixty countries, making Moana Maniapoto the first non-U.S. songwriter to win the International Songwriting Competition.[18] *Moko* continues to speak, on faces and in song.

TE PEHI KUPE'S *MOKO* IN THE PUBLIC DOMAIN

What does it look like when we encounter Te Pehi Kupe's *moko* outside of these sacred domains? When it enters the public domain, the design may become not identity but image, not content but form.

Perhaps the boldest feature of the sesquicentennial Norton Critical Edition of *Moby-Dick* is the cover, emblazoned with Te Pehi's self-portrait. In using this cover design, this edition of *Moby-Dick* follows in the tracks of the HarperCollins/Basic Books edition of Claude Lévi-Strauss's *Structural Anthropology*. Norton Critical Editions treat literary works in their cultural, social, and historical contexts. Nonetheless, the Norton edition provides little discussion of Te Pehi's self-portrait. A note on the back cover identifies the front cover art as "Self-portrait of the face of Tupai Cupa, whose story Melville found

in *New Zealanders,* and on whom he based Queequeg—a discovery by Geof-
frey Sanborn, first announced in this Norton Critical Edition." In the graphics
section, the portrait is reproduced and proclaimed to be "The Original Quee-
queg." But for a few phrases on the back cover used to frame other topics,
those two statements form the entirety of the discussion.[19]

In other words, the three hundred-plus pages of scholarly analysis in the
book do not examine what the *moko* patterns mean, or ask what it means to
find in Te Pehi's self-portrait the original of one of the most famous charac-
ters in American literature. The scholarly analysis also does not discuss the
source of the Te Pehi self-portrait, Craik's *The New Zealanders,* a lacuna that
makes it impossible to assess the claim that Te Pehi Kupe is indeed "the origi-
nal Queequeg." Perhaps even more significant, overlooking the origins of the
portrait risks enacting what some Māori scholars of *moko* go so far as to term
identity theft. Nowhere in the Norton edition is "Tupai Cupa" even identified
as Māori.

These omissions are the more remarkable because Melville's novel dra-
matizes questions about what Māori tattoos mean in the U.S. marketplace and
beyond. The "'balmed New Zealand heads" (*Moby-Dick,* 19) that Queequeg
sells in the streets of New Bedford in the opening chapters of *Moby-Dick* are
toi moko, or tattooed Māori heads.[20] Historically, the international demand for
these ancestral heads was just as high as Melville suggests: Queequeg sells all
but one of his supply (and presents the remaining head to Ishmael along with
half of his money and all of his friendship). In 1831 colonial authorities in Syd-
ney attempted to ban the trade of *toi moko,* perhaps deploring the fact that at
the time "Baked Heads" warranted their own entry in the customs ledgers.[21] In
his 1838–42 voyage, however, the commander of the U.S. Exploring Expedi-
tion to the Pacific, Charles Wilkes, was nonetheless able to obtain two, which
are held today by the Smithsonian.[22] Later travelers followed suit, and what
appears to be the world's largest collection of such heads (thirty-four) has
been held for a century by the American Museum of Natural History in New
York.[23] In other words, at the time Melville was traveling in and writing about
the Pacific, *toi moko* circulated within and beyond that region. In his novel, he
ironizes this very market for tattoos and heads.

Tattooed heads have powerful, even volatile effects. On one hand, these
two book covers appropriate Te Pehi Kupe's signature tattoo. On the other
hand, the covers circulate and reproduce a tattoo pattern that conveys con-
cepts still central to Māori culture. A simultaneous exploiting of media occurs:
the publishers use the 1826 image to frame and market their editions. And,

much as Te Pehi used the technology of pen and paper to draw multiple copies of his *moko*, the book covers also distribute a Māori form of art and life, and specifically reproduce what he termed his particular "mark of the individual" (*New Zealanders*, 331).

But, it is important to note, it is impossible to read Te Pehi's patterns—or to understand "the original Queequeg"—if these tattooed heads continue to be treated as separate from the body of Māori culture. Absent this connection, the patterns remain signs without referents, information without meaning—the very situation Melville dramatizes when he presents Queequeg's tattoos as "a wondrous work in one volume; but whose mysteries not even himself could read" (*Moby-Dick*, 480–81). On the other hand, we have seen that Te Pehi's tattoos *are* readable within the vital Māori tradition of *moko*.

IS QUEEQUEG MĀORI?

Queequeg is, of course, from Kokovoko, which "is not down in any map; true places never are" (*Moby-Dick*, 55). Te Pehi Kupe, on the other hand, is a paramount chief of the Ngāti Toa tribe, whose mappable geographical areas came under attack, sending him to London in 1826 to request weapons.[24] What does it mean, then, to assert, as the Norton Critical Edition does, that Te Pehi's self-portrait depicts "the original Queequeg"?[25]

Melville read Craik's account of Te Pehi's visit to England, which includes the self-portrait, and he borrowed and transformed Te Pehi's journey in depicting Queequeg's travels. (In the biography, Parker notes that Melville "encountered [*The New Zealanders*] in 1850 after writing Bulkington into his manuscript as Ishmael's companion; once Melville read about Tupai Cupa he brushed his tall Virginian aside" [40].) On the other hand, the ship *Essex*, capsized by a whale, is not proclaimed "the original *Pequod*," and Owen Chase, its captain, is not declared to be "the original Ahab." Instead, these historical ships and persons are treated, appropriately, as sources, and they are discussed in the Norton edition in the "Analogues and Sources" section of the book. The Te Pehi Kupe portrait, however, is placed in the illustrations section of the book, under the heading "Whaling and Whalecraft."

The "Tupai Cupa" self-portrait stands as the original Queequeg—and as part of the "Whaling and Whalecraft" category rather than the more literary category of "Analogues and Sources"—only if Māori and Pacific literatures and cultures are treated as unknowable, or as far off the map as Kokovokan ones are. Craik is a source, an important one, but in a novel that dramatizes

searching for sources, *The New Zealanders* does not yield "the original Queequeg." Melville's presentation of tattoo, as a sign of origin that quickly slips into serving as the sign of a sign, challenges the use of a definite article before "original." It also challenges the suggestion that Queequeg is a "Maori in disguise."[26]

Rereading Melville's portrayal of Queequeg's tattoos and *toi moko* alongside the extensive tradition of Māori tattooing (including Craik's portrayal thereof) acknowledges the Māori and Pacific origin of these designs, and establishes the narrative's relation to these cultures. Indeed, Melville uses these tattoos to serve as a sign of origin, associating Queequeg with the Pacific through the tattoos he bears and the heads he sells. (For Ishmael, who finds the designs unreadable, the Pacific tattoos also serve as a sign of disorientation.) In Melville's work, of course, no sign stands alone. Tattoos serve also as the sign of geographical travel, for example in Ishmael's tattoos, both realized and projected, which carry the exact dimensions of the whale's skeleton he saw in the Arsacides and leave space for "a poem I was then composing" (*Moby-Dick*, 451). And, finally, tattoos serve as the sign of a sign, particularly in the copy of his tattoos that Queequeg carves into the coffin/lifebuoy that will bear Ishmael, and the story, to safety.

As the foregoing discussion suggests, a substantial body of scholarship on *moko*—and on Te Pehi Kupe's self-portrait—has been published, including Craik's book in 1830 and H. G. Robley's *Moko*, in 1896 the first book-length study of the tradition. This analysis continues to the present with works by prominent scholars including Ngahuia Te Awekotuku. This collection of material allows for the detailed reading of Te Pehi's patterns just presented, placing the bearer in what becomes a genealogy of design. Still, none of these works examines Queequeg's tattoos or Melville's presentation of *toi moko*.

Craik's book, published anonymously[27] as part of the Library of Entertaining Knowledge series, collates published and unpublished accounts of Māori and of New Zealand, including a captivity narrative of the Englishman John Rutherford, who was tattooed by Māori and bore a facial *moko*. For his information on "Tupai Cupa," Craik relied upon an account given to him by one Dr. Traill. (The misspelling of Te Pehi Kupe in 1830 leads to a mispronunciation of the name; by the time Taylor published in 1855, however, Te Pehi Kupe's name had been noted more accurately.) Traill had visited Te Pehi while the Ngāti Toa visitor to England was suffering from measles. After Te Pehi recovered, Traill gathered an account of the visitor and his English host, Captain Reynolds. Traill also served as chairman of the Liverpool Local Association of

the Society for the Diffusion of Useful Knowledge, which sponsored the series in which *The New Zealanders* appeared.[28]

As Geoffrey Sanborn has also noted in "Whence Come You," many details of the journey coincide for Te Pehi and Queequeg. In particular, both accounts emphasize several common elements. Each traveler exhibits a strong desire to travel, to the point where he jumps aboard a ship uninvited and grasps ring-bolts to show determination to stay. He experiences a sometimes difficult reception from white sailors, so that he responds physically to a sailor who affronts him intentionally. Despite the mixed welcome from his fellow sailors, he saves a white man from drowning by diving into a sea no one else will enter.[29] And he himself creates a copy of the distinctive tattoos that he bears.

To reexamine these common elements with an eye to the way the writers present *moko* and Māori culture more generally, in Craik's account, Te Pehi recovers from measles in Liverpool, and his ability to create a self-portrait of his *moko* without looking at a mirror spurs repeated requests for him to draw his image: "for a fortnight a great part of his time was occupied in manufacturing these pictures of the scars with which his face was impressed" (*Moby-Dick*, 333). After Queequeg recovers from his own life-threatening fever, he carves portions of his tattoo into his coffin, copying the designs into the wood that will form Ishmael's lifebuoy.

Important differences between the two accounts suggest that Melville does more than transpose Craik's narrative into fiction. Melville frequently reverses or inverts Craik's account, particularly when it comes to portraying the use of money, culture, and language. Craik suggests that Te Pehi Kupe is incapable of navigating the marketplace. When a street vendor tries to tempt him with a basket of oranges, he thinks it is a gift: "It was found impossible to make him understand the matter; and he was therefore permitted to empty the basket, the woman being paid without his knowledge" (*Moby-Dick*, 329). And Captain Reynolds, Craik declares, is such a good friend that, though he himself is "in slender circumstances," he "steadily resisted repeated proposals that had been made to him to have Tupai exhibited for money" (*New Zealanders*, 321). In other words, that Te Pehi is not displayed is assumed to be only because of Captain Reynolds's good will. Queequeg, on the other hand, until he meets Ishmael, acts as his own agent in the marketplace, representing himself as a harpooner and selling *toi moko* in the streets of New Bedford. The transactions are profitable. Until he shares his wealth, he has thirty pieces of silver to Ishmael's "little or no money" (*Moby-Dick*, 3). Judas was paid this price for revealing Jesus, and it is presented as blood money (see, for example, Matt.

27:1–10), possibly suggesting that Queequeg's silver results from an analogous betrayal.

Melville adopts the broad outlines of Craik's narrative, but changes key elements in order to show that traveling involves entering unfamiliar cultural territory for both white men and Māori and Pacific Islanders. In Craik's account, Te Pehi drinks from the finger-glasses at an English dinner table before learning of his mistake: "The use of finger-glasses and table-napkins he very soon apprehended; and although at first he drank the water from the former, he never again fell into that error" (*New Zealanders*, 322). Melville reverses the situation, and adds humor. Queequeg tells Ishmael of a white captain visiting Kokovoko and washing his hands in the drinking calabash. Ishmael reports, "the Captain coolly proceeds to wash his hands in the punch bowl;—taking it I suppose for a huge finger-glass."[30] Adding to the joke, there is no indication that the captain ever learns of his error.

The question of differing technologies is key to travel for Te Pehi. His trip was motivated by his desire to obtain guns to combat a rival chief, who had acquired guns from the English and was using them to invade Te Pehi's traditional territory. Te Pehi had lost a daughter to the wars; her body, according to Craik, had been consumed in ritual cannibalism ("killed and cooked," Robley notes in parentheses [*Art and History*, 14]). English authorities denied Te Pehi's requests for guns; instead, Dr. Traill gave him a combination "travelling knife, fork and spoon."[31] (The combined eating utensil is replaced, in Melville's account, by Queequeg's using his harpoon at the Spouter Inn's breakfast.)[32] Melville alters the motivation for travel, which has nothing to do with guns, and instead emphasizes Queequeg's "wild desire to see Christendom" (*Moby-Dick*, 56). In this way, however, he preserves and emphasizes an element implicit in Craik's account—the supposed contrast between "cannibals and Christians," which inspires, among other passages, Ishmael's maxim, "Better sleep with a sober cannibal than a drunken Christian" (*Moby-Dick*, 24).

Where Te Pehi knows only a few words of English and Captain Reynolds serves as interpreter, Queequeg tells his own story (and Melville presents it in the third person, here and elsewhere preserving for Ishmael something of the interpreter function). Where in the Craik account the friendship between Reynolds and Te Pehi occurs after Te Pehi saves the captain's life, Ishmael and Queequeg form a firm friendship absent any such heroics, but based on a mutual recognition of shared humanity. Emphasizing Queequeg's humanity in particular, Melville modifies the account of the life-saving sequence; Queequeg saves the same man who has insulted him.

Nowhere does Melville emphasize Queequeg's humanity more than in portraying his tattoos. And in depicting the tattoos, Melville departs furthest from Te Pehi's self-portrait. The descriptions of what Queequeg's tattoo look like are changed entirely; but, perhaps most important, the modifications he makes emphasize the repeated errors Ishmael makes before truly seeing Queequeg's tattooed face.

Craik attempts to present what the designs mean according to Te Pehi Kupe. Some of this information about "Tupai Cupa's" tattoo accords with *moko* artists' and scholars' accounts. Each design element is deliberate, Craik notes: "the figure, he explained, not being by any means a mere work of fancy, but formed according to certain rules of art, which determined the direction of every line" (*New Zealanders*, 331). Craik also begins to account for the way the designs correlate with authority and rank, power both achieved and inherited: "The depth and profusion of the tattooing, he stated, indicated the dignity of the individual; and according to this rule, he must himself have been a chief of distinguished rank, as scarcely any of the original skin of his countenance remained" (*New Zealanders*, 333). Craik presents tattooing, here and throughout *The New Zealanders*, as one among many Māori practices, depicting it first in a chapter on "customs of the people" (*New Zealanders*, 133). He treats it on its own terms and does not attempt to associate it with writing or assimilate it to European practices. (He does note that tattooing was practiced by ancient Thracians and by the Picts of northern Britain.)

Where Craik gives a neutral, factual (even if introductory) account of tattoos, Melville departs somewhat from Craik's narrative presentation and entirely from Craik's visual presentation of tattoos. In both basic motifs and overall patterns, Te Pehi's self-portrait uses no square elements. Even the *pākati* lines—here, notches or hatching on the side of the nose—are rounded into spirals. Queequeg's facial tattoos, on the other hand, are "large, blackish looking squares."[33]

Melville, in other words, makes dramatic modifications to the tattoo portrait, thereby offering a playful account of Ishmael's contorted perceptions of the harpooner. In Melville's account, Queequeg's tattoo and face are not separable. Ishmael learns to see the tattoo and the face as simultaneous or as coinciding. Ishmael must let go of his expectation that the marks consist of impermanent wounds that will heal; that the marks transform a white man; and that the marks reveal him to be "some abominable savage or other" (*Moby-Dick*, 22).

At first sight, Ishmael presumes that his roommate has been injured in a fight and had his face covered with sticking plaster—Melville's comic exploi-

tation of the desire to see in the foreign something familiar. When he sees Queequeg in clearer light, Ishmael then realizes that his roommate has been "stained" with "squares of tattooing" (*Moby-Dick,* 21), although he persists in believing that Queequeg is a white man who has been tattooed by "the cannibals" (*Moby-Dick,* 21). Not until he sees that Queequeg has no hair on his head "but [for] a small scalp-knot twisted up on his forehead" (*Moby-Dick,* 21), does Ishmael conclude that he is in fact rooming with an uninjured, tattooed, "head-peddling purple rascal" (*Moby-Dick,* 21).

In presenting the tattoo's visual aspects, Melville makes an extended conceit of Ishmael's rationalizing the foreign as something familiar. Ishmael's thinking about Queequeg, thus dramatized, is, first, He's been in a fight and is wearing bandages; second, He's a white man tattooed against his will; and third, He's a tattooed cannibal! In the process, Melville departs entirely from Craik's method of factual reporting, instead exploring the effect of the tattoos on the first-time viewer. In another departure that underscores this one, Melville does not follow the curvilinear pattern of Te Pehi's tattoo, instead emphasizing the square nature of Queequeg's. In other words, in presenting Queequeg's tattoos, Melville follows a very different sequence from the one he dramatizes with Ishmael. Where he presents Ishmael attempting to fit Queequeg's designs into a known pattern, Melville, in treating Queequeg's tattoos, departs so far from Te Pehi's self-portrait that Queequeg's design is not a *moko.* Instead, the patterns are much closer to the square bands of facial tattoo men may receive in the Marquesan *tiki.*

Now, to make even more explicit the differences in the narrative presentation of the tattoo: Craik presents the biography of "Tupai Cupa" before he presents the *moko* self-portrait. He puts the story before the tattoo, introducing first the man and then the tattoo. Melville reverses that order: Ishmael encounters the tattoos first, then learns of Queequeg's biography. The structure of the opening chapters further emphasizes that the biography is separated from Ishmael's first encounter with the tattoos. The reader, too, encounters first the face and then, after the intervening chapters on Father Mapple's sermon and Queequeg's god Yojo, the biography. The adjoining chapters in which Ishmael joins first Father Mapple's Christian congregation and then Queequeg in honoring Yojo establish a parallelism between Christian and pagan practices (through parodying Calvinism and Presbyterianism in particular [*Moby-Dick,* 99–101]), which prepares the way for appreciating Queequeg's biography. The parallel chapters portray first Ishmael and then Queequeg responding to the religion of the other, evoking sympathy for the distance Queequeg has traveled from his native land. The order allows Melville, more than exploring

immediate impressions, to test surface against depth, or the tattoo against the face that bears the design.

Queequeg's tattoo, it is true, is not a *moko*, but Melville begins to allow for the relationship between the social demands and responsibilities of the *moko* art form and the individual person who carries the patterns on her or his face.[34] Queequeg's patterns, for example, mark him as a native of Kokovoko even as he has been cut off from the Pacific, his contact with Christians having "unfitted him for ascending the pure and undefiled throne of thirty pagan Kings before him."[35]

ON THE TRAFFIC IN HEADS

In addition to his own tattoos, Queequeg carries another volatile sign of the Pacific that has been removed from its Pacific context—the *toi moko* or tattooed ancestral heads that he sells. Melville shows these heads as separated from the body of Māori culture, a process that is continued by presenting the Te Pehi Kupe portrait as "the original Queequeg," absent any discussion of Te Pehi Kupe, the information the *moko* carries, or Māori culture.

Recall that these human heads have been literally separated from human bodies; this act of violence is extended when the heads and designs continue to be removed from the living traditions and identities that give them meaning. Speaking of the power of spiritual and cultural treasures, which would include *moko* and *toi moko*, Hirini Moko Mead declares, "For the living relatives the taonga [spiritual and cultural treasure] is more than a representation of their ancestor; the figure is their ancestor and woe betide anyone who acts indifferently to their tipuna [ancestor]."[36] *Moko* embodies the living connection between people and their cultural and genealogical ancestors; viewed in this light, failure to acknowledge the connection creates a further act of violence.

Alienated from the traditional context, the heads become what Melville terms "great curios" (*Moby-Dick*, 19). The alienation occurred almost simultaneously with contact with whites, when Joseph Banks, Captain James Cook's naturalist, purchased one in March 1770 along the coast of New Zealand (*Endeavour Journal* 2:31). Melville calls attention to the process by which *toi moko*—and other representations of *moko*—are separated from the body of Māori culture. Conceiving of the face and the design as separate or separable, from one another or from Māori culture, uses a logic similar to that which alienates *toi moko* from their sacred, ancestral context, and brings them to the international marketplace.[37]

The "traffic in heads" (*Art and History*, 166) escalated to the point that Melville presents in *Moby-Dick*, with Queequeg engaged in a traffic in New Bedford that only Ishmael, innocent of information, does not understand. This sequence Melville does not find in Craik, unless he extrapolates from Craik's discussion of the way Te Pehi proposes that in future he trade flax for muskets. The only "product" Craik presents Te Pehi as representing is himself, and the copies of his *moko* that he creates and gives away.[38]

Peter Coffin, the landlord of the Spouter Inn, plays an extended joke on Ishmael that is based on the market for heads by telling him that he does not know why his roommate is out until almost midnight: "I don't see what on airth keeps him so late unless, may be, he can't sell his head," adding, to hone the taunt, "I told him he couldn't sell it here, the market's overstocked" (*Moby-Dick*, 18). When Ishmael insists that he is not "green" and knows it is impossible for a man to sell his own head, Coffin explains that the harpooner "has just arrived from the south seas, where he bought up a lot of 'balmed New Zealand heads (great curios, you know), and he's sold all on 'em but one, and that one he's trying to sell tonight, cause to-morrow's Sunday, and it would not do to be sellin' human heads about the streets when folks is goin' to churches. He wanted to, last Sunday, but I stopped him just as he was goin' out of the door with four heads strung on a string, for all the airth like a string of inions" (*Moby-Dick*, 19). So much for Coffin's claim that the market is overstocked; by this Saturday evening, just before he meets Ishmael, Queequeg has sold all but one of the heads. In Melville's elaborate joke—on both the naïve Ishmael, who does not understand Coffin, and on the reading audience, who *does*—it would not do to sell heads on Sunday, but the other six days of the week are fine. The humor is compounded by the fact that Ishmael the narrator recounts the joke played on his inexperienced self.

Ishmael's protestations that he is not "green" lead to Coffin's assertion of another code. Melville shows the landlord using the heads as a shorthand to signal that Ishmael's prospective roommate is a "cannibal." The landlord promises Ishmael that if the harpooner hears his head insulted, "you would be done brown" (*Moby-Dick*, 18), a reference to Queequeg's "cannibal" origins. But it is a reference Ishmael fails to understand. Pages later, after Queequeg has returned home and Ishmael has gone through the laborious process of observation that leads him finally to conclude that his roommate is not white, Ishmael demands of Coffin, "Why didn't you tell me that that infernal harpooneer was a cannibal?" Coffin's response invokes the code he has been using all along, which Ishmael now begins to learn: "I thought ye know'd it;—didn't

I tell ye, he was a peddlin' heads around town?" (*Moby-Dick*, 23–24). Like Queequeg's tattoos, the coded information about the head was, to Ishmael, hidden in plain sight. Everyone gets the joke that Ishmael tells on himself. The painful joke that Melville tells goes even deeper: the exchange dramatizes the way *toi moko* have been alienated from their homes.

As a sign of their new friendship, the first gift Queequeg presents Ishmael is "his embalmed head" (*Moby-Dick*, 51)—then come the fifteen silver pieces. Once Ishmael understands "his embalmed head" for what it is, there is no joke about Queequeg's giving his own head to his new friend, or about his new friend having therefore to dispose of it. Instead, Ishmael and Melville move on: "after disposing of the embalmed head to a barber, for a block, I settled my own and comrade's bill; using, however, my comrade's money" (*Moby-Dick*, 58). The sold heads form part of the funds that pay the bill. The remaining *toi moko* will be used in hat making. Ishmael does not specify whether money is exchanged for the final head, which has now been removed completely from its own physical and cultural body, and will serve as a mannequin to help adorn or clothe others. In other words, the head is being treated as pure form, devoid of content or meaning, not unlike the *moko* on the book covers.

The fact that Melville does not specify that Ishmael sells the head, simply stating that he "disposes" of it, makes it possible to revise previous assessments of the transaction. Where Sanborn states that Ishmael "goes out peddling" ("Whence Come You," 133) with the head, thereby establishing that peddling heads is "a *white man's* business" ("Whence Come You," 130; italics in original), Melville instead specifies that Queequeg participates in the market (and omits noting whether Ishmael does as well).[39] This market is racialized in terms of commodities (white men's heads are not for sale), but Melville presents the market for *toi moko* as promoted by both whites and Pacific Islanders. Melville portrays Queequeg as an agent in this marketplace and emphasizes the difference between those who know about the market for heads (Queequeg, Coffin, Ishmael the narrator, the reader) and those who do not (Ishmael the traveler, whom the narrator later describes).

COPIED ORIGINALS

The process of treating a design as pure form is one Melville explores elsewhere in the narrative, examining the way tattoo originals are reproduced and circulated. Melville emphasizes that Queequeg's copy of his tattoo is partial, incomplete, and functional: "Many spare hours he spent, carving the lid with

all manner of grotesque figures and drawings; and it seemed that hereby he was striving, in his rude way, to copy parts of the twisted tattooing on his body" (*Moby-Dick*, 480). After recovering from his illness and adorning his coffin, Queequeg uses it as a sea chest, storing his clothes inside. He thus places in the coffin the outer coverings of his body, and places on the outside of the coffin copies of his tattoo designs, again calling attention to the idea that tattoos convey both interior and exterior, and involve seeing both face and design.

Queequeg's copy of his tattoo differs from Te Pehi's in that Te Pehi made multiple copies of what he termed (filtered through Reynolds, Traill, and Craik) "the distinctive mark of the individual" (*New Zealanders*, 331). Te Pehi created the first *moko* portrait, and complied with requests to make more. Queequeg, on the other hand, decides on his own to make one copy, and not until Melville's book is published does the copy multiply, or become turned into pure form.

Once the coffin/sea chest leaves Queequeg's hands, it is sealed, rendering the inside inaccessible and simultaneously turning it into the lifebuoy that will save Ishmael. The wood is no longer functional as Queequeg's coffin or sea chest; it serves a different purpose. The lifebuoy becomes an example of design treated as pure form, and an inside that is inaccessible to the narrator and story it carries to safety. But Melville suggests that even the original design is unreadable. He thereby calls attention to the place of his narrative in relation to Pacific motifs that he portrays but cannot interpret.

Ishmael declares, "And this tattooing, had been the work of a departed prophet and seer of his island, who, by those hieroglyphic marks, had written out on his body a complete theory of the heavens and the earth, and a mystical treatise on the art of attaining truth; so that Queequeg in his own proper person was a riddle to unfold; a wondrous work in one volume; but whose mysteries not even himself could read, though his own live heart beat against them" (*Moby-Dick*, 480–81). The passage proclaims the existence of a prophecy that is to remain unknown, unreadable, even to its bearer. It seems that both Ahab and Ishmael wish to read Queequeg's "wondrous work"—and cannot. In this way, Melville signals the existence of a body of Māori and Pacific Islands knowledge that exceeds his narrative. This knowledge, embodied in tattoo, carved into the lid of the coffin (much as the Norton edition presents the tattoo on its cover), nonetheless carries Ishmael—and the story—to safety.[40]

Even as an unreadable copy, the Pacific vessel thus is the answer to the question posed by English reviewers of *The Whale*. Absent the postscript, and therefore the lifeboat that saved Ishmael, some reviewers scorned Melville's

work as impossible, since its narrator had presumably gone down with the ship. As a *readable* copy, on the other hand, Te Pehi Kupe's *moko* portrait returns to the novel some of its Pacific origins. In yet another way, the book makes sense only in relation to the Pacific vessel.

The fact that Melville portrays repeatedly the way Pacific designs are turned into form once they leave the hands of Pacific Islanders makes it difficult to continue reading Queequeg along the lines of scholarly tradition. Queequeg is often read as embodiment of a natural rather than cultural world—"the natural man" ("Queequeg's Coffin," 249)—or as a material rather than a signifying presence. Reading him as nature, Michael Rogin suggests, "Only Queequeg is untroubled by the meaning of objects, for he participates in nature unselfconsciously. Queequeg's text is written on his body; tattooed with hieroglyphics he cannot read, his skin and his clothing are one."[41] In an argument analogous to Rogin's, Geoffrey Sanborn suggests that Queequeg uses clothing "not to symbolize his inner being, but to reflect and extend his external form." Sanborn continues, suggesting that Queequeg's "tattooing similarly represents, in the words of Susan Stewart, 'not depth but additional surface'" (*Sign of the Cannibal*, 149). Rather, Queequeg stands for Māori and Pacific Islands ways of knowing and living that have been overlooked in Melville scholarship. The tattoo comprehends both nature and culture, clothing and skin, depth and surface—in short, the nuances of individual and collective identities and forms of signification that Te Pehi Kupe's *moko* portrait invokes.

TE PEHI KUPE AT HOME

Queequeg cannot return to his homeland; the novel cannot follow him there. In this way, both Craik's and Melville's narratives adopt a similar stance toward Te Pehi Kupe and Queequeg, respectively, treating them as travelers away from home. It is possible, in the written historical record outside of Craik's work, to trace Te Pehi Kupe's fate (and we know that Queequeg goes down with the *Pequod*). But it would seem that Claude Lévi-Strauss, practicing anthropology, would have the tools to follow Te Pehi Kupe into his home cultural worlds.

Lévi-Strauss presents his consideration of the self-portrait in the context of a structuralist discussion of split representation.[42] The portrait, he observes, is formed of two joined profiles. Realism in portraying the design sacrifices realism in portraying the face. Put another way, Te Pehi Kupe chose to portray the full design, which meant depicting the face as two-dimensional. Another

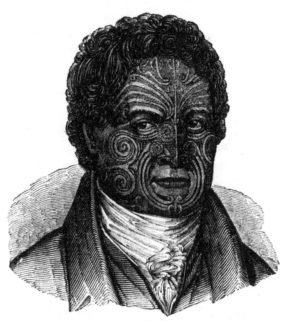

Portrait of Tupai Cupa.

FIGURE 7. Engraving from John Sylvester's portrait of Te Pehi Kupe. Reprinted from
George Lillie Craik, *The New Zealanders* (London: Charles Knight, 1830), 331.

portrait of Te Pehi, an engraving created from John Sylvester's sketch of the
visitor, makes this point quite clear (figure 7). Sylvester's portrait presents the
face as three-dimensional, but in so doing can only depict three-fourths of the
moko. The portrait thus loses the details, outlined above, that complete Te Pe-
hi's design, making it a full facial pattern by including the areas alongside the
lower and upper jaw line and cheek.

Lévi-Strauss takes Te Pehi Kupe's realism of design rather than realism of
face to be representative of an important strand in Māori thought. "In native
thought," Lévi-Strauss declares, "the design *is* the face, or rather it creates it"
(*Structural Anthropology*, 259). The comment involves more than just a recog-
nition of differing means of representation. Implicit is an assumption that cul-
tures not under discussion, ones such as his own, emphasize the face over the
design and, correspondingly, prioritize individual rather than social identity;
conversely, cultures such as the ones under discussion emphasize the design
over the face, and prioritize social rather than individual claims to identity.

Discussing this form of representation thus shades into discussing a differing way of being.

Moreover, this formulation, which seems to state that the face and design cannot be separated, does nonetheless part them by considering them as separable elements and elevating one element over the other. The tattoo and face, rather, come into being together; the *moko* is fitted to the face. So in portraying his *moko*, Te Pehi Kupe is also portraying his face.

Lévi-Strauss offers his comments in the context of discussing Māori portrayals of tattoo, as carved in wood and drawn on paper, and comparing the method of split representation found in such Māori works to that found in, among others, works by the Caduveo, formerly part of the Guaicuru nation of southern Brazil, and by the Haida and Tsimshian of the Northwest Coast of North America. In all of these art works, which depict the face using split representation, Lévi-Strauss suggests, the design is not made for the face so much as the face is made for the design: "the face itself exists only through decoration. In the final analysis, the dualism is that of the actor and his role, and the concept of *mask* gives us the key to its interpretation" (*Structural Anthropology*, 261). These cultures Lévi-Strauss classifies as mask cultures.[43] With a facial *moko*, where the pattern is carved into the human face, by extension, the actor cannot remove the mask. Lévi-Strauss is not the only anthropologist to read the *moko* as mask; Gell, too, reads the practice as "an art which is nothing but art," one that exhibits "sheer form" and comprises "a screen (or mask)" (*Wrapping*, 237).

Like the cover of the Norton edition of *Moby-Dick*, the Lévi-Strauss book cover presents Te Pehi Kupe's tattoo portrait in blue and gold. *Structural Anthropology*, though, presents the tattoo pigments in gold, with the clear-skinned elements that form the tattoo patterns depicted in the same blue that forms the cover's background. The skin is the same color as the cover, creating a mask effect that does not exist in the Norton or Craik versions. The cover portrait emphasizes Lévi-Strauss's point about the importance of the design, but also has the effect of losing the face, making it one with the book's cover. Both elements are logical extensions of the claims Lévi-Strauss makes in considering *moko*.

Both elements also have the effect of reversing the design. As contemporary *tā moko* artist Henriata Nicholas proclaims, "The most distinctive quality of *Moko* is the way the negative interplays with the positive. The skin is the positive and the ink is the negative—therefore, the ink inserted into the skin is accentuating the pattern to be shown, which is the skin."[44] The pattern is the

clear-skinned elements that are emphasized by the markings, the clear-skinned elements that merge into the background of the book cover. In other words, the book cover creates the mask by losing the *moko* design.

The permanent mask presented on the book cover indicates that the actor has assumed a permanent role. Lévi-Strauss, however, takes it one step further, emphasizing not the permanence of the *moko* "mask," but the way in which that design is represented. Again, it is not the practice of tattoo, but the mode of representing tattoo, that he draws upon to postulate a distinct mode of being. He suggests, "the actor himself is dissociated in the split representation," which has the effect of "flattening out as well as displaying the mask at the expense of the individual wearing it" (*Structural Anthropology*, 262). So closely allied are actor and role in these cultures, he suggests, that the tattoo cannot even be *portrayed* without dissociating, and even doing violence to, the human who wears it.[45]

Perhaps. And perhaps, instead, the conception of individual and social identity as expressed in the *moko* and in Te Pehi Kupe's self-portrait is not quite accounted for in this formulation. Lévi-Strauss's structuralist analysis proceeds without reference to any specific *tā moko* artist or wearer, both of whom place the design in relation to the personal and the collective, and without even naming Te Pehi Kupe, the man who drew the portrait he uses to help make his claims. Treating the designs as pure form leaves even the anthropologist in the situation Melville described: Māori culture becomes a sealed vessel; the viewer has no access to the inside.

In his *moko* portrait, Te Pehi Kupe does not dissociate himself, any more than Melville portrays Queequeg dissociating himself in copying portions of his tattoo. Dissociation would occur, rather, if Te Pehi were to portray the total face absent the total design. In Te Pehi Kupe's portrait, a person's identity is individual and genealogical; the sign of the tattoo is both corporal and corporate. Losing the details about his ancestors would mean losing part of his identity, or dissociating himself, far more than would assuming that the arbitrary conventions of the perspectival portrait more faithfully depict a person.

Those perspectival conventions, which are privileged in the tradition of art that John Sylvester employs and Lévi-Strauss prefers, can in fact be seen as a *distortion* in the tradition of art that Te Pehi Kupe enacts. Māori carvers also rely upon split representation, because that method portrays Māori concepts of space and time: "Maori carving did not try to represent the effects of perspective or any of the other distortions produced by viewing from one fixed point at one instant in time."[46] Instead, Māori carvers produce an ideal or objective

art, portraying human features, for example, as they are at all times, not at one moment. Despite assumptions to the contrary, tattoos are not fixed: they can be added to and renewed. But in his portrait of his tattoo, lest he dissociate himself, Te Pehi Kupe avoids this use of perspective. Recall that Melville dramatized Ishmael's gazing on Queequeg's tattooed face and learning to see the face and the designs together; along these lines, viewing Te Pehi Kupe's portrait as separate from the body of Māori culture dissociates it.

Te Pehi Kupe draws his own tattoo, first at his own initiative and then at the request of others; he reproduces his own individual mark (much as the fictional Queequeg draws part of his tattoo design to sign the *Pequod* papers, and carves portions of his tattoo into the coffin/sea chest/lifebuoy). In drawing his tattoos, he is not dissociated from them; they continue to circulate, his individual marker stamped across multiplying book covers. Neither is he dissociated from his social role or individual identity, both of which are signaled by the marks. Nor is he dissociated from his face. That separation comes only after he returns to Aotearoa from his long trip to England, when in 1830 he is killed (*Te Ika a Maui*, 327). (The *Dictionary of New Zealand Biography* notes that Te Pehi Kupe died in a battle in which he declared to a Ngāi Tahu man named Moimoi, "Why do you with the crooked tattoo, resist my wishes—you whose nose will shortly be cut off with a hatchet?")[47]

Te Pehi Kupe produces his *moko* portraits, in the process reproducing himself. Within his own lifetime he makes multiple copies of his *moko*, participating in reduplicating the same sign, the one that serves as his own individual mark. Te Pehi's portrait, like Melville's novel and Lévi-Strauss's study, shows the ways the sign can shift. The sign can be duplicated, it can even be forged; it can be separated from its maker (who is here also its referent); it can be removed from the collective and cultural identity that it produces along with individual identity.

Copied out from its home contexts, *moko* participates in a new economy. The patterns circulate on the covers of books, where they become a new form of literary and cultural capital. In turn, scholars who study tattoo and readers of such books as Melville's, Lévi-Strauss's, or the present one, participate in this economy, which often profits from removing the mark of the individual from the network of relationships that create and give meaning to the *moko*. As the patterns circulate and are consumed by a new generation of readers, artists, and tattoo bearers, the question remains whether *moko* is recognized as a living cultural and spiritual treasure, or whether further violence removes the patterns from their storehouses of meaning.

Another Aesthetic

BEAUTY AND MORALITY
IN FACIAL TATTOO

In the world market, tattoo may also encounter a vastly different standard of beauty. In Lee Tamahori's film *Once Were Warriors*, when Nig receives a full Māori facial tattoo, his younger brother admires the pattern but says, "I wear mine on the inside." Immanuel Kant, too, suggested that the designs are beautiful, but only when separated from the human face. The widely distributed versions of contemporary tattoo created in Alan Duff's novel *Once Were Warriors* and Tamahori's film based on it depict Māori facial tattoo as present only among Māori gangs. By contrast, this chapter identifies an aesthetic that celebrates *moko* as a living face of Māori genealogy, worn by old and young, women and men: a sovereign design of a people resisting colonization.

Assessing Māori carving, Joseph Banks declared in 1770, "I may truly say [it] was like nothing but itself."[1] The botanist, traveling with Captain James Cook's first exploring expedition, was not the only observer to suggest that Māori art is incomparable. Banks's function on the voyage was to document and categorize the travelers' observations, but in viewing art in Aotearoa, the native term for New Zealand, he reaches for comparisons and admits incomprehension. Related patterns, carved into human skin in *moko* (Māori tattoo), lead to similar acknowledgement that the practice does not fit his understanding: "There[2] faces are the most remarkable, on them they by some art unknown to me dig furrows in their faces a line deep at least and as broad, the edges of which are often again indented and most perfectly black" (*Endeavour Journal*, 13).

But if he cannot find an equivalent to *whakairo* (carving) or understand the tattooing method, the question of the beauty of *moko* leads him to betray a contradiction in his own understanding of the aesthetic. On one hand, he proclaims, "This may be done to make them look frightfull in war; indeed it has the Effect of making them most enormously ugly, the old ones at least whose faces are intirely coverd with it." On the other, he admits, "Yet ugly as this certainly looks it is impossible to avoid admiring the immence Elegance and Justness of the figures in which it is form'd, which in the face is always different spirals" (*Endeavour Journal*, 13). In this formulation, the elegant, seemly "figures" of the design are admired, even if reluctantly, in a formulation that suggests it would be preferable if it were possible to avoid admiring the patterns. Nonetheless, despite the figures' "immence Elegance and Justness," their effect on the human face is deemed to be "ugly." To offer such an assessment, the observer must separate the tattoo from the human face.

This contradiction recurs in some of the most widely propagated observations on *moko*, including those offered by the eighteenth-century German philosopher Immanuel Kant and two contemporary figures from Aotearoa / New Zealand, novelist Alan Duff and film-director Lee Tamahori. In their disparate works, the figures of *moko* are admired, while the faces on which they appear are presented as problematic. The effect of this contradiction is to question the basis by which beauty is determined. This observation points in turn toward a reconsideration of tattoo and aesthetics.

Such a reconsideration follows naturally on Banks's observations about *moko*. If such forms of art and life as *moko* are without equivalent—like nothing but themselves—then these practices also extend the bounds of the aesthetic. The study of how we recognize and appreciate beauty, even as practiced by such a scrupulous thinker as Kant, is not quite able to classify *moko* in terms of given categories of judgment and taste. In his *Critique of Judgment*, Kant attempts to fit *moko* into a pattern that will also accommodate the natural beauty of a flower and the created beauty of a cathedral, but to do so, must separate the designs from the face that bears them.

Kant's consideration of *moko*, like Duff's and Tamahori's, suggests that from the standpoint of aesthetics, *moko* brings into question the very creation of categories of beauty and taste. This questioning of the categories occurs not because *moko* is outside the limits of beauty or taste, although some observers certainly thought so, but because *moko* is for many viewers a unique aesthetic experience. Viewing *moko* has a profound effect on the observer, who becomes aware of and emphasizes the act of judging: the decision that is in-

volved in determining what is suitable, pleasing, proper—and what is not. The shock of viewing *moko*, for many people, throws into relief their attempts to find an equivalent, to understand, to classify, to categorize what seems to be uncategorizable.

The apparent incongruity of *moko*—designs carved or pricked into the human face—is matched by the apparent incongruity of the fact that an eighteenth-century German philosopher and a twentieth-century Māori novelist and filmmaker use *moko* in very similar ways. In his consideration of the faculties of judgment and in their depictions of contemporary Māori gangs, Kant on one hand and Duff and Tamahori on the other use *moko* to embody a questioning of the category of the beautiful. All three portrayals depict *moko* as possessing a singular beauty that does not fit other definitions of the category.

To Kant, Duff, and Tamahori, the beauty of *moko* is precisely the problem. That is, in all three presentations, despite the divergent media and times in which they appear, the beauty of *moko* is not celebrated. Rather, it is presented as powerfully—and perplexingly—undermining familiar associations. In particular, these presentations of *moko* challenge the correlation between the beautiful and the good, which founds more typical definitions of the aesthetic. At bottom, the question remains not just, "Is facial tattooing beautiful?" but also, "Is facial tattooing good?" And even, "Is it moral to tattoo the human face?" This question is debated not just by Kant but also by contemporary scholars of philosophy.

The very questions—not to mention the answers—depart sharply from the aesthetic practiced by *moko* artists, wearers, and scholars. A brief examination of the *moko* aesthetic reveals that it is possible to see the tattooed face as both beautiful and moral—and as exemplar of Māori continuity and sovereignty. In turn, the *moko* aesthetic casts new light on three of the most famous portrayals of this art.

MOKO AESTHETIC

Moko is a living art in the Māori world and has always been so, even during eras when the practice was declared dead. Despite gloomy (and erroneous) statements to the contrary, the practice of *tā moko* never halted completely. Writer-scholar Ngahuia Te Awekotuku declares that even before the *moko* revival of the past twenty or thirty years, "The Maori world . . . has never been bereft of the tattooed face. There has always been at least one such face at *marae* (ceremonial sites) in the country."[3] Historian Michael King, writing

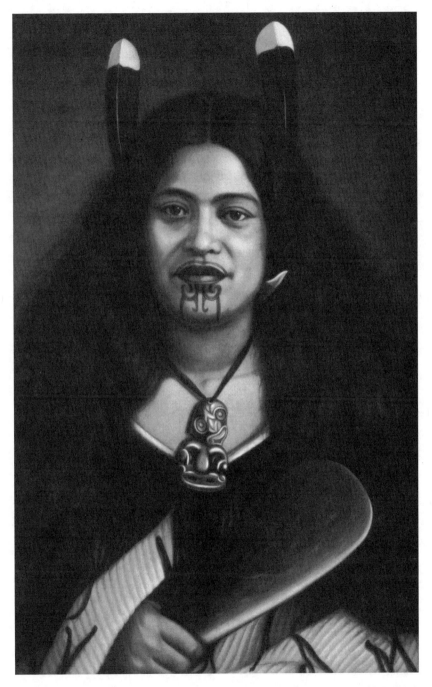

FIGURE 8. Painting by Gottfried Lindauer. *Pare Watene*, 1878. Oil on canvas. Published with permission of Pare Watene's *iwi* and Auckland Art Gallery Toi o Tamaki.

about *moko* in the early 1970s, notes that it is "as authentic and sacred as it had ever been, despite adaptations."[4]

Depictions of *moko*, and particularly of *moko*-wearing ancestors, are accorded deep respect and reverence. The *moko* image is not just a representation but also an embodiment of powerful genealogies that connect the bearer to the land and the divine. The portrait of Pare Watene (figure 8) is renowned for carrying this dignity, beauty, and meaning.

In its own right, and because of its vital persistence, *moko* represents cultural continuity. *Tā moko* artist Gordon Toi Hatfield makes this continuity clear at the opening of his book, *Dedicated by Blood / Whakautu ki te toto*. "Throughout our history," he declares, "moko has always maintained its cultural importance."[5]

The people who wear Hatfield's designs emphasize that the patterns embody a connection between past, present, and future. Tuhipo Maria Rapido Kereopa proclaims, "The moko is my voice; it is my visible presence in this time and in this space. It is my rite of passage to the past and to the future. It is the revolving door to my tūpuna and my descendants" (*Dedicated*, 13). (The book offers a glossary, but tūpuna does not appear in that glossary, thus placing upon the reader the responsibility of concluding from the context that the word means ancestors.) Kereopa establishes her *moko* as a visible sign of her link to her antecedents and descendants, the *moko* as hinge between past and present, living sign of vital Māori culture.

Considering Duff, Tamahori, and Kant alongside the statements of contemporary *tangata mau moko*, or *moko* wearers, makes clear a strong sense of a specific aesthetic that underpins *moko*. Te Awekotuku declares that *moko* "was worn to fascinate, terrify, seduce, overcome, beguile, by the skin; it was carried to record, imprint, acknowledge, remember, honour, immortalise, in the flesh, in the skin; it was also affected to beautify, enhance, mutate, extend the flesh, the skin, the soul itself."[6] This is an aesthetic that continues unabated in contemporary *moko*, one that encompasses design and identity, the patterns connecting the individual, through genealogy, to the sacred.

In this aesthetic, *moko* is part of what the writer Witi Ihimaera terms "a huge archive of Māori literature": "This is literature in its extended meaning, not just written but oral, not just on the page but also on the walls of a meeting house, as imprinted by facial tattoo, and so on."[7] *Moko* is a form of literature. Along with the carved meetinghouses to which Ihimaera refers, *moko* bears narratives, helps define who people are, explains some of the ways in which the ancestors continue into the future, borne by those who wear *moko* today, their

FIGURE 9. *He Tohu* (meaning sign) design created by Henriata Nicholas for this book. The design depicts kaitiaki (spiritual guardians) that protect the change and growth happening in Pacific art forms like tā moko today. This sign challenges those who tread within the stories of our past to celebrate who we are with respect. Published with permission of the artist.

living skin carved or imprinted with designs that explain fundamental patterns of meaning and judgment. In this inclusive aesthetic, which has the power to transform the individual and the world, the tattooed face is beautiful because of both the tattoo *and* the face.

This aesthetic can help achieve a radical decolonization, a declaration and living embodiment of Māori sovereignty. Tame Wairere Iti, a well-known Ngāi Tūhoe activist and artist who wears a full facial *moko*, declares, "The resurgence of *ta moko* among Maori is a direct means of asserting our *tino rangatiratanga* (absolute sovereignty)."[8]

"He Tohu" (figure 9), a design created by *tā moko* artist Henriata Nicholas for this book, celebrates the continuity of *moko*. Her design challenges us to respect *moko* as a vital art that is guided by *kaitiaki*, spiritual guardians. Design as expression of story, spirit, and sovereignty is at the heart of a *moko* aesthetic.

A SIGN OF THE PAST

Alan Duff uses tattoos to signify a divide between the noble warrior past and the degraded urban present of the Māori family he depicts. In the novel (as distinct from the film), the Hekes live in a state-funded housing project in Rotorua. The setting is ironic, for the area has long been a locus of cultural tour-

ism and is famous for the Māori Arts and Crafts Institute, an important teaching center of Māori culture.[9] The Hekes, however, live a life cut off from the *marae*, the ceremonial gathering place. Lacking this identity, their lives are a round of drink and violence: in the first novel of the Heke family trilogy, Jake beats his wife Beth, their younger son Boog is consigned to a state-run juvenile home, a man rapes their daughter Grace while one of Jake's wild parties rages, Grace kills herself, and their eldest son Nig joins the Brown Fists gang, where he is given a full facial tattoo and, soon thereafter, is killed in a gang battle.[10] Against this litany of degradation and suffering, Duff shows his characters' search for meaning, which focuses most significantly on attempts to reconnect with Māori warrior traditions. Duff portrays differing paths to this past: a deep way and a shallow way, both epitomized by differing approaches to *moko*.

The violence of the warrior past and gang present, as Duff's novel depicts them, set off something of a firestorm when the book was published. Even before the release of the film, the novel sold thirty thousand copies and appeared twenty-eight times on the Booksellers New Zealand bestseller list.[11] Reviewers rushed to explain—or distance themselves from—the book's focus on such a violent world ("It is the world of the Maori under-class," the *Landfall* reviewer explained, "which I know only from a scared distance, scuttling past gang members on a street corner.")[12] Much of the reception praised the book's daring subject matter or experimental narrative style—deeming it, for example, "a watershed of social realism"[13]—but critiquing the book's focus on finding Māori solutions for Māori problems.[14] In an attempt to counter these critiques, in an interview with Vilsoni Hereniko, Duff declares, "In *Once Were Warriors* I exalted Maori culture" ("Interview," 330). He suggests that critiques of his work, at bottom, protest his willingness to "hang out dirty Maori washing."[15]

Outside of his fiction, Duff is well known for making controversial public pronouncements, declaring, for instance, "There was so much politically correct talk in our country that us Maoris were hard done by, as if we were morally pure before the whites arrived, and then they came along and everything that went wrong with us, it was due to the whites."[16] Summing up Māori literature prior to the publication of his novel as similarly idealistic, Duff declares, "Nanny down on the beach, gathering kaimoana [seafood] for her mokopuna [grandchildren], tears of love leaking from her eyes . . . it's just pathetic" ("Two Lakes," 32). After the success of *Once Were Warriors*, he has presented his commentary in such forums as interviews, his nationally syndicated newspaper column, and his nonfiction book *Maori: The Crisis and the Challenge*. Despite his provocative—and sometimes deliberately offensive—comments,

which have led some scholars to place Duff in a position outside Māori literatures,[17] Duff's presentation of contemporary *moko* is one of the most widely disseminated and iconic. Turning the consideration from Duff's politics to his aesthetics—specifically his presentation of Māori tattoo—casts new light on both his work and the way *moko* function in contemporary worlds.

Moko is a most visible sign of Māori art and identity. As such, it is a flashpoint in a book that charts a vast distance between the warrior past and gang present. At stake is nothing less than whether past arts can be adapted for contemporary purposes and, thus, what it means to be Māori in the present and future. *Once Were Warriors* thus takes on issues familiar the world over, anywhere questions of cultural purity or innovation are debated or ethnic unity or heterogeneity is claimed.

In specifically colonial and postcolonial situations, Duff's work revisits territory covered by Frantz Fanon's well-known formulations of these positions. In considering the distinct situations of particular African nations, Fanon suggests that the "native intellectual"[18] and "native artist" (*Wretched*, 224) portray cultural change: "That extremely obvious objectivity which seems to characterize a people is in fact only the inert, already forsaken result of frequent, and not always very coherent, adaptations of a much more fundamental substance which itself is continually being renewed" (*Wretched*, 224). From his title forward, and particularly in his focus upon *moko*, Duff's narrative examines the ways in which the "fundamental substance" of Māori culture is renewed—or foreclosed.

In a chapter titled "Deep Tattoo," Duff presents the chiseled *moko* of the past as preferable to the gang tattoos of the present. The chapter presents a culmination of two understandings of the past, which in turn form differing pathways to the future. In this depiction, the "deep tattoo" of the chapter title is the one that is chiseled into the face of the Māori warrior of the past, trumping the "electric job" (*Warriors*, 175) that marks the Brown Fist's gang recruit.

Moko embodies a living connection to the past. Near the book's end, Beth Ransfield Heke invites the paramount chief of her tribe to help create a future for the neighborhood children by educating them in the ways of their past. His teaching culminates in his pronouncing "a single word: Moko" (*Warriors*, 174).

Te Tupaea translates past practices into the present, fusing the young people's understandings of contemporary tattoos with traditional *moko* to teach them Māori ways and words. In a passage in which the chief's voice and the narrative voice intercut, Duff writes, "Tapped his face, then his pinstriped rump, with a chuckle. Tats, that's what they call it nowadays, eh? He told

them of how the warriors of old used to have full-facial tattoos and on the nono—patting his rump with a smile—down to their knees, to signify their warriorhood. Silence. Looking over at them. You got that? *Warriorhood*. And it was—pausing, with the skills of an accomplished orator—It was *chiselled* in" (*Warriors*, 174; italics in original). In his account, the designs, carved into the face, serve as a sign of their warriorhood, the bearers' strength, their ability to endure pain.

The point emphasized here is not the designs themselves, although the designs have beauty and convey important information about the bearer's status and identity. Rather, the point is the grueling process of creating the designs. Enduring the ordeal confirms the bearer's right to wear those designs on her or his face. Duff makes the right almost exclusively masculine—tattoos on women "make em look cheap"[19]—and emphasizes solely the warrior qualities of the tattoo. (Some scholars, practitioners, and tattoo wearers suggest that *moko* could also indicate the bearer's sacred priestly knowledge, as well as other forms of status, ability, and accomplishment.) This portrayal of *moko* is significant, if selective.

Counter to Duff's characterization of women's tattoo, the *moko kauae*, or chin tattoo, conveys great dignity in Gottfried Lindauer's portrait of Pare Watene. And contemporary *tā moko* artist Henriata Nicholas's designs—whether for men or women—are inseparable from spiritual and cultural power. The designs express deep personal and cultural authority, a living history that embraces both men and women.

On the other hand, the association Duff makes between *moko* and the warrior is well established. The Englishman John Bright, who visited Aotearoa in 1839, for one, declares, "Some are more, some less, tattooed, than others; these lines are said to be considered by them as armorial bearings are by us; they inherit them by descent, and acquire them by deeds. This relates to the marks on their faces; other parts of their bodies are also decorated, especially the buttocks, arms, and calves of their legs; this, as they always go to war stark naked, is deemed ornamental to the warrior."[20] Tattoos, on the other hand, are more than just ornamental. They are a visible sign that one has achieved status, endured pain with courage, and confronted the possibility of death. Displaying tattoos in battle emphasizes one's fearlessness, and is thus in its own right a triumphal display of warriorhood.

This aspect of tradition is the one that Duff's chief emphasizes. He proclaims that "*your* warrior ancestor" uttered "not one cry" even though "this *manly* painful chiselling went on for months" (*Warriors*, 174; italics in orig-

inal).[21] Carving the designs into the skin made the face so swollen that "he would have to be fed through a funnel" (*Warriors*, 174). Duff juxtaposes this thick description of the pain, the swelling, the refusal to cry out in agony, with electric tattooing used to mark Māori gang members.

These passages on tattoo present a disjuncture: *moko* is associated with ancestors. It is not portrayed as a living practice for anyone other than gang members, whom Duff presents as replica warriors, and ones headed directly for death. Duff seems to suggest that it is not possible to produce what Nicholas Thomas terms "indigenous modernity" ("Gender," 65), so that, by extension, indigeneity can only exist in inaccessible archaic forms or inauthentic replicas. Soon after Nig receives his tattoo, he goes to a battle his gang leader has set up to ensure that Nig will die. As a result, *moko* is not presented as a vital practice; the emphasis, as in the book's title, is on a splintered past. The book's title is a sentence fragment, a dependent clause without a referent. The passive verbs in the book's title defer action—as well as warriorhood, or identity—which must occur in another unspecified time, in some other place.

Duff suggests that it is not possible for contemporary tattoo to adapt or carry forward traditional *moko*. An "electric job" creates Nig Heke's "full facial" (*Warriors*, 175). Duff emphasizes the speed and the copied origins of this contemporary art: the "electric needle with its ink injection going *bzzzzz* along the pre-drawn lines on the fulla's face," the "design a replica of olden-day moko, which the tattooist'd copied out of a book from a photograph of a real tattooed Maori head" (*Warriors*, 175). The speed of the electric ink injection, the fact that Nig's face is "transforming before a man and his apparent girlfriend's eyes" (*Warriors*, 176) contrasts with the laborious, months-long *tā moko* process Te Tupaea has described on the preceding page. More, that Nig's *moko* is a replica of a "real tattooed Maori head" suggests that his is unreal or less real.[22]

In Duff's portrayal, contemporary *moko* do not exist; instead, the gang members' debased tattoos are associated with sexual and social deviancy. In other words, Duff invokes not *moko* but another tradition, one created outside the Pacific and one that uses tattoo to diagnose the sexual or psychological ills of the bearer. This tradition, discussed in chapter 6, sees tattoo as a pathology and is very much at odds with the rich meanings carried by *moko*.

Duff parallels the tattoo's departure from its origins and Nig's departure from the Heke family. The chapter, placed as chapter 16 out of 19, brings together many of the book's themes, embodied in the presentation of Nig's *moko*. The *moko* is the visible sign of Nig's alienation from his genealogy, which is

indicated previously when the gang leader forbids Nig to attend his sister's funeral, declaring, "I ain't heard a no sista called Grace in this family" (*Warriors*, 132).

As a consequence of negating connection between past and present *moko* practices, the designs are depicted as appropriate on the ancestor-warriors' faces and out of place on Nig's. Duff presents a dream in which Nig is judged wanting by his warrior ancestors: "their tattooed faces were deeply etched, whilst his manhood markings were but lightly marked."[23] The implication is that the quick electric replica cannot signify a man, only a member of a gang. That status, too, is in turn only temporary.

In Nig's dream, his warrior ancestors disown him: "he came upon several men with facial tats of exquisite design," who were beating someone's "face till he rattled" (*Warriors*, 183). Nig asks the men, "Are you my Maori ancestors? Because they looked so much like him, mirrors of himself. They paused from the beating to give a kid hostile looks, and one answered, No. We are not of your cowardly blood, for we know you are knowing fear. We are warriors" (*Warriors*, 182). Frantic to prove his affinity with his ancestors, Nig points to his face, "his new tattoos just like theirs and freshly swollen from doing," but the ancestor declares, "He is no longer one of us" (*Warriors*, 183) and continues beating the face that Nig now recognizes as his own. The passage signals that Nig has moved away from both of his genealogies—even his newly acquired gang family, which soon arranges for his death. Nig's fate fulfils the first words he speaks in the book, when he walks away from his mother, declaring, "What future? No future for Maori" (*Warriors*, 10). *Moko* itself becomes history in Te Tupaea's speech and Nig's dream.

Here, wearing a *moko* does not mean wearing a sign of the future, but a sign of the past. *Moko* embodies the disjuncture Duff presents between Māori past and Māori present or future. He portrays *moko* as fixed in the past, part of the fragmented history invoked by the book's title. Fanon's "fundamental substance" of culture is here not continually renewed but frozen in time and place, for the gang tattoos do not adapt but only repeat past forms.

Yet the designs themselves, considered separate from Nig's face, are beautiful. In presenting the tattoo artist at work, Duff offers free indirect discourse about tattoo: "Now, he knew the design and its stock of variations so well he could do it by heart. Was the big thing to do these days amongst these gang members. And a man tried to do a very professional job because even if it wasn't exactly his cuppa tea, the design, the original he'd taken it from, was no

less than exquisite. A man'd heard that the real thing back in the old days was chiselled in" (*Warriors*, 175). The passage reiterates the critique. Presented as almost mass-produced, done by rote memory for all the gang members, in this passage the tattoos are not "the real thing." Even so, the designs are "no less than exquisite."

The formulation reveals a recurring contradiction: the designs are beautiful, but not on the face that stands immediately before the observer. Taken from books, the designs do not derive from a living genealogy. Instead, the narrative places a gulf between the warrior past and gang present of *moko*. No matter how exquisite the designs are, in this book *moko* represent the beautiful but not the good, the beautiful but the dead. The film version of the book also uses *moko* to consider the renewal of aesthetics and reaches a differing, perhaps corollary, answer.

SIGNS WITHOUT A PAST

Duff's depiction of *moko* received worldwide distribution in the film that director Lee Tamahori created based upon the novel. Duff's novel, originally published by Tandem Press in New Zealand, was also picked up by Vintage International. (Duff did write a screenplay, but playwright Riwia Brown's was the one that Tamahori filmed.) When it was released the movie achieved financial success, gaining the position of the largest grossing New Zealand film in history; and matched economic achievement with critical success, winning fifteen international awards.[24] As a result, the film conveys one of the more influential contemporary depictions. Given that the novel and film were received as uncovering new territory in the depiction of Māori, it is revealing to note that in many ways the book's and film's portrayals of *moko* continue in the path of previous depictions, particularly in the way they present as problematic the beauty of facial marking.[25]

For the film, artists including Guy Moana and Inia Taylor designed the *moko* that appear on the faces of the gang members, such as Julian Arahanga's Nig. Moana and Taylor ensured that the designs were general *moko* patterns that did not employ motifs particular to any tribes. That is, they present a stylized version of the art rather than particular patterns sacred to the genealogy of design that is *moko*. Moana's and Taylor's designs were then applied temporarily to the actors' faces. The design process has several important effects: it preserves the sanctity of a particular tribe's practices, keeping the designs

from appearing on the faces of filmic gang members and from receiving mass distribution. It also emphasizes, as in the Duff novel, the departure the gang members make from their traditional genealogies in order to join the gang.

The *moko* created for the film are distinct from tattoos that are created by inserting pigment under skin. As the makeup supervisor, Debra East, states, "the real tattoos didn't always show up that well on camera. Our tattoos, although perhaps more basic, have better definition and look better on film."[26] The comment calls attention to the simplified—if dramatic—design elements of the filmed tattoos. In a film celebrated for its highly stylized presentation of blacks, reds, and browns—all primary colors in Māori art historically—perhaps the most stylized is the film's signature element, the gang members' *moko*.

Nig Heke's exemplifies the design features of the film *moko*. His forehead rays, or *tīwhana*, are a motif that also appears in traditional *moko*. His *tīwhana* follow the patterns of traditional *moko* in that they use doubled lines; his brow features four doubled rays. His *tīwhana*, however, are more angular and less contoured than are most traditional designs, sweeping along the brow line, then cutting in at the eye before jutting back along the temple. His cheek designs present similar doubled lines, also a component in traditional *moko*. Those designs depart from the tradition of featuring both an upper- and lower-cheek design field. Many traditional designs featured both an upper-cheek spiral and a lower-cheek spiral; most designs that did not include both spirals preserved the upper cheek as blank space. Nig's design, on the other hand, consists of one simple double spiral that occupies the middle of the cheek. That is the case even though he is an elder son and, therefore, according to some contemporary *moko* wearers and artists, entitled to wear both an upper-cheek and a lower-cheek spiral.

This feature recurs in the other *moko* in the film. In those designs, too, rather than using upper- and lower-cheek design fields, a single spiral takes up the entire cheek. As a result of using the entire cheek for a single spiral, the patterns are even bolder and stronger than traditional motifs—and less detailed. The film *moko* tend not to use *pākati* lines, hatching or notches that, like ladder or chevron patterns, demarcate without filling in space within a spiral. The patterns also tend not to use the anchor *koru* or elaborate scroll patterns discussed, for example, in Te Pehi Kupe's *moko*. The exception in Nig's tattoo are two small design squares by his ear, which feature a darkened background and create a clear-skinned pattern of *koru*, or coiled or looped spirals. As noted in discussing Te Pehi Kupe's tattoo, square elements are not a regular feature in traditional *moko*. *Moko* that do feature design patches by the ear usually fit

those patches to the contours of the cheek spirals, which means that their edges are not squared but rounded.

As a result of these design alterations, the film's bold patterns do not convey, as could be typical in *moko* motifs, information about the bearer's accomplishments, inherited or earned rank, or training in sacred knowledge. They also do not reflect the long process of approval of the designs by the extended family and the tribal elders, in which tattooing often commences only when it is determined that the bearer has earned the right to wear such sacred patterns. In the film, the status the patterns signal is Nig's entry into the gang. Before he receives his tattoo, he must be inducted into the gang by being beaten, after which the leader extends his hand to Nig and declares, "Now you've met your new family."

Much as Nig's entering the gang means acquiring a new family, the film *moko* create a new tattooing genealogy. "*Once Were Warriors* had a huge impact in the tattoo world," *moko* artist Inia Taylor declares in the movie's press kit. "There's not one tattoo that we drew on in felt pen in that movie that I haven't seen done for real since." At the same time, Taylor notes that the film's tattoo designers attempt to be "true to form": "I just tried to portray these guys visually as true to form as they really are. All the research was done basically by looking at real people." The film both creates and draws upon contemporary tattooing practices. The influence of the film's tattoos attests to the power of the invented designs. It also raises a question about cultural continuity, given that these invented designs have been deliberately separated from past *moko* practices.

In the "Tattoo Gallery" in the DVD release of *Once Were Warriors*, Tamahori comments, "None of them are real. We put them all on. We were very faithful to a lot of old patterns, but we created them all ourselves. They're all a new construct." His comments and the film's portrayal render the gang in a more sympathetic manner than does the book, particularly regarding *moko*. He suggests that the gang members, even though they are outlaws, are "very proud of their culture," and are "going for the tattoos that came from their history."

In keeping with this revised assessment, the film alters several key aspects of the gang's tattoos. The scene where Nig receives his tattoo is not filmed; after being beaten into the gang (a scene which is presented), Nig simply shows up one day at the bar sporting a facial *moko*. As a result, the book's contrast between the chiseled and electric *moko* appears only implicitly—in the DVD's "Tattoo Gallery," where the full-screen explanatory captions note, "Tattoos

included skin carving and scarring in addition to the insertion of pigment." The captions explain further, "It is said that traditionally a Maori of rank did not get a real face until receiving a *moko*."

Nig's film *moko*, moreover, covers only half of his face, a fact not specified in the book. The half-facial *moko* could indicate that he has only partially joined the gang. Peter Buck suggests that sometimes the half-tattoo indicated that the tattoo had not been finished: "Tattooing was commenced on one side of the face, and sometimes the other side was completed later on in life. The half tattoo was termed *papatahi* (one side)."[27] In the film Nig retains a strong connection to his family. He serves as a pallbearer at Grace's funeral, sporting his *moko* and his Toa gang jacket. (The word *toa*'s meanings include *warrior*.)[28] And he is not alone in attending the funeral; Beth tells him, "Your mates did you proud," because his fellow gang members join him at the *tangi* to show support. In a departure from the novel, at the film's end, Nig remains very much alive, and is shown with Beth and his surviving younger siblings, helping her to reconstitute the family. In other words, his joining of the gang in the film does not alienate him from his former genealogy or lead to his death. The half-facial *moko*, as opposed to the book's full facial *moko*, may indicate that some of his allegiance remains with the Hekes.

Nig's half-facial tattoo could also signal that only his mother is of sufficient rank to warrant a tattoo that shows his descent from her line. Jake Heke denounces the Māori obsession with genealogy, because to his wife's family, "I wasn't good enough for their royal highness." The tattoo could thus convey that Nig descends from a ranking family on his mother's side, but that his father's side bears much lower rank. Jake identifies himself as descending from "a long line of slaves."

Eliminating the tattooing scene, the gang's absolute separation from their genealogies, and Nig's death by gang violence mitigates dramatically Duff's explicit and implicit critique of gang *moko*. The film seems to go a long way toward redeeming this art form. On the other hand, the film, too, retains some presentations of *moko* that continue the book's critique of the form, at least as it appears on the faces of gang members.

One of the film's tattoo designers, Inia Taylor, is a well-known *tā moko* artist, and he and Moana help create designs that are just as exquisite as Duff's tattoo artist declares. Despite Taylor's involvement, however, and despite the fact that his intricate designs are one of the film's most iconic features, the film presents gang *moko* as problematic. To emphasize this point, Riwia Brown's screenplay adds a line that does not appear in the novel. When Boog admires

his older brother Nig's recent facial tattoo, and Nig asks, "Would you like one, bro?" Boog declares, "No, thanks, bro. I wear mine on the inside."

The scene departs from the novel in several ways: it shows Nig returning to the Heke family for a visit after he has joined the gang. And it makes explicit the critical response to the idea that *moko* could be a visible, living practice. The film suggests that Boog, too, is acquiring a *moko*, especially through his contact with the Māori culture of his ancestors, but that his invisible *moko* has a better chance of informing the future than does a visible facial tattoo. This scene, like the novel, creates a disjuncture between past and present tattooing practices. In keeping with the film's presentation of *moko* as part of the past, in the "Tattoo Gallery," an explanatory note reads, "the meaning of the lines and the designs themselves have, for the most part, been lost."

When it comes to portraying *moko* and cultural continuity, both book and film make corollary assumptions. The book's *moko* do not possess a future; the film's do not possess a past. In removing *moko* from the past or the future, both presentations deny the possibility that *moko* can appear on the faces of contemporary Māori as a living practice, an adapted form of tradition. Conceiving of *moko* in these ways separates the Māori past from the future.

Both Duff and Tamahori emphasize urban, violent aspects of Māori culture. Tamahori's opening scenes in particular form a montage of concrete and barbed wire locations, bringing together into a seamless whole parts of Auckland that do not otherwise adjoin one another. As Stephen Turner notes, "The opening sequence seriously distorts the physical environment of Auckland in an effort to make the city look something like south-central Los Angeles, a bona fide tough urban neighborhood of world renown."[29] Tamahori thus borrows urban U.S. film conventions—reviewers repeatedly note John Singleton's *Boyz n the Hood* as an analogue—but within those parameters conveys Māori content.

In emphasizing the urban qualities of Rotorua and Auckland, it is possible that Duff and Tamahori follow in the path of the gangs they portray, employing what Nicholas Thomas terms a "technology of fear." Thomas sees a continuity in the past and present uses of full-facial *moko*, suggesting that "gang members with full-face *moko*, usually mixed with the non-Maori tattoos that might be seen on working-class shoulders anywhere" look "intimidating, in a fashion that is arguably fully consistent with the primary purpose of such tattoos in the Maori warfare of the precontact and colonial periods. This was and is a technology of fear. It is also an expression of 'Maori art.'"[30]

In some ways, however, associating *moko* with the aesthetics of fear accounts for only one implication of the art, and has more in common with long-

standing critics of *moko* than with champions of the art. Harawira Craig Peerless, a United Nations district security advisor who wears a full facial *moko* that has been approved by his *iwi*, suggests, "I want to see ta moko back on the pae pae, the speaking platform on the marae. That's the way it used to be; it was the norm. I think *Once Were Warriors* did a lot to set ta moko back."[31] Peerless's primary quarrel with the film is the presentation of gangs as "the only group in Maori culture that had maintained the moko" ("Security Man"). As the Aotearoan (if not the international) filmgoer knows, gangs do not have a monopoly on the designs depicted in Tamahori's work. This observation coincides with Puawai Cairns's survey of attitudes toward *moko*, which functions differently for international and domestic audiences: on the one hand, "ta moko was slowly becoming subsumed as an icon of New Zealand difference on a global stage of increasing sameness and cross-cultural consumerism." On the other hand, "it was still an icon of intimidation and aggression to the mainstream domestic gaze."[32]

In New Zealand today, these associations can sometimes lead to discrimination and human rights violations. One *moko* wearer filed a complaint after being denied a job; another received a legal settlement for being denied service at a bar.[33] The New Zealand Human Rights Commission issued a report on race relations in 2005. While generally positive, the report noted, "The right to wear moko 'continued to be an issue.'"[34]

The facial *moko*, in Duff's and Tamahori's works, is associated with quick gang genealogies. On the other hand, outside the book and the film, several well-known Māori activists wear full-facial *moko*. Turner suggests that for a local audience, the affective response to the film's full-facial tattoos "springs from association with the threat of Maori sovereignty, not that of real gang violence, which is after all conducted mostly between gangs" ("Sovereignty," 86). Both book and film, then, may gain part of their charge locally from political activities that do not appear on the page or screen.

Do the works by Duff and Tamahori presuppose a Māori or a non-Māori viewer? Both Duff and Tamahori use formal conventions—features of the modernist novel and the urban gang film—that are familiar to international audiences. And both present Māori concepts that extend and modify those conventions. To the extent that their differing works thus challenge the confining of Māori culture to a fixed past the works address both Māori and non-Māori audiences. To the extent that book and film suggest that *moko* is consigned to the past or cut off from tradition, however, these works assume a

primarily non-Māori viewer. The significance of this assumption becomes clear in Kant's thinking about how the viewer perceives *moko*.

Kant's discussion of *moko* is brief but telling. He declares that the tattoo designs themselves would be beautiful—if they did not appear on the face of a human being:

> Much that would be liked directly in intuition could be added to a building, if only the building were not [meant] to be a church. A figure could be embellished with all sorts of curlicues and light but regular lines, as the New Zealanders do with their tattoos, if only it were not the figure of a human being. And this human being might have had much more delicate features and a facial structure with a softer and more likable outline, if only he were not [meant] to represent a man, let alone a warlike one.[35]

The passage presents the "embellishment" of tattoo designs as beautiful in themselves—"liked directly in intuition"—but as superfluous to the figure of a human being. The human being, like the church, requires no embellishment; even beautiful designs are inappropriate to the purpose of a human body.

Even gender is presented as not necessary in and of itself, but only dependent upon the viewer's concepts of what is masculine and "warlike." Here, determining the beauty of a church, a tattooed "New Zealander," or any man, is based upon deciding whether the church, Māori, or man meets its purpose. For churches, apparently, simplicity; for the human figure, a plain, unadorned face; for a man, *not* possessing a "softer and more likable outline."[36]

Kant offers his consideration in the context of discussing whether it is possible to have a pure judgment of taste, that is, to determine objective principles so that all viewers would agree that a particular item is beautiful. He determines that there are two kinds of beauty, "free beauty" and "accessory beauty" (*Critique*, 76). Kant's terms are "freie Schönheit (pulchritudo vaga)" and "anhängende Schönheit (pulchritudo adhaerens)."[37] The German terms translate literally as "free beauty" and "attached beauty."[38] Free beauty is judged independently of the item's purpose; it "does not presuppose a concept of what the object is [meant] to be." Accessory beauty, on the other hand, "does presuppose such a concept, as well as the object's perfection in terms of that concept." So free beauty is judged without reference to purpose, and

stands on its own, "self-subsistent." Accessory beauty is judged only in reference to purpose. That is, "it is conditioned beauty" (*Critique*, 76).

Kant judges a flower to have free beauty, as well as birds and crustaceans— all items from the natural world about which the viewer need know nothing in order to appreciate their beauty. They "represent nothing, no object under a determinate concept" (*Critique*, 77). In other words, not knowing their purpose, the viewer is able to judge the items without reference to anything other than their beauty, which thus exemplifies the "free" beauty Kant denominates. A church or a man, on the other hand, *does* possess a purpose, or a "determinate concept" in the viewer's mind (a purpose known to the viewer but not spelled out here in Kant's discussion). The viewer therefore judges the items in question not only on their own terms, but also in relation to how well they fit the given purpose or determinate concept. Fixed or free beauty thus belongs not just to the object itself, but also to the *judging* of the object.

A tattooed man, because he does not adhere to the concept of a man held by the implicitly non-Māori viewer Kant describes, is not beautiful. On the other hand, the subjunctive verbs and phrases Kant uses focus on the first-time viewer—who "would," "could," or "might" judge the tattoos in a particular way because they appear upon a man's face. The subjunctive case is more pronounced in German than in English, and holds out some small possibility that the viewer and the reader could see the tattoos—if not the tattooed face—as beautiful.

Lest it seem that Kant's formulations have been long reconsidered by philosophy scholars, let us examine briefly two contemporary considerations of the tattooed face, both of which repeat problematic elements of the formulation. In his book, *Kant and the Claims of Taste*, Paul Guyer states that, according to Kant, "the 'flourishes and light but regular lines' of Maori tattooing are *incompatible* with the dignity of the humans they decorate."[39] Guyer's phrasing removes the subjunctive element of Kant's statement; in the process, the statement becomes a much more direct critique of Māori facial *moko*, an outright declaration that *moko* is not commensurate with human dignity. Guyer expands upon this idea in an article, suggesting that Kant offers his statement about tattooing to make the point that it is necessary to find ways of beautifying humans "that are both consistent with and even harmonious with the requirements of morality."[40] The strong implication is that tattooing is inconsistent with those requirements. To state it plainly, Guyer suggests that facial tattooing is immoral.

Robert Wicks, in an attempt to correct Paul Guyer's statement, protests, "One can appreciate the beauty of a human face shining through tattoos that have been applied to it, just as one can appreciate the beauty of a church shining through graffiti that has been painted upon its walls."[41] In other words, the human face can be beautiful *despite* the tattoo, just as the church can be beautiful despite the graffiti. Wicks reiterates his point, that Guyer "does not capture the experience of appreciating a tattooed face that is *otherwise* beautiful" ("Faces," 362; italics added). Again, if the tattooed face is beautiful, it is not because of the designs but because the face is beautiful absent the tattoos.

Neither of these contemporary scholars allows for the possibility that the tattooed face can be beautiful because of both the facial contours and the designs that follow and emphasize those contours. Despite their differences, they thus share and repeat a central element in Kant's formulation, the assumption that the viewer of the tattooed face is not Māori. More, the formulations do not allow for a viewer who appreciates another aesthetic—a culturally specific aesthetic or an aesthetic inclusive enough to encompass Māori design practices.

Kant does not address this potential viewer, and neither do the later scholars. The viewer would presumably view the *moko* favorably, since it would conform to the viewer's concept of "conditioned beauty." That omission, in works that scrupulously attempt to anticipate all possible angles of considering beauty in order to determine processes of taste and judgment, means that the default viewer is the *ignorant* observer of a tattooed face. In attempting to establish standards of beauty and judgment, all three passages have the effect of subsuming all viewpoints into one, which is presented as disinterested and knowing. (That this observer remains innocent of information about Māori *moko* is not presented as a problem but as a necessary outcome of the aesthetic being proposed.)

Despite the seeming fairness—and subjunctive slipperiness—of Kant's formulation, the passage attempts to make all viewers uphold non-Māori standards of judgment. The contemporary scholars, despite their disagreements, repeat this element of the formulation. Although the pages of a philosophical critique seem far removed from annexations of land and other geopolitical movements in the world, the implications of this assumption underpin ruthless imperialism. If all viewers maintain non-Māori forms of taste, in the process of judgment Kant describes, then even Māori must learn to view the facial *moko* through the eyes of non-Māori, must become non-Māori in order to see the standards of beauty detailed here.

Gayatri Spivak offers a related observation about the restrictions placed upon the speaking or judging subject in Kant's *Critique*: "The point is, however, that the New Hollander or the man from Tierra del Fuego *cannot* be the subject of speech or judgment in the world of the *Critique*. The subject as such in Kant is geopolitically differentiated."[42] In other words, theories of aesthetics can serve, wittingly or unwittingly, as the handmaiden of colonialism and imperialism.

Such limited views of beauty are consonant with those of the missionaries who denounced *moko* as "the Devil's Art"[43] and helped lead to a decline in the practice. The Tamahori DVD "Tattoo Gallery" captions refer (mistakenly) to this decline: "The practice of full facial tattoos for men ceased in the 1800s." (In the film no mention is made that the gang's tattoos derive from a vital tradition of *moko*, a fact known to Aotearoan if not to international audiences.) Despite such statements, the resistance movements in the 1860s created a revival, using *moko* to declare their allegiance to Māori rather than English leaders (*The Coming*, 300). In describing one of the important figures in this resistance, Te Awekotuku notes, "Tawhiao Matutaera Te Wherowhero, paramount chief and Second Maori King, personified resistance to Pakeha invasion; his face was exquisitely adorned and he encouraged the art's revival."[44]

At the same time that missionaries criticized *moko* on Māori faces, however, and discouraged the practice, the design world was intrigued by the patterns. *Toi moko* featured in *The Grammar of Ornament*, a Victorian handbook of design theory,[45] which reproduced a visual plate featuring "tattooing on the head" (*Ornament*, 13). (The image is identified as "Female Head from New Zealand, in the Museum, Chester" [*Ornament*, 14], despite the fact that the designs are those that appear almost exclusively in male facial *moko*.)[46] The design expert, Owen Jones, sees in such patterns both barbarity and beauty: "in this very barbarous practice the principles of the very highest ornamental art are manifest, every line upon the face is the best adapted to develope [*sic*] the natural features" (*Ornament*, 13).

Outside of their homelands, it was not only reproductions of tattooed heads that circulated. More than two hundred ancestral tattooed heads were expropriated and circulated worldwide, many of them ending up in fine museums in the United States and Europe. An estimated two hundred heads remain in overseas institutions, and a growing number are being repatriated. The Museum of New Zealand Te Papa Tongarewa holds about fifty-five in a consecrated facility. Te Papa spokespersons note that the museum has worked for five years to request and facilitate such repatriation, and that when possible the museum

will use DNA testing and chromosomal tracking to return the heads to the appropriate tribes.[47]

Kant's aesthetic theories find beauty in the designs when they are separated from the human face; this conceptual move coincides with the practice of alienating these tattoos from a Māori context. The abstract removal of the designs from the face, in the considered realm of aesthetic theory, goes along with the sometimes brutal removal of Māori heads from Māori bodies to satisfy an international market. In both philosophical and design realms, tattooed faces have been systematically separated from their ancestral world.

Still, despite this separation presupposed by international theories and marketplaces, in Aotearoa the practice of *moko* continues apace. The aesthetic of *moko* continues in defiance—and sometimes in disregard—of such affronts. The tattooed face is a living face of Māori culture. Writer Witi Ihimaera takes Mataora, the name of the human who brought *moko* back from the underworld, as the title of the book he edited on contemporary Māori art, *Mataora: The Living Face*.[48] (Mataora's wife Niwareka accompanies him in moving from her birthland into the world of light, and brings with her the fine art of weaving.)

Summing up the power of *moko*, Te Awekotuku declares, "It was, and still is, about metamorphosis, about change, about crisis, and about coping too; and for many contemporary wearers, the descendants of those first illustrated chieftains encountered by Cook, painted by Parkinson, Ta moko is a strategy too, a means of encounter, an expression of self."[49] *Tā moko* as metamorphosis, as strategy, as story—this is the living art that creates the tattooed face as beautiful *because* the face and the tattoos are inseparable. So much depends upon the aesthetic.

4

Marked Ethics

ERASING AND RESTORING
THE TATTOO

When Christian missionaries and colonial laws arrived in the Pacific, tattoo became a flash point for conflict. Some nineteenth-century Christian missionaries banned tattoo, declared the practice dead, and in Tahiti even flayed tattooed skin to enforce their ban. In the face of such suppression, native people staged tattoo rebellions to assert their sovereignty. Tattoo embodies cultural survival and reveals a new history. For decades after it was proclaimed dead in the French Pacific, Hawai'i, and Tonga, tattoo continued under the clothes imported by the missionaries.

Across the Pacific, even in Samoa and Aotearoa New Zealand, where the traditions of *tatau* and *moko* continued uninterrupted, Christian missionaries and colonial authorities attempted to halt or discourage the practice. Mrs. Favell L. B. Mortimer, for instance, writing anonymously for the American Tract Society to honor the fortieth anniversary of the Tahitian mission in 1836,[1] presents tattoos as a test of the Christian missionaries and the *mission civilisatrice*. She thus notes that religious and civil authorities encouraged chiefs to ban tattoos, because the body markings led people to "many other of their old heathen habits."[2] Nonetheless, because so many young men and women persisted in seeking tattoos, "The only way to prevent tattooing was at length found to be, having the parts that were marked, disfigured by the skin being taken off, and foul blotches left where beautiful patterns had been pricked in" (*Toil*, 204).

In other words, missionaries (who also acted as civil authorities at this time) concurred with the selective flaying or skinning of Society Islanders, an act so extreme that it violates their own principles of Christianity and civil society. So powerful is *tātau* as a marker of Tahitian ways that the foreigners are willing to abrogate their faith selectively in order to erase this Pacific pattern. Even so, Mortimer's statement contradicts its own logic: tattoos must be removed, a process of which she approves; but, she notes, as a result "foul blotches" are left in place of "beautiful patterns." The despoiled tattoo pattern serves as shorthand for outsiders' interventions into Tahitian ways. Mortimer praises the results, where today her reader might deplore them.

Tātau serve as a visible sign of the battle for sovereignty over Tahitian bodies, hearts, minds, and souls. Similarly, the distinct histories of tattoo in many places in the Pacific, including Hawai'i and Tonga, led to edicts against the practice, severe penalties, and, in some cases, a decline in the tattoo art and way of life. Since the early 1980s in Tahiti, and more recently in Hawai'i and Tonga, a vibrant tattoo renaissance has put tattoos upon Pacific bodies anew. This renaissance attests to a vital cultural presence.

Against the historical and continuing presence of tattoos, on the other hand, many accounts provided by missionaries, travelers, and anthropologists present the tattoo as having been erased. Even the most recent anthropological study of tattooing repeats, "Tahitian tattooing was abandoned due to suppression by Christian missionaries in the 1830s"; "they stopped tattooing in the 1830s"; and "there is an undeniable, almost one-and-a-half-century-long absence of tattooing in Tahitian history."[3] Here I want to urge a reconsideration of this conventional history and offer an analogous reconsideration of the conventional history of tattoo in Hawai'i and Tonga.

For one thing, several of the accounts discussed in this chapter attest to the continuing presence and practice of tattooing well into the 1840s and beyond. For another, often the tattoos' absence is produced only in the accounts themselves, erased only in the narratives. The tattoo renaissance of the past twenty-five years, which Kuwahara documents in *Tattoo: An Anthropology*, in other words, continues a practice that went underground, covered by the clothing missionaries introduced. Much as Ngahuia Te Awekotuku and her colleagues have recently corrected the mistaken written record that suggested *moko* had halted in the mid-nineteenth century, it is high time to reexamine the written record of tattoos in Tahiti, Hawai'i, and Tonga. Investigating these three traditions reveals a repeating pattern.

The assumption has been that Europeans ended indigenous political power and tattooing in the early colonial period. To the contrary, both the political and cultural traditions stayed alive, and have flourished in the postcolonial present. In Tahiti, explicit tattoo rebellions raged against missionary and French government attempts to assert power. In Hawai'i, the practice continued in the prominent person of Kamehameha after the endpoint usually assigned to the practice; there, tattoo became associated with writing (the word *kākau* refers to both tattooing and writing) and, in turn, with a decolonization of both the book and the body. In Tonga, political rebels used tattoo to revolt against the Tongan king's missionary-inspired ban of the practice; and in an unusual corollary, an English missionary experienced a conversion and himself sought a full-body tattoo.

A Pacific tattoo ethic persists despite such efforts at suppression: that ethic both connects and defines past and present, ancestors and descendants, gods and humans. An ethic of tattoo both demarcates and bridges the sacred and profane—forces that are relational, and that shift with the introduction of distinct skin patterns. Tattooing in historical Pacific practices added a protective skin between the sacred and the profane. The designs both preserved sacred power for the bearer, and prevented that power from harming those who did not carry such power: tattoo "kept *mana* [sacred power] within and at the same time protected a *noa* [non-sacred] person from it" (*Tattoo: An Anthropology*, 39). Removing tattoo involved a dangerous unbinding of that which is sacrosanct.

Covering the body with European clothing, we shall see, helped to suppress tattoo, as did narratives that proclaimed that the tattoo had been halted, erased, or removed. To counter the tattoo ethic, missionaries introduced a written code of law, one based upon doing away with such visible markings of the sacred; but they violated their own moral clarity both in using brutal violence to establish the European concept of the legal and illegal and in providing loving descriptions of the customs they worked to stamp out. (They also overlooked a long tradition of tattoo that commemorated Christian pilgrimages to Jerusalem, in which pilgrims received figures including the Jerusalem cross. Flannery O'Connor's story "Parker's Back," about the way a tattoo of a Byzantine Christ both reflects and propels the transformation of the title character, invokes this long tradition.)[4] In a corollary paradox, missionary accounts focus on the penalties they impose for violating their tattoo bans, but omit what the penalties look like when inflicted on actual people.

Many of the people who sought tattoos in the Marquesas and Tahiti did so clandestinely because of the laws against the practice. At least some tattoo wearers sought the designs in deliberate defiance of the laws and the Christian mission that helped create and enforce them. Moa-e-tahi, a Tahuata-born man who lived in Hakaui, Nuku Hiva, wore a tattoo that declared, in Marquesan letters that adorned his arm, "Kahau hee atua Ioava! Ii kehu, ahi veu; vave te etua!" In English: "You are invited to follow the god Jehovah! (His) anger is ash, the flames are wet! Hurry to the gods!"[5] Steinen, who describes the tattoo, documented Marquesan art beginning in 1897; Moa-e-tahi's *tiki* establishes that, almost forty years after the practice was first forbidden, tattoo was used to mount an articulate challenge to such laws.

. Moa-e-tahi, moreover, was not alone in bearing such dissident tattoo. Steinen records two women who bear similar messages, including one, Mahi-aitu, who wears the phrase, "I toua éi tapu," or "in the war for sacred decoration" (*Die Marquesaner* 1:96, translation mine). The tattooed phrase describes its own function: it bears witness to the continuing presence of sacred decoration, and the fact that proscriptions make its existence an act of war. Her tattoo is a proclamation of battle. The words declare that she fights to preserve practices sacred to the island of her birth, Uapo: specifically tattoo, which the missionaries would overturn. (In this formulation the missionaries serve a devil-God.) The tattoo declaration invokes the native power of the islands against laws that would unseat those powers.

Such tattoos are doubly subversive, as they wield script taught in missionary schools to challenge the schools' assumptions. These tattoos indigenize writing and taunt the missionary-inspired prohibitions. It is reasonable, then, that Moa-e-tahi, Mahi-aitu, and others across the Pacific who continued to bear traditional and innovative patterns would not have revealed such designs to the missionaries and colonial authorities whose accounts form the basis of tattoo histories.

It is not reasonable, however, for tattoo histories to overlook the evidence provided by other travelers—often travelers who themselves received tattooing—that the practice continued after such bans. Yet tattoo scholars including Roth and Gell cite accounts by writers like Bennett, Coulter, Banks, and Krusenstern while omitting the key fact that these writers themselves received tattoos. (And in Krusenstern's case, most of the people on his ship received tattoo in the Marquesas. "There are some among them," he reports of tattooing, "who have particularly acquired this art, one of whom took up his residence on

board the ship, where he found sufficient employment, as almost all the sailors underwent the operation."[6] Krusenstern does not report that he himself received a tattoo, but Loewenstern declares, "Tattooing becomes more and more popular on our ship. The native works from morning til night. Even Krusenshtern [*sic*] had a tattoo done.")[7] The tattooed traveler also demonstrates that the practice continues.

Omitting the fact that the writer was tattooed (and that tattooing thus continues beyond the endpoints assigned to it) distorts the historical reality and vitality of tattooing. It also reveals an important feature of culture in Oceania, which has always been on the move. As writer-scholar Epeli Hau'ofa declares, "I point out that our past holds constant travel, constant interplay of cultures, and that the coming of the Europeans was just one aspect, just broadening that."[8] Despite that fact, Hau'ofa continues in the same interview, "somehow or other we have this notion of stasis, assisted in part by anthropologists, who wanted at one stage to record traditional cultures before they disappeared" ("Oceania Interview," 24). As Hau'ofa indicates, anthropologists were not the only ones who contributed to the idea of a static tradition. So, too, did many of the writers we will examine. In reality, though, "people in the past really lived very much like people in the present. There were always cultures mixing. Things were fluid, they were not frozen" ("Oceania Interview," 23). In this way Hau'ofa's Oceania is created by people who travel constantly across both geographical and cultural seas, "crisscrossing an ocean that had been boundless for ages before Captain Cook's apotheosis."[9]

WRITING *TĀTAU* IN TAHITI

One of the earliest and most detailed descriptions of Tahitian *tātau* is provided by Joseph Banks, who traveled as a naturalist with Captain James Cook on his first journey to the Pacific. In 1769, Banks proclaimed,

> every one is markd thus in different parts of his body according may be to his humour or different circumstances of his life. Some have ill designd figures of men, birds or dogs, but they more generaly have this figure Z eithier simply, as the women are generaly markd with it, on every Joint of their fingers and toes and often round the outside of their feet, or in different figures of it as square, circles, crescents &c. which both sexes have on their arms and leggs; in short they have an infinite diversity of figures in which they place this mark and some of them we were told had significations but this we never learnt to our

satisfaction. Their faces are in general left without marks, I did not see more than one instance to the contrary.[10]

The "significations" of the designs remain elusive, the patterns seeming to provide a text that the outsider cannot read. Tattoos in the Society Islands did not consist of a writing system (an assumption that attempts to assimilate *tātau* to familiar scripts).[11] *Tātau* did mark the onset of adulthood, increase the aesthetic beauty (and attest to the honor and sexual fertility) of the wearer, and feature gender-distinct patterns.[12]

Banks reports further:

> yet all the Islanders I have seen (except those of Ohiteroa) agree in having all their buttocks coverd with a deep black; over this most have arches drawn one over another as high as their short ribbs, which are often 1/4 of an inch broad and neatly workd on their edges with indentations &c. These arches are their great pride: both men and women shew them with great pleasure whether as a beauty or a proof of their perseverance and resolution in bearing pain I can not tell. (*Endeavour Journal*, 1:336)

One of Banks's shipmates, Sydney Parkinson, created a sketch of these arches (figure 10). Banks once again indicates the limits of his observations; he does not know whether the designs indicate pleasure at the aesthetic appearance of the designs or pride at having borne pain in order to acquire them. He conveys the ubiquity of the practice for both men and women. Even though he records gender-specific patterns that women bear on their hands, knuckles, and the outsides of their feet, he also suggests the pleasure both men and women demonstrate in revealing their *tātau*, particularly the arches.

The arches that adorn the men are termed *avàree* (*Observations*, 557). Gell, following Steinen, suggests that *avàree* translates as "to raise [or lift] a taboo," indicating that "tattooing, on men as well as on women, denoted the lifting of restrictions on social intercourse."[13] Supporting this idea is the fact that one meaning of the word '*āvari* is to inaugurate, or to open. Forster further describes *tātau* terminology: "the parts which are one mass of black on the buttocks are named *toumàrro*, and the arches which are thus designed on the buttocks of their females, and are honourable marks of their puberty, are called *toto-hoòwa*" (*Observations*, 557). *Taomaro*, or "girdle of spears" (*Wrapping*, 145), is apparently the term for the black buttock patterns on both men and women. The gender-specific term for the women's arch is *toto hua*, which can translate as true blood (frankly or squarely blood).[14]

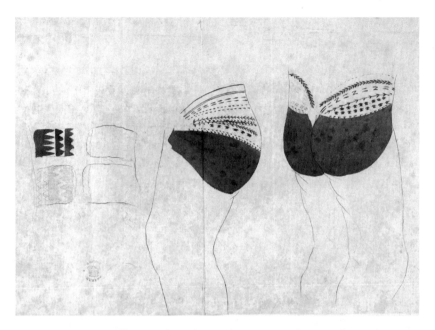

FIGURE 10. Illustration by Sydney Parkinson. Tattoo designs on loins and
buttocks, probably Raiatean. August 1769. Pen, wash, and pencil on paper.
Published with permission of the British Library.

In Tahiti, Banks details the process by which a twelve-year-old girl receives
an arch upon one buttock (the other buttock having been tattooed previously).
So great was the pain of the *tātau* that first one buttock was marked, and then,
as long as a year later, the second one was completed. The arches could be
added at still a later time (*Endeavour Journal*, 1:309). Not until both buttocks
bore the arches were young women considered to be women, "being only
Counted as Children till they have their Tattowing done" (*Journal of James
Morrison*, 221). (Tattooing was begun on girls, J. R. Forster reports, when "the
marks of puberty" were visible [*Observations*, 433, 434].[15] Young men were tat-
tooed at a slightly older age than were girls, so received their marks later than
the onset of puberty.)

Except in a few cases when high-ranking women were "set aside" for mar-
riage, tattooing was not a prerequisite for sexual activity (*Tahitian Society*,
2:611). *Tātau* may also show that *tabu* have been lifted from children, who
otherwise possess contagious sacred power because they come straight from
the gods. The head was considered a particular locus of this sacred power. In

passing into adulthood, the *tabu* is lifted and "the head is made free," a transition indicated by "a small spot on the inside of each arm, just above the elbow, which is a mark of distinction."[16]

TĀTAU REBELLION

The story of tattoo parallels the Tahitian struggle to retain political and cultural power. Tattoo became a highly visible form of protesting missionary and French civil authority. The practice was banned officially in Tahiti and Mo'orea in 1819, in Ra'iatea, Taha'a, Borabora, and Maupiti in 1820, and in Huahine and Mai'ao in 1822. As noted, punishments for people who obtained *tātau* were severe. Such penalties feature in the book, *The Night of Toil; or, a Familiar Account of the Labors of the First Missionaries in The South Sea Islands*, published by the American Tract Society and written by Mrs. Favell L. B. Mortimer (though published under no author's name). The book traces, "in a form acceptable to youth," the forty-year work of the first missionaries in Tahiti and the Society Islands in particular. Mortimer cites as her sources "the journals and letters of the missionaries, published in the seven volumes of 'Missionary Transactions,' and 'The Quarterly Chronicle'" (*Toil*, 5). She adds commentary to the published sources.

Mortimer details the forms of discipline imposed upon tattoo artists and wearers. Indeed, she focuses much more upon the punishments than on the tattoos themselves: "In the island of Raiatea, two deep pits were once dug on the side of a hill; each was about fifteen feet deep, and was smaller at the top than at the bottom, so that it appeared impossible to climb up the sides. A woman who had run away from her husband and got herself tattooed, was put in one of these pits, and the man who tattooed her in the other" (*Toil*, 203). This "strange punishment" (*Toil*, 203) works against the order that tattoos represent. Tattoos connect the individuals to the living culture and community of Ra'iatea; the earthen prisons separate the individuals from such collectives.

In continuing to recount penalties for tattooing, Mortimer identifies the reasons the practice has been prohibited. Echoing missionary William Ellis, whose work had featured Tahiti prominently, she declares, "It may be thought hard by some, that people were not allowed to be tattooed, or to tattoo others. But the chiefs had forbidden these practices, for very wise reasons. They found that when the natives chose to be tattooed, they soon returned to many other of their old heathen habits" (*Toil*, 203–4). In other words, tattoos contain deep patterns of behavior and belief. Changing "old heathen habits" requires alter-

ing such fundamental patterns. Tattoos, like Pacific lifeways, remain a blatant reminder of the civilizations that precede missionaries.

Indeed, many people persisted in seeking tattoos. Mortimer describes the young people in particular who sought to continue their practices of adornment and acquisition of adulthood:

> Ill-disposed young people were very determined in their resolution to be tattooed, and would have one limb after another thus marked, in spite of a punishment after each offence.
>
> These obstinate offenders were made useful to their country. In Tahiti they, as well as other criminals, began a broad road, that was to be made all round the island. In many places they brought great blocks of coral from the sea to build piers. The same persons might often be seen engaged in these fatiguing labors. (*Toil*, 204)

As Mortimer suggests, the people who continue to seek and make tattoos are indeed "ill-disposed" to the changing order of things, in which the art of *tātau* becomes the stain of crime. Their punishment: to build the roads that enable missionaries, chiefs, and traders to bring new laws to the rest of the island. Some of the stones for building roads come from the ancient *marae*, or meeting places, long central to practices of feasting, dancing, and worship. Forced to perpetuate the new laws' surveillance, the tattooed people (and other violators of the new legal statutes) build roads to enable the new laws to embrace new areas so that more tattooed people can be required to build more roads. When road building fails to prevent *tātau*, then, as noted above, authorities resort to the extreme act of skin removal.

Given such harsh punishment, Mortimer is vague about why young people continue to seek *tātau*. The only reason hinted at in her narrative is the beauty of the patterns—the beauty that is replaced with something foul when authorities peel away the tattooed skin. Ellis, whose *Polynesian Researches* serves as a source of Mortimer's narrative, is more explicit; after the ban, young people seek *tātau* to enact a deliberate political rebellion.

Ellis reminds his readers, "Among other prohibitions, that of tatauing, or staining the body, was included. The simple act of marking the skin was not a breach of the peace, but it was intimately connected with their former idolatry, always attended with the practices of abominable vices, and was on this account prohibited. In the month of July, it was discovered that a number, about forty-six young persons, had been marking themselves."[17] The simple act of marking the skin, in other words, is never simple. (A few pages earlier, Ellis

has presented the published code of laws for Huahine, the island where the tattoo rebellion occurs.)[18] The party of forty-six young persons—a number that Ellis suggests is significant enough to have in the past warranted violent reprisal—are instead sentenced to build stonework along the sea.

But the forty-six unnamed youth are joined by two prominent political figures. First, Taaroarii, son of the "king" of Huahine, and second, Moeore, son of the "king" of Ra'iatea. Taaroarii's action, "being considered as an expression of his disapprobation of his father's proceedings, and of his determination as to the conduct he designed to pursue, produced a great sensation among the people" (*Polynesian Researches*, 3:218). Both Huahineans and missionaries, in other words, understand the *tātau* as a direct challenge to the new code created by senior leaders and missionaries. The response to violating the code is to reassert it: Taaroarii's father administers a trial, and his son, too, is sentenced to build stonework. (Published penalties for tattooed women were mat weaving or clothmaking.)

Still, the sentencing of even the chief's son does not deter further tattooing, which continues to be sought by not only "several unsteady young men and women" but also "two principal personages in the island, [who] by having their bodies tataued, joined their party: these two were, the son of the king of Raiatea, who was residing at Huahine—and his sister" (*Polynesian Researches*, 3:218–19). (The sister remains unnamed in Ellis's account.) Men and women from across the social spectrum acquire *tātau* in order to create a collective based upon an older code. The tattoo patterns mark the young people's allegiance to a differing order and, in fact, attest to the continuing presence of that prior order.

"Their party was now strong," Ellis states, "both in point of number and influence, and we expected that the simple circumstance of marking the person with tatau, was only one of the preliminaries of their design" (*Polynesian Researches*, 3:219). Once again, the simple act of tattooing is not simple. The tattoo patterns reflect the bearers' political designs, which become explicit in the visible markings. As for Taaroarii, "as soon as they were strong enough, he intended to assume the government of the island, and abolish the laws— that under his reign every one should follow his own inclinations with regard to those customs which the laws prohibited" (*Polynesian Researches*, 3:219). Moeore joins this "large party of wild young men," Ellis reports, thus enlarging this group to include two chiefs' sons "whose designs were evidently unfavourable to peace" (*Polynesian Researches*, 3:219–20). The language here is contradictory: the young men are "wild," yet they hold "designs" at odds with

the new ones Ellis has helped introduce and which he helps propagate through his narrative. The young people's designs are embodied in the *tātau* they bear, in contradiction of the new laws, and in testament to their own political will. The young people are of course wild only in the sense that they violate the new order by enacting the old: the political patterns they establish, like the *tātau* patterns they bear, are shrewd and deliberate.

Such open defiance, enacted by a large group and joined by two significant leaders, amounts to a declaration of civil antagonism, and it is met by a public council convened by Hautia, deputy governor of the island. In presenting the council's deliberations about how to respond to the *tātau* rebellion, Ellis reiterates the connection between tattooing and lawlessness: "It appeared from the declarations of several, that the conduct of the young men, and especially the chiefs' sons, had not proceeded from any desire to ornament their persons with tatau, but from an impatience of the restraint the laws imposed; that they had merely selected that as a means of shewing their hostilities to those laws, and their determination not to regard them" (*Polynesian Researches*, 3:220). The *tātau* becomes a dramatically visible—and highly public—means of resisting the laws.

For both the people who formulate the new codes and the people who invoke an older code, the *tātau* serves as a synecdoche for an entire way of life. The charge of lawlessness obtains, of course, only according to the new code, with which the missionaries are closely enough associated that one chief, Taua, advises the missionaries to prepare to flee the island. Ellis and the other missionaries comply, waiting aboard ship and ready to depart in an instant if they hear a prearranged gunshot signal. Several gunshots shatter the air, but the signal is unreadable; Ellis reports that they cannot hear how many shots have been fired, and thus do not know whether the signal tells them to stay or flee. Even this sign remains perplexing. The islanders produce another text the missionaries cannot decipher.

Ellis resolves the *tātau* rebellion with a brief anticlimactic notice that Moeore and his party have surrendered and been set to work in small parties. No mention of Taaroarii's fate (or of Moeore's sister) is made. The narrative structure, in other words, emphasizes the *tātau* rebellion much more than its resolution. That emphasis reveals that the continuing *tātau* practices unsettle the missionaries and the laws and pose a challenge that exceeds the narrative. Rather than addressing this challenge head-on, Ellis allows the story of the tattoo rebellion to trail off into silence.

Ellis does not note whether the repeat *tātau*-offenders were forced to suf-
fer the flaying penalty described by Mortimer, or the further penalty noted in
the code of laws he reproduces in his book: "The man and woman that persist
in tatauing themselves successively for four or five times, the figures or or-
naments marked shall be destroyed by blacking them over" (*Polynesian Re-
searches*, 3:186–87). He does not describe the enforcement and effect of these
penalties.

One reason for this peculiar silence is that the penalties reveal that which is
outside his narrative: the outrageous fact that *tātau* predate his narrative and
continue despite the legal code that his narrative helps extend. The narrative
of *Polynesian Researches* presents a scandal in the continuing of *tātau*, where
a modern reader might identify a scandal in the effects of the ban the mis-
sionaries helped institute. He provides detailed descriptions of *tātau* patterns
themselves, however, thus giving more space to the beautiful patterns that he
is trying to erase than the distorting ones that he helps impose.

The blacked-over patterns in Tahiti, unlike traditional blacking-over in the
Marquesas Islands, represent the price of crime. Neither Mortimer nor Ellis
describes any tattooed people who received this penalty. Frederick Bennett,
however, an English physician who visited the Society Islands several times
during his 1833–36 whaling journey, reports, "We felt much regret, not un-
mingled with indignation, when we beheld, in the house of the royal chief
of Raiatea, a native woman, of naturally agreeable features, disfigured by an
extensive patch of charcoal embedded in her cheek—a punishment inflicted
upon her by the judges for having slightly tattooed herself."[19] Moreover, "a
second female showed us her hand, which afforded a similar instance of judi-
cial severity; we could only cling to the hope that the British missionaries had
not given sanction to such barbarities" (*Whaling Voyage*, 1:117–18). In fact,
the British missionaries had not only given sanction to such penalties, they
had helped formulate and promulgate them. The narratives they wrote were a
primary means of that promulgation.

Bennett, who reported that Society Islanders were penalized for being tat-
tooed, was himself tattooed on his upper arm while visiting Raʻiatea, selecting
his design from the body of the tattooist: "The artist I engaged was a Tahitian;
and from the numerous patterns displayed on his person we selected a circu-
lar figure, named *pote*" (*Whaling Voyage*, 1:118). In Santa Christina [Tahuata]
Bennett added to his arm a "Marquesan design," which he does not otherwise
name or describe: "The artist, (who was a native of La Dominica [Hiva Oa],)

amused me during the operation with a sagacious discourse upon the excellent
bargain I had made with him; for, he said, the musket-balls, flints, and tobacco,
he received as his fee, would be soon expended, while the tatooed figure he
gave me would remain for life" (*Whaling Voyage*, 1:307).

The revised code of laws of 1825 further codified the prohibitions and pen-
alties against tattooing, but throughout the 1820s missionaries in the Society
Islands reported outbreaks of resistance "aimed at 'destroying the whole of us
including King & Chiefs.'"[20] For more than a decade beginning in the mid-
1820s, the millenarian Māmaiā movement, which was associated with *tātau*,
used scripture and revelation to prophecy against the missions and the new
laws.[21] Before the *tātau* rebellion Ellis describes, but after the general con-
version in 1815, "Maohi carved their opposition on their skin, in the form
of tattoos. This nonviolent form of protest was masterminded by women of
the *Tutae Auri* (meaning very hard excrement) movement, with Pomare II's
widow among its practicing members" (*The Word*, 171). (The term *Ma'ohi* re-
fers to the indigenous people and culture of the Society Islands.) Bennett, who
visited the islands shortly thereafter, notes that Queen Aimata was part of a
full-fledged rebellion in 1831, when she "was implicated with a large portion
of the population, acting in direct opposition to the existing laws of the island,
and anxious to abolish the trammels they imposed, and to reinstance the vi-
cious usages of former days" (*Whaling Voyage*, 1:76). (The very tattoos that
Bennett himself sought formed part of those "vicious usages.")[22]

The *Tūtae 'āuri* movement (which means literally either "excretion [from]
iron" or "iron[like] excreta"),[23] had extensive influence. The name conveys the
rebels' stubborn strength in holding to their own ways, a strength that inspired
fear among missionaries. In describing the situation at Taiarapu in 1823, the
missionary William Crook recorded in his journal, "all the young men with
very few exceptions and many of the young women turn out very wild. They
go by the name of Tutai Auri or Rust of Iron" ("Mamaia," 212). A note of hys-
teria enters Crook's diary in February 1824, when he deplores the increasing
numbers who join the movement, including mission-educated students: "The
behavior of the tutoi auris as they are called is arrived at an alarming pitch.
There are no less than six of our school-boys now in the mountains and people
going off from week to week" ("Mamaia," 213).

In this rebellion, too, women played an important role. Crook cites "Taine
vahine," daughter of the chief of Hitia'a, Inometua, as a key instigator of the
movement to abrogate the new laws. Explicitly setting their activities against
those of the missionaries, the members practiced tattooing on Sundays in par-

ticular. At this time, the entire district of Ahui was reported to be devoted to the *Tūtae ʻāuri* movement, and almost everyone there had been tattooed, "even the judges" ("Mamaia," 213).

Members of this movement were also sometimes referred to as *arioʻi*, a fact that helps explain missionaries' alarm over the movement. One of the reasons the missionaries in the Society Islands were so opposed to *tātau* was that the designs were associated with (although not limited to) *arioʻi*, an exclusive society dedicated to 'Oro, god of war.[24] (In many travelers' accounts, *arioʻi* are famed for their flamboyant and nonreproductive sexuality, and their practice of radical reciprocity, both forms of economy counter to the ones Europeans recognized). The *arioʻi* were bards, poets, historians, and priests. Partly because of this association, many missionaries saw the *tātau* as a notorious pagan practice.

In addition to the designs already described, specific *arioʻi* tattoos featured eight grades that included, first, *Avae Parai* (blotted-legs or black-legs) and second, *Harotea*, light-print, which consisted of "filigree bars crosswise on both sides of the body from the armpits downwards towards the front."[25] John Rutherford's torso tattoos may be an example of *Harotea*, which would therefore suggest that such tattoos were not limited to *arioʻi* ("Tatu," 295; *Wrapping*, 149). As some of Rutherford's tattoos radiate from the back across his short ribs, they may also exemplify the third order of *arioʻi* patterns, *Taputu*, or *Haʻaputu* (piled or gathered together), "diversified curves and lines radiating upwards towards the sides from the lower end of the dorsal column [spine] to the middle of the back."[26] That case, too, would indicate that the designs were not exclusive to the *arioʻi*. Georg Forster reported of *arioʻi*, "the more they were covered with punctures the higher was their rank."[27]

By bearing histories as elaborate as their *tātau*, the *arioʻi* threatened the new order the missionaries introduced. In response to the new order, on the other hand, Maʻohi tattooing was quite adaptive. Reflecting their contact with Europeans, in the 1820s and 1830s some tattoo designs incorporated muskets and compasses.[28] Even when tattoo designs reflected European goods, however, many missionaries saw tattooing as a threat to the gospel they brought.

In his history of the Tahitian mission, the missionary John Davies records several instances of specific *tātau* rebellions, and sums up:

> many of the young people shewed a strong inclination to return to their former diversions, and marking their bodies with the *tatau* according to former practice, and tho' this at first took place among those that were not baptized or

brought under the discipline of those more immediately under the inspection of the miss[ionaries], the defection by degrees reached further, and many of the baptized began to associate with those that had returned to those vain and sinful practices.[29]

After the French claimed the islands officially in 1842, resistance continued throughout the nineteenth century. In 1874 two French colonial inspectors complained that the Native Affairs department in the protectorate had allowed "ancient Kanaka customs" to thwart the process of making the islands French (quoted in *Tahiti Nui*, 196). In 1897, about two hundred Ra'iteans were arrested for rebelling against the French by blockading the main port—and were exiled to the Marquesas Islands. Even in 1900, after spending five months in Tahiti and the Tuamotu Archipelago, A. C. E. Caillot reported that the islands were "French [only] in name" (quoted in *Tahiti Nui*, 233). The Ma'ohi refusal to speak French, reported in 1915 by a colonial inspector (*Tahiti Nui*, 229), exhibits a dramatic form of resistance. Indeed, even in the late twentieth century, one in five Ma'ohi were not fluent in French (*The Word*, 173).

Despite linguistic and other forms of resistance, the laws against *tātau* do seem to have led to a public decline in the practice. As a result, documentation of Ma'ohi *tātau* is less extensive than that of Samoan *tatau* or Māori *moko*. Gell suggests, "This drawing [figure 10], and a detail in a corner of an oil-painting by Hodges which shows much the same thing, are the only reliable records left" (*Wrapping*, 123). Another contemporary anthropologist, who is also a tattoo artist, reports, "There are fewer than 20 known illustrations of authentic ancient Tahitian tattoos."[30]

Despite the prohibitions, however, the practice persisted. One visitor, writing in 1850, declares, "The art is much lost, for the missionaries have discouraged it; but there are few even now that are not marked."[31] On his second visit to Tahiti in the late 1840s, even after the French have claimed the islands, Walpole, a lieutenant in the British navy, reports that a noted tattoo artist practiced frequently in the house of a well-known woman named Teyna: "Tatooing was performed by a man of great reputation, a far-famed native; he was a frequent guest; and with miniature hoes with sharp points at the edge, and a small hammer, any mark you wished was imprinted on the body" (*Collingwood*, 2:312). For this reason, a note of caution is in order: it is perhaps wise to avoid endorsing such assessments as those offered by Kotzebue more than twenty years prior to Walpole, that "the missionaries have abolished the custom of tattooing" (*New Voyage*, 1:174). A narrative proclamation that *tātau* have vanished

helps create that absence. One of the ways that people attempted to erase *tātau*, all of these accounts suggest, is through such narratives. On the other hand, such contradictory accounts also make possible a paradoxical reconstruction—of *tātau's* meaning and persistence despite such assumptions.

The revival of *tātau*, like the Ma'ohi sovereignty movement and cultural renaissance, attests to the living traditions that persist despite attempts to erase them. The Ma'ohi musician Angelo, in his song "Arioi" from the album of the same name, creates a tribute to the ario'i society and "calls for Maohi to tattoo their beings with the strength of Oro" (*The Word*, 176). Poet Henri Hiro calls for a return to ancestral history, including tattooing. In his poem "Fero / L'Attaché," presented in Tahitian and in a French translation, he declares,

> Let us tattoo! And mark without ceasing our skin
> With the seal of our Ma'ohi era:
> Such is the sign with the face of Elders,
> Promise of future
> For these children who come to us.[32]

In this call for his listeners and readers to tattoo their Ma'ohi history on themselves, Hiro suggests that the Ma'ohi era has never ended. *Tātau* is the unceasing sign or seal of that era, which connects the past (the tupuna, or ancestors) to the future (the children) through the present (the people who wear *tātau*).

In the Tahitian version of the poem, the phrase Hiro uses in urging his audience to tattoo themselves imparts an even deeper injunction. He proclaims, "Ei hono vai tāmau no te mau uì" (*Pehepehe*, 35), which conveys a strong sense of not only marking oneself but literally mastering or absorbing permanently the epoch of the ancestors. The words *vai*, *tāmau*, and *mau* create an incantatory repetition of this call: *tātau* becomes a visible sign that people remain fast, hold fast, fasten themselves to the Ma'ohi epoch in body and being. In other words, the poem uses tattoo to embody the continuity of Ma'ohi culture—a continuity that Hiro suggests it is urgent for his Tahitian listeners and readers to absorb.

This is the territory that Makiko Kuwahara charts in her anthropology of contemporary Tahitian tattooing, the way today's designs make the past present: "Through tattooing, discontinuous time becomes continuous" (*Tattoo: An Anthropology*, 230). The official *tātau* revival began in 1981 when a Tahitian and a Marquesan sought out a Samoan *tufuga ta tatau* or tattoo artist. The Sa-

moan tattoo artist then traveled to Tahiti to demonstrate tattoos, ironically for the Bastille Day Festival ("Polynesia Today," 187). In other words, the artist and recipients made a French national holiday indelibly Ma'ohi and Pacific and sparked a full-scale *tātau* revival. By 1993, as many as three hundred tattoo artists were working in Tahiti, at a time when the population was about eighty thousand ("Polynesia Today," 190). The designs incorporated in the Tahitian revival have a strong Pacific basis, but take their stand in the world. Tattoo artist Chimé, who works in Tahiti, describes the sources of his designs: initially he borrowed motifs from his grandfather's Marquesan woodcarving; his more than five-year-long "world tour of tattooing" took him to places including Germany, Switzerland, Italy, Thailand, and Borneo; he then studied design techniques including Samoan and Māori tattoo.[33] His itinerary represents in miniature the Pacific tattoo's travels around the region and into the world.

"*AORE ROA IA E ARO!*": REVISITING HAWAI'I

In Hawai'i people continued to seek tattooing after the practice was pronounced dead—including such prominent persons as Kamehameha. Here, the language denotes parallels between tattoo and writing; the same word designates both practices. Art and literature thus invoke traditional designs to decolonize both the body and the book.

Ages before the arrival of European or U.S. visitors, traditions of travel, navigation, and culture exchange defined Oceania. In Hawai'i, one story relates that tattooing came to the islands from Tahiti. A Hawaiian tells the story in Fornander's *Hawaiian Antiquities*.[34] About twenty-seven generations before 1900,[35] the chief Olopana and his wife Luukia voyaged to Tahiti and back to Hawai'i: "Upon the arrival of Olopana and his companions, the people of Hawaii saw that their hands and arms were tatued. The people became so infatuated with the idea that they too had their arms and hands tatued" (*Fornander*, 4:156–57). The Tahitian district of 'Oropa'a, moreover, is named after Olopana (*Ancient Tahiti*, 567).

The story also attests to the ways people copied tattoo patterns from one another, across Pacific and sailing cultures. Twenty-one or so generations after Olopana's voyage, James Cook would voyage from Tahiti to Hawai'i, his sailors bearing Ma'ohi and Māori patterns on their bodies. Cook may have been unaware that he followed in Olopana's path, but Kanaka Maoli who asked such visitors to tattoo them and who borrowed tattoo motifs from introduced technologies—including written text, goats, guns, and dominoes—carried on a

long tradition of incorporating new technologies and designs into indigenous Hawaiian traditions.

As in the Society Islands, tattooing in Hawai'i endured a decline and has exhibited a revival. On the other hand, in part because of a constricting bias in the written descriptions, scholars have found it even more difficult to reconstruct traditional Hawaiian tattooing. The historical descriptions of Hawaiian tattoo, provided by sources including Captain James Cook,[36] ship's surgeon David Samwell, and draftsman Jacques Arago,[37] for example, compare the patterns to Society Islands, Māori, or Carolinian tattooing, and dismiss Kanaka Maoli tattooing as less complex.

In the 1990s anthropologist Alfred Gell follows in this tradition, announcing, "Hawaiian tattoo does not seem ever to have amounted to very much, and was certainly at no stage a major channel for artistic expression, as it was in New Zealand, the Marquesas, or Samoa" (*Wrapping*, 275). This tradition of dismissal concludes, "Hawaiian tattoo was neither aesthetically nor socially of great importance" (*Wrapping*, 275). So the argument goes: the "feudal" or "centralized" political organization of Hawai'i did not require tattooing; Kamehameha was the first "modern" ruler, and he himself was not tattooed, so many of his subjects emulated his lack of tattooing (*Wrapping*, 286–87). In other words, anthropology of art scholar Adrienne Kaeppler suggests, "the early demise of tattoo was a function of the rise of Kamehameha and a new social order."[38]

The argument is, however, based upon an incorrect premise. Kamehameha was, in fact, tattooed, suggesting that the other conventional anthropological views of Hawaiian tattoo also need to be revised. In *Ruling Chiefs of Hawaii*, Samuel Manaiakalani Kamakau reports, "Then Kamehameha and all the chiefs waited until the death of Ka-lola. They wailed and chanted dirges, and some were put to sleep with the dead, and the chiefs tattooed themselves and knocked out their teeth. Kamehameha was also tattooed and had his eyeteeth knocked out."[39]

This major error in Kaeppler's (and, by extension, Gell's) thesis has been corrected by Kealalōkahi Losch. Central to Kaeppler's reading is a clear historical line of demarcation: "The end of the ritual importance of tattoo with its emphasis on the process of tattooing occurred during the rise and flourishing of Kamehameha I" ("Hawaiian Tattoo," 170). As Losch notes, Kamehameha was in fact tattooed to commemorate Kalola's death.

Further complicating the suggestion of a clear endpoint to ritual tattooing, Kamehameha's widow Ka'ahumanu is one of the tattooed persons Kaeppler

examines. Ka'ahumanu served as Kuhina Nui or High Councilor to Kame-
hameha[40] and acquired her tattoos to commemorate Kamehameha's death.[41]
Kamāmalu (wife of Kamehameha II) sought her tattoo after her mother-in-
law, Keōpūolani's death, declaring, "*He eha nui no, he nui roa ra kuu aroha!*
Pain, great indeed; but greater my affection!" (*Polynesian Researches*, 4:181;
italics in original; "Hawaiian Tattoo," 164). Her statement is doubly dramatic
in that she was receiving a traditional tongue tattoo, to express grief, and as a
result spoke to the missionary after clearing her mouth of blood. Moreover, at
the same time, "a number of chiefs were assembled, for the purpose of having
their tongues tataued." They declared to Ellis, "*Aore roa ia e aro*! That will
never disappear, or be obliterated!" (*Polynesian Researches*, 4:180, 181; italics in
original). The practice was very widespread. Arago, a draftsman whose skill
in drawing led to many requests that he tattoo Hawaiians, testifies that "since
the death of Tammeamah, all the Chiefs, and numbers of the lower classes,
have engraved his name upon their arms, together with the date of his death"
(*Voyage*, 2:148).

Moreover, these instances of tattooing sought by prominent women and
men defy the missionaries' condemnation of memorial tattooing in particu-
lar. Losch speculates that the missionaries sent to Hawai'i by the American
Board of Commissioners for Foreign Missions may have discouraged tat-
tooing because such ritual mortification was explicitly forbidden in Leviticus
(19:28). The board attempted to suppress *kākau* in general and mortuary tat-
too in particular. Nonetheless, both Ka'ahumanu and Kamāmalu continued to
practice mortuary tattooing, marking themselves with patterns that attested to
their grief. The practice continued after Kamehameha's reign (and marked his
death, for that matter), despite the fact that his reign supposedly marked the
endpoint of Hawaiian tattooing.

Further, in 1841, John D. Paris, a missionary at Kau, a southern district on
the island of Hawai'i, reports three men "tattooed from head to foot."[42] (Tat-
tooing on the big island, according to anthropological accounts, was the least
prominent or widespread of all the islands ["Hawaiian Tattoo," 169]). In 1899
Augustin Krämer recorded a tattoo design named by its wearer "alanui o Ka-
mehameha" or "road of Kamehameha" ("Emory," 248). It thus seems wise to
reconsider ostensibly sharp lines of demarcation that define where Hawaiian
tattoo ended. To this day, the practice continues, flourishing due to a revival
begun in the 1970s by Mike Malone and Keoni Nunes and continued today by
Nunes and other artists including Ipo Nihipali.[43]

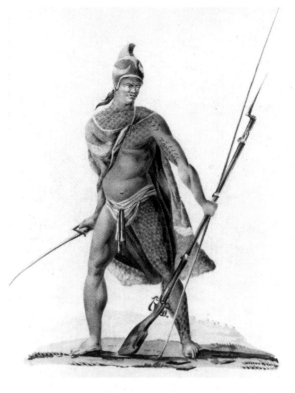

FIGURE 11. Illustration by Jacques Arago. *Owhyhee, Grand costume de guerre des officiers de Tahmahamah II*, Hawai'i, full war costume of one of the officers of Kamehameha II, c. 1819. Original pencil, pen and ink, gray wash. Note the inner arm tattoo that commemorates Kamehameha's death. Published with permission of Honolulu Academy of Arts.

According to Mary Kawena Pukui, "tattoo was primarily a mark that designated individuals as part of a village, devotees of the same god, or descendants of a common ancestor" ("Hawaiian Tattoo," 166). *Uhi* patterns, particularly zigzags and chevrons, invoked the backbone or spine that is a visible metaphor for genealogy. In *ka ʻōlelo Hawaiʻi*, the Hawaiian language, the word for the process of creating a tattoo is *kākau*; the product is *uhi*.[44] The *moʻo* or lizard is associated with the ancestral features of *kākau*.[45]

Figure 11 gives an example of male *uhi* patterns. As Tricia Allen documents, this drawing by Arago is the original on which many later drawings, paintings, and prints were based. Figure 12, another drawing by Arago, gives an example of female *uhi* patterns.

FIGURE 12. Jacques Arago, *Wahoo, Taimooraah . . . Jeune Fille Dansant*, O'ahu, Taimooraah
. . . a young woman dancing, c. 1819. Original pencil, pen and ink, gray wash.
Published with permission of Honolulu Academy of Arts.

Kaeppler declares, "Sources for the study of Hawaiian tattoo are few and
unrevealing" ("Hawaiian Tattoo," 157). She provides, nonetheless, a reveal-
ing account of the sources that do exist that parallels the discussion provided
in this chapter for the Society Islands. Men would often feature one tattooed
arm or leg, probably the arm or leg that would not be protected by the feather
cloak, and would therefore be exposed in battle; so tattooing had a sacred, pro-
tective function. Other men had tattoos that covered one half of their face,
or one half of their body from head to foot. This pattern is named the *pahu-
pahu*, or halfway design, and was featured particularly in Maui (Pukui quoted
in "Emory," 249).

Kaeppler's overview of these sources allows her to suggest that "asymme-
try is associated with sacred ritual" and that the move toward symmetry in tat-
toos coincided with an "evolution from protection to decoration" ("Hawaiian
Tattoo," 169). In other words, as Hawaiian society changed, in response to the

arrival of Haole and because of its own internal dynamics, tattooing became associated less with sacred genealogies and more with fashion.

Kamehameha's wife, Ka'ahumanu, for instance, was tattooed by visiting foreign artist Arago, who reports, "she begged me to ornament her with several new designs, and Rives informed me that she strongly desired a hunter's horn on her posterior, and a figure of Tamahamah on the shoulder, to which I consented with great pleasure."[46] Arago also reports that his tattooing skills were in general demand: "At Kayakakooah [Kealakekua], as well as at Koiai [Kawaihae], I was constantly occupied making designs on the legs, the thighs, the shoulders, the head and breast of women of the people, the wives of the governor, and even the princesses."[47] Many people sought tattooing to adorn their bodies, in designs that adapted and incorporated new patterns. Such inventiveness shows the vitality and continuation of tattoo; counter to previous suggestions, it does not necessarily show a decline.

In Hawai'i today, the art of *kākau* flourishes. The first professional association of *tātau* artists was launched by Keoni Nunes. Ta Tatau, the Association of Pacific Island Tattooists, works to promote and represent Pacific Islands tattooists within the profession of tattoo artists. Describing the work of Keoni Nunes, Losch declares, "He promotes his organization in the mainstream tattoo industry and thus is representing us to the rest of the world with the term, 'tā tātau'" (*Revival*, 60).

The first half of Tricia Allen's book *Tattoo Traditions of Hawai'i* presents extensive historical accounts and representations of *uhi*. The second half consists of writings by tattoo artists and tattoo wearers who express some of the deep meanings the art has today. Audra Marie Sellers declares, "My tattoos are enriched with meaning—every line, and every space. To put it simply, they depict my family, my love, and they express the very essence of my being."[48] Some writers explain that they cannot divulge the meaning of their design publicly, because its meanings are personal and sacred, while others reveal part of the sacred energies expressed in their patterns.

Sam 'Ohukani'ōhi'a Gon III, an expert in Hawaiian protocol, notes that his design emphasizes balance, presenting visual manifestations of land and sea "link[ed] in a guardian relationship." The visual images of earth and ocean invoke the relationship between nature and spirit: "At the core of the armband design, elements of pō and ao are symbolized. Pō has many meanings: the night, ancient past, and the realm of the ancestors, while ao is daylight, enlightenment, and the modern world." From the interrelationship of apparent opposites emerges a living link between ancestors and the present: "'pale

ka pō, puka ke ao' (the night is the shield, through which the day emerges)."
In other words, "our ancestors protect and set the firm foundation of the traditions and knowledge of the past, and we descendants live in the world of enlightenment that their efforts established for us" (*Tattoo Traditions*, 177). The ancestors continue to act in the present, and their presence is embodied in such designs.

Samantha Fairchild, a tattoo artist, comments on the tradition-based designs she has created with and for Hawaiians seeking tattoo. The designs often feature repeated patterns, with "each segment representing a past generation of traceable ancestry. Key elements within each segment may include images of 'aumakua [personal or ancestral gods], lineal representations of earth, wind, sea, and sky. Small dots throughout the pattern usually mean the eyes of the ancestors protecting the wearer. Often the original ancestral home or Island, position, or skill within a village is illustrated, or sometimes a favorite story" (*Tattoo Traditions*, 200).

The connection between tattoo and story, or tattoo and writing, runs deep. In literature, Chris McKinney's novel *Tattoo* uses the occasion of creating a prison tattoo to tell the story of the protagonist's violent life in Kahaluu. The tattoo, an elaborate kenji character, is not tied directly to native Hawaiian patterns, but the novel attests to the vitality of tattoo in Hawai'i. The novel reached the bestseller lists in Hawai'i.

Carolyn Lei-Lanilau suggests that *kākau* is a metaphor for writing: "The closest approximation to 'writer' as it is known in Hawaiian is *kākau*, which means 'to print,' as to make a tapa pattern or to tattoo."[49] By extension, writing based upon such Kanaka Maoli arts as *kākau* can work against expropriation, can indigenize such forms as the book.

'Īmaikalani Kalāhele, for example, makes the connection explicit, using *uhi* patterns in graphic poetry. (As noted, *kākau* is the practice that creates *uhi*.) In "H-3: A Series of Questions," poet-artist Kalāhele critiques the process of destroying sacred sites to create another major O'ahu freeway system, H-3. The graphic image that accompanies the poem (or perhaps the poem accompanies the visual image) makes clear the connection between land, genealogy, and *kākau* (and, by extension, such writing and printing as these poetic and graphic texts). The poem asks, "Going where? / For what?"—a question repeated in visual form in the *mo'o* or lizard, which hovers above and spills outside the frame of the land that is cut by the freeway (figure 13). As Ho'omanawanui notes, the *mo'o* is "a traditional 'aumakua [personal or ancestral god] associated with the area," and is suspended above the Ha'ikū mountains cut through

FIGURE 13. Illustration by ʻĪmaikalani Kalāhele. *H-3: A Series of Questions.*
Published with permission of the artist.

by the freeway.[50] Hawaiian tattoo artist Kwiatkowski notes that "certain tattoo designs were connected with the *ʻaumakua* of the individual who wore the design."[51] Since *ʻaumakua* possess both protective and destructive power, the *moʻo* will guide or thwart viewers based on their relationship to the land and freeway.

The *moʻo* is also associated with the *kākau* or tattooing patterns central to the image. The *moʻo* is rooted in the same word as the Māori *moko*, the word for the distinctive tattooing of Aotearoa, and invokes genealogies—the same chevron patterns that cut across the frame of the mountains. That affiliation suggests that the tattoo patterns are more powerful than the freeway and supersede what the freeway connects, namely two major military installations. That affiliation also suggests that the deep culture carried by tattoo patterns both predates and outlasts such recent encroachments upon the land and its genealogies. *Kākau* becomes a means of making books advance indigenous patterns.

Kākau has become the word for the art of writing, suggesting that such writers as Kalāhele, who explicitly invoke the patterns in their written work, continue in another form the practice that dates back twenty-seven generations before 1900. The practice of creating a written *kākau* also suggests important points for reconsidering the anthropological interpretation of Maʻohi and Kanaka Maoli tattoo. The primary evidence for establishing Maʻohi and Kanaka Maoli tattoo traditions are the narrative descriptions of the art. It is therefore just as important to examine the traditions and conventions that shape these descriptions. In other words, there is little if any foundation for scholars' dismissing Hawaiian tattooing as less complex or significant than related Pacific traditions of the art. Such judgments are based upon prior narrative assessments of the art, rather than upon investigating *kākau* itself.

Moreover, such accounts help produce the features they ostensibly describe: writers who wish to erase tattoo suggest that tattoo has been erased; those who suggest that tattoo is not complex need not portray its complexity. Even scrupulous anthropological accounts are written versions of culture; they participate in the same narrative fields they survey and they benefit from examining, rather than reproducing, the parameters of past narratives. If *tātau* and *kākau* were suppressed by missionary-sponsored laws or disapproval, and by changing social and cultural practices, they were also suppressed in many visitors' descriptions of tattoos.

There is, however, no reason to give extra weight to the narrative descriptions that suggest the practice has ceased or is unimportant. Many equally significant narratives suggest that *tātau* and *kākau* continue, and note such important points as Kamehameha's practice of mortuary marking, a fact that shows *kākau* persists after most written records have tried to bury it.

FUNDAMENTAL MANHOOD: THE TONGAN TATTOO

In a reversal of the typical conversion narrative, an English missionary sought full-body tattooing so that he could enter fully into Tongan life after he renounced his Christian associations; and Tongan rebels used tattoo to rise up against the Tongan king, whose ban of the practice was inspired by missionaries. In Tonga, tattoo has invited a consideration of fundamental manhood—with an emphasis upon the fundament. Historical writers focus on the tradition of Tongan anal tattooing. Contemporary writer Epeli Hauʻofa, taking up this emphasis, uses anal tattooing to spark a humorous reevaluation of everything from the field of anthropology to the workings of taboo.

Tātatau in Tonga is described by Englishman George Vason, who lived in the islands from 1797 to 1801. Initially a missionary, he experienced a "declension from God"[52] after living apart from his fellow missionaries, first in the household of Mulkaamair [Mulikihaʻamea] and later on his own independent and "considerable estate" (*Tongataboo*, 156). He adopts Tongan clothing and life, marrying a Tongan woman (and later apparently marrying more than one Tongan wife). Michelle Elleray, examining the 1840 version of Vason's narrative, terms this process a "reverse conversion."[53] His first marriage was launched initially according to Tongan practices; later the missionaries wished to sanctify the marriage according to their ideas, telling the woman "that it was a solemn engagement for life, to be faithful to her husband, and that nothing but my death could release her from the bond. When she understood this," Vason reports, "she would not consent" (*Tongataboo*, 126). Vason joins Tongan society fully when he receives the *tātatau*.

Vason seeks the *tātatau* to avoid mockery. A form of social coercion enforces the *tātatau*:

> Whilst going from place to place, on these triumphant excursions of pleasure [to celebrate the ending of a war], I was frequently exposed to the reflections and sarcasms of the young people, especially in the hour of bathing, which generally recurred three times every day, for being destitute of that cuticle vesture, which modesty has taught the South-Sea islanders to throw around them as an excellent imitation and substitute for garments; I mean the Tatoo. (*Tongataboo*, 178)

Vason's unmarked body stands out as singular, marked by its lack of meaningful patterns: "On these occasions, they would raise a shout of merriment and call me by opprobrious epithets, such as Ouchedair, &c. I was at length determined to no longer be singular and the object of ridicule" (*Tongataboo*, 178–79). Tattooing in Tonga was apparently sought by individuals rather than groups (in other words, Tongan tattooing was not performed on cohorts of young men who received the designs simultaneously, as in Samoa or the Marquesas). Even so, the practice secured a place in the collective, making the individual less "singular." One historian notes that "being tattooed was less a choice for Tongan men than a matter of social necessity."[54]

Vason is exceptional, first in Tonga for his untattooed body, and then outside of the Pacific for his tattooed body. In New York, for example, he presents another bathing scene that harkens back to the Tongan scenes but is inverted. He swims in the New York harbor, only to be witnessed by a fifteen-year-old boy, who "looked at me with great surprise, as though he could not believe

his senses" (*Tongataboo*, 180). "I thought you had got some clothes on," the boy says, and Vason becomes aware that he is once again a spectacle—now because of his tattoos rather than his lack. Others gather around upon hearing the boy's exclamations, but he attires himself before they can witness the scene that his tattooed body makes. After this point, the only way in which he displays his tattooed body is in the narrative. Unlike John Rutherford, Joseph Kabris, and James O'Connell, he does not perform his tattoos on stage, confining his performance instead to the written page.

Like these responses to his tattooed body, the tattooing process is itself complicated, and takes place in stages. He undertakes the process at "Vavou" [Vava'u], but finds the pain too great to endure until he returns to "Arbai" [Ha'apai]: "There, I summoned up resolution to have the tatooing finished by a professed operator in the neighborhood. It was performed only every third day, the pain being so exhausting, and the large tumours which immediately follow not subsiding before that time" (*Tongataboo*, 179). Such a professed operator could obtain his position as a result of talent (the position and training were not necessarily hereditary).[55] Vason's account predates O'Connell's and Rutherford's and, unlike theirs, acknowledges that he did not take the *tātatau* in one sitting. (His account also forgoes the fiction that his tattoo was forced upon him physically.) His account thus accords more closely with the actual practice. It may also support Gell's contention that whereas Tongan aristocracy sought tattooing from Samoan practitioners in either Tonga or (even more prestigiously) Samoa, "demotic" tattooing was practiced by Tongan artists on non-aristocrats (*Wrapping*, 107, 108). Vason's claim that he achieved chiefly status would hence be complicated by the fact that he was not tattooed by a Samoan artist.

Vason's closing description of his *tātatau* suggests that vanity (rather than the modesty he claims) motivated his choice. "When it was completed," he acknowledges, "I was much admired by the natives, as the European skin displays the blue colour, and the ornaments of the tatooing to very great advantage: I looked indeed very gay in this new fancy covering" (*Tongataboo*, 179). Back in England, Vason rejoined the Christian fold and told his story to his book's coauthor, a Nottingham clergyman.[56] He also married a wealthy woman and became governor of the prison at Nottingham (Orange in *Tongataboo 1840*, 217), itself an "office of considerable emolument."[57] When he died, he was buried in the Nottingham Baptist Burial Ground, and his story warranted a two-page notice in *Monumental Inscriptions in the Baptist Burial Ground, Mount Street, Nottingham*. Part of his redemption, no doubt, was achieved by

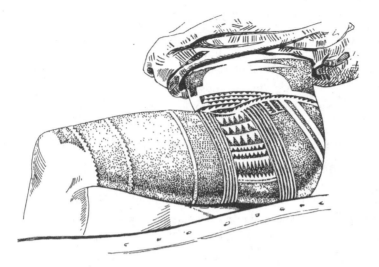

FIGURE 14. Jules Dumont d'Urville, Tongan man's tattoo. Reprinted from
H. Ling Roth, "Tonga Islanders' Skin-Marking," *Man* 6 (1906): 7.

marrying "Miss Leavers" and narrating his fall from and return to Christianity
(Orange in *Tongataboo 1840*, 217), but even so, his story continued to attract
notice. After his death, James Orange edited another version, *The Narrative of
the Late George Vason* (1840), in which Orange frames Vason's narrative with
a moralizing essay about the time "when, in an utter abandonment of every
principle of pious feeling and moral habit, he assumed the revolting customs
of a savage life."[58]

Vason relates his story wrapped in English clothes and the English lan-
guage. He does not describe or otherwise reveal the *tātatau* patterns. As Van-
essa Smith notes, "the desire to 'clothe' is an ambiguous sign of the recovery
of the Christian subject, the product of a post-lapsarian, as well as a renewedly
civilised, impulse" (*Literary*, 37). Even the Christian community Vason re-
joins, which must literally rehabilitate him, is haunted by its own Fall. Perhaps
in keeping with the sense of shame this Fall brings, no visual record of Vason's
designs survives. In fact, few visual records of Tongan tattooing exist in such
accounts. Dumont d'Urville provides one of the few sketches (and gives no
written description) (figure 14).

Later Vason distances himself from the designs by not describing them, cre-
ating a narrative veil that covers them. The patterns, however, remain very
visible when he first attempts to return to European society. He calls out to the

Royal Admiral ship, which will eventually carry him away from Tonga, "How do you do countrymen?" (*Tongataboo*, 197). But the sailors laugh at him, "as they supposed, from my dress, that I was a native who had picked up some European phrases" (*Tongataboo*, 197). (Even the ship takes him full circle: like the *Duff*, which brought him to Tonga, this ship is traveling for the Missionary Society, bringing new missionaries to the Pacific.) At first he can speak only a few phrases of English, which renders him "unintelligible" (*Tongataboo*, 197) to the sailors, but his vehemence makes the captain, William Wilson, recognize that he is not Tongan and agree to take him on board.

For the entire voyage to China, however, he retains his Tongan dress, revealing his tattoos in all their glory. Even after another lapsed missionary, Benjamin Broomhall, who had married a Ma'ohi woman in Tahiti,[59] takes pity on him and gives him some of his clothes, "I was very scantily covered till our arrival in China. The thought of my adverse circumstances, and my return, in such a condition to a civilized country, so painfully depressed my spirits, that I wished to stay behind on some island" (*Tongataboo*, 204–5). Even after the tattoos are finally covered by European dress, in emulation of "those who were more decently clothed" (*Tongataboo*, 205), they continue to serve as an indicator of his condition, which he fears renders him unfit to return home.[60]

He wishes to consign himself to some anonymous, uninhabited island, "secured from the reproof and scorn" that he feels that his condition will inspire (*Tongataboo*, 209). The "gay" and "fancy covering" of the tattoos, related only a few pages earlier, is not seen as such by the company he now keeps. Vanity and modesty have been reversed: where in Tonga the first demanded that he seek the marks, in England the second demands that he cover them behind clothing and behind a narrative that does not describe the patterns.

Tātatau also feature in the narrative of William Mariner, who arrived in Ha'apai in 1806, a few years after Vason, as the only surviving crew member of the *Port-au-Prince*. (He also reports on the failure of Vason's missionary colleagues: they had not even managed to communicate their evangelical purpose, the Tongans having believed that the previous English visitors were living in the islands because they preferred the warmer climate.) The fifteen-year-old was adopted by Finau 'Ulukalala and lived in Tonga for four years. After he returned to England, he became a successful stockbroker. John Martin arranged his account in writing, and it provides several tattoo details that remain veiled in Vason's account.

Martin, a physician, emphasizes the supposed medical implications of tattooing, noting that "it is very apt to produce enlargements of the inguinal

and axillary glands."[61] The glandular consequences of tattooing are not usually emphasized in travelers' descriptions; this note that tattooing enlarges the glands near the groin and armpit reinforces a common response to the Tongan practice. As early as Cook's third voyage, Georg Forster had exclaimed, "The tenderest parts of the body were not free from these punctures, the application of which, besides being very painful, must be extremely dangerous on glandulous extremities, and justly excited our astonishment: '*et picta pandit spectacula cauda!*'—Hor" (Resolution 1:433). (The exclamation refers to a passage in Horace's *Satires* 2.2.26, which describes a peacock, and runs in English, "and it presents a spectacle with its painted tail."[62]) Even contemporary anthropological accounts focus on the tattooed "glandulous extremities" and "tail," which spark a value-laden response. One refers to the "sado-masochistic genital/anal tattooing which seems to have been a Tongan specialty" (*Wrapping*, 103).

In other words, a mixture of astonished fear and fascination continues to greet the practice of tattooing the groin. In Martin's account, Mariner proclaims, "Even the glans penis and the verge of the anus does not escape. It is considered very unmanly not to be tattowed, so that there is nobody but what submits to it as soon as he is grown up" (*Tonga Islands*, 266). The comment about unmanliness follows immediately upon the note that the penis and anus are tattooed; the two statements' proximity suggests that the writer attempts to explain why a grown Tongan man would submit to an operation that (from the writer's viewpoint) threatens his masculinity by puncturing his anus and the head of his penis. The comparison implies that only a differing standard of manliness could explain such a procedure.

Mariner describes *tātatau* from the standpoint of an observer, rather than a recipient. "It is frequently two months before it is completely finished," he notes. "The parts tattowed are from within two inches of the knees up to about three inches above the umbilicus: there are certain patterns or forms of that tattow, known by distinct names, and the individual may choose which he likes. On their brown skins the tattow has a black appearance, on the skin of an European a fine blue appearance" (*Tonga Islands*, 266). Vason, by contrast, provides many fewer details about his own tattoo; it is almost as if those marks are so close that he cannot describe them. Rather than telling the story of a specific tattoo, on the other hand, the Mariner account attempts to generalize, reporting a typical length of time for the process, describing the region of the body covered, and noting that the same *tātatau* pigment looks different on Tongans and Europeans.

The varying standards of manliness that he must meet cause Vason great personal pain. Indeed, he does not describe the tattooing that covers his penis and anus—possibly he does not have the language that will enable him to do so in a published account. When Vason declines to give a more particular account of the practices in which he joined in Tonga, he states, "I forbear to describe the disorderly meetings that were held, at particular spots, for nocturnal dances, and the tumultuous excursions of young men through the country during the night" (*Tongataboo*, 132). His coauthor averts his eyes further, noting in a footnote, "Quaedam ignorare sapientis est" (*Tongataboo*, 132). The retreat into Latin is overly prudish, since this tag suggests only that it is the philosopher's obligation to remain ignorant of certain things, the same things that Vason has just stated he knows, but will refrain from detailing. Martin, on the other hand, manages Mariner's potentially shocking descriptions by using his medical terminology to place the markings (and the body parts they adorn) at a clinical distance.

Even in Tonga, writing was used in an attempt to place *tātatau* at a distance. The first written laws, the Code of Vava'u, which was promulgated officially in 1839, forbade the practice.[63] Formulated by Tāufa'āhau, who would become known as King George, the laws applied to the islands over which he had authority, Vava'u and Ha'apai. After Tāufa'āhau became Tu'i Kanokupolu in 1845, the code was extended to Tongatapu and the rest of Tonga (*Church and State*, 126–27). The code, which Sione Lātūkefu includes in *Church and State in Tonga*, proclaims, "It is not lawful to *tatatau* or *kaukau* or to perform any other idolatrous ceremonies, if any one does so, he will be judged and punished and fined for so doing" (*Church and State*, 225). The law thus forbids tattooing and circumcision, which are presented as idolatrous ceremonies, specifically counter to the Christianity Tāufa'āhau accepted when he was baptized as King George. As in the Society Islands, missionary advice shaped the laws Tāufa'āhau wrote. Later laws forbade dancing, and made it a requirement to wear clothing.

Still, outlawing and actually halting the practice are two different things. As Campbell notes, rebellions occurred at key points. In 1843, people in Vava'u revived traditional funerary and other practices and in 1856 the tuku'ofo reappeared (a ceremonial presenting of gifts at a funeral).[64] In 1852, the last Tongan civil war was fought when Ma'afu and Lavaka, joined by other chiefs, defied King George's authority and "gave asylum to any fugitive from the laws promulgated by the King" (*Church and State*, 152). In this war, people who had not converted to Christianity found themselves allied with Roman Catholic

Tongans—fighting against the King, who had aligned himself with Wesley-
an Methodist missionaries. When it became clear that no French man-of-war
would come from Tahiti to aid the rebels, the war ended. Even after this peace,
however, in the 1860s a tattooing rebellion struck (*Island Kingdom*, 101). In
1906, Basil Thomson offered the confident prediction, "Twenty years hence
there will be no tatued Tongan left" ("Skin-Marking," 9). Again, such predic-
tions should not be taken as fact. Such predictions do indicate, to the contrary,
that in the twentieth century, despite the fact that *tātatau* had been forbidden as
early as 1839, tattooed Tongans maintained an important presence.

Indeed, several Tongans identify relatives who were tattooed in the twen-
tieth century, suggesting that just as the *moko* never disappeared entirely from
Aotearoa, the *tātatau* continued in Tonga long after it was believed gone.
Aisea Toetu'u, for example, who now works as a tattooist himself, notes that
his grandfather was reportedly one of the last men to wear the tattoo.[65] That
would mean his grandfather had been tattooed in the first half of the twenti-
eth century. And Rodney (Ni) Powell, another tattooist who has helped spark
revived interest in Tongan tattoo, notes that his own uncle sailed to Samoa to
receive a *pe'a*, since the practice was illegal in Tonga in the mid-1950s. After he
received his tattoo, "he was secretly proud and would only show it to a select
few relatives."[66] The threat of imprisonment meant no one in Tonga would
mark his skin, but it did not mean that tattoo disappeared from Tonga, since
enterprising Tongans were willing to travel to acquire one.

In his novel *Kisses in the Nederends*,[67] contemporary writer Epeli Hau'ofa
satirizes virtually every aspect of received portrayals of Pacific bodies—in-
cluding tattoos. This particular work possesses the distinction of being the
only Pacific Islands book about an anus. Hau'ofa's good-natured but incisive
humor confronts head-on both sacred beliefs and apparently inviolable taboos
that structure life within and beyond the Pacific.[68]

The book follows the travels and travails of Oilei Bomboki, as he tries to
heal his inexplicably suppurating, painful, and mephitic anus, using every cure
available on the island of Tipota (in Tongan, literally teapot), and finally jour-
neying to New Zealand for an anal transplant.[69] The fictional island serves as a
stand-in for decolonizing communities across the Pacific, allowing Hau'ofa to
scrutinize everything from local gossip to international graft in development
funding, from a mock-ethnography of the human body to nuclear testing in
a globalizing Pacific. The fundament that forms the book's ostensible subject
thus allows Hau'ofa to embark on a hilarious, if pointed, examination of what
it means to be human.

Hauʻofa's depiction of tattoo both invokes and inverts the conventional presentation of that Pacific art. As such, tattoo stands as a representative example of his satiric depiction of both Pacific cultures and the way social scientists study those cultures. One of the healers Oilei Bomboki consults is Babu, a yogi-like guru and con man who espouses a philosophy of healing the world through first kissing one's own anus and then inserting one's nose in the other's anus. This movement, the Pan Pacific Philosophy for Peace, or the Third Millennium, parodies both present globalization in the Pacific and past millenarian movements. Adherents to the movement call themselves Millenarians, invoking such nineteenth-century movements as the Māmaiā in Tahiti, and the Pai Marire (literally "Good and Peaceful") movement in Aotearoa.[70] At the same time, the movement's emphasis on world conversion invokes the zeal now inspired by capital as much as Christianity.

A tattoo serves as the emblem for this movement. Poking fun at himself, Hauʻofa presents the head of the sociology department at the University of the Southern Paradise as bearing a tattooed anus that embodies the movement's philosophy. (Hauʻofa thus invokes his own autobiographical experience with "the nederends," and his experience as professor and head of department of sociology at Fiji's University of the South Pacific.) "He's got the most beautifully tattooed anus for the Third Millennium," a devotee proclaims. "We'll take a drawing of it and use it as our logo" (*Kisses*, 120). In an interview with Subramani, Hauʻofa emphasizes the inversion he creates here. As a result of his own anal surgery, "Somewhere down below there is a most artistically carved scar that looks like a Polynesian face tattoo" (*Kisses*, 158) To confirm the association between the Polynesian face tattoo and the anal-tattoo logo, Hauʻofa reiterates in the interview's next sentence, "I made a reference to it on page 120 of the novel" (*Kisses*, 158).

In using this metaphor, Hauʻofa inverts the tradition of facial tattooing, placing the mark of identity on the anus rather than the face. Here the head, traditionally the locus of contagious sacredness, or *tabu*, exchanges places with the usually reviled anus. Hauʻofa thus reverses the sacred and the profane. In so doing, he also invokes the Tongan tradition of anal tattooing experienced by George Vason and described in clinical terms by Mariner and Martin. Hauʻofa's descriptions are not so delicate, courting the outrageous with his descriptions of burying one's nose reverently in the other's anus. Moreover, the face tattoo, so unique that it may serve as the individual's signature, here becomes a mass-distributed emblem of a global movement. The tattoo as marker of collective identity becomes matter for parody. When new members join

the movement, they are, as Oilei's wife Makarita announces, "branded with the Mark of the Third Millennium" (*Kisses*, 149). The individual facial tattoo becomes an anal tattoo, which in turn becomes a mass branding—where the term "brand" designates both the marker and the marketable. Hau'ofa satirizes hierarchies both internal and external to Pacific Islands societies. When the book's closing words exclaim, "Kiss my arse!" (*Kisses*, 153), Hau'ofa offers an invitation as much as a command or an insult.

Hau'ofa makes fun of brown-nosing or arse-kissing, particularly that directed toward local elites and toward donor nations, but simultaneously confronts that which is taboo. Babu declares, "We must greet, love and dance with each other in the middle of our zones of taboo, for we have not created any real taboos, only the fears and phobias that we, in our limitless capacity for self-delusion, have swept to the boundaries of our cherished conventions, where they remain to haunt us into insanity and violence" (*Kisses*, 105). Nothing escapes Hau'ofa's satire, not the book's emblem of a tattooed anus, not this statement. But if the book has a motto, it is this declaration.

Like Hau'ofa's *Tales of the Tikongs*, this book knows that the source of comedy is rage,[71] and uses humor to both renew and heal the reader's outrage at otherwise routine injustice and nonsense. Hau'ofa emphasizes the difference between the natural and cultural; the former is exemplified in the anus, a simple body part, and the latter is figured in the arse, the body part reviled and made a locus of fears about purity and danger.[72]

In other words, Hau'ofa not only references but also inverts Tongan *tātatau* tradition, with special attention to social hierarchies and absurdities. Other contemporary Tongans reviving the *tātatau* tradition from a less comic angle include tattoo artists Aisea Toetu'u and Ni Powell. Aisea Toetu'u began his tattoo practice by creating a traditional full-body *tātatau* on himself, using traditional tools that he fashioned. In 2003, Samoan *tatau* artist Su'a Sulu'ape Petelo applied a full traditional Tongan tattoo, consulting Dumont d'Urville's drawing and other traditional patterns in *ngatu* and *fala* (tapa and fine woven mats). (As noted, Samoan tattoo artists have traditionally created Tongan tattoos.)

The names of some of the *tātatau* patterns include Lomipeau, the legendary *vaka* (canoe) of the Tu'i Tonga, which sits across the back; the Ngatu 'uli across the thighs, which represents the three Tongan dynasties; and the 'Ulumotu'a and Fahu, or symbolic matriarch and patriarch of Tongan families.[73] The figure of the *vaka*, which sits across the lower back, much as the *va'a* (canoe) figure sits in a similar place in the Samoan *tatau*, attests to the way tattoo contin-

ues its long history of traveling, like Pacific navigators, within and beyond the region. The Pacific tattoo's travels have taken it through banishment, under clothing, and now once again out into daylight. The art is celebrated and renewed, in literature, music, dance, and in tattoo artists' performances on skin.

Tattoo in the Society Islands, Hawai'i, and Tonga thus holds important implications for rethinking some of the central assumptions about Pacific history and culture. Studies of tattoo to this point have concluded, probably erroneously, that tattooing halted soon after missionary prohibitions of the practice. Missionaries offered this conclusion because they wanted it to be true; *tatau* was a powerful sign of beliefs that existed before the good news they brought. Some travelers seconded this conclusion, as they predicted that Pacific cultures (and peoples) were dying out. (Some of these writers deplored this seemingly inevitable fate; other visitors coldly attributed it to the march of evolutionary progress.) The early anthropologists, like most other traveling writers who came to the region, believed they were part of an eleventh-hour expedition to record pieces of a vanishing culture. Given that assumption, it is not hard to understand why they missed vital practices that had gone underground and under clothing.

Willowdean Chatterson Handy wrote a monograph on Marquesan tattooing in the early 1920s. Yet such were the long Mother Hubbard dresses introduced by the missionaries, which sweep the ground when women walk, that she discovered only by accident that the clothes covered elaborate tattooing. When she first caught sight of Tuu-ape's legs while Tuu-ape was bathing, Handy reports, "I discovered immediately that it was not out of shame that she hid her patterned legs but out of fear of the criticism of the authorities who considered it ugly and had forbidden tattooing long ago."[74] Handy's gender may have also allowed her access to the designs that women's dresses covered.

Similarly, during his 1890–91 trip to Hawai'i, Samoa, and Tahiti with the historian and memoirist Henry Adams, the artist John La Farge lamented that the numbers of women who wore traditional clothing were declining across the Pacific. In a narrative that draws on his letters and was published posthumously as *An American Artist in the South Seas*, La Farge writes from Samoa, "I am told that there are scarcely any more Typeeans—and they are clothed

to-day, as indeed, I fear, are most islanders who are handsome, except the good people here, who still preserve the real decencies to some extent."[75] La Farge regretted the change, which made it harder for him to draw or paint nudes. When he and Adams later traveled to Tahiti, for example, Adams complained, "we have been over the ground in Samoa, and we recognize here the wreck of what was alive there; but here the women wear clothes."[76]

Tattoo artists who employed new designs after encountering Captain James Cook and other visitors thus carry on this tradition of innovation. It is possible to examine changes in tattooing without suggesting those changes depart from a past golden-age ideal. But so far, many studies denigrate the adaptations.

For example, in the Society Islands, one suggests, "From [William] Ellis's description, one can still detect the lingering survival of the original design (he does not mention the blackening of the buttocks, only the arches rising from the sacral area and covering the loins) but evidently both the legs and chest were by this time [1831] used as a veritable scrapbook for the display of heterogeneous and mostly European-inspired motifs" (*Wrapping*, 136). The statement presents the changing practices of tattoo as a decline—only "traces" of the original design remain in Ellis's description, and rather than revealing the purity suggested by the phrase "original design," tattooing has become a "scrapbook" to record "heterogeneous" motifs. (Similar statements have been made about Tongan tattoo, and Hawaiian tattoo has been considered under the mournful title, "The Corruption and Decay of Hawaiian Tattoo.")[77]

These statements seek a lost purity that is only imagined, and that is often invoked in attempt to support the commentator's standing in the present.[78] The cultural purity sought by anthropologists is structurally similar to the moral purity sought by missionaries.[79] As Albert Wendt declares in his oft-reprinted essay "Towards a New Oceania," "There is no state of cultural purity (or perfect state of cultural *goodness*) from which there is decline: usage determines authenticity."[80] Missionaries who supported the flaying of tattooed parishioners reveal that locating a state of moral purity is similarly difficult. Instead, both before and after the arrival of Europeans, tattoo exemplifies the plenitude and interplay of cultures in Oceania.

Recognizing the way culture moves, it remains important to note the depredations caused by travelers who brought disease, legal systems that banned tattoos, and other unasked-for wonders. But it becomes equally important to note that across the Pacific people resisted such depredations, using script-tattoos and other strategies of subversion. And sometimes people just lived their

own lives, which could include traditional tattooing and itself demonstrate an important form of sovereignty. Through all of these eras, tattoo moves. Over the course of more than thirty generations, the practice journeys from Tahiti to Hawai'i and back, inflected on its return by Samoan, Māori, and other practices the tattoo has encountered in its global travels. The art that is a way of life journeys underground, under clothing, and once again into the world of light.

Locating the Sign

VISIBLE CULTURE

When the practice is first encountered, and after it is banned, tattoo serves as a sign of an entire way of life. The first white travelers to acquire tattoo were thus incorporated into the Pacific, making it difficult to return to their original homelands. In the 1820s, John Rutherford displayed his Māori and Tahitian tattoos in England in order to finance his return to the Pacific. In England his facial tattoo became a mark of his belonging to a foreign place, one that also signaled his desired destination. Before the discipline of anthropology existed, the patterns designated ways of life that would later be termed "culture."

In Herman Melville's *Typee*,[1] the practices and beliefs that define Taipi society are made visible in the full-body and full-facial tattoo that almost all men wear.[2] In other words, some twenty-odd years before E. B. Tylor became the first ethnographer to use the term "culture" to refer to "a particular way of life, whether of a people, a period or a group,"[3] Melville uses tattoos to present that concept. As Raymond Williams indicates, before this, the word *culture*, based on the word *cultivation*, referred to a process; the word formed a dependent noun that required designating what was being cultivated or, later, improved. Even before Tylor's innovative use of this term, however, Melville and other traveler-writers use tattoo to make visible the concept of a way of life. They also present thereby many of the impossible injunctions that continue to shape conceptions of culture and study of contact between or among differing cultures.

Travel literature presents perhaps the most recognizable sign of the Pacific—indeed, the very concept of culture—as requiring a profound separation between observer and observed. Moreover, as we shall see, that separation between observer and observed remains key to the idea of culture that informs anthropologists' accounts of Pacific tattoo. Despite the long tradition devoted to maintaining a separation between visitor and host, however, white men did historically receive elaborate Pacific tattoos in the eighteenth and nineteenth centuries; if they attempted to return home, they encountered an injunction to explain themselves. The narratives they write must account for the way the visible marker of the Pacific appears anomalously on their faces. The (fictive) explanation they give, typically, is that the tattoo was forced upon them. This chapter thus proposes that the forcible tattoo, like the concept of culture, is a ruse to manage a difference that can move.

In *Typee*, Melville's first book, tattoos serve as an apparent sign of difference, visible proof that the traveler has arrived in an exotic place. Melville emphasizes that all of the men from the Taipi Valley, on the island of Nuku Hiva in the Marquesas, feature tattoos that cover their faces and bodies. His narrator describes not just a particular chief, Mehevi, but also the very type of the Taipi warrior when he declares, "That which was most remarkable in the appearance of the splendid islander was the elaborated tattooing" (*Typee*, 78). So far, so conventional: the unmarked visitor observes the marked islander, and sees in the tattooing a pure sign of the Pacific.

But tattoos do not necessarily remain a sign of difference. Rather, depending upon the sign's location, the patterns attest to potential similarity. Should his crew jump ship, the despotic captain in *Typee* threatens, they will receive facial tattooing at the hands of the islanders. Toward the book's end, the narrator, Tommo, who jumped ship despite the warning, does indeed flee the Taipi valley rather than receive facial tattooing. He fights against being "disfigured in such a manner as never more to have the *face* to return to my countrymen" (*Typee*, 219). The designs can mark the visitor, shattering the separation he creates between himself and the people he observes and thereby transforming the visitor, his observations, and any homeward journey he wishes to make.

In Melville's *Typee* and *Omoo*,[4] as in many travel narratives, tattoos embody the visitor's attempt to locate, interpret, and preserve the sign that distinguishes the Pacific. The attempt, notably, means ensuring that tattoos remain on Marquesans rather than whites. The sign of the Pacific, transferred to the white visitor, challenges the distinctions that the traveler wishes to preserve.

That this examination of visible signs of culture occurs in the Marquesas Islands, and in Oceania more broadly, is not incidental. As anthropologists Geoffrey White and Ty Kawika Tengan note, "The Pacific has been one of the most desired regions for traditional anthropology."[5] Moreover, "The Pacific Islands have been host to fieldwork by many of the pioneers of twentieth-century anthropology, from Bronislaw Malinowski and Raymond Firth to Margaret Mead and Marshall Sahlins. The reasons are obvious. The region spans one-third of the world's surface and an even larger percentage of its (colonized) indigenous people. In short, it is home to an anthropological mother lode of linguistic and cultural diversity" ("Disappearing Worlds," 383). Indeed, going back to the nineteenth-century beginnings of anthropology as a method of inquiry, the Pacific helped inspire the creation of ethnography and, before that, sparked proto-ethnographic narratives by travelers. This region—and particularly the tattoo that distinguishes its peoples—is central to the process by which visitors, a whole series of them, create the very idea of culture. Travelers and anthropologists use the tattoo as a way to visualize the practices and parameters of social identity (and individual innovations and adaptations thereof): that which will coalesce into the term culture.

Tylor helped found the practice now known as anthropology. In *Primitive Culture*[6] he draws myriad descriptions from travelers and missionaries into a single overarching view of human belief and behavior. He launched anthropology by writing the first ethnography, which he proposes as a "science of culture" (*Primitive Culture*, 1). His method is comparative, and it discerns commonalities among the cultures he studies. "Little respect need be had in such comparisons," he declares, "for date in history or for place on the map": "as Dr. Johnson contemptuously said when he had read about Patagonians and South Sea Islanders in Hawkesworth's Voyages, 'one set of savages is like another'" (*Primitive Culture*, 6). Manifold differences between Patagonians and Pacific Islanders do exist, of course, visibly in the fact that the latter were renowned for their tattooing, but those differences are not the point in Johnson's dismissal or Tylor's praise. Rather, Hawkesworth's account of voyages in the Pacific helps shape both Johnson's inattention and Tylor's attention to cross-cultural congruencies. (Hawkesworth's *Account of the Voyages . . . in the Southern Hemisphere*, which drew on past explorers' journals, was one of the most significant ways Captain James Cook's first Pacific voyage entered popular imaginations in England and Europe.)

Tylor transforms the similarities among cultures into a virtue that forms a principle of his study: the co-occurrences he identifies among the practices

he studies lend themselves to articulating general causes of "the phenomena of culture, and of the laws to which they are subordinate" (*Primitive Culture*, 21). Focusing on such similarities allows him to "eliminate considerations of hereditary varieties or races of man" (*Primitive Culture*, 7). If his account is not focused upon race, however, it is subject to evolutionary assumptions that one culture stands at a higher level or more advanced stage than another. He suggests, for instance, that "the European may find among the Greenlanders or Maoris many a trait for reconstructing the picture of his own primitive ancestors" (*Primitive Culture*, 21). (His study acknowledges vestigial forms of the past in the superstitions exhibited by the "modern European peasant" [*Primitive Culture*, 7]—what Tylor terms survivals and Raymond Williams will designate as residual practices.) Most of all, though, his account emphasizes that the concept of culture is created by recognizing the way people live in other places.

Before such contact with others or their ways occurs, no concept of culture exists; social practices are simply givens, the way things are, forming a horizon as invisible and boundless as the sky. As soon as other people are encountered, bearing other practices, the horizon becomes visible. That is one of the reasons why the name for white people, in many parts of the Pacific, is *papālagi*, or "sky-breakers." The arrival of these new folks, who bore guns, Bibles, and other goods, threatened to change the prior order of things, even the relationship between earth and sky. For their part, that is also one of the reasons why Melville, like many other writers, including Charles Stewart and Jack London, insisted upon the separation between the visitor and the islander. That tattoos were not fixed but could mark the visitor as well as the islander threatened not only individual observers but also the very concept of cultural difference that was the foundation of travel narratives and anthropological accounts of the Pacific.

The tattoo is a highly volatile sign: it can embody difference, and is appealing to the observer who wishes to assign such conveniently visible characteristics to the region. But it can also erase difference. The former sense is almost irresistible to the visitor describing the region; the latter threatens to undermine the basis of the visitor's account by making the visitor no longer just in the Pacific, but of it. The assumption is that becoming too close to the Pacific destroys the ability to see the region for what it is and, by extension, destroys the observer. The further question is whether the visitor, in getting close enough to scrutinize the tattoo, in turn threatens to destroy the Pacific patterns she or he seeks.

The latter question is more than rhetorical. Traveler-writers such as Melville and Jack London, and anthropologists including Willowdean Chatterson Handy and Margaret Mead, pose the same question with urgency. The presence of the outside observer, which allows the tattoo to be identified and recorded, also exposes Pacific Islanders to what Melville terms the "polluting examples" and "ruin" of civilization (*Typee*, 15) and Jack London designates the "new taboo."[7] Melville refers specifically to deadly venereal diseases and London to leprosy, both of which sailors brought to the islands. In their eagerness to see and record tattoos in their books, visitors were part of the assault on the continued existence of tattoos on living Marquesan bodies.

The population of the Marquesas Islands was threatened by contact with whites. Where Melville saw a garden in Taipi Valley in 1842, by the time London visited in 1907 he saw only "an untenanted, howling, tropical wilderness" (*Snark*, 163). Along these lines, Chatterson Handy declares that in 1920–21 she had documented Marquesan tattoo designs because "the race was dying, we had been told."[8] This assumption was widespread in anthropology's early days as an academic discipline. Similarly, looking back upon her contemporaneous research in Samoa, Margaret Mead declared in 1972, "I did not know then, could not know then, how extraordinarily persistent Samoan culture would prove, and how fifty years later the grace that I had attempted to record as something that was surely going to vanish would still be there."[9]

In the Marquesas, French colonial authorities, who had officially annexed the islands shortly before Melville's 1842 visit, forbade tattooing as early as 1858 and banned the practice outright in 1884. (In claiming these islands, the French followed the American lead; in 1813, Captain David Porter had annexed the islands for the United States, but for many reasons American dominion did not endure.) In light of these attempts to reshape Marquesan land and culture, it would not be surprising if tattooing, the most distinctive practice in Henua'enata, the Marquesas, were threatened with extinction.

Henua'enata, the people's longstanding name for their islands, means *the land of men*, or *the land of the people*; Enata is the name for the *people* who live in these islands. Greg Dening emphasizes that historically Enata tattoo conveyed an entire cosmology: "It was a violence and a pain done to them their whole life long. For men at least, it ended only when there was no part of their body untouched. Their whole skin became perfectly cultivated. As if nothing was to be left to nature their blank spaces were filled in with their culture's signs and symbols. Their tattoos were boundaries to their spirits."[10] When the German physician Karl von den Steinen began documenting tattoo

motifs in 1897, he was able to identify at least 96 named (and signifying) motifs (1:102–36).[11] These tattoos, persisting nearly forty years after the practice was first forbidden, invoke intricate conceptions of the *tapu* or *sacred*, a proliferating field of hierarchies that define Enata life (*Wrapping*, 171–72). The designs form a membrane between the sacred and profane, protecting a way of being. Figures 15 and 16 are examples of male and female Enata tattoo.

The spiritual and social distinctions registered so finely in Enata tattoo, when viewed by an outsider, invite speculation about gross differences between peoples. Visitors see in the fine distinctions variations of a single sign that indicates a departure from nature. Such a visible marker of the social allows travelers to approach the concept of a distinct way of life. This idea of culture, of course, arises alongside proclamations of a total Enata demise.

Despite the predictions offered by visitors, however, Enata culture—and tattooing—continues to thrive. As of the mid-1990s, about twenty-five to thirty Enata tattoo artists practiced in the Marquesas.[12] Many other Enata tattooists were at work in Tahiti, and many of the three hundred tattoo artists in Tahiti were using Enata designs ("Polynesia," 190, 188). Po'o Ino, who was born in Nuku Hiva and works in Hawai'i, returned to French Polynesia to participate in "Tatau i taputapuatea," the first International Tattooing Festival, convened in Raiatea in April 2000. He declared, "[Tattoo] identifies us, who we are, which family we're from, which island are we from and where is our place in the Society."[13] A similar efflorescence of contemporary Marquesan art has occurred in forms including tapa painting, tiki carving, and pareu painting —all of which feature motifs drawn from tattooing.[14]

On the other hand, even the leading contemporary anthropological book on Pacific Islands tattooing, Alfred Gell's *Wrapping in Images*, does not reflect that the tattoo traditions are alive, and instead confines the practice to the pages of colonial-era travel and anthropological narratives. Relegating the practice to the pages of books rather than the skin of living Pacific Islanders preserves a distance between observer and observed, here making the one contemporary and consigning the other to the past. This move is a variation upon the *"denial of coevalness"* that Johannes Fabian identifies as an enduring tendency in ethnography: *"a persistent and systematic tendency to place the referent(s) of anthropology in a Time other than the present of the producer of anthropological discourse."*[15] This move also erases the spiral time of the Pacific, in which "there is no linear past to return to since the past has never been separated from the present."[16]

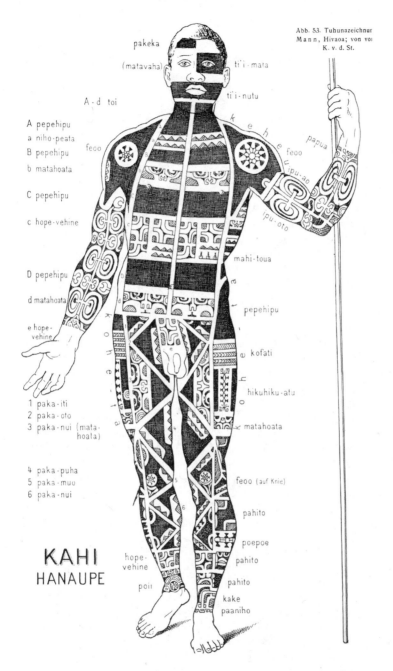

FIGURE 15. Illustration by Kahi of Hanaupe, Hiva Oa. A Marquesan man's tattoo.
Steinen also identifies the artist as a tattoo-master. Reprinted from Karl von den Steinen,
Die Marquesaner und ihre Kunst (Berlin: D. Reimer, 1925), 1:103.

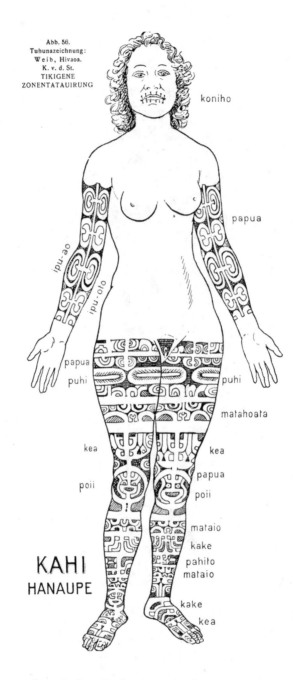

FIGURE 16. Illustration by Kahi of Hanaupe, Hiva Oa. A Marquesan woman's tattoo.
Reprinted from Karl von den Steinen, *Die Marquesaner und ihre Kunst*
(Berlin: D. Reimer, 1925), 1:103.

In other words, this temporal strategy recalls the marked difference that Melville and other writers sought—and created in their accounts. Both untattooed and tattooed visitors help create the concept of culture through their depictions of the Marquesan patterns. Their purposes and methods diverge, of course, depending upon whether the designs adorn the observer's skin.

<div align="center">UNMARKED OBSERVERS</div>

Marquesan tattooing in particular caught the attention of the world because it is an elaborate, even superlative, tattooing practice. In traditional Enata tattoo, every part of a man's body is adorned, often including his hands, feet, and face. One Marquesan practice in particular fixates the visitor's gaze and reveals key moments in creating the concept of culture through the contemplation of tattoo pigment. The anthropologist Willowdean Chatterson Handy, part of the first anthropological expedition to the islands in 1920–21, describes this practice: "Several testify that when a man was completely tattooed in design, if he could bear it, the spaces were gone over and filled in until all pattern was obliterated and he was completely black."[17]

These complete fields of pigment take the practice of tattooing to its logical extreme, and therefore become particularly charged points of observation by visitors. As an exaggerated version of the typical Marquesan tattooing pattern, visitors' comments about the comprehensive design become particularly important in formulating their thoughts about what it is that tattoos make visible. Characteristic observations of this practice thus help define what Tylor and later writers would term "culture."

David Porter, for one, captain of the U.S. navy ship *Essex*, noted in 1813 that the tattooing of Enata men could be so extensive that it changed the color of their skin. He presents his comments in the context of describing the men's complexions: "The old men, (but particularly the chiefs) are entirely black; but this is owing entirely to the practice of tattooing with which they are covered all over, and it requires a close inspection to perceive that the blackness of their skin is owing to this cause."[18] Porter provides that close inspection, but he does so in order not to racialize the practice or the people who wear the designs. Instead, he emphasizes that the black skin is not acquired at birth but attained later, through art.

He describes the detailed patterns discernible through the blackness, and though the comparison he uses is quite awkward, it emphasizes the craft that goes into creating the tattoo. "When the eye is once familiarised with men or-

namented after this manner," he explains, "we perceive a richness in the skin of an old man highly tattooed comparable to that which we perceive in a highly wrought piece of old mahogany: for, on a minute examination, may be discovered innumerable lines curved, straight, and irregular, drawn with the utmost correctness, taste and symmetry" (*Cruise*, 294). The metaphor is abrupt: despite parallels between Marquesan carving and tattooing motifs, a man is by no means a piece of wood. Still, his comparison recognizes the "highly wrought" artistry present in tattooing, and he uses the incongruity to present the practice in terms comprehensible to his United States reading audience.

Porter offers such detailed descriptions of Marquesan life despite the way his journey is framed by war: the War of 1812 against the English, whose economic forces Porter challenges in the Pacific by capturing English whaling ships; and the revenge war he launches against the Hapaa on behalf of the Teii, whose chief had exchanged names with Porter while Porter worked to refit the *Essex*. Even in the midst of war, Porter aims to "familiarize" the reader's eye with tattoo ornamentations and other features of Marquesan life. The familiarized eye sees the patterns in the blackness, the designs that distinguish life in these islands.

When another visitor, the U.S. naval chaplain Charles S. Stewart, visits the islands in 1829, however, he makes the blackness of tattooed skin a matter of race. He describes a man whose tattoos had been rendered so complete that design itself has been effaced. His account, in *A Visit to the South Seas*, describes the process in terms not of acquiring tattoos but of a man's removing himself from his natural tribe. The marks threaten to separate the man from his children, by making him a member of a different race: "Judging from the complexion merely, they would never have been thought his children, for, while scarce darker than a clear brunette themselves, he, in every part of his person exposed, was black as a Moor, from the effect of tatau."[19] The full black tattoos represent years of tattooing, but here become the material of racial classification.

Stewart's visit followed Porter's by only sixteen years, but the difference in the accounts represents more than a passage of time. Stewart's description places Enata practices into categories derived from the observer's world. Juxtaposed with Porter's, his account also exhibits a distinct temperament and orientation to the Pacific.

Porter accepts, and Stewart rejects, the Marquesans' differing practices of dress and adornment. Porter muses, "I find no difficulty in believing, that an American lady, who exposes to view her face, her bosom and her arms, is as

modest and virtuous as the wife of a Turk, who is seen only by her husband; or that a female of Washington's Group [the Marquesas], who is seen in a state of nature, with every charm exposed to view, may be as modest and virtuous as either" (*Cruise*, 295). (Despite his cosmopolitan recognition that women's dress reflects their surroundings more than their morality, Porter applies other standards to Enata names for their lands; he follows Captain Joseph Ingraham's practice, recorded in Jedidiah Morse's *American Gazetteer*, by naming many of them after U.S. presidents.) Stewart, on the other hand, objects to the dress of Enata women—or lack thereof. He declares, "I am more and more disgusted with the nakedness, and a hundred other of the odious appurtenances of heathenism forced on us at every turn" (*Vincennes*, 309). Stewart, like Porter, recognizes that a differing standard prevails in the Marquesas— that which he terms "heathenism"—but rather than considering his own standards, or evaluating the parameters of the Marquesan ones, he rejects the other as odious.[20]

Being wrapped in images so completely that the patterns disappear is a profound culmination of the *pahu tiki* practice. In Stewart's reliance upon U.S. standards, the closest analogy to choosing such blackness is changing one's racial markings. This prospect he avoids at all costs, to the point of minimizing contact between himself and his Marquesan hosts.[21] Rather than examining such designs, he retreats to the exploring vessels, which create maps to support U.S. economic interests in the Pacific (particularly whaling which, thanks in part to Porter's attacks on British ships and in part to the maps created by the U.S. Exploring Expedition, reached a peak between 1845 and 1855).[22] *Tiki* is presented as art and alchemy, capable of altering nature itself. If racial identity can be reassigned, such categories are both more and less fixed than might at first appear.

The tattoo can render the islander black indeed, an outer indication of the inner moral state Stewart believes he observes. In common with Christian missionaries including William Ellis in Tahiti, Stewart tempers such condemnation by believing that the Marquesans are redeemable. In Stewart's account, the light of the Gospel, however, only emphasizes the black tattoo. This paradoxical Christian fascination with defining the practices of "heathenism" recurs. Missionaries' accounts are often full of minute descriptions of the very "customs and observances as were peculiar or striking"[23] that they worked to eliminate.

As scholars from Charles Roberts Anderson on have noted, in *Typee*, Melville both appropriates and transforms prior narratives of the Marquesas, in-

cluding Porter's and Stewart's. In confronting tattooing, Melville's narrative exemplifies what Walter Herbert describes as "Melville's knack of constructing the moment by playing off the way it had been constructed by others" (*Encounters*, 14)—but to a very different end than Herbert discusses. Whereas Melville creates a playful and humorous depiction of naked women swimming out to welcome the arriving American ship, calling attention to the metaphors and assumptions that Porter, Stewart, and his own narrator use, in his portrayal of tattoos he hardens the previous presentations. These distinctions prove important in honing the incipient concept of culture.

Typee stands as an exemplar of the untattooed visitor's account of these designs, an early and famous depiction that both draws upon past and shapes future accounts. With its characteristic features of travel narrative and proto-ethnography, *Typee* inspired other travelers and writers. Jack London, for one, attributes his own lifelong wanderlust to his reading *Typee* as a boy. As he recounts in *The Cruise of the Snark*, Jack London and his traveling companion and wife, Charmian, retraced Melville's footsteps through Taipi Valley. As they traveled, they sought the tattoo: Charmian London's captions on the photograph albums from their 1907–1908 South Pacific cruise on their ship *The Snark* note every time they meet people who are tattooed.[24]

Particularly in portraying the Taipi practice of going over the tattoo until a solid field of pigment is achieved, *Typee* intensifies Porter's metaphors and Stewart's critique. Melville's narrator describes "four or five hideous old wretches, on whose decrepit forms time and tattooing seemed to have obliterated every trace of humanity" (*Typee*, 92). This presentation goes beyond Porter's mention of a "highly wrought" art, beyond Stewart's concern that tattooing can alter a supposedly natural racial identity. This presentation suggests that tattooing taken to the extreme obliterates the human. The passage makes it clear that Melville presents the same process of repeating the tattoo: "Owing to the continued operation of this latter process, which only terminates among the warriors of the island after all the figures sketched upon their limbs in youth have been blended together—an effect, however, produced only in cases of extreme longevity—the bodies of these men were of a uniform dull green color—the hue which the tattooing gradually assumes as the individual advances in age" (*Typee*, 92). These green men, it turns out, have been taken beyond the bounds of both art and human nature by the dual operations of time and tattooing. (Melville's, it would appear, is the only description that suggests that Marquesan tattoo produces this color; others comment on the black or blue pigment of the adorned skin.)

Indeed, the metaphors Melville uses to describe the process draw upon craft and nature—yet without emphasizing artistry, as does Porter, or humanity, as does Stewart. His narrator declares, "Their skin had a frightful scaly appearance, which, united with its singular color, made their limbs not a little resemble dusty specimens of verde-antique. Their flesh, in parts, hung upon them in huge folds, like the overlapping plaits on the flank of a rhinoceros" (*Typee*, 92). Verd antique (which may also reference marble with green veins running through it) probably indicates the verdigris that brass accumulates, and thus the term specifies a surface coloring, a superfluous covering of the vessel that is the human body. The green coloring that the metaphor emphasizes is derived either from oxidation or the passing of time—not from art. Similarly, comparing the men's skin to rhinoceros hide suggests that tattooing has removed the men from the bounds of the human—placing them outside even the racial categories Stewart invokes, which attempt to manage the place of people in nature. These comparative passages introduce the way tattoo, in Melville's account, makes visible important features of Taipi life.

Throughout *Typee*, the tattoo, a marker of the particular, is established as universal to Taipi, simultaneously serving as rule and variant. Kory-Kory's and Fayaway's tattoos exemplify the gender-specific pattern, Marnoo's the exception that confirms the pattern. Melville presents playful descriptions of the tattoos worn by his male attendant Kory-Kory and his female attendant Fayaway, and admiring descriptions of those worn by Marnoo, the *tabu* traveler within the islands, whose patterns form "the best specimen of the Fine Arts I had yet seen in Typee" (*Typee*, 136). Melville emphasizes facial tattoos in describing Kory-Kory and Marnoo, a matter that will closely concern the narrator.

He underscores the prototypical elements of the tattoos that each character bears. His narrator compares the facial designs that wrap Kory-Kory's face in three longitudinal bands of tattooing to "those unhappy wretches whom I have sometimes observed gazing out sentimentally from behind the grated bars of a prison window," and likens Kory-Kory's bodily designs to "a pictorial museum of natural history, or an illustrated copy of 'Goldsmith's Animated Nature'" (*Typee*, 83). These humorous metaphors emphasize the narrator's own newness to tattoo, a feature announced in the declaration, "Kory-Kory, I mean thee no harm in what I say in regard to thy outward adornings; but they were a little curious to my unaccustomed sight, and therefore I dilate upon them" (*Typee*, 83).

Fayaway, on the other hand, like most young women, is notable for her lack of tattoos. While not completely "free from the hideous blemish of tat-

tooing" (*Typee*, 86), she is still "very little embellished" (*Typee*, 86), even less
so than are her young female counterparts. Marnoo's "face was free from the
least blemish of tattooing" (*Typee*, 136), an exception that establishes the male
facial tattoo as almost universal. (Both descriptions, of course, present the fa-
cial tattoo in particular as a blemish.)

Kory-Kory's tattoos are black, Fayaway's are so slight that their color re-
mains unspecified, and Marnoo's feature "the brightest blue" (*Typee*, 136). In
creating this tattoo color scheme, Melville is not so much referring to U.S.
racial categories as he is examining Taipi methods of marking. In other words,
it is possible to revise the assessment that tattoos are "acting as a code for racial
difference that visibly links color to freak status."[25] That is, "Tommo's terror
at having his face marked" does not indicate so much "a fear of being black"
("Racial Freak," 242)—a consideration that once again relies on U.S. catego-
ries—as it indicates a fear of being placed within Taipi hierarchies.[26] Tattoo
makes visible those hierarchies.

At the first chapter's close in *Typee*, Melville establishes the central role tat-
too plays in the book and in the islands by presenting the "Island Queen her-
self, the beauteous wife of Mowanna, the king of Nukuheva" (*Typee*, 7). The
joke he makes when the Island Queen displays her own tattoos depends upon
the ubiquity of the practice in Nuku Hiva.

The commander of the French squadron invites Te Moana and "his con-
sort" (*Typee*, 7) aboard the U.S. flagship to display the civilizing process in
the persons of the royal couple. Historically, such a visit occurred during Mel-
ville's second visit to Nuku Hiva, after he had escaped the Taipi when he re-
turned briefly aboard the U.S. Frigate *United States*. This ship's Abstract Log
notes, "during our visit the King & Queen visited the Ship, he being dressed
in a French uniform given him by the French Admiral, and she in a red skirt
which reached a few inches below the knee, about 15 years of age, with hand-
some features, and tattooed on all visible parts."[27] Melville's Te Moana and
Vae Kehu (the latter unnamed in *Typee*) are adorned in elaborate, exaggerated
European dress, but in Te Moana's appearance, the narrator finds "one slight
blemish": "a broad patch of tattooing stretched completely across his face, in
a line with his eyes, making him look as if he wore a huge pair of goggles; and
royalty in goggles suggested some ludicrous ideas" (*Typee*, 7–8). Despite the
exaggerated European military uniform he wears, what excites comment as
"ludicrous" are the permanent goggles his tattoos provide, evidence of a prior
claim to power, one based on the bearer's affiliation with Enata rather than
French traditions.

More than the king's appearance, the queen's behavior excites a humorous reaction that undermines French authority. The queen pulls further open the shirt-collar and rolls up the pants leg of an old sailor, the better to admire his "bright blue and vermilion pricking, thus disclosed to view" (*Typee*, 8). "The embarrassment of the polite Gauls at such an unlooked-for occurrence may be easily imagined," Melville's narrator proceeds wryly, "but picture their consternation, when all at once the royal lady, eager to display the hieroglyphics on her own sweet form, bent forward for a moment, and turning sharply round, threw up the skirts of her mantle, and revealed a sight from which the aghast Frenchmen retreated precipitately, and tumbling into their boat, fled the scene of so shocking a catastrophe."[28]

This fictional Island Queen displays her tattoos in a move with doubled effects: it dismisses French persons from the U.S. flagship and, by extension, French claims to the islands. It also establishes that the islands are here embodied in the figures of Te Moana, the Island Queen, and their tattoos. The joke depends upon the tattoo's indelible nature, as well as its adornment of an intimate region of the Island Queen's body. Anthropologist Willowdean Chatterson Handy locates what she believes to be a copy of Vae Kehu's famous tattooed girdle ("Island Queen," 167). For now, the point is that the Island Queen's tattoo, placed as it is on the threshold of the narrative, signals the ubiquity—and differing authority—of this Nuku Hivan sign.

The sign is presented as normative (if sometimes humorous) on the Enata, but as threatening on a white man. In chapter thirty, which features an extended consideration of tattoo, Melville's narrator Tommo expresses abhorrence at the prospect of "being rendered hideous for life" (*Typee*, 218) when the tattoo artist Karky wishes to adorn Tommo, beginning with his face.[29] Although Melville's narrative repeats that Karky wishes to tattoo Tommo's face first, it does not note the fact that a tattoo that begins on the face would mark Tommo as a *ka'ioi*, one of the young cohort that accompanies the principle tattoo subject, the high-ranking *opou*; the *opou*'s tattoos, in contrast, begin on the soles of the feet and proceed upward to the face (*Tattooing in the Marquesas* 5; *Wrapping*, 198). The marks would thus doubly fix Tommo's position: not only *outside* of U.S. but also *within* Marquesan hierarchies. The prospect of his own tattooed face, invoked at the book's outset as a warning against leaving the ship's company, impels Tommo to leave the Taipi. Presented in this way, the tattoo is a double negative. Invoked as a sign of Tommo's refusing first his place aboard ship and later his place on shore, the tattoo, were it to imprint his face, would negate his negation.

The tattoo would not "destroy his mediate position" between the Taipi valley and the outside world or prevent him from "retaining such links to the outside world as memory, his ability to perform a sailor's work, and the desire to return to the ship";[30] rather, it would fix his mediate position, and Tommo resists fixed roles. Both aboard ship and with the Taipi, he refuses to continue in a subaltern state. In this way, Melville anticipates Gayatri Spivak's attention, in regard to the very different histories and locations of the Indian subcontinent, to the ways that the subaltern can deny that which is ascribed to her. Spivak suggests, in her later consideration of the subaltern, that the subaltern is muted, and "the place of 'disappearance'" marked by "a violent aporia between subject and object status";[31] Melville uses the tattoo to make visible that shuttling between subject and object status. By presenting the patterns as a sign that takes the bearer outside of art and nature, he creates a place for himself to articulate his narrative's own difference: from past narratives, from the Taipi.

First and last, Melville presents the white man's face as naturally unadorned, free from tattoo's "embellishment," a word that recurs in his descriptions of the art.[32] The intervening descriptions do not present the tattooed Marquesan man's face as natural, however, but as an inevitable marker of assuming a place in Marquesan society. In other words, tattoo makes visible the way that a personal and social identity is acquired. Tattoo embodies culture: for the Marquesans (except for the aged chiefs whose green skin has taken them beyond the bounds of art and humanity), an embellishment or visible extension of their existing place in the islands; for Melville's narrator (and any other white man), an affront that takes him forever outside his homeland and fixes him in the strange world of the beach, making visible his place in the liminal contact zone that renders him always not quite white and not quite Marquesan.

Tommo declares, in a retrospective protest against his possible facial tattooing, "What an object he would have made of me!" (*Typee*, 219). The phrase, which Melville renders comically, nonetheless presents a serious commentary on the transformation a tattooed white man undergoes. Previously a subject who observes the tattooed other, when he is tattooed himself, he becomes an object of the subject's gaze, made other to himself. The process embodies and materializes the mysterious movements of the *tabu* in *Typee*.[33] The tattoo is a powerful and dangerous operation that makes visible the movements from subject to object, from sacred to profane, and from outsider to insider. Both tattoo and taboo inspire fear in Tommo because their operations are seen as, on the one hand, inscrutable and, on the other, all too obvious in their effects.

In some ways, the fear of tattoo corresponds to the fear of cannibalism: both represent an irrational anxiety about being consumed by the Pacific. On the other hand, we have seen that in capitalist markets, tattoo offers a means of consuming the exotic. When tattoo becomes not an item to be purchased by choice, but a mark of being forcibly incorporated into the Pacific, then it signals terror.

Melville makes explicit the potential horror of the tattooed white man, who has undergone an irreversible transformation. He presents one such figure at the beginning of *Omoo*, his sequel to *Typee*, which continues to narrate a fictional version of his Pacific travels. Tommo escapes from the Taipi by committing violence against Mow-Mow, from whom the narrator has previously distanced himself by describing the one-eyed chief's "hideously tattooed face" (*Typee*, 236). As he departs from the Marquesas, the narrator comments further upon Lem Hardy, a "renegado from Christendom and humanity" (*Omoo*, 27). The description makes explicit the suggestion in *Typee* that tattoos take one beyond the bounds of not only Christianity, but also humanity.[34] As Melville's narrator departs Nuku Hiva, he thus comments upon a notorious figure who is himself unable to leave the island.

In this description, Hardy's facial tattoo fixes him in the Pacific, rendering him the object Tommo has been dreading that he might become. "A broad blue band stretched across his face from ear to ear," the narrator announces, "and on his forehead was the taper figure of a blue shark, nothing but fins from head to tail" (*Omoo*, 27). The tattoo is even more horrible than Cain's, which *Genesis* presents after all as God's mark, placed upon Cain to protect him in his wanderings after he is cast out for murdering his brother: "Some of us gazed upon this man with a feeling akin to horror, no ways abated when informed that he had voluntarily submitted to this embellishment of his countenance. What an impress! Far worse than Cain's" (*Omoo*, 27). Cain's mark indicates that he has been cast out from his people, and, like Hardy's, it is a mark that Cain himself requests for protection. Where Hardy's mark gains him a place in the Marquesas, it also marks him forever as outside his English home, much as Cain's indicates his exile. Yet in this exaggerated account, Hardy's Marquesan tattoo is far worse than Cain's: "*his* was perhaps a wrinkle, or a freckle, which some of our modern cosmetics might have effaced; but the blue shark was a mark indelible" (*Omoo*, 27). In other words, permanent, expansive Enata tattoos threaten to take the bearer even further beyond the bounds of the human than does Cain's.

Beyond the limits of the human and possibly even into the realm of the de-
monic, in Melville's first two books. *Typee* anticipates *Omoo*'s horrified gaze at
the white man's tattooed face. Tommo's "unconquerable repugnance" (*Typee*,
220) at the prospect of facial tattooing coincides with a pattern that Melville
weaves throughout *Typee*. He associates tattooing of the white man with a
"diabolical purpose" (*Typee*, 219), suggesting that the "infernal Karky" will
not rest until he achieves the "utter ruin of my 'face divine'" (*Typee*, 220). The
tattoo would thus transform Tommo's face from an image of God into a devil-
ish or demonic one, but even on Taipi, "naked tattooed limbs" look to Tommo
like they belong to a "set of evil beings" (*Typee*, 227). This series of metaphors
heightens the fear and horror Tommo expresses at the prospect of his own
tattooing. It also coincides with the narrator's comment that the art is closely
associated with the Taipi religion and the mysterious *tabu*, both of which he
finds "inexplicable" (*Typee*, 221).

Melville, however, far from suggesting that the marked face is godly, uses
the prospect of the tattooed face to comment on the very formation of human
boundaries and limits, including conceptions of divinity and its opposite. He
twice uses the word "grotesque" to describe the tattooed Marquesan body. One
instance emphasizes the need to reach for a metaphor in order to do justice to
describing the tattooing on Mehevi's body: "All imaginable lines and curves
and figures were delineated over his whole body, and in their grotesque vari-
ety and infinite profusion I could only compare them to the crowded group-
ings of quaint patterns we sometimes see in costly pieces of lacework" (*Typee*,
78). The other emphasizes the place of tattooing in creating a state of reverie:
"when my eye, wandering from the bewitching scenery around, fell upon the
grotesquely tattooed form of Kory-Kory, and finally encountered the pensive
gaze of Fayaway, I thought I had been transported to some fairy region, so
unreal did everything appear" (*Typee*, 134).

In Melville's time, the word grotesque maintained a powerful association
with the destruction of proportion, reason, and order. In *The Grotesque in Art
and Literature*, Wolfgang Kayser traces the effect of the grotesque:

> We are so strongly affected and terrified because it is our world which ceas-
> es to be reliable, and we feel that we would be unable to live in this changed
> world. The grotesque instills fear of life rather than fear of death. Structurally,
> it presupposes that the categories which apply to our world view become in-
> applicable. We have observed the progressive dissolution which has occurred
> since the ornamental art of the Renaissance [when the art of the grottesco was

rediscovered]: the fusion of realms which we know to be separated, the aboli-
tion of the law of statics, the loss of identity, the distortion of "natural" size and
shape, the suspension of the category of objects, the destruction of personality,
and the fragmentation of the historical order.[35]

Particularly in its presentation of tattoos, which seemingly mark the Mar-
quesan man and woman as such but can also travel to the white man, *Typee*
confronts and tests categories that define not just one world view but vary-
ing worldviews. The narrative broaches the fusion of realms that are at once
separate and inseparable. It approaches the insight that tattoo may suspend
the category of both objects and subjects, and distort or destroy personal and
historical order. In associating tattoo with the grotesque, Melville confronts
the making and unmaking of worlds. His work emphasizes not just the fact that
differing worlds exist, but that the tattoo's ability to move from one to another
may undo these worlds and unravel being itself.

Melville's works are not included in Kayser's examination, but they share
the concerns Kayser discusses. The point is not just to recognize that *Typee*
confronts the power of the grotesque, as one of Melville's contemporaries,
Edgar Allan Poe, had done more explicitly in his first short story collection
Tales of the Grotesque and Arabesque.[36] The point is that Melville uses tattoo
to make visible the concern with human limits, what Poe defines as a "*grotes-
querie* in horror absolutely alien from humanity" (*The Grotesque*, 79; italics in
original). If Melville's tattoo, like Poe's story of the double murder, makes the
boundaries of the human visible, and therefore indicates the alien or inhuman,
what increases the horror is that the tattoo does not mark a stable difference
between the observer and observed, subject and object. The tattoo may travel
from one to the other, incorporating the visitor into the Pacific.

Posed against such threatening transformations, the visible difference that
is "culture" offers to institute boundaries. Indeed, to jump forward in time,
the best-known contemporary study of Pacific tattoos is written by an anthro-
pologist who relies solely upon colonial-era accounts to create his study. Much
as Tylor used travelers' narratives to form the first ethnography, Gell revisits
prior accounts to create a meta-study of Pacific tattooing. Despite the theoreti-
cal sophistication of Gell's account, some of the same assumptions structure
his and Tylor's narratives. Gell's account typifies the treatment of tattoo as
visible culture—and of culture as that which requires separation between ob-
server and observed.[37]

Much as do the previous accounts, Gell asserts that a crucial difference exists between the societies of the observers and the observed. "Tattooing in the West," he declares, "is characteristic of marginal subcultures, especially those which suffer repression (e.g. criminals, common soldiers and sailors, lunatics, prostitutes, and so on)" (*Wrapping*, 19). He suggests that the crucial difference between the "subcultural" tattooing practice in the West and in such places as the Pacific lies in the degree to which the practice is accepted—that is, whether it is embraced by a minority or majority group.

Gell's statements are worth quoting at some length because his account has become an accepted authority in studies of tattooing outside the Pacific, and even within Pacific studies has been received as a comprehensive account. Yet the assumptions he presents about cultural differences are structurally problematic, and his rhetorical moves signal deep contradictions in comparing the Pacific and the world.

"Outside the West," he continues, "in tattooing cultures of the preliterate/tribal category, tattooing is not subcultural in this sense, but it is perfectly possible that the lifestyle and values associated with subcultural tattooing in the West continue to be associated with the practice, the only difference being that these are now socially dominant, constituting the majority culture and no longer the minority one. In other words, these are societies which are dominated by criminals, soldiers, and prostitutes, not societies which repress them" (*Wrapping*, 19).

Gell's next statement uses rhetoric to stake a very strong claim, reiterating the claim in the guise of acknowledging its potential to offend. "This conclusion," he suggests, "obnoxious to standard anti-ethnocentrism, is not wholly true, as more detailed investigations will reveal, but it cannot be rejected out of hand because it appears to denigrate non-western societies" (*Wrapping*, 19). By defining itself in distinction to standard anti-ethnocentrism, the account proceeds under the flag of a nonstandard, self-aware ethnocentrism. This association between criminals, soldiers, prostitutes, and Pacific societies, while acknowledged here to be "not wholly true," is certainly not "rejected out of hand." Instead, the claim is repeated throughout the book, and features once again in the conclusion.

In addition to this problematic description of eastern Pacific societies (his study focuses on what he terms Polynesian tattooing), his statement does not treat tattooing as a living art in the Pacific. This omission stands, despite the proliferation of contemporary tattooing, a vital practice when his study was written. Omitting contemporary tattoo practices helps demarcate as distinct

from one another the two regions he describes, the one in the past and dominated by "criminals, soldiers, and prostitutes," the other in the present and "repress[ing] them." While apparently acknowledging similarity (both regions he describes confront the same behaviors, while one creates a moral critique of those behaviors and the other does not) the account enforces difference.

After this passing gesture toward considering the ethnocentric basis of his study, the next point Gell makes, following anthropologist Sperber, is a proposal to consider tattooing according to "consistent 'epidemiological' principles" (*Wrapping*, 19); that is, tattooing is a "somatic illness" (*Wrapping*, 19) or "cultural 'disease'" (*Wrapping*, 163) whose spread can be traced within the Pacific, within the world, or between the Pacific and the world. In other words, tattooing becomes a contagion, an infectious (if cultural) disease. Rather than consider the threats to the tattoo from the biological contagions spread by visitors to the region, this approach makes tattooing into a metaphor of contagion.

Tattooing, however, is a way of life, and culture is hardly a disease one catches. What is most virulent may be instead the way Gell uses the concept of culture to associate tattooing with pathology. The idea of culture, of course, originates in part in the Pacific through just such travelers' narratives as Gell's book examines. The diseases that threaten the continuation of Pacific tattoo include the venereal contagions Melville cites, the leprosy London deplores, and perhaps the classic anthropological conception of culture—with its insistence upon separating observer and observed. The Pacific tattoo, which can travel from one to the other, both reveals and redresses such conceptual gaps. These accounts finally make visible the way the visitor both creates and threatens to destroy the difference she or he seeks in the Pacific—the difference made visible by the tattoo.

MARKED OBSERVERS

To turn briefly to the tattooed visitor, on the other hand, we find a figure that does not seek absolute difference in the Pacific, but instead threatens to undo that search. The white men who received Pacific tattoos are less likely to propose or attempt to maintain the differences that will coalesce into the concept of culture. Even some of the earlier observers who received tattoos had also considered tattoo to be inexplicable; but the patterns were not always presented as marking such a basic difference between people. One influential early observer, Joseph Banks, the naturalist on Captain Cook's first voyage, focused

on the motivation behind the tattoo and wondered what the marks signified. But he did not suggest that they created any boundary other than that between superstition and (implicit) reason.

Banks pondered why people in Tahiti sought the tattoo: "so essential it is that I have never seen one single person of years of maturity without it. What can be a sufficient inducement to suffer so much pain is difficult to say; not one Indian [Tahitian] (tho I have askd hundreds) would ever give me the least reason for it; possibly superstition may have something to do with it, nothing else in my opinion could be a sufficient cause for so apparently absurd a custom."[38] Though he cannot determine why Tahitians acquire the designs, he closely observes *how* they do so, recording the details of a twelve-year-old girl's tattooing.

Unrecorded in Banks's journal is the transformation in his own thinking that must have occurred in order for him to receive an *ario'i* tattoo,[39] thereby taking upon his own body the marks he had termed "absurd." Following his return to England and the fame his voyage brought him, a correspondent, Charles Davy, writes to Banks, "I should be much obliged to you for an exact copy of the characters stain'd upon your arm."[40] Salmond suggests that Tahitians and other Pacific Islanders were not the only ones, of course, who changed as a result of meetings between English and Pacific cultures: "it may have been that Cook's sailors (or some of them) were no longer purely 'European,'" but instead "had come under Polynesian influence."[41]

As for how tattooed white men characterized the people who created the marks they bore, much depended upon not only the time of their travels but also their social standing at home. Joseph Banks, who came from one of the wealthiest families in England at the time, traveled to the Pacific and returned home famous, feted, and later knighted. In his time, he acquired a Tahitian mark of distinction, but one he did not discuss in his writings. It did not render him unable to return home, or stigmatize him as having traveled too far. In the terms developed by Porter, Stewart, and Melville, his fate was not determined by his bearing the practices of another place, the identity of another race, or a sign of standing outside the human. His status remained untouched, an aristocratic place in England amplified by his contact with the Pacific. Though he wore a tattoo, he remained essentially unmarked; as a result, his accounts, unlike those of other tattooed men, neither blur nor attempt to regulate the difference between the observer and the observed.

Outside the Pacific, in the nineteenth and early twentieth centuries, tattooing flourished in high society. In 1862 the Prince of Wales (later King

Edward VII) was tattooed; in 1882 his sons, the Duke of Clarence and the Duke of York (later King George V) acquired copies of their father's tattoos. Much of the male English aristocracy followed suit, and were joined by European counterparts including Czar Nicholas II of Russia, Queen Olga and King George of Greece, Prince Henry of Prussia, Archduke Stephen of Austria, King Oscar of Sweden, the Duke of Genoa, and the Princesses de Leon and de Sagan.[42] In the 1880s and 1890s the New York City-based tattoo artist Martin Hildebrandt (the first professional tattooist in the U.S.)[43] noted "that well-bred ladies from uptown had been coming to him in such numbers" that he was considering moving his Oak Street studio uptown (*Strange Art*, 99). Even Lombroso, who in 1895 focused on "The Savage Origin of Tattooing," begins his article by inveighing against the fashion that has "women of prominence in London society" seeking tattoos: "The taste for this style is not a good indication of the refinement and delicacy of the English ladies."[44] The designs first made their marks on the aristocracy and working class (though by the 1920s, Sanders suggests, following Parry, the aristocracy had backed away from seeking tattoos). Broadly speaking, only after World War II did the middle classes seek the designs. It would seem that such aristocrats as Banks were immune from the social marking the tattoo otherwise conferred. On the other hand, tattooed soldiers, sailors, prostitutes, and criminals confirmed their lower status. Outside the Pacific, the marks did not suggest social mobility so much as a social rigidity.[45]

Non-aristocratic white travelers who received tattoos on their Pacific travels found that the tattoo suspended them in between Nuku Hiva and England, Europe, or the United States. These men were forced to explain or manage the tattoo. Their stories, too, reveal important aspects of the way culture is created through viewing the Pacific tattoo, a sign of shared Pacific practices turned into a performance. White men who chose to acquire the marks necessary to gain standing in the Pacific often returned to their homelands only to emphasize the necessity and deny the choice behind their tattoo. In so doing, they exhibited not only their patterns but also their recognition that in leaving the Pacific, they had traded one culture's demands for another.

Outside the Pacific, the tattoo also flourished in communities that included soldiers, sailors, and criminals—the groups to whom Gell assigns the tattoo. Social scientists, who were founding their fields at this time, focused on the tattoo's ostensible criminal association. The design theorist Loos proclaims that a tattooed European man who died without having murdered simply died before he could commit the deed that was his destiny.[46] The early criminologist Lom-

broso suggests that "this custom is a completely savage one" and proposes that "criminals, with whom it has had a truly strange, almost professional diffusion," exemplify atavism in being tattooed ("Savage Origin," 803).

Perhaps for that reason, most working Europeans and Englishmen who acquired the tattoos seemed to long for the tattoo's homeland after they had departed it. The marks that gave them a place in the Pacific seemed to deprive them of one in their own native lands. Joseph Kabris, for example (whose name has also been spelled Cabri and given as Jean Baptiste Cabris), from Bordeaux, received a full-body and full-face *pahu tiki* tattoo in Nuku Hiva. As the literal translation of *pahu tiki* has it, the tattoo "wrapped him in images." In 1804 he was "rescued" by the Russian explorer Johann von Krusenstern—against Kabris's will, and in a sequence of events the Russians claimed was accidental and weather-driven. Kabris had been a sailor since age fourteen, captured and pressed into service first on French ships, and then on an English whaler. Upon arrival in Europe, he displayed his tattoos, first at courts in Russia, France, and Prussia, and then at country fairs in France, where he was known as Kabris Le Tatoué. He also displayed his tattoos in a pamphlet titled *Précis Historique et Véritable du Séjour de Joseph Kabris*,[47] which featured a frontispiece portrait of the tattooed inhabitant of the Isle of Mendose (Nuku Hiva). (Figure 17 is a version of this frontispiece.) For the eighteen years he lived after leaving Nuku Hiva, he regretted having departed the islands.[48]

Edward Robarts was born in Wales and lived in Nuku Hiva at the same time as did Kabris. Before he jumped ship at the Marquesas, he had served as a ship's cook. According to his narrative, he resisted acquiring a tattoo until he realized that it could allow him entry into a feasting society, and therefore gain him food in times of famine. His tattoo was apparently much less extensive than Kabris', consisting of a rectangle on his breast, "six inches one way and four the other."[49] When he left Nuku Hiva in 1806, tempted by false promises of free land in Botany Bay, his wife Enoaaoata and their children left their homeland to travel with him. He termed that departure the beginning of "a change for the worst" (*Beach Crossings*, 331). When he finished writing his narrative, a fourteen-year endeavor, he was penniless in Calcutta, and his wife and three of their children had died in a cholera epidemic (*Beach Crossings*, 28).

Another white traveler who received a Pacific tattoo displayed the designs upon his return to England, but he did so in order to fund his return trip to the Pacific. John Rutherford, an Englishman, went to sea at age ten, having worked before that in a cotton factory. He dictated his narrative because he could not write. Rutherford received a *moko* facial tattoo in 1816, and features

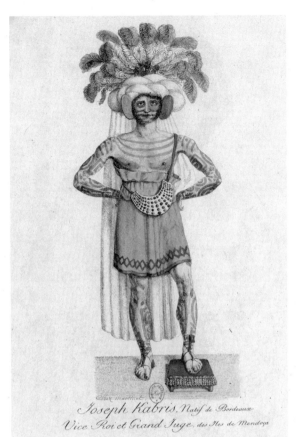

FIGURE 17. Joseph Kabris. *Joseph Kabris, Natif de Bordeaux, Vice-Roi et Grand Juge des Iles de Mendoça* (Paris: Chez Martinet, n.d.). Published with the permission of the Bibliothèque nationale de France.

in George Lillie Craik's *The New Zealanders*,[50] which weaves Rutherford's account of life in Aotearoa into the first book-length study of Māori people. One of the key signs of his experiences there—a testament that in Craik's account means that Rutherford knows whereof he speaks—is the facial *moko* he bears. When Craik introduces John Rutherford, he features a full-bust portrait of the tattoo (figure 18). Rutherford himself must have valued the accurate presentation of his designs, for he sat for his portrait unclothed from the waist up in freezing weather (*New Zealanders*, 278).

His *moko* features prominent forehead *tīwhana*, or rays, and mouth *rerepehi* patterns. In keeping with *moko* design practices, he does not bear cheek

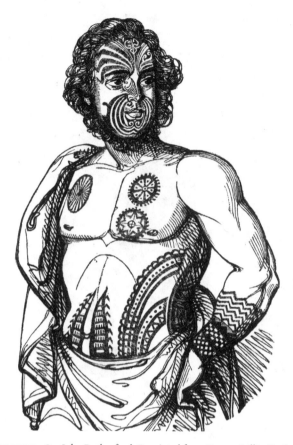

FIGURE 18. John Rutherford. Reprinted from George Lillie Craik,
The New Zealanders (London: Charles Knight, 1830), 87.

spirals, not being a firstborn Māori son (as an upper-cheek spiral would in-
dicate). While he may have been eligible to wear a lower-cheek spiral, if he
achieved the position or rank he claims to have earned, his design does not
appear to include that spiral, either. Indeed, the design evident in his portrait
demonstrates that he bears the general pattern of a *moko*, one that marks him
with broadly male facial designs. The design signals that he has been marked
by *moko*, without indicating a very specific standing in *iwi*-based, or tribal, so-
ciety. (Indeed, while he claims to have been a chief, he also presents himself
as a prisoner.) Rutherford's body tattoos appear to be designs he received in
Tahiti, where he first lived after leaving Aotearoa.

After Rutherford lived for ten years in Aotearoa, he returned by way of Ta-
hiti to his native Manchester and promptly began displaying his tattoos in ven-
ues including his narrative. He accompanied "a travelling caravan of wonders,
shewing his tattooing, and telling something of his extraordinary adventures"
(*New Zealanders*, 278). The point of his narrative display, too, which altered
several key facts, was to earn money to return to the Pacific, although he ap-
parently died before making that trip.

Rutherford states that his tattooing was forcible and unannounced: both el-
ements recur in accounts created by tattooed white men. In the story Ruther-
ford dictates to a friend (who then provides the written narrative to Craik), the
tattooing occurs abruptly in both the narrative and Rutherford's experience. In
response to admiring comments about the gilt buttons on his waistcoat, Ruth-
erford cuts off the buttons and presents them to the chief's wife and daughters:
"The whole of the natives having then seated themselves on the ground in a
ring, we were each of us held down by five or six men, while two others com-
menced the operation of tattooing us" (*New Zealanders*, 135). Rutherford states
that his entire tattoo was applied in four hours, though male facial *moko* often
took months to apply.

Later scholars determined that Rutherford had voluntarily acquired his
moko.[51] In Craik's account, however, Rutherford's story is presented as truth,
embodied in tattoo. Where allegations of fictional embellishment followed
Melville's account of life with the Taipi, Rutherford's tattoos seem to make
visible the truth of his narrative about the people of Aotearoa.[52]

Craik places Rutherford's account in the context of the accounts of others,
and he attempts to explain Rutherford's desire to return to the Pacific: "Upon
the whole he seemed to have acquired a great deal of the frankness and easy
confidence of the people with whom he had been living, and was somewhat out
of his element amidst the constrained intercourse and unvarying occupations
of England. He greatly disliked being shown for money, which he submitted
to, principally that he might acquire a sum, in addition to what he received for
his manuscript, to return to Otaheite" (*New Zealanders*, 278). Tattoos are cen-
tral to his narrative and stage performances, and to his attempt to return to the
Pacific. As a sign of Māori and Tahitian worlds, they make visible his desired
destination. They also represent the changes he has undergone, the character-
istics of Māori life he has absorbed. In other words, Craik, one of the sources
for Melville's writing of *Moby-Dick*, begins to move toward expressing the
idea of culture, specifically as embodied in Pacific tattoo.

Rutherford offers a deliberate misrepresentations of the facts in order to forestall suspicions of cultural disloyalty that his tattoos otherwise raise. It is one thing to acquire tattoos forcibly, another to seek them voluntarily. The first case shows a loyal English subject's making the best of a bad situation, and adapting to the circumstances he finds; the second reveals a dangerous disregard of propriety and willingness to depart from English society. The "culture" that tattoos make visible quickly becomes a slippery concept, one that requires justifying the standing place of the tattooed Englishman.

Rutherford probably changed the geographical area of his exploits in order to disguise the facts that he jumped ship rather than being captured, and that he sought the tattoo voluntarily. James Drummond, who edited an edition of Rutherford's narrative in 1908, suggests that Rutherford was in not the Tokomaru area, as he claimed, north of Poverty Bay and to the English a relatively unexplored region at the time, but rather the Bay of Islands area. His narrative then loses the distinction Craik gave it, of focusing on "a part of the northern island considerably beyond the furthest limit known to have been reached by any European" (*New Zealanders*, 86). If Rutherford's narrative is about places already known to the English, then his tattoos become the only novelty he bears. Rutherford's improvisational truth indicates that he recognizes the suspicion his tattoos inspire in England, and that he uses the tattoos as the only form of currency he possesses, attempting to convert the designs into money and into a passage to the tattoo's homeland. He seeks the life pattern signified by the designs—a pattern divergent from England's.

Kabris, Robarts, and Rutherford regret leaving the Pacific.[53] For these men, their tattoo becomes a primary marker after they have left the region, one that dictates that they fashion an identity and a livelihood based upon the marks and the wider experience of Pacific life these designs indicate. The unmarked visitor, on the other hand, like Porter, Stewart, and Melville, had the luxury of seeking a separate Pacific culture, and a mark that made that separation visible. In the latter writers' accounts the tattoo demarcates differences, whether between clothing practices, races, or human and inhuman realms.

The marked visitor, however, cannot present such a tidy separation between the observer and the observed, between the visitor and the islanders. Kabris, Robarts, and Rutherford bear the marks that prove they have themselves been observed by the islanders, incorporated to some extent into the Pacific. As a result, such narrators cannot present the observed way of life as separate from themselves. Claims that they were shipwrecked or captured and forcibly tattooed represent retrospective attempts to justify their having

sought the tattooing.[54] They offer these explanations to excuse their *lack* of separation, to justify their accounts. The marks at once authorize the narrator to speak of the way of life he describes and deauthorize him as having perhaps voluntarily joined that which he now narrates. He thus must step back from the way of life that he otherwise brings almost too close for comfort. The tattooed visitor's claim that he was forcibly incorporated into the Pacific is the counterpart to the untattooed visitor's testimony that the Pacific offers difference made visible. Culture, like the forcible tattoo, is a ruse to manage a shifting line of difference.

Transfer of Desire

ENGENDERING SEXUALITY

When viewed by scientists outside the Pacific, the mark of the foreign became the sign of deviance. Tattooed men (who sought penetration by the needle) were deemed homosexuals. Tattooed women were deemed promiscuous. Even today, many medical experts suggest that tattoo predicts a pathological sexuality. Fiji and Pohnpei, where historically women created and received the designs, reveal a general aspect of Pacific tattoo: body art designates a mature adult sexuality, and Pacific conceptions of gender and sexuality revise the strict axis of homosexuality and heterosexuality.

THE TATTOOED VIRGIN AND OTHER RAPES

"The very process of tattooing is essentially sexual," Albert Parry declares in his book *Tattoo: Secrets of a Strange Art as Practiced Among the Natives of the United States*. "There are the long, sharp needles," he continues. "There is the liquid poured into the pricked skin. There are the two participants of the act, one active, the other passive. There is the curious marriage of pleasure and pain."[1] The passage suggests that tattooed skin is pricked—the word is deliberately chosen—in a manner that invokes sexual intercourse and announces the body as penetrated. (Parry's "natives" of the United States are white people who practice this sexualized art.)

The pricked-body analogy helps to prepare the reader for Parry's claim that many men seek in tattooing a "form of homosexual experience" (*Strange*

Art, 21–22). Men who wish to be pierced by the tattoo needle, the logic goes, are homosexual or seek at the least a homosexual experience. For their part, even if they have not had sexual intercourse, tattooed women have been penetrated and are thus deemed nonvirginal (*Strange Art*, 3). The prosecutor in a 1920s gang-rape case in Boston, for instance, declined to pursue charges when he discovered that the sexually inexperienced victim had a butterfly tattoo on her leg: "Though technically a virgin before the rape, the girl was, in effect, accused of being a person of previous sexual experience—because of her tattoo" (*Strange Art*, 4). (By this reasoning, moreover, it would not be possible to rape a sexually experienced woman.)

In a 1972 U.S. legal context, a woman's butterfly tattoo was again read as a sexual temptation "to be chased and caught."[2] Even if no corresponding case exists in contemporary courts, tattooed men and women continue to be viewed in highly sexualized ways. In his study of psychological motives for tattooing, physician Walter Bromberg diagnoses an "erotization of the skin through tattooing" as well as many cases of "influence of a latent homosexual factor."[3] Similarly, a 1990 article in *American Family Physician* advised doctors to be aware that their tattooed patients will demonstrate a proclivity toward "lesbianism," "homosexuality," or "bisexuality" as well as "sexual exhibitionism," "sexual sadomasochism," or "sexual fetishism" (not to mention other conditions, including bipolar disorder and schizophrenia).[4] In 1996, psychiatrist Armando Favazza underscored this assessment: "Many studies link multiple tattoos with antisocial personality, an increased incidence of assaultive behavior, impulsivity, and difficulties in heterosexual adjustment."[5] Recent studies repeat the assessment that tattooed patients tend to take sexual and psychological risks (see, for example, Lynne Carroll and Roxanne Anderson, "Body Piercing, Tattooing, Self-Esteem, and Body Investment in Adolescent Girls," and Timothy A. Roberts and Sheryl A. Ryan, "Tattooing and High-Risk Behavior in Adolescents").

Parry's book offers a sensationalized description of what is supposed to be tattoo's inherent sexuality. That lurid and emphatically sexual consideration of tattoos is repeated in the previously cited physicians' and psychiatrists' considerations of the designs. It is also echoed in contemporary anthropologist Alfred Gell's *Wrapping in Images: Tattooing in Polynesia*.[6] Gell declares, "The sight of a tattoo evokes imagery of sexual subjection, piercing, and flux, which are equally resonant seen from the perspective of either sex; these resonances arise from the manner in which tattoos are made." Gell makes even more explicit the idea that looking at a tattoo invites sexual penetration. A foreign

object has pierced the tattooed body. Hence, when the eye follows the design, "the onlooker's eye is drawn into the body of the other." Viewing a tattoo is thus "intrinsically sexualized"—an act that necessarily makes "looking at a tattoo an analogue (and hence an incitement) to sexual intercourse" (*Wrapping*, 36).

These assessments suggest that every aspect of the tattoo—creating or receiving the designs, and wearing or looking at them—is sexualized. Such postulates might be summed up in the assessment, "The subject is tattooed, and is therefore highly sexual," or even, "The onlooker sees tattoo, and therefore copulates." (Presumably, physicians and psychiatrists who classify tattoo as deviant or pathological exempt themselves from the latter part of this postulate.) While this chapter will present a detailed challenge to assumptions about tattoo's sexual implications, it is worth noting at the outset corollary facts that immediately complicate such assumptions: penetration is not necessarily (or merely) sexual, and sexuality need not be penetrative.

Nonetheless, writers often invoke the sexualized understanding of tattoo. In *The Rose Tattoo*,[7] for instance, Tennessee Williams traces the way copies of the same tattoo move from one body to another, indicating in the process illicit heterosexual desire. The rose tattoo passes from Rosario Delle Rose to his lover, the blonde Estelle Hohengarten, where it remains years after his death as proof that he has betrayed his wife, Serafina. When the stricken widow tells her story to a would-be suitor, he acquires a rose tattoo on his own chest, the better to appeal to Serafina. The play provides a condensed version of the tradition that uses tattoo to read sexuality: desire consummated and displayed on skin. The tattoo remains the same, substituting one body for another in its demonstration of desire.

Sarah Hall's novel about a tattoo artist, *The Electric Michelangelo*, which was shortlisted for the Man-Booker Prize, offers a culmination of the view of tattooing as sexualized. Grace, a circus performer in 1930s Coney Island, commissions an artist to create a masterpiece on her using a tattoo that she creates, a single eye repeated in varying sizes everywhere on her body except for her face, neck, and hands. As a woman and as a performer, Grace declares of the viewing public and, by extension, all human beings who eye women, "They can think what they like, but what they cannot do is use me with their damn eyes. Not ever again."[8] The eye image both invites and returns the glance of the viewer, whose stare is "mirrored, deflected, equalled" (*Electric*, 258). In this view, a woman—the ultimate tattooed subject—can at best hope to respond to the look that has already dishonored her. Here, the tattoo repeats a

violation that has already occurred and, by calling attention to that repetition, attempts to redirect the intruding gaze.[9]

Hall participates in a tradition of women who disrupt expectations about tattoo's sexual meanings. This tradition goes back at least as far as Elizabeth Stoddard's novel *The Morgesons*,[10] in which two women use their tattoos to shape the way others respond to their sexuality. (Helen bears a literal tattoo, while Cassandra, who is scarred facially, refers to her marks as tattoos.) In *Bodies of Subversion*,[11] Margot Mifflin documents one hundred-plus years of historical analogues of these fictional characters, women who have used tattoo to define themselves, in the process sometimes encouraging and sometimes thwarting others' sexual expectations and desires. Even women who redefine the sexual implications of the marks, however, present them as a badge of the psyche. In that way, such portrayals remain within a tradition that reads tattoos as a legible sign of sexuality and, specifically, of a psychological basis for that sexuality.

The diagnostic tradition (and even the rewriting of that tradition) thus assumes a correlation among tattoo, sexuality, and psyche. Positing that correlation creates a determining if not deterministic triangle where each element predicts and signals the others: tattoo indicates sexuality indicates psyche. Tattoo, as an aberration, helps the practitioner diagnose a corresponding (pathological or at the least unusual) sexuality and psyche. The normative model of sexuality and psyche presumed here, it goes without saying, is based upon heterosexuality and upon the tattoo's absence.

Tatau, on the other hand, assumes a distinct understanding of sexuality and, as we have seen in chapter 1, of the subject's psychological standing places. Traditional Pacific tattoo designates neither an unusual sexuality nor an abnormal psyche. Where tattooing is ritual and collective, the patterns attest to the bearer's social (rather than simply sexual) position. Social position can include sexuality, but the marks by no means indicate deviant or pathological desires, actions, or psyches.

As it traveled beyond the Pacific, *tatau* thus entered (and was used to make visible) sexual and psychological registers far from the practice's home meanings. Pacific *tatau*, like Pacific conceptions of gender and sexuality, do not occur "outside" these new, normative understandings of sexuality and psyche. But these new definitions proceed alongside and do not displace long-standing Pacific ones.

As Lee Wallace suggests in considering a documentary on *fa'afafine*, *Queens of Samoa* (1995), "If I now insist on the salience of the categories of homosexu-

ality, transvestism, and transsexuality to *fa'afafine*, that is also to insist on the salience of *fa'afafine* to those categories, from which it nevertheless remains distinct."[12] *Fa'afafine*, men by anatomy, adopt practices associated with the female gender, literally assuming "the ways of a woman." Wallace's point is that European-Pacific sexual difference exists, both historically and in the present, but that European definitions of sexuality and identity were formulated in part in response to distinct Pacific practices. *Fa'afafine* should thus be neither equated with nor elided from European definitions.

In other words, as Hall and Kauanui suggest, Pacific sexual and gender practices exceed European categories: "sexuality is an integral force of life—indeed the cause of the life of the universe—and not a separable category of behavior and existence. The discrete analytical categories of 'homosexuality' and more fundamentally 'sexuality' itself, are a colonial imposition."[13] Pacific sexual practices both coexist with and challenge European norms. Besnier, observing *fa'afafine* and other gender-liminal subjects in the Pacific, detaches gender-liminal status from homosexual practices. For *fa'afafine* (and their counterparts in Tahiti and Hawai'i, *māhū*, and in Tonga, *fakaleitī*), "sexual relations with men are seen as an optional consequence of gender liminality, rather than its determiner, prerequisite, or primary attribute."[14] Moreover, a gender-liminal person may emphasize or minimize female or male characteristics and practices in differing social situations, and even in adulthood a biologically male individual may acquire or shed gender-liminal status.[15] In thus highlighting the overlapping, sometimes variable sexual, biological, and cultural factors that create gender, *fa'afafine* "make gender into something made or invented."[16] Gender-liminal Pacific subjects thus reveal a distance between sexual acts and gender identity. This distance has implications beyond the Pacific, helping to challenge "a sexual grid defined by the strict axes of homosexual-heterosexual distinction" (*Sexual Encounters*, 140). There are more constellations of gender identities and sexual practices than homosexual and heterosexual categories admit, an insight that returns us to the apparently firm correspondence between sexuality and psyche even as it unsettles it.

In particular, the distance between sexuality and identity removes two legs of the diagnostic tattoo triangle. In the Pacific, much as the tattoo does not indicate an abnormal state or condition, sexuality and psyche do not determine one another. As we will see, tattoo may indicate aspects of the bearer's sexuality or psyche, but there is no necessary correlation or causal relationship.

This examination involves briefly revisiting some of the major tattooing traditions already discussed, and investigating some of the primary features of

gender and sexuality expressed in those traditions. Then we can turn in greater detail to Vitian and Pohnpeian traditions, in which women are the tattoo artists, and (in Vitian traditions), the primary tattoo recipients. In an important sense, gender and sexuality are not separable from the whole fabric of Pacific cultures, so the entire discussion of Pacific tattoo up to this point has provided insight into these features of Pacific life. Still, it is useful to extract and consolidate the points we have covered thus far, and to examine whether the meaning of tattoo changes in places where primarily women wield and wear the designs. This discussion also provides a capstone to the book's major points, returning briefly to the varying tattoo practices already discussed, but with a new focus on changing conceptions of gender and sexuality.

NORMALIZING DESIGN

Where the interpretive tradition in psychology and medicine sees tattoo as deviant, sexualized, and primitive, across the Pacific tattoo formed a routine part of becoming fully social and human. To examine the first of these assessments, a relatively quick study of a number of these traditions reveals that design is not deviant. It is worth creating a narrative overview of these traditions because outside observers who associated tattoo with sexuality provide only sparing descriptions of women's patterns in particular. Tattoo scholars thus largely omit discussion of women's tattoo.

Samoan *Tatau*

One of the major design features of Pacific tattoo is that traditional patterns are often gender-specific, with certain patterns and design fields reserved for women and others set aside for men. In Samoa, if choosing to wear the full-body tattoo, men take the *tatau*, termed colloquially the *pe'a*, and women take the *malu*. Many of the design elements from the women's *malu* also appear in the *pe'a*; but where the women's patterns leave open space between the motifs, the men's are often filled in with thick bands of pigment. A song written down in 1899 by Augustin Krämer and still sung by the Samoan national rugby team assigns men the pain of tattoo and women the pain of childbirth, suggesting that the two rituals are structurally similar ways of becoming fully adult, fully human, and a contributing member of society.[17]

Scholars have reported that the Samoan *tatau* has sexual implications. Traditional Samoan clothing revealed part of the designs of both *malu* and *tatau*.

In 1899, Krämer notes, "we are told that formerly girls were not permitted to expose knees or thighs before they were tattooed while the family sensed no displeasure at the sight of these parts when they were tattooed."[18] Correspondingly, when an artist creates a male *tatau*, "He sees to it that after the loincloth has been put on, a little is exposed above it in the back, for this is considered pretty" (*Samoa Islands* 2:82). In this reading, the partially revealed tattoo both makes it safe to reveal these parts of the body, and entices the viewer.

It is thus possible to propose a highly sexualized reading of the designs. *Malu* is the specific name of the design that appears in the soft hollow space behind a woman's knee, as well as the general name for the woman's tattoo. The design is shaped like a rotated diamond or lozenge and is unique to the woman's tattoo. Gell offers the most pronounced reading of the shape's possible sexual implications. He suggests, "The *malu* in the popliteal space [the area in back of the knee] is a vulva, but one lacking any orifice, permanently impenetrable. As a symbolic device, the *malu* is a perfect emblem of Samoan sexual mores, at once emphatically signalling the potential eroticism of the *taupou*, yet placing it permanently beyond reach" (*Wrapping*, 85). A *tāupōu*, a daughter of a chief who outranks her brothers and other girls her age, embodies the prestige and sacredness of a community. Her virginity is highly protected. Gell suggests that the shape of the *malu* echoes that of the vulva, thus imaging a "perfectly sealed—and incidentally, doubled—vagina."[19] As with the Boston court case cited previously, in this interpretation everything depends on a woman's virginity. However, while a *tāupōu* is "permanently beyond reach," the girl who fills the *tāupōu* role will become a woman: after she marries, she will still carry a *malu*, but not the virginity it ostensibly signals. As Figiel emphasizes, many sexually experienced women also wear *malu*.

Figiel underscores the effect of the *malu* for nonvirginal women. Her focus is significant because most women hold this condition, along with the *malu*, for many more years than they maintain their virginity. In *They Who Do Not Grieve*,[20] Lalolagi receives the *malu* from the tattoo artist after he has already become her lover. Here, the *malu* adorns a sexually experienced woman, but as discussed in the first chapter, more than indicating her sexuality, it marks her sociality. And here a woman's body is penetrable, whether in tattooing or lovemaking, on terms chosen by the woman.

In Figiel's novel, the effect of the designs on Lalolagi is social: the incomplete designs make her an outcast. However, the effect of the designs on Lalolagi's U.S. lover, the film actor Captain Harris, or Alisi as she calls him, is erotic. This World War II–era visitor is mesmerized by "her tattooed leg glit-

tering, alive" (*Grieve*, 225). Figiel emphasizes that he sexualizes tattoo: "It was the most erotic thing he'd ever seen" (*Grieve*, 225). For the newcomer, who does not understand Samoan society, the designs are sexual; for the outcast member of the community, the incomplete designs both determine and record her social position.

Figiel's women choose when to acquire and when to display their *malu*. Both before and after she receives the designs, and after other women in the village punish her for her decisions, Lalolagi determines when she wishes to take a lover. Figiel examines the way *malu* embodies a woman's sexual and social choices. Thus, *malu* may be used to represent sexual experience and social isolation as much as to image a sealed-off, impenetrable, socially approved innocence. Both before and after Lalolagi is cast out, Figiel suggests that *malu* expresses a full social and personal identity, one that includes sexuality. Lalolagi's incomplete *malu* attests to her public shaming and private sexuality— neither of which Figiel associates with an unusual or abnormal psychology. Instead, the subject-formation that Figiel presents is continual, collective, and determined by more than the erotic. The subject-formation does, however, reflect gender differences, with a woman's sexual activities being much more closely observed and regulated than a man's.

Male *tatau*, too, point beyond sexuality to a man's full social identity, a matter not of individual psychology but of taking one's place in the collective. For men, the sexual implications of the *pe'a* inspire less social concern and more celebration. In his essay on *tatau*, Wendt emphasizes the erotic implications of the *pe'a*. The word names both the male *tatau* and the flying fox, a nocturnal fruit-eating bat: "If you look at the tatau frontally, the male genitals, even with a penis sheath, look like the pe'a's head, and the tatau spreading out over the thighs and up towards the navel and outwards looks like its wings outstretched. The expression is 'Faalele lau pe'a!' Let your flying fox fly! Show how beautiful and courageous you've been in enduring the pain of the tatau, parade it for all to see. The sexual connotations are also very obvious" ("Tatauing," 18). For men, the sexuality exhibited by the *pe'a* is free from an exaggerated concern with virginity or its loss. The *pe'a* demonstrates strength and status. Again, sexuality is not solely a matter of individual psyche but is included in the larger patterns of sociality.

As readings of Wendt, Figiel, and Lacan suggested in chapter 1, the cumulative demands of the collective certainly shape individual psychology; the social, moreover, is created in relation to those individuals who are cast out. But the process does not pathologize these subjects or assign them a psycho-

logical neurosis. Instead, it places them outside the community—focusing on the boundaries of the village rather than of individual identity.

Māori *Moko*

Analogous to Samoan *tatau*, in both traditional and contemporary practice, Māori *moko* has designated distinct patterns for men and for women. As in *tatau*, *moko* create the bearer's full personal and social identity, expressing a sexuality that forms part, but not necessarily the focus, of that status. *Moko*, too, complicate suggestions that tattoo indicates excessive sexuality or a psychological disorder. The changing uses of *moko* do, however, indicate changing conceptions of gender and identity. The traditional *rangi paruhi*, or fully tattooed face, allows men to follow in the path of the heroic figure Mataora, who brought *moko* from the underworld when his wife Niwareka brought *tāniko*, weaving with colored fibers. The *moko kauae*, or chin tattoo, forms designs specific to women.

H. G. Robley and W. Colenso both record tattooing songs that accompany a woman's *moko kauae* and make explicit that a woman with blue lip and chin markings is seen as not only beautiful and desirable but also necessary. One chant enjoins the tattoo recipient,

> Keep thyself still, lying down, oh young lady,
> (Round the tap goes.)
> That thy lips may be well tattooed,
> Also thy chin;
> That thou mayest be beautiful.
> Thus it goes fast.
> For thy going to visit the houses of courtship,
> Lest it should be said of thee,
> Whither does this woman think of going with her red lips?[21]

The indication is that unmarked lips will be viewed as unusual or even ugly; on the other hand, adorned lips and chin signal a woman's attractiveness. The song reflects the acceptance of *moko kauae* as standard for women, an expected beauty mark.[22] Not *moko kauae* but the lack of such patterns would be notable, indicating someone who did not fit. Analogous songs for the tattooing of men specify that in acquiring the marks specific to a male *moko* pattern the man thereby registered both his desirability and strength (*Art and History*, 116–17).

At several significant historical points, however, artists altered these standard, gendered patterns. These changes represent not decline but adaptation: in the face of a sometimes cataclysmic history of invasion and displacement, artists have long used innovations in technologies and ideas to carry forward the vital traditions of *moko*. Such responses indicate an active, sometimes defiant, indigenization of new traditions.

In one example, a carver used *moko* to accord honor to a carved figure of Mary and her infant son, Jesus. In 1845, Patoromu Tamatea or another carver created a Madonna for the Catholic Church. His female figure holds a carved, tattooed male child, yet Mary's tattoo, like that of Jesus, is a *rangi paruhi*, a full-face design using patterns usually reserved for men (figure 19). Understanding Catholic beliefs from within Māori traditions, and employing Māori traditions to express new ideas, the carver created a virgin mother. Her full-face male tattoo design indicates that she is sacrosanct, designating the mystery by which the child she holds could only have been produced by virgin birth. On the rare occasion when a woman was of such high genealogical rank that she had no peers, she would remain unmarried for life, a status signified by her full *moko*.[23] The carver has suggested this high rank by giving the Madonna a *rangi paruhi*, a full facial design otherwise reserved for men.[24]

In a major departure from the historical tradition of gendered tattooing, during the latter half of the nineteenth century, the tattooing of men with *rangi paruhi* decreased even as the tattooing of women with *kauae* increased.[25] According to Michael King, after male *moko* had halted, *moko kauae* revivals occurred at varying times, from 1900 to 1914, from 1910 to 1920, and in the 1930s (*20th Century*, 2). Given the extensive and almost continuous dates of the "revival," however, it is more accurate to view *moko kauae* as a tradition that continued without interruption into the twentieth and twenty-first centuries.

This sense of continuity is emphasized by Ngahuia Te Awekotuku and her colleagues in the "Ta Moko: Culture, Body Modification, and the Psychology of Identity" project at the University of Waikato. Te Awekotuku proclaims repeatedly, "There has never been a time in our history when a tattooed face has not graced the *marae*, or ceremonial courtyards, of our land. They have always been there—the art survived, and it is now efflorescent."[26] Despite suggesting that the era of *moko* is over, King noted in the 1970s that particularly among women, "demand for *moko* remains. Several old women without tattoos asked me if I would do them when they heard I was studying the subject" (*20th Century*, 4). In other words, throughout the twentieth century and into the twenty-

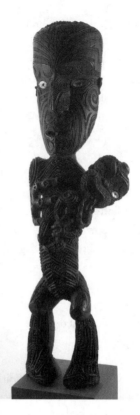

FIGURE 19. "Madonna and Child" *whakapakoko* (figurative carving). Wood and paua shell.
The artist's identity is in question, but he or she probably belonged to the Ngāti Pikiao *iwi*.
Published with permission of Auckland Museum.

first, older women continued to play a significant role in maintaining the presence of the tattooed face on *marae*.

During the twentieth century, two women tattoo artists helped to establish this presence by joining their male colleagues in creating *moko kauae*. Kuhukuhu Tamati, from Whatawhata, tattooed Waikato women during the First World War and the 1920s, and "people who remember her saw nothing untoward about the fact that a *tohunga-tā-moko* [artist or priest of tattoo] was also a woman" (ibid.). Hikapuhi of Ngāti Whakaue tattooed women at Lake Rotorua and the Bay of Plenty (ibid.). Accounts by Dumont d'Urville suggest that women practiced tattooing in the nineteenth century.[27] Today, Māori women tattoo artists include Christine Harvey of Rekohu, Henriata Nicholas of Rotorua, and Julie Kipa of Whakatane.

Perhaps in response to changing conceptions of gender and identity, more women than men sought *moko* in the earlier parts of the twentieth century. Some of the women King interviewed in the 1960s and 1970s for *Moko: Maori Tattooing* attest that they chose to acquire their *moko kauae*. Nohinohi Heu of Kawhia, for instance, declared, "It is my *Māoritanga*" (*20th Century*, 6). Others were compelled to take the design. Ngaropi White of Ruatoria recounts, "I tried to hide in a tent. They caught me, dragged me out, and made me have it. I didn't like it but they held me down" (ibid.). Regardless of whether the women sought the designs or were subjected to the process, the comments indicate that the marks were seen as a central embodiment of Māori culture and identity, "a focal point of all that was idealised and valued in Maori culture" (*20th Century*, 1). Women continued to wear *moko kauae*, fostering the tradition, even as fewer men sought tattoo.

The traditional association of *moko kauae* with beauty and *rangi paruhi* with strength became mapped onto a new order brought by the Pakeha. King suggests, "The role of women in Maori society did not undergo the same upheaval as that of men. There was no association of their *moko* with fighting and consequently the demise of one custom [men's *rangi paruhi*] had no effect on the other [women's *moko kauae*]" (*20th Century*, 6). One of the upheavals that occurred was due to the market economy, which at first held more opportunities for men and specifically for untattooed men. Particularly because full-facial male tattoos had been instrumental to Māori wars for independence in the nineteenth century, barefaced men found it easier to seek employment in Pakeha-owned enterprises. In contrast, women's *moko kauae* offered a way to keep *moko* vital while allowing the *iwi* or tribe to adapt to new economic demands. In its adaptations as in its originary practices, the cultural calculus that inspires *moko* is more than individual.

In this way, women were able to take distorted images of their social position and transform them into something positive. If after the arrival of settlers "Māori women, as with women in general, were rendered invisible,"[28] they also possessed more freedom to carry on traditional practices. The same imported assumption that saw women as aligned with domesticity and the home rather than as "public actors in the political arena" ("Māori Women," 96) gave them the ability to wear *moko*.

But gender practices were of course more complicated than expecting men not to wear *moko* into a Pakeha world and allowing women to wear *moko* in family and tribal homes. Some women were forced to acquire *moko*, and most did not at this point join the market economy. Even so, there is no necessary

association between women, home, and traditional practices and economies. Women tour guides, for example, were rewarded monetarily for their cultural expertise. Particularly in Rotorua, an area famed for cultural tourism beginning in the nineteenth century, women guides featured (sometimes temporary) *kauae* designs.[29] Through its association with both older women and with guides, *moko kauae* became associated with women who hold positions of specifically cultural authority. Meanwhile, *rangi paruhi* continued to invoke the male warrior tradition. In keeping with these associations, contemporary Māori *moko* is most often worn by comparatively older women and younger men.[30]

As the designs have traveled into the world, the gender-specific patterns are sometimes deliberately violated. White men in the United States and England wear women's *moko kauae* patterns. Te Awekotuku recounts how she confronted one such man, Ron Athey, a U.S. performance artist she met in London.[31] Athey, an openly gay performer, wears a Māori woman's *moko* design on his chin. Perhaps relevant to the highly sexualized readings of tattoo outside of the Pacific, one of his performance pieces features him impaled upon a pyramid, emphasizing that his body is penetrable.[32] These drastic divergences in the use of *moko kauae* show that much of the design's meaning depends upon where the marks appear.

Tongan *Tātatau*

Further complicating the diagnostic association between tattoo, abnormal sexuality, and psyche, men in Tonga—whether visitors or not—experienced pressure to acquire *tātatau*. The marks signaled a lack of singularity, showing that one belonged in the social space of the islands. One meaning of the verb *tatau* in Tongan is *to be equal, equivalent, or exactly similar.*[33] In Tonga, as in Samoa, women's tattoo patterns appeared like lacework to European visitors, although the written and visual archive does not record many details. One scholar notes that some women featured indelible dots on their hands and fingers, but remarks, "Whether such dots were meaningful or purely decorative must remain a question."[34] Women could apparently choose to acquire such marks, described by two men who traveled with Cook on his third voyage as "a few small lines or spots on the inside of their hands" and "only a few lines or spots about the hands or fingers."[35]

Hawaiian *Kākau*

Descriptions and studies of Hawaiian tattoo patterns, similarly, do not emphasize women's traditional tattoos. The traditional asymmetrical tattoos are mentioned as intending to afford protection to men in battle. Neither visitors' descriptions nor contemporary analysis discuss whether women acquired such asymmetrical tattoos. Visitors note instead that women featured tattoos on their hands and tongues, as in Samwell's comment (made during Cook's third voyage), "They have their Hands curiously & prettily tattawed, which they told us had been done on the death of some Chiefs, but what is a remarkable Circumstance, we observed that almost all of them both young and old had their Tongues tattawed."[36] Mary Pukui and Paahana Wiggin record hand designs worn by women from Kau and Puna.[37]

In studies by Gell and Kaeppler, on the other hand, women are noted for the "whimsical" designs they exhibit after contact with American and European travelers; the implication is that they seek tattoos as fashion (whereas previously men sought tattoos as a sacred genealogical ritual). However, much as it is necessary to correct mistaken beliefs about when tattooing ended in Hawai'i, such dismissals of women's tattoo in both traditional and adapted forms urge a reconsideration. If women did not universally wear tattoo in Hawai'i (or in Tonga), their ability to elect which designs they wore establishes tattoo as a chosen practice. If the rite was neither required to be a woman nor a sign of sexual depravity, then women who chose the patterns were neither fulfilling nor denying gender patterns and expectations. They were exercising artistic, cultural, and personal freedom.

Marquesan *Tiki*

In the Marquesas, the tradition was that both men and women almost universally wore gender-specific tattoos. *Enata* tattooing afforded distinct design fields for men and women. Facial tattoos, chest tattoos, and the solid fields of pigment that could almost obscure the initial underlying patterns were specific to men. Women wore tattoos on the hands and arms, as well as the feet and ankles; many of these tattoo motifs appear in men's designs as well, although the rare girdle design appears to be unique to women. Men were tattooed in groups as large as forty to eighty to accompany the young chief. Whether or not they acquired the designs with other girls of the same age, women's hands

had to be tattooed before they could prepare food for or eat food from the communal dish. After the completion of tattoos, the new wearers proudly displayed their designs in feasts and ceremonies. Shocked observers declare that sexual revelry may have accompanied these feasts. The public displays suggest that neither tattoo patterns nor sexuality were personal matters. Rather, the total pattern of community life was reflected in both skin adornment and sexuality. No private dramas of depravity may be diagnosed here; instead, the public spectacle offers a performance of the process by which the individual meets the genealogical.

Tahitian *Tātau*

The Society Islands exhibit an exception to these gender-specific patterns (but not to the patterns' public significance and connections to sacred genealogies). There both women and men boasted the buttock arches and fields of pigment recorded by Joseph Banks and James Cook. The fact that these designs applied to both men and women may reflect the practice in Tahiti by which birth order rather than gender establishes rank.[38] As noted, though, in addition to this standardized, gender-neutral pattern, Ma'ohi men and women also had the freedom to acquire additional, sometimes gender-specific designs. Banks notes that women featured a Z-shaped figure on the joints of their fingers, toes, and outsides of their feet. That same Z-shaped design forms a central part of the tattoos depicted in photographs that accompany contemporary writer-activist Henri Hiro's poem exhorting Ma'ohi, "Let us tattoo!" Thus, even prior to the arrival of Europeans, *tatau* reflected both individual taste and a larger pattern.

Contemporary Ma'ohi tattoo exhibits certain gender-defining elements, as well, with more men, especially dancers and other performers, adopting full-body tattoos. Tattooed by a Samoan artist in 1982, Ioteve Tehupaia was, with Tavana Salmon, among the first to seek a contemporary full-body tattoo. Teve, a Marquesan from Nuku Hiva, is a dancer whose high-visibility tattoos then inspired many others—both Ma'ohi and other Pacific Islanders—to seek out their tattoo traditions.[39] From 1982 to 1985, as Makiko Kuwahara notes in *Tattoo: An Anthropology*, Tavana invited Samoan tattoo artists to attend Heiva, an annual cultural and artistic festival in Tahiti at which many Tahitians received tattoos. After he appeared at the 1988 Festival of Pacific Arts, at subsequent Festivals many more participants wore tattoos, and tattoo artists were officially recognized and included in the Festival ("Polynesian Tattoo," 32).

Today more Ma'ohi men than women are tattoo artists, and tattooing culture is often strengthened through *taure'are'a* groups, usually single-sex adolescent cohorts that are loosely organized and allow for considerable movement around the islands.[40] Kuwahara identifies a gender difference in the way the designs are used today: "Thick, black and bigger motifs of tattoo are associated with Tahitian masculinity" (*Tattoo*, 188). Tahitian men thus make warrior strength visible in these designs. It is possible, however, to revise the assessment, "In terms of women's tattooing, there is no difference between Tahitian and non-Tahitian women" (ibid.). Contemporary Ma'ohi women use traditional patterns to, among other things, represent their names, using not written script but tattoo design to declare who they are.[41] Tahitian tattoo practices exhibit continuity as well as discontinuity, wrapping specifically Ma'ohi skin in patterns whose genealogy is cultural and ancestral as well as personal. The individual name, tattooed in designs that correspond to earlier alphabetic and an-alphabetic proclamations of identity, carries these patterns writ large. Insofar as these patterns conform to Tahitian practices, they signal a safe sexuality, one that does not violate *tapu*; insofar as they defy colonial prohibitions of tattooing, they signal deviation from new constraints on sexuality. These new missionary-inspired laws attempt to define Tahitian practices of tattooing and sexuality as aberrant, and anticipate the diagnostic tradition that predicts a connection between tattooing and sexual and psychological deviancy.

SOCIALIZING DESIGN

All of the traditions just discussed establish that Pacific tattoo is anything but deviant. The next tradition we consider reveals that, moreover, Pacific tattoo departs from a male-focused penetrative sexuality. In other words, the tradition that sees tattoo as deviant also notes that a male tattoo artist penetrates the skin of a woman (thereby raping her or at least making her nonvirginal) or a man (thereby emblazoning on the skin the bearer's latent homosexual desires). In Fiji, however, women were the sole tattoo artists and recipients of traditional designs.

Fijian tradition is thus distinct from many Pacific traditions. The patterns remain gender-specific, but with a key difference. Here, young women rather than men acquired the tattooing, *vei-qia*, and the designs were created by a woman, a *mātai-ni-qia* or "tattoo artiste."[42] These older women, skilled in tattooing, have also been described as hereditary priestesses.[43] This tradition of

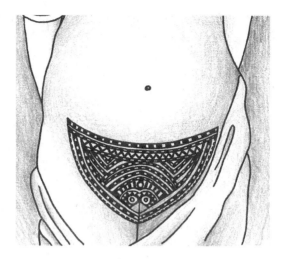

FIGURE 20. A Vitian Fijian woman's tattoo, front. Drawing by Linling Lu after Theodor Kleinschmidt. Source material courtesy of the Museum für Völkerkunde Hamburg. Published with permission of the artist.

tattooing is particularly characteristic of Vitian Fiji, the culture areas that were generally inland and therefore were less subject to the influence of Tongan practices. According to Malakai Navatu, who provided a written account of *vei-qia* for Brewster's book *The Hill Tribes of Fiji*, the women who performed the art were specifically referred to as *Lewavuku* (*Lewā vuku*), or the *wise woman*, and *Lewandaumbati* (*Lewā dau bati*, literally, "expert tattooer"), or the *woman operator*.[44] Navatu begins his account by emphasizing the great respect which people accorded to the practice: "Tattooing was the revered and beautiful ornamentation of the women to which great weight was attached both by men and women" (Navatu, 185).

The marks covered the buttock and genital areas, beginning with "the sacred part" (Navatu, 185). As the girl began by lying on her back in front of the women priests, Navatu is hereby suggesting that the pubic area, probably the mons veneris, or even the region surrounding the vagina, was the focus of the initial designs. Another, much more clinical, report describes the patterns as "beginning about an inch below the cleft of the buttocks and ending on the thighs about an inch below the fork of the legs. The designs covered the mons veneris and extended right up to the vulva"[45] (figure 20).

According to William Mariner, "The operation is managed by their own sex, though by no means to that extent to which it is performed on the Tonga

men, contenting themselves chiefly with having it done on the nates [buttocks] in form of a large circular patch, though sometimes in that of a crescent; and most of them have it also done on the labia pudendi, consisting of one line of dots on each side, just within the verge of the external labia" (*Mariner*, 267). If Mariner's description is correct, then the *vei-qia* pattern varied considerably from one region to another, or the pattern changed over the course of the nineteenth century, elaborating into the denser designs that Kleinschmidt, Navatu, and others record.

"The pattern traced," as Navatu describes it, "was like that printed on native cloth like the painted cloth of Nairukuruku. There were different methods of doing tattooing, like the different kinds of games, and they had two names—one, the 'Net,' because it looked like the meshes of a net; two, the *Thala* (*Cala*)."[46] The creation of the design was a major undertaking. One mid-nineteenth-century observer reported, "Months are often occupied in the process."[47] A later nineteenth-century observer concurs, "The tattooing is not completed at a single sitting, but is completed in stages" (*Vitilevu*, 159). As they received the net or Cala designs on their sacred parts, the girls became women. Once the tattooing was complete, a feast marked the occasion, and a girl was "then eligible for marriage to her betrothed" (*Vitilevu*, 159). The art and its implications were thus both most private and most public (figure 21).

Young women were usually tattooed after they had reached puberty and before they were married. The ceremony was private and occurred in secluded forest areas. (In 1886, women were still tattooed frequently in a partial cavern below the sacred summit of the Nakauvadra Mountains. In this cavern, it is said, the first woman ever to be tattooed, Adi Vilaiwasa, the daughter of Degei, received her designs [*Hill Tribes*, 83, 84].) On the other hand, very public observances marked the completion of the ceremony. Four days after the women's tattoos were completed, a feast was held to celebrate the "shedding of the scales" (Navatu, 186). This feast name refers both to the healed scabs falling off of the new tattoo, and to the chief Degei, who became associated with a serpent god and the underworld, and under whose aegis tattooing occurs. The shedding of the scales suggests that the young women have acquired a new skin, much as a snake sheds its skin. The *vei-qia* gives them the visible sign that they are now women.

The tattoo was seen directly only by the woman's husband and by other women. Women saw the design during the "shedding of the scales," during bathing, and when they asked to see the designs. As in Tonga, where untattooed men were taunted while bathing, in Vitian Fiji untattooed women could

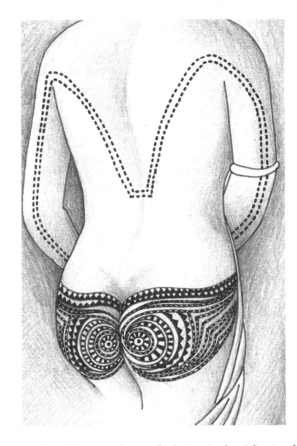

FIGURE 21. A Vitian Fijian woman's tattoo, back. Drawing by Linling Lu after Theodor
Kleinschmidt. Source material courtesy of the Museum für Völkerkunde Hamburg.
Published with permission of the artist.

experience similar shame and ridicule.[48] Even beyond the bounds of these par-
ticular situations, however, outward signs indicated when a woman had been
tattooed. After acquiring the *vei-qia*, she received, for instance, a dress that
marked her debut as a newly tattooed and thus publicly recognized woman. In
his account of *vei-qia*, Joseva Bembe Tumbi declares, "Then the girl who had
been tattooed would be invested with the *liku* (native grass dress, the badge of
womanhood, as the *malo* was that of manhood), the name of the dress being
the *Vorivori ni Susung-i Tiko* (the debut or coming out)" (Tumbi, 187). Unable
to wear a woman's clothes until she wears a woman's design, the *liku* becomes
a public wrapping that attests to a more private adornment.

In addition to the short, fringed *liku* skirt, another visible sign that a woman had acquired the sacred patterns was evident in tattoo designs that marked a young woman's fingers. The missionary Thomas Williams reports circumspectly, "The command of the god affects but one part of the body, and the fingers are only marked to excite the admiration of the Chief, who sees them in the act of presenting his food" (*Fiji*, 126). The pubic area is the unnamed part that must be tattooed to satisfy Degei; the designs on the fingers, elsewhere described as "barbed lines and dots" (*Decay of Custom*, 218), are presented here as superfluous. But the finger patterns play an important part in signaling that the requisite sacred tattooing has occurred. The girl thus adorned has visible marks that she has been "presented to the ancestral spirits, renamed and dedicated to the tribal service" (*Hill Tribes*, 177). As a result, it is appropriate for her to present food to a chief.

An additional indication that a woman's skirt covered sacred patterns was sometimes given in mouth tattooing, designs that could be created after a woman had given birth. In some islands, "after childbirth a semicircular patch was tattooed at each corner of the mouth" (*Decay of Custom*, 218). For women who lived in the hills of Viti Levu, sometimes the designs around the corners of the mouth were joined, following the lines of the lips and giving the wearer "a badge of matronly staidness and respectability" (ibid.). In these areas, the mouth tattoos are presented as marks of status and even of age. Hence, "The spots at the corners of the mouth notify, on some islands, that the woman has borne children, but oftener are for the concealment of the wrinkles of age."[49]

One account, however, indicates that mouth tattooing was applied to the young woman when she received her sacred tattoos. This practice means that the mouth tattoo, like the finger designs, points toward tattoos hidden by the *liku*. Such tattoos have a much more erotic implication. Tattooing was performed in order that the women could gather to witness the falling off of the scales, and thereby see the girl's visible acquisition of her womanhood. In addition, Navatu suggests, "It was also done for the sake of the woman's husband, that when he went to sleep with her that he, too, when he undid her *liku* (grass dress) might see the beautiful tracery. For that reason the woman's lips were tattooed that her husband might desire to kiss them" (Navatu, 186). Here, the mouth designs signal the woman's desirability to her husband. In keeping with this interpretation is Gell's suggestion that Vitian mouth tattooing is "displaced genital tattooing" (*Wrapping*, 85). (Where Gell generalizes this statement about mouth tattooing, it seems important to note that the patterns' meaning depends very much upon specific local interpretations.)

Some accounts hint that the designs make the women who wear them ir-
resistibly erotic. Thomson reports, "After infinite persuasion the son of a *Vere*
was induced to dictate one of the chants, and it proved to be an extremely
lascivious ode in praise of buttock tattooing—the only instance I am acquaint-
ed with in Fijian chants in which lechery and not religious awe animated the
composer" (*Decay of Custom*, 219). Moreover, he continues, "Vaturemba [Va-
tureba], the chief of Nakasaleka in the Tholo [Colo] hills, who was always
plain-spoken, chuckled wickedly when I questioned him upon the matter, and
declared that physically there was the greatest difference in the world between
mating with a tattooed and an untattooed woman (*Sa matha [maca] vinaka nona
ka vakayalewa, na alewa nkia [qia]*)." The chief's phrase refers roughly to a
woman's "parts" as having become desirable and feminine through tattooing.

Whether the tattoo marks designate a woman's steady, well-controlled, and
matronly sexuality, as in some presentations, or indicate to the contrary her
passionate potential, as in others, *vei-qia* creates marks of distinction.[50] All of
these accounts of the patterns contradict Gell's suggestion that tattoo degrades
the recipient. And all of these designs are created by women for women. That
gender-specific nature of the patterns, and their delicate location, can create
difficulty for male observers. Some resort to embarrassed euphemism or exag-
gerated sexualization in describing the marks. Others try to halt the practice,
only to be thwarted because of the gendered nature of the designs. That the
designs are created by women for women in fact makes it more difficult to
modify the ritual.

When missionaries attempted to intervene against the practice they, rath-
er than the practitioners, could be charged with indecency. Thomson, who
served as a magistrate, reports, "Interference with it by a man, albeit a Mission
teacher, was evidently considered indecent in itself, for men cannot, without
impropriety, concern themselves with so essentially feminine a business. More
than one teacher was charged before my court with indecency for having re-
turned to the village to admonish the tattooers while the operation was being
performed" (*Decay of Custom*, 219–20). Here, the missionary who tries to im-
pose a new law on ancient practices is barred from so doing by the very courts
in whose name he attempts to act. (The difficult position in which a missionary
tries to uphold one form of propriety by violating another has already been
noted in reference to Tahitian tattooing.)

Even while the tradition continued, it incorporated modern adaptations.
Women continued to receive the full *vei-qia* as a mark of their entry into adult-
hood and hence into service to the community. But by 1910, according to

Thomson's account, men also began to be tattooed: "With the introduction of writing it has become common for young men and women to tattoo their names on the forearm or thigh of the person to whom they happen to be attached, and there are comparatively few who do not carry some memento of their heart's history thus ineffaceably recorded" (*Decay of Custom*, 220). Much as artists across the Pacific enlarged their repertoire with motifs resulting from their contact with new religions and technologies, Vitian artists created innovative textual designs. Written accounts do not reveal whether men began creating as well as wearing tattoos, and it seems clear that the ritual tattoo remained in the hands of women.

Even with these innovations, the tattoo connects generations to one another. Navatu suggests that the sacred tattoo creation proceeds only after the ancestors have been invoked: before embarking on the procedure, the wise women "prayed to the spirits of the dead to soften the skin of the girl so that the operation should not pain her too much" (Navatu, 185). The ancestors, thus made present, help guide the ceremony, bringing the girl into the realm of women who can become full members of the community and thus marry and bear further descendants. The *vei-qia* hence makes visible a genealogy of design and descent.

While Vitian men were not tattooed, in late adolescence they did undergo a public ceremony of circumcision or incision (partial splitting of the foreskin), a ritual that corresponded to the women's *vei-qia* ritual. Male priests enacted the circumcision or incision ceremony; female priests enacted the tattooing ceremony. Both rituals reveal the young man and woman as fully adult, renamed and ready to serve their communities through joining their genealogies to those of others.

The explicit genealogical element of the tattoo is made clear in the festivities when a young couple celebrates the birth of their first child. In the mid-nineteenth century, Williams described the occasion: "The Fijian father must celebrate the birth of a child by making a feast; and, if it is the first-born, sports follow, in one of which the men imitate on each other's bodies the tattooing of the women. The name of this feast is *a tunudra* [*i tunudrā*], and seems to regard the woman rather than the child" (*Fiji*, 138). Before she is married and gives birth, the young woman is marked; after he marries and his wife gives birth, the young man is marked in a retrospective (and temporary) imitation of her *vei-qia*.

Her patterns show her desirable potential, revealing the sexuality that accompanies the ability to conceive a child. His patterns replicate hers after husband and wife have joined their genealogies, carrying the ancestors' lines into

the future. The feast is given to honor the midwives. The men's appropriation of the women's design is collective and public; they mark the patterns on one another in festive imitation of the woman's ritual. More than just clowning, the copied patterns recognize that the man has been seen as desirable and has helped to continue genealogies. (The patterns may also be a humorous way to avert anxiety about the fact that only the maternity of a child is certain.) Observers who missed the social meanings of the body thus missed the significance of Fijian women's tattoos, which attested not only to the wearer's sexual maturity or childbearing experiences but also to the way women tattoo artists helped create the patterns that described human beings' place in time and relationship to the gods.

In contemporary Fiji the practice of tattooing has changed, but the focus on the body's social meanings continues. Observing that in Nahigatoka Fijians are preoccupied with commenting on other people's bodily shapes, Becker suggests, "Body morphology is a primary lexicon of social processes, not a means of self-representation; it is a matter of social, not personal, concern."[51] Becker's assessment founds her study of the way Fijian culture shapes the experiences and meanings of embodiment; it also returns us to the insight that tattooing, as a way of making the body legible in culture, has meanings that are as much social as personal. That insight explains both that Pacific tattoos bring the bearer into the community and that outside the Pacific tattoos diagnose the bearer as distanced from society.

These extra-Pacific diagnostic traditions find expression in contemporary Fijian writing. Perhaps because the traditional tattoo revival has not yet been as widespread in Fiji as in other places across the Pacific, tattoos may be used to indicate that the wearer has departed from Fijian traditions and embraced a degraded present. In Joseph Veramu's novel *Moving Through the Streets*,[52] for instance, tattooing practices in Suva have departed drastically from the sacred ritual that wise women used to usher young girls into adulthood. Veramu presents tattooing as an embodiment of degraded relationships between men and women in urban Housing Authority developments—"a respectable name for a slum" (*Moving*, 4). In the rough communities Veramu portrays, pregnant women "perpetuate their husbands' (or lovers') genealogies" (*Moving*, 142), not the women's own genealogies, and not a joining of the couple's lines of descent. Instead, impregnating a woman is, for men, "a visible symbol of their virility," one marked by tattoo: "Some like Varasilade and Vakati wore sleeveless tee-shirts with the first names of girls they had impregnated tattooed on their biceps" (*Moving*, 142). Veramu's portrayal of contemporary tattoo-

ing is of course selective, but it emphasizes the distance his urban characters have traveled from personal and cultural genealogies that could give them the meaning they seek instead in random violence.

<div align="center">

CROSSING OVER:

"PRIMITIVE" WOMEN "PUBLISH" A WHITE MAN

</div>

Pacific tattoo further complicates the "tattoo as deviant" tradition, which assumes that the patterns are "primitive" and possess only an obscure or privatized meaning. Pohnpei reveals a historical instance in which not only were women the tattoo artists, but they also practiced upon a white man, James O'Connell. He presents their work as an elaborate art that they, but not he, can read. The women thus make his body a book, and he proceeds to publish their production on the stages of New York, Buffalo, and New Orleans. The Pohnpeian traditions, and O'Connell's descriptions thereof, thus emphasize the highly advanced and very public script that is tattoo, here one wielded by women.

In Pohnpei, the genealogies expressed in *pelipel*, or traditional tattoos, emphasize matrilineal descent. Here, men historically derived political and economic power and social standing from their mothers and sisters; membership in the clan is matrilineal.[53] Ignoring the woman's genealogy would thus make no sense. Pohnpei, one of the Caroline Islands, is also home to a tradition in which women artists created tattoos, not only for women but also men.[54] Women tattoo experts, *Katin intin* [*nting*], tattooed both genders on the hands, arms, legs, and thighs; women were additionally tattooed on the abdomen, mons veneris, and buttocks.[55] (Examples of male patterns are provided in figures 1 and 2; figures 22 and 23 are examples of female patterns.) The patterns were usually given, as in Fiji, to mark the accession to adulthood, and to prepare the recipient for marriage.[56] Patterns recorded lineage and clan history, as well as important events in the life of the individual or island.[57] The designs varied according to the kin group, family, subsection, rank, and conditions of the bearer (*Ponape*, 268).

O'Connell's observations about Pohnpeian tattoo are discussed in detail in the introduction. Many of the features O'Connell experienced and described are also emphasized in Paul Hambruch's 1910 account. Tattooing is a respected art and way of life; the designs are created and applied by women. Women receive more elaborate tattoos than do men, although many of the patterns repeat for both men and women.

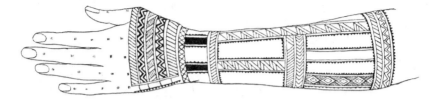

FIGURE 22. A Pohnpeian woman's arm tattoo. Illustration by Paul Hambruch. Reprinted
from Paul Hambruch and Anneliese Eilers, *Ponape: Gesellschaft und Geistige Kultur,
Wirtschaft und Stoffliche Kultur* (Hamburg: Friedrichsen, De Gruyter, 1936), 2:274.

 Hambruch emphasizes that Protestant missionaries have attempted to halt
the practice. (He speaks of people from the Boston Mission fighting zealously
against tattooing.) Yet he attests that the primary thing the missionaries seem
to have achieved is to make people shy about discussing their designs. The art
is still vital, he declares, and people are very proud of their patterns. He notes
that even Christian parents still allow their daughters to receive the *pelipel.*
And with the help of a Catholic missionary, who urges people to show their
designs, he is able to view and record designs.

Nān Kătin, of Palikir, offers an account of Pohnpeian tattoo, which declares
that the woman tattoo-master sits atop the recipient of the tattoo while two
women assistants make the skin ready by stretching it. This account reports
that men receive the *pelikomŭts̀* or penis tattoo, half of the design one day and
the other half of it the next. "Here, too, the design would be hammered in,"
Nān Kătin declares wryly.[58] Neither O'Connell nor Hambruch discusses or
draws such a design (though Hambruch publishes Nān Kătin's description).
Each portion of the design is complete only after it has been hammered in
three times. After the two assistants stretch the skin tight to receive the design,
then the tattoo artist begins hammering. "When she is finished," Nān Kătin
states, "she repeats it another two times; then it is complete" ("Ko żoi," 269,
translation mine).

Nān Kătin notes that tattoo begins on the right side of the body. As with the
penis tattoo, each portion of the tattoo is applied in turn, first one half and then
the next day, the other half. A sense of balance and proportion is thus empha-
sized in this Pohnpeian perspective on the practice.

Examining the patterns reveals that same sense of balance. For an example,
consider the elaborate hip, groin, rear, and leg tattoo that features in figure

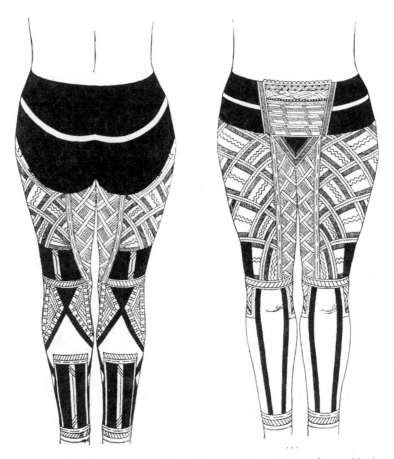

FIGURE 23. A Pohnpeian woman's leg, abdomen, and buttock tattoo, front and back.
Illustration by Paul Hambruch. Reprinted from Paul Hambruch and Anneliese Eilers,
Ponape: Gesellschaft und Geistige Kultur, Wirtschaft und Stoffliche Kultur
(Hamburg: Friedrichsen, De Gruyter, 1936), 2:277.

23. The design is formed by the interplay of light and dark, of clear skin and
marked skin, of positive and negative. Both elements are necessary to create
the pattern, which weaves ink and skin together to form a kind of living tapes-
try. Viewing the tattoo from the front, side, or back yields a completely differ-
ent perspective, with each view emphasizing a particular aspect of the body.

The front view presents a thick two-part hip girdle, which wraps the body
horizontally in a full field of pigment, broken only by the clear-skinned line
that divides the field in two. The hip girdle, with its completely darkened

areas, makes the clear line almost glow in contrast. Two broad vertical lines that reach from just above the knee to the ankle in turn balance this horizontal wrapping of the hips. The broad vertical lines emphasize the clear fields of skin that are thus framed in the front of the lower leg. Horizontal and vertical, dark and light work together to create the effect of balance and unity.

The vertical lines on the lower leg in turn lead the eye to the vertical lines that run between the knee and the upper groin area. The patterns on the inner thigh and outer thigh similarly move the eye toward the darkened triangle that adorns the groin area. Hambruch says that the darkened areas of the tattoo "shimmer dark-blue" (*Ponape*, 278, translation mine).

In this way, the body becomes aligned with power, kinship connections, and even the sacred. Hambruch does not translate the tattoo terms he records, and his spelling is inconsistent, sometimes even when referring to the same pattern.[59] Nonetheless, the tattoo terms he records are very suggestive of the rich meanings the patterns carry. One of the most frequently occurring design elements, for example, Hambruch records as *manaman*, a term that means power and authority and invokes spirituality.[60] In the leg tattoo just discussed, for example, the pattern appears in the band of slanting regular parallel lines that completely circles the ankle and the area just above the knee. Variations of the pattern are central to the outer- and inner-thigh patterns and border the dark triangle of the lower groin area, both joining and separating that pattern from the surrounding designs. A variation of this pattern also borders the shield figure that adorns the upper abdominal area, creating a boundary and a connection between the shield and the shimmering dark-blue hip and rear girdle.

Another, more literal correspondence occurs with the pattern Hambruch records as *nini* (*ngingi*), which gives a clear visual representation of "teeth" by creating a toothlike or serrated edge (*Ponapean-English Dictionary*, 70). The serrated edge conveys both strength and protection. This pattern adorns the top of the groin design, pointing in regular repeated half-circles toward the navel. Frequently this pattern appears elsewhere in somewhat less stylized form, where the teeth are more pointed as, for example, in the male and female hand tattoos that appear in figure 1 and in figure 22, creating the band nearest the fingers. Both male and female hand tattoos also feature a wide-band pattern that circles the wrist, using vertical designs to both join and set apart the hand and arm designs. This wrist pattern, the widest element of the horizontal patterns, forms a *luwou*, or bracelet (*Ponapean-English Dictionary*, 54).

Hambruch does not note whether the female leg patterns he records include the *nting sarawi*, or sacred tattoo that appears just above a woman's knee

(*Ponapean-English Dictionary*, 69), but presumably that pattern may be the fully darkened triangles that appear on the back side of the leg, just over the knee. These fully darkened triangles reference the fully darkened V shape of the lower groin tattoo. The power and beauty of all of these designs pay tribute to the generative and fertile strength of women. Viewed from the front, the designs move the eye toward the source of human life, toward the physical space from which lineages are carried forward. Viewed from the rear, the two dark triangles move the eye toward the clear skin that remains open at the top of the calf, which in turn calls attention to the thick dark lines that join at the lower opening of the darkened V shape. That element of the design calls attention to the balance of light and dark, closure and opening.

To return briefly to the tattooed Irishman, O'Connell does not mention whether he received the analogous penis tattoo, and he is also silent about whether he witnessed or experienced a ceremony that is a corollary to tattooing, the voluntary partial castration termed *lekilek*. This ceremony excised one testicle, usually the right one, in "an expression of contempt for pain upon becoming a man and an emblem of prestige" (*Pohnpei*, 228). The *lekilek* for men corresponds to the more extensive and intensive *pelipel* design for women.[61] Outward adornment testifies to rigors endured, and to the fully adult status of the wearer. The marks proclaim the bearer fully man, fully woman—or perhaps in O'Connell's case, fully anomalous. (In addition to the standard male tattoos, he claims to wear an abdominal tattoo, which is usually given to women.)

In the 1830s, O'Connell's public performances helped carry Pacific tattoo to the United States. But displays of tattooed men in England go at least as far back as 1692, when Prince Giolo ("Jeoly") exhibited his tattoos in England. As a result, the existence of women tattoo artists was announced outside the Pacific in the late seventeenth century. Giolo, a Visayan man from Meangis, an island east of the Philippines, wore tattoos that have been identified as closest in style to Carolinean designs.[62] In other words, Carolinean designs were apparently the first ones exhibited in England and the United States.

The English traveler and privateer William Dampier began journeying with Giolo to Europe, and he notes in his travel narrative that Giolo's wife had created Giolo's tattoos. (Dampier is famous for helping liberate the shipwrecked sailor Alexander Selkirk from the island of Juan Fernandez; Daniel Defoe would fictionalize the castaway as Robinson Crusoe.) Both the patterns and the tradition of women tattoo artists are documented as far back as Giolo's account of his own tattoos. Giolo reached England before the word "*tatau*"

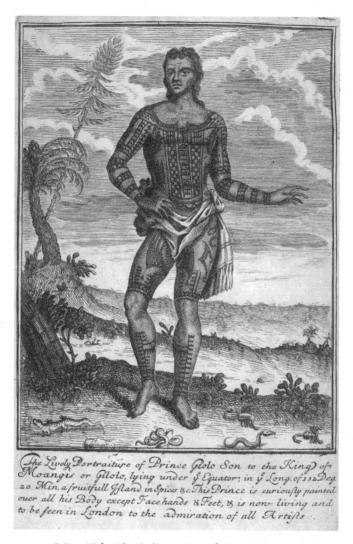

The Lively Portraiture of Prince Giolo Son to the King of Moangis or Gilolo, lying under ÿ Equator; in ÿ Long. of 152 Deg. 20 Min. a fruitfull Island in Spices &c. This Prince is curiously painted over all his Body except Face hands & Feet, & is now living and to be seen in London to the admiration of all Artists .

FIGURE 24. Prince Giolo. *The Lively Portraiture of Prince Giolo* . . . (London, c. 1692). Published with permission of the British Library.

did. Lacking the term, which James Cook and Joseph Banks would import into English in 1769, the broadsheet advertising his appearance (figure 24) heralds designs that are "curiously and most exquisitely Painted or Stained" on his body.[63] Dampier describes the patterns as "painted all down the Breast, between his Shoulders behind; on his Thighs (mostly) before; and in the form of several broad Rings, or Bracelets, round his Arms and Legs."[64]

From Giolo's account, Dampier understands that "the Painting was done in the same manner, as the Jerusalem Cross is made in Mens Arms, by pricking the Skin, and rubbing in a Pigment" (*New Voyage* 1:497). The reference indicates that some English travelers recognized the Jerusalem Cross as an analogue to Pacific tattoo. In this reference, even the known analogue is named as something foreign, associated not with traditions that travelers have assimilated and brought back to England, but with a foreign place. The English observer compares two exotic traditions, both of which are presented as distant from his homeland. The lavish descriptions Dampier provides of Giolo's patterns, which were "very curious, full of great variety of Lines, Flourishes, Chequered Work, &c. keeping a very graceful Proportion, and appearing very Artificial, even to wonder" (*New Voyage* 1:497), anticipate the astonished portraits Captain James Cook and his men provided in their initial accounts of Pacific tattoo. These early encomiums, and narrative and stage displays of Pacific tattoos, extend Nicholas Thomas's suggestion that any extant European traditions of tattooing could not have been widely known, not at the time Dampier nor at the time Cook traveled and wrote.

As for a more troubling aspect of the way Pacific tattoos reached Europe: Giolo had been captured by Mindanaoans and lived as a slave for four or five years in Mindanao. He and his mother were purchased first, notes Dampier, by "one Michael a Mindanayan" (*New Voyage* 1:498) then by another ship's supercargo, William Moody, and later by Dampier. Dampier reports the sale indirectly, noting that after he agreed to consider traveling on Moody's account, Moody "would give me the half share of the two painted People, and leave them in my Possession, and at my Disposal" (*New Voyage* 1:496). Dampier decided that he would first display Giolo in Europe and then return him to his home, thereby establishing a spice trade. Giolo's mother died (perhaps of dysentery, typhus,[65] or smallpox) almost immediately after Dampier met her. Dampier declares that he "tended [Giolo] as carefully as if he had been my Brother" (*New Voyage* 1:502). Nonetheless, just as he reached the Thames, Dampier was prevailed upon to sell his share in Giolo, and his new owners "carried [Giolo] about to be shown as a Sight," presenting him (just as Dampier does in narrative) as the "Painted Prince." The broadsheet advertising the painted prince indicates that Giolo was still alive nine months after his arrival in England (*Devil's Mariner*, 221); but Dampier records the fact that Giolo soon died of smallpox in Oxford.

The confluence of European desire and disease brought the bearer of tattoos to England and then killed him. The tattoos became a displayed object

at the price of the tattooed subject's life. The playbill makes it clear that the process of displaying Giolo required treating him as not a living person but as a fixed instance of art: "This excellent Piece has been lately seen by many persons of high Quality" ("Figures" 32). When Giolo stopped living physically, he simply carried to its logical conclusion the trajectory that made him a "Piece" to be exhibited. In a note that now seems haunting, the broadsheet declares, "but his Language is not understood, neither can he speak English" ("Figures" 32). The language gap isolates both the designs and the human being who bears them.

This early instance of world demand for Pacific tattoos reveals that in the process of exporting the designs, the patterns' deep meanings can be lost. That is not to say that all such movement should be halted, but simply that it should be examined carefully. As many examples in this chapter suggest, the designs have circulated within the Pacific for centuries, in the process helping to express intricate understandings of gender and sexuality that are obscured in the conventional U.S. and European models of tattoo as desire made visible.

Epilogue

THE QUESTION OF
BELONGING

Just as tattoo may variously indicate membership or being cast out from membership, depending upon who defines its meanings, so, too, the patterns raise a related question of belonging. That is, who owns tattoo?

Netana Whakaari declares that while a human being may lose human companions, land, and property, only death may deprive a person of her or his *moko*. By that account, the marks carved into the face would appear to belong to the person who bears them. Petelo Suluʻape, on the other hand, part of a long line of hereditary tattoo-priests, recounts a story of how *tatau* arrived in Samoa. In his version of the myth, the two women swimming from Fiji gave the art to first his family alone and later to one other family.[1] The tattoo-master would seem to have inherited the designs along with his family name.

Many Māori follow tradition in seeking the approval of their family and elders before acquiring a *moko*, as do many Samoans before obtaining a *tatau* or *malu*. This practice places ownership of the designs in the hands of the family and the larger community. Tusiata Avia reports that this understanding of the designs is alive and well. Her cousin notes, "I remember when I would dance the taualuga I would feel embarrassed when people would pull up my lavalava to show off my malu. After some time—I think I was seventeen—someone said to me: 'You don't own the malu, it belongs to the family and they like to show it off.' That's when I understood that even though it is on my skin it doesn't necessarily belong to me."[2] Even after the patterns have been received

by the individual bearer, they belong in some sense to the collective who authorizes their bestowal.

In these and other Pacific practices, the tattoo belongs at once to the bearer, the creator, and the people who serve as descendants from and caretakers of the patterns. As we have seen, the tattoo designates the personal and the corporate, the private and the public, the sexual and the social; it marks variously and sometimes simultaneously the profane and the sacred, the extravagant and the essential, the playful and the political, the in-group and the outcast. It comes wrapped in language, history, genealogy, culture, belief, and power, and as it shapes and is shaped by these fields and forces, its workings may be both conservative and volatile. In its home contexts (and those home contexts are created wherever the people of the designs gather or live), the tattoo is owned simultaneously by bearer, artist, and community. In this light, the artist mediates between the individual recipient and the authorizing community. But the artist also has the ability to take the designs beyond the bounds of the community, which may or may not agree with the decision to do so.

As the patterns move outside their home contexts, who owns tattoo? Some tattoo artists advocate sharing the patterns with anyone who desires them. Petelo Suluʻape, for example, indicates in the previously cited statement that the designs are his family's to take around the world as they deem appropriate. Paulo Suluʻape, part of this same family of tattoo-priests, also believed "that to receive the peʻa the recipient must have some respect and appreciation for its history, values, and aesthetic."[3] Bearing that in mind, he said, "I think that the time is right that we should share."[4] In other words, the patterns and practice may be shared because the artist has authority to do so and judges that the desire to wear the designs indicates a respect that makes the person worthy. As Samoan tattoo-masters have shared their art around the Pacific during the renaissance of the past decades, this philosophy has also helped foster renewed tattoo practices for Tahiti, the Marquesas, Hawaiʻi, and Tonga. (In the case of Samoan tattoo artists helping to renew Tongan tattoo, the contemporary artists are following the path of their predecessors: two hundred years ago and more, Tongan courts hosted Samoan tattoo-priests.)

According to the protocol that guides one to seek permission to acquire tattoo, only the rare visitor whose design had been approved by a local family and community received a traditional tattoo. In cases where tattoo occurred in a communal setting, as with the early-nineteenth-century visitor John Rutherford's *moko*, the designs were applied with the help of others and, by extension, with community approval. On the other hand, most tattooed travelers

today receive the designs without family and community permission, and thus wear something other than traditional tattoo. In the case of *moko*-based designs, some would say non-Māori wear a *kirituhi*, or tattoo not based on genealogy, while others might see in such patterns a badge of theft.

Tattoo emphasizes that the communal tradition and the individual talent rely upon one another. Any artist makes her or his art using materials—whether patterns, language, or skin—that also belong to others. At the same time, culture is not fixed but is instead shaped by constant adaptation and exchange. Even in their home places, the patterns bear traces of having traveled across the Pacific, borne by artists and by tattooed travelers. Moreover, what looks like fragmentation from one angle may look like vibrant innovation from another. For instance, the nineteenth-century doctor Frederick Bennett chose tattoo patterns from the living skin of a Tahitian artist and a Marquesan artist. His move invokes the specter of travelers who acquire Pacific patterns on a whim, turning a sacred art into a kind of elaborate token or permanent souvenir. But his move also demonstrates that the art was vital years after missionaries announced its death.

So, too, an art once created for export may or may not be disconnected from the contexts that provide its native significance. Many contemporary Samoans wear *taulima*, or armbands inspired by the full-body *pe'a* or *malu*. The *taulima* was described in the 1890s in Samoa and was first popularized by Peace Corps volunteers in the 1960s and 1970s, who wanted to take with them a Samoan design when they returned home. Such armbands are now the most popular form of *tatau* among Samoans in New Zealand, who wear *taulima* to express their own cultural affiliations.[5]

A further concern may be the bearer's knowledge and awareness (or lack thereof). As a way of considering cultural appropriation and adaptation, consider three non-Māori who recently acquired *moko*: musician Ben Harper, boxer Mike Tyson, and playwright William Shakespeare. The three represent important features of *moko* and tattoo today, exemplifying the way the practice is reshaped as it moves into other parts of the world, and the way the practice in turn reshapes the world.

Some non-Māori who wear tattoo patterns based on *moko* acknowledge and respect the provenance of the designs. Consider the design that covers United States soul and folk singer Ben Harper's entire back and arms. The *tā moko* artist Gordon Toi Hatfield created the design for Harper and applied it in Aotearoa. But first Hatfield and his family traded stories with Harper, who declares, "At that moment, my moko had begun. He did not physically draw

lines until the next morning; the unification of our worlds was as much part of the moko as the pattern itself."[6]

Harper's comment suggests that he understands a point made by many Māori who wear *moko*: the physical lines are just the most visible part of the design. The designs belong to a pattern larger than the individual, and they make visible the way the individual is joined to a life and a practice that precedes her or him; the joining in turn carries the larger pattern into the future. Even though Harper's adapted design is not literally a genealogical one, he points toward the foundation of *moko*. In the genealogical design, the *moko* indicates who the bearer is, serving as a hinge between ancestors and descendants, and thus depicting past, present, and future. Stated another way, *moko* portrays where the person is now, as well as where she or he has been and is going.

For his part, the tattoo-master Hatfield sees such meaningful artistic exchange and work a way to counter appropriations of Māori design. He states, "I would much rather see Māori in charge of how we portray ourselves culturally to the world" (*Dedicated*, 87). His comment recognizes and attempts to work against the worldwide use of Māori designs "from fashion houses in Paris to Hollywood movies and advertising agencies" (*Dedicated*, 87). In other words, if Māori artists decide when it is appropriate to place *moko*-inspired designs on non-Māori, they gain more control over determining which patterns are placed where, and how those patterns are used. The comment suggests that even in the face of widespread unauthorized use of Māori motifs, it is possible for a Māori artist to create a significant *moko*-based pattern for a non-Māori person.

A different relationship to living tradition emerges when people who are not Māori wear *moko*-inspired patterns but do not understand the cultural basis of their designs. Mike Tyson, the former championship boxer, sports a facial tattoo that adorns one side of his face and derives from *moko* patterns. In news conferences in February 2003, however, when he was debuting his tattoo, he described the design as "Mayan,"[7] while his trainer characterized it as an "African tribal thing."[8] The disparate descriptions—none of which come very close to the actual cultural or geographical origins of the designs—suggest that Tyson and his trainer associate the patterns with the exotic in general. Such descriptions treat the design, reportedly created in Las Vegas, as a generic example of what is sometimes termed tribal tattoo. As a result, the particular histories and genealogies of the patterns are lost.

Tyson's description of the designs' meaning, moreover, exemplifies what may occur when the patterns are disconnected from the body of Māori culture. When asked to characterize his tattoo, Tyson responded, "A tattoo is personal."[9] His statement is contradicted by the fact that he chose the most public place possible for a tattoo. In the United States, a facial tattoo offers a bold and even confrontational proclamation of identity. Moreover, he is a sports celebrity who displayed his new facial tattoo in a press conference held on the eve of a high-profile boxing match. So Tyson at once offers a defiant invitation to consider what the symbol means and at the same time declares that its meaning is off-limits to the cameras that broadcast his new tattoo around the world.

But his statement reveals that in the absence of the family and community connections usually signaled by a *moko*, the patterns appear to be privatized. In other words, Tyson suggests that the tattoo contains a significance that remains personal to the bearer, defined by the individual. Such a basis for determining the tattoo's significance is very distinct from that offered traditionally, where individuals and communities define meanings that are simultaneously personal and collective.

It is important to analyze the claim that tattoo is personal not because Tyson is a profound cultural commentator, but because his statement represents a key aspect of tattoo viewing in the United States today. In her studies of contemporary tattoo communities in the United States, anthropologist Margo DeMello identifies two forms of tattoo: the literal, in which people wear and interpret information carried by tattoo according to an accepted cultural tradition; and the symbolic, in which "the ability to read such tattoos is restricted to members of a particular social group or only to the wearer."[10] DeMello concludes, and most scholars concur, that in the United States the meaning of the tattoo design is symbolic, readable only by the few or the one. In part, such claims are offered to oppose the interpretation of tattoo as pathological. In other words, the mark indicates not a problem, but whatever the bearer says it does. DeMello even identifies a genre, the "tattoo narrative," which people use to convey such meaning.[11] In the absence of the story, her studies suggest, the symbol's meaning remains elusive.

Of course, while Mike Tyson describes the tattoo's meaning as personal and refuses to tell the story of its meaning, some viewers consider it more than personal and as such discern a preexisting narrative in its pattern. For art historian Ngarino Ellis and other *moko* scholars, wearing such a pattern in ignorance raises concerns about misappropriating the tradition.[12] The point is not

that Tyson does not know the patterns' meaning; after all, the design is *moko*-based, so he does not wear a particular individual's signature or community's pattern. But the process by which he received the designs involves a painful removal of the features that make the designs personal to Māori: stripped away from the designs are their history and meaning, their past and their future. What Tyson describes as personal becomes available for his consumption only after it has been first depersonalized—removed from Māori faces and bodies. This process involves violation and sometimes outright violence and thus itself creates disparate tattoo narratives.

DeMello identifies a further stripping away of cultural contexts that occurs in contemporary United States tattoo. Outside the Pacific, she suggests, tattoo became associated with the working class; today many people acquire tattoo only after dissociating it from those connections. In contrast to what they see as "standardized" working-class tattoo, middle-class tattoo wearers create personal designs with unique meanings, often meanings that express the "primitive self" (*Bodies*, 4, 161). At the same time that she critiques the way this process marginalizes working-class tattoo, her work exemplifies the assumption that the tattoo has already been completely and finally separated from its Pacific contexts. She declares, "Tattoos are living embodiments of cultures that no longer exist" (*Bodies*, 14). That mistaken belief contributes to the deterritorialization of tattoo—its removal from Māori and Pacific faces and bodies, its separation from the places and people honored in the designs.

It is the same belief that allows a Los Angeles man to wear a facial *moko* that was designed historically for a Māori woman, while stating that he did not know any Māori people still existed. Art historian Te Awekotuku asks performance artist Ron Athey if he knows what he wears, and reports, "He inquired how much Maori blood I had and claimed he did not know that there were any of us still around" ("More Than Skin Deep," 248). Both parts of his response exhibit the assumption that Māori culture is freely available for the taking—either because Māori blood has been supposedly diluted over the centuries, or because Māori people have otherwise vanished. In other words, the assumption that Māori exist only in the past lets Athey bring their design into the present in Los Angeles or in London where Te Awekotuku meets him.

The wholesale removal of the motifs from their Māori frames devalues both a specific culture and the principle that cultural specifics matter. As *tā moko* artist Derek Lardelli notes, with no Māori involved in the creation or application of Mike Tyson's design, it is not the real thing.[13] Instead of presenting a message that includes information about the bearer's family and history, it presents

an image, one that Tyson presents to the world in press conferences and uses to increase the audience for his pay-per-view boxing matches.

Even after such an image has been removed from its genealogical contexts, viewers continue to speculate about what it means. In response to Tyson's tattoo, University of Memphis instructor Kya Reaves told an Associated Press reporter, "It's indicative he wants it to represent the warrior in him." Such interpretations suggest that even when the design is viewed outside the specific frames that give it a prior collective significance, people wish meaning to remain more than personal. If the tattoo bearer declines to share the narrative that explains the design, viewers will be happy to tell the story. In some ways this impulse is unique to the "personal" tattoo of today; in other ways, the impulse hearkens back to the languages that people have always wanted to see in tattoo. In the absence of a tattoo lexicon, viewers from James O'Connell to Jacques Lacan create tattoo stories.

This celebrity tattoo is a corollary to the patterns created by advertisers and fashion houses who borrow Māori design to create and market an image. The elements of *moko* become a means to sell a product. Removed from their frames of meaning, the designs become pure form. As was the case in Kant's *Critique of Judgment*, the beauty of the *moko*—and the form—becomes available when the pattern is removed from the Māori face. Sony's 2003 ad campaign for digital cameras and computers uses Māori warriors in full facial and body tattoos to promise travelers the world; put another way, the ads suggest that technology is the new way to capture and preserve *moko*. Paco Rabanne's 1998 haute couture line and Jean-Paul Gaultier's spring–summer 2000 line offer a knowing use of *moko* elements that conflates the exotic and the erotic.[14] In this way, the sacred mark may become part of a marketable brand, as Hauʻofa indicates in his satire of globalization and other models of salvation, which rely upon the voracious desire to incorporate all.

Finally, while appropriations of tattoo continue to proliferate, the art continues to thrive in its cultural homelands. People who wear *moko* emphasize that it remains a living art, but more significantly, that it embodies the larger life of the community. "Moko represents to me the life essence, the living force, the wealth of folklore passed down from generation to generation," declares Jason Kennedy Tumanaakimatua Graham. "The moko is a medium for all to remember and never, never to forget" (*Dedicated*, 50). Here is the vital *moko*, complete with the genealogies that connect the bearer to past and future. Far from serving as an empty form, *moko* is a medium. In Graham's description, that medium conveys memory and history and the life of the people.

In a recent poster, visual artist Cushla Parekowhai calls attention to *moko*'s function as a medium that conveys a living cultural power. She and Te Herenga Mātauranga (Librarians for Social Change) designed the poster for a conference that was convened in Auckland in July 2000 (figure 25). The conference was titled in English "Dislocating Shakespeare." Her poster dislocates Shakespeare in verbal as well as visual ways. As featured on the cover of the Winter 2001 issue of *Shakespeare Quarterly*, nowhere on the poster does the English title of the conference appear. Instead, the poster reads, "Te Whakapīoi a Wī," which might be translated as "Decapitating Will" or as "Contorting the facial features of Will." (*Pīoi* is a ritual chant sung while brandishing a severed head, and *whaka* is a causative prefix; *whakapī* means to contort the features, as in a *haka*. *Wī* is a transliteration of the English name Will.)[15] The aggressive suggestion of decapitation is softened by the fact that a portrait is the potential subject of the beheading; on the other hand, the distortion of features that occurs in the *haka*, a form of challenge, suggests that a battle or a test of strength is enjoined. When the challenge involves figures of such cultural authority, it puts at stake the question of who and what gets represented.

One form of representation is referenced in the location of the conference, which appears only in Māori and is given as "Tāmaki Makaurau Aotearoa," the name of the Māori electoral district that encompasses the city of Auckland, New Zealand. Parekowhai uses not a traditional name for Auckland but a contemporary one that carries political currency; in using the term Aotearoa, on the other hand, she chooses a traditional Māori name for the North Island. The location thus joins pressing political realities with a name that antedates the arrival of English. The date of the conference is given not in English but in a mixture of Māori and Roman numerals: VII–X Hōngongoi MM (July 7–10, 2000). The millennium is located in an amalgam of Māori and Latin.

But one of the most striking features of the poster is the magnificent *moko* that adorns one half of William Shakespeare's face. Shakespeare's face is an adapted version of perhaps the most famous portrait of the bard, the three-quarter profile believed to have been created by Martin Droeshout for the 1623 First Folio edition of Shakespeare's works. As Michael Neill notes, this is the image that is used as a guarantor of quality in advertising everything from brewers to business schools.[16] The side of the face that is not fully visible is the one that features the *moko*. Shakespeare's portrait thus both reveals and conceals the facial tattoo Parekowhai gives him. The fact that he bears a *moko* is proclaimed; the design details remain mostly hidden. The conventions of the

FIGURE 25. Illustration by Cushla Parekowhai. *Taowiriwiri te tangata.*
Courtesy of the artist.

three-quarter profile are such that his *moko* remains more a type than a particular mark of the individual.

Parekowhai calls attention to the conventions of English and Māori art. She creates a border around the portrait and places in the corners of the border four differing images of an historical Māori chief, giving this reduplicated image the position of the four winds that are invoked in both Māori oratory ("From the Editor," iii, v) and archaic English mapping. At first glance the chief's complete *moko* appears to be visible, for she presents mirror images of two portraits of the same chief. Those portraits are Parkinson's "Portrait of a New Zeland [*sic*] Man, 1769" and Thomas Chambers's version of the same portrait, "The Head of a Chief of New Zealand, the face curiously tataowed, or mark'd, according to their Manner," which Chambers created to illustrate the published version of Parkinson's *A Journal of a Voyage to the South Seas.*[17] In the lower left corner, Parekowhai places the chief's right side (as depicted by Parkinson), and in the upper right corner, a mirrored version of this image that appears to present his left side. In the upper left corner of the poster she places the chief's right side (as envisioned by Chambers), and in the lower right corner, a mirrored version of this image that appears to present his left side. These images, versions of sketches drawn by Parkinson on Cook's first voyage, reflect and multiply the portrait. So Parekowhai teases the viewer with the possibility that three-quarter perspective can reveal the full Māori face, while actually repeating the same side of the face as in a mirror.

Much as Te Pehi Kupe employed conventions of Māori art to reveal the full *moko*, using what Claude Lévi-Strauss termed split representation, Parekowhai suggests that three-quarter portraiture both can and cannot reveal Māori features. What is more, in presenting both Parkinson's portrait and Chambers's version of Parkinson's portrait, she calls attention to the fact that we confront a copy of a copy, a representation of a representation. Much as Droeshout is believed not to have seen Shakespeare but to have created his portrait based on another artist's depiction of the writer, Parekowhai presents a lineage of design and power: image descended from image. In these parallel lines of descent, the Chambers and the Droeshout portraits are of the same generation, and the *moko*-bearing Droeshout portrait is of the same generation as the mirrored version of the Chambers portrait. More than presenting endlessly reflexive versions of an always-receding referent, Parekowhai calls attention to the way history and meaning are created through such genealogies. In other words, she makes visible the way genealogies structure both Māori and English conceptions of art, history, and identity.

In the poster's border, Parekowhai juxtaposes the mirrored chiefly portraits with *kōwhaiwhai*, abstract curvilinear designs often used in painting that employ patterns similar to those found in woodcarving and *moko*. Since the term *kōwhaiwhai* references her family name, and Parewhai is itself a design name for a *kōwhaiwhai* pattern,[18] her placing of a *kōwhaiwhai* pattern along the poster's four sides also provides a way for her to "sign" the poster. Such a signature evokes the way *moko* were used historically to sign deeds and treaties.

The *kōwhaiwhai* pattern is obscured by the portrait, although since the design elements repeat on all four sides of the portrait, it is possible to piece together the full pattern. The painted scroll pattern thus surrounds and precedes the portrait, but is also displaced by it. Like *moko*, *kōwhaiwhai* is a means of conveying genealogies: the patterns often adorn the sacred meeting house that forms the heart of a Māori settlement: "The whole house became a genealogical plan of the ancestry of the tribe, linked together by the rafters painted with *kōwhaiwhai* scroll patterns symbolizing the eternal life spirit flowing along the descent lines."[19] Since both *kōwhaiwhai* and *moko* place the bearer in genealogies, Shakespeare is being surrounded by and incorporated into Māori lines of descent. His *moko* may claim for him Māori antecedents as well as descendants.

The name Parekowhai gives to this image, "Taowiriwiri te tangata," emphasizes the genealogical elements of the portrait. The name may be translated as "Shakespeare the man." Literally, the *tao* is a short spear, *wiriwiri* means to be shaken about vigorously, and *te tangata* means the man. So Parekowhai presents Shakes-spear the man. The form she uses for the name, moreover, is a traditional declaration of genealogical identification, which claims ("only slightly outrageously," Parekowhai notes)[20] that the greatest artist in the English language is Māori.

This genealogy indigenizes Shakespeare, but more, it makes Māori global, suggesting that in language, in design, in power, Māori has been global for at least as long as has Shakespeare. Shakespeare's works were carried on the voyage that created the Parkinson and Chambers images Parekowhai references. The Shakespeare portrait and the chiefly portrait represent a first meeting of *moko* and the bard of Tudor family history, one mediated by the varying frames and spaces Parekowhai juxtaposes. The *moko* and Shakespeare affirm—even as they rival—one another's authority. The lines of power depicted in the poster are living forms of culture, power, and representation. In Parekowhai's bravura depiction, as in all of the Pacific tattoo we have examined, such genealogies carry the past as well as the present and future.

Notes

NOTES TO INTRODUCTION

1. James O'Connell, *A Residence of Eleven Years in New Holland and the Caroline Islands*, ed. Saul Riesenberg (Honolulu: University of Hawai'i Press, 1972), 153 (hereafter cited as *Residence*).

2. O'Connell's unreadable texts, moreover, characterize Chinese writing as relying on ideograms and suggest that the English alphabet has twenty-four letters.

3. O'Connell suggests further that tattooing exhibits the signs or "heraldic symbols" of particular chiefs: "The marks upon my body have often been read to me, being expressive of the names of deceased chiefs" (*Residence*, 146). Riesenberg notes that in Pohnpei there is no memory "of use of the designs as heraldic symbols or of reading them as names of the dead" (*Residence*, 147 n. 61).

4. David Hanlon, *Upon a Stone Altar: A History of the Island of Pohnpei to 1890* (Honolulu: University of Hawai'i Press, 1988), 81 (hereafter cited as *Stone*).

5. The Students of the Community College of Micronesia, *Some Things of Value: Micronesian Customs as Seen by Micronesians*, ed. Gene Ashby (Eugene, Ore.: Rainy Day Press, 1983), 99 (hereafter cited as *Value*).

6. Te Awekotuku notes, regarding the Māori practice of *tā moko*, "some women, usually war leaders, had tattoos covering their faces, similar to men's." Ngahuia Te Awekotuku, "More Than Skin Deep: *Ta Moko* Today," in *Claiming the Stones, Naming the Bones*, ed. Alazar Barkan and Ronald Bush (Los Angeles: Getty Research Institute, 2002), 243 (hereafter cited as "Skin Deep").

7. When given to honor those who have just entered adulthood, the feast is termed *kamadipw en kadepwedepw*, Feast of Bathing, and refers to the end of the four-day period when bathing was proscribed, "following the tattooing done on both sexes and the semicastration practiced on adolescent boys." Saul Riesenberg, *The Native Polity of Ponape* (Washington, D.C.: Smithsonian Institution Press, 1968), 89.

8. Saul Riesenberg, "Introduction," in *Residence*, 40.

9. Paul Hambruch and Anneliese Eilers, *Ponape: Gesellschaft und Geistige Kultur, Wirtschaft und Stoffliche Kultur* (Hamburg: Friederichsen, De Gruyter, 1936), 2:273.

10. Kenneth L. Rehg and Damian G. Sohl, *Ponapean-English Dictionary* (Honolulu: University of Hawai'i Press, 1979), 69.

11. David Hanlon, "Beyond 'the English Method of Tattooing,'" *The Contemporary Pacific* 15, no. 1 (2003): 21 (hereafter cited as "Beyond"). Hanlon suggests that Pohnpeians equate history with tattooing: "written history in Oceania, or the 'English method of tattooing,' as James O'Connell deemed it" ("Beyond," 21; see also *Stone*, 41). O'Connell's narrative, however, states that his hosts shared his devotion to Porter's book because "they supposed printing was the English method of tattooing" (*Residence*, 109–10).

12. Albert Wendt, "Tatauing the Post-Colonial Body," *SPAN* 42–43 (1996): 15–29 (hereafter cited as "Tatauing").

13. Many articles resulting from this study have been published by individual and collective members of the research cohort. Those articles are cited individually throughout this book. Te Awekotuku is writing a book on *moko* that has not been published at the time of this writing.

14. Ngahuia Te Awekotuku, "Ta Moko: Culture, Body Modification, and the Psychology of Identity" (hereafter cited as "Ta Moko"), in *The Proceedings of the National Māori Graduates of Psychology Symposium 2002*, ed. Linda Waimarie Nikora et al. (Hamilton, New Zealand: University of Waikato, 2003), 123.

15. C. Jones, "*Stigma*: Tattooing and Branding in Graeco-Roman Antiquity," *Journal of Roman Studies* 77 (1987): 140; C. Jones "Stigma and Tattoo," in *Written on the Body: The Tattoo in European and American History*, ed. Jane Caplan (Princeton, N.J.: Princeton University Press, 2000) 7–9 (Caplan's volume hereafter cited as *Written*).

16. Quoted in Mark Gustafson, "The Tattoo in the Later Roman Empire and Beyond." in *Written*, 21 (Gustafson's article hereafter cited as "Roman").

17. Charles W. MacQuarrie, "Insular Celtic Tattooing: History, Myth and Metaphor," in *Written*, 44 n. 62 (MacQuarrie's article hereafter cited as "Celtic Tattooing").

18. The report of the papal legates notes that the legates were charged with curbing abuses in the Anglo-Saxon church, while the *Historia regum*, the only contemporary English source to record the visit, states that the legation renewed friendship with Rome and increased Anglo-Saxon faith. These two accounts are the "only direct contemporary evidence we have regarding the legation's purpose." Catherine Cubitt, *Anglo-Saxon Church Councils* c. *650*–c. *850* (London: Leicester University Press), 153.

19. "Celtic Tattooing," 36; Juliet Fleming, "The Renaissance Tattoo," in *Written*, 79.

20. Arthur West Haddan and William Stubbs, eds., *Councils and Ecclesiastical Documents Relating to Great Britain and Ireland* (Oxford: Clarendon Press, 1871), 3:458. Translation mine.

21. Henry Liddell and Robert Scott, *Greek-English Lexicon* (New York: American Book Company, 1897), 1431.

22. Jane Caplan, "Introduction," in *Written*, xvii.

23. Nicholas Thomas, "Introduction," in *Tattoo: Bodies, Art, and Exchange in the Pacific and the West*, ed. Nicholas Thomas, Anna Cole, and Bronwen Douglas (Durham, N.C.: Duke University Press), 14–16.

24. Nikki Sullivan critiques writers who propose a correlation between people from lower social classes and tattoo, who "demonstrate an inability to represent the tattooed body as anything other than a self-defeating response to inegalitarian systems of social stratification." Sullivan, *Tattooed Bodies: Subjectivity, Textuality, Ethics, and Pleasure* (Westport, Conn.: Praeger, 2001), 17.

25. In her work on tattoo in Europe during the early modern period, Juliet Fleming identifies the English terms for tattooing before the mid-eighteenth century. She also reports that William Lithgow, an early modern pilgrim to Jerusalem, received tattoo. Her essay "The Renaissance Tattoo" is published in *Res: Anthropology and Aesthetics* 31 (Spring 1997): 34–52, and included in Caplan's *Written on the Body* and in Fleming's book *Graffiti and the Writing Arts of Early Modern England*. Fleming thus helps initiate the conversation about tattoo traditions in England and Europe, suggesting that we have overlooked Renaissance tattoo because tattoo has been "projected on to the barbaric other and ever after read backward as that other's sign" (*Written*, 82).

26. Rey Chow, "How (the) Inscrutable Chinese Led to Globalized Theory," *PMLA* 116, no. 1 (2001): 71, 73.

27. Jacques Derrida, *Of Grammatology*, trans. Gayatri Chakravorty Spivak (Baltimore: Johns Hopkins University Press, 1976), 110 (hereafter cited as *Grammatology*).

28. Michael King, *Moko: Maori Tattooing in the 20th Century* (Auckland: David Bateman, 1999). No page numbers given; this quotation appears in chapter six. Te Awekotuku points out that one of Netana Whakaari Rakuraku's granddaughters, Hine Te Wai, today wears a proud moko on her chin. Ngahuia Te Awekotuku, "Mata Ora: Chiseling the Living Face," in *Sensible Objects: Colonialism, Museums and Material Culture*, ed. Elizabeth Edwards, Chris Gosden, and Ruth B. Phillips (New York: Berg, 2006), 135.

29. Herman Melville, *Moby-Dick*, ed. Hershel Parker and Harrison Hayford (New York: Norton, 2002), 32.

30. The heads historically have been termed *moko mōkai*, a term that some prefer not to use because it means literally "slave heads" and therefore conveys less respect than does the term *toi moko*, which characterizes *moko* as an art that marks the human head. *Upoko* or "heads" is another term sometimes used to refer to these sacred ancestral relics.

31. Linda Tuhiwai Smith, *Decolonizing Methodologies: Research and Indigenous Peoples* (Dunedin, New Zealand: University of Otago Press, 1999), 89. Italics in original.

32. Barry Barclay, *Mana Tuturu: Maori Treasures and Intellectual Property Rights* (Auckland: Auckland University Press, 2005), 109.

33. Of course, in U.S. copyright law, the copyright belongs to the picture taker, not the subject of the picture.

34. George Lillie Craik, *The New Zealanders* (London: Charles Knight, 1830), 330–31.

35. So even the artist negotiates "the terms in which I can reference the process of application and the final product." Henriata Nicholas with Ngahuia Te Awekotuku, "*Uhi Ta Moko*—Designs Carved in Skin," in *Beyond Words: Reading and Writing in a Visual Age*, ed. John Ruszkiewicz, Daniel Anderson, Christy Friend (New York: Pearson Longman, 2006), 158 (hereafter cited as "Carved in Skin").

36. Allingham quoted in Peter Gathercole, "Contexts of Maroi [sic] *Moko*" in *Marks of Civilization*, ed. Arnold Rubin (Los Angeles: Museum of Cultural History, UCLA, 1988), 172.

37. Robley scrapbook, Fuller Collection, Bernice Bishop Museum, Honolulu.

38. Margaret Mead, *The Maoris and Their Arts*, Guide Leaflet Series No. 71 (New York: American Museum of Natural History, 1928), 33.

39. Teresia Teaiwa critiques the way military or paramilitary force supports Pacific tourism, which in turn disguises the force that makes tourism possible; such "militourism" has deep roots and may create esteemed institutional routes. Teresia Teaiwa, "Reading Paul Gauguin's *Noa Noa* with Epeli Hau'ofa's *Kisses in the Nederends*: Militourism, Feminism, and the 'Polynesian' Body," in *Inside Out: Literature, Cultural Politics, and Identity in the New Pacific*, ed. Vilsoni Hereniko and Rob Wilson (Lanham, Md.: Rowman & Littlefield, 1999).

40. Margaret Melkin and Andrew Melkin, "This Magnificent Accident: Interview with Witi Ihimaera," *The Contemporary Pacific* 16, no. 2 (2004): 362.

41. Makiko Kuwahara, "Multiple Skins: Space, Time and Tattooing in Tahiti," in *Tattoo: Bodies, Art, and Exchange in the Pacific and the West*, ed. Nicholas Thomas et al. (Durham, N.C.: Duke University Press, 2005), 33.

42. Ngahuia Te Awekotuku, "Maori: People and Culture" in *Maori Art and Culture*, ed. D.C. Starzecka (Auckland: David Bateman, 1996), 27.

43. Petelo Sulu'ape, "History of Samoan Tattooing," *Tattootime* 5 (1991): 107 (hereafter cited as "History").

44. Mrs. Favell L. B. Mortimer, *The Night of Toil; or, a Familiar Account of the Labors of the First Missionaries in The South Sea Islands* (New York: American Tract Society, circa 1838). Hereafter cited as *Toil*. No publication date is given in the book, but the author notes that she is recounting the story of the first forty years of the Christian missions in Tahiti, the first of which began in 1796. In the Huntington Library's copy of *The Night of Toil* a curator identifies in a penciled-in note that the book was published in the nineteenth century, but does not specify a date.

45. Matt Matsuda, *Empire of Love: Histories of France and the Pacific* (New York: Oxford University Press, 2005), 94.

46. Karl von den Steinen, *Die Marquesaner und ihre Kunst: Studien über die Entwicklung primitiver Südseeornamentik nach eigenen Reiseergebnissen und dem Material der Museen* (New York: Hacker, 1969), 1:95. Translation mine.

47. Epeli Hau'ofa, "Our Sea of Islands," in *A New Oceania: Rediscovering Our Sea of Islands*, ed. Eric Wadell, Vijay Naidu, and Epeli Hau'ofa (Suva, Fiji: University of the South Pacific, Beake House, 1993), 7. Against the colonial accounts that evacuate longstanding histories and practices of voyaging, and that are still used to support

models of economic dependence and island isolation, in the sea of islands the ocean forms not a barrier that separates islands but seaways that join them.

48. *Stigma* 4, 7, 11; Alfred Gell, *Wrapping in Images: Tattooing in Polynesia* (Oxford: Clarendon Press, 1993), 67 (hereafter cited as *Wrapping*).

49. Herman Melville, *Typee: A Peep at Polynesian Life* (Evanston, Ill.: Northwestern University Press, 1968), 220.

50. George Vason, *An Authentic Narrative of Four Years' Residence at Tongataboo, one of the Friendly Islands, in the South-Sea by—Who went thither in the Duff, under Captain Wilson, in 1796. With an appendix, by an eminent writer* [Solomon Pigott] (London: Longman, Hurst, Rees, and Orme, 1810), 179.

51. E. B. Tylor, *Primitive Culture* (New York: Harper, 1958).

52. Adolf Loos, "Ornament und Verbrechen," *Sämtliche Schriften* (Vienna: Verlag Herold, 1962), 1:276.

53. Albert Parry, *Tattoo: Secrets of a Strange Art as Practiced among the Natives of the United States* (New York: Simon & Schuster, 1933), 21–22 (hereafter cited as *Secrets*).

54. John Briggs, "Tattooing," *Medical Times* 87, no. 8 (1959): 1038–39.

55. Lisa Kahaleole Chang Hall and J. Kehaulani Kauanui, "Same-Sex Sexuality in Pacific Literature," in *Asian American Sexualities: Dimensions of the Gay and Lesbian Experience*, ed. Russell Leong (New York: Routledge, 1996), 114.

56. Lee Wallace, *Sexual Encounters: Pacific Texts, Modern Sexualities* (Ithaca, N.Y.: Cornell University Press, 2003), 140.

57. Epeli Hau'ofa, *Kisses in the Nederends* (Honolulu: University of Hawai'i Press, 1995).

NOTES TO CHAPTER 1

1. Albert Wendt, "The Cross of Soot," in *Flying Fox in a Freedom Tree and Other Stories* (Auckland: Penguin, 1988), hereafter cited as "Cross."

2. Sia Figiel, *They Who Do Not Grieve* (Auckland: Vintage, 1999), hereafter cited as *Grieve*.

3. Samoan works that present completed tattoos include Wendt's *The Mango's Kiss*, a story by Emma Kruse Va'ai, and a story by Mabel Fuatino Barry.

4. This chapter thus takes up the conversation Nikki Sullivan calls for in her consideration of "the ways in which identity and difference are constituted in culturally and historically specific ways." Sullivan, *Tattooed Bodies: Subjectivity, Textuality, Ethics, and Pleasure* (Westport, Conn.: Praeger, 2001), 185. Sullivan's *Tattooed Bodies* presents detailed readings of theories (criminological, psychoanalytic, metaphysical, ethical) that might apply to tattooed bodies, along with brief readings of portrayals of tattoo. Her book thus leaves open the possibility of examining the specific cultures and histories (whether in Oceania, the United States, or Australia) that shape identity and difference in tattoos.

5. Alfred Gell, *Wrapping in Images: Tattooing in Polynesia* (Oxford: Clarendon Press, 1993), 67 (hereafter cited as *Wrapping*).

6. Tattooing tools more than three thousand years old have been discovered with pieces of Lapita pottery figures, including some that may bear tattoo designs. Sean Mallon and Uili Fecteau, "Tatau-ed: Polynesian tatau in Aotearoa," *Pacific Art Niu Sila*, ed. Sean Mallon and Pandora Fulimalo Pereira (Wellington: Te Papa Press, 2002), 21–22 (hereafter cited as "Tatau-ed"). The Lapita culture is a forerunner of cultures that anthropologists would later term Polynesian.

7. The term *tatau* appears in the Samoan, Tahitian, and Tongan languages. Transliterated, it forms the English word *tattoo* as well as the German *Tätowierung* and the French *tatouage*. In Samoan *tatau* is used to indicate both the singular and the plural forms (*tattoo* and *tattoos*).

8. In an early and significant example of working against these categories, Roger Robinson declares that Albert Wendt's work demands "a much more agile response from his readers than is implied in simplistic views of him as anti-colonial propagandist or Third World Classic." Robinson, "Albert Wendt: An Assessment," in *Readings in Pacific Literature*, ed. Paul Sharrad (Wollongong, Australia: New Literatures Research Centre, University of Wollongong, 1993), 172.

9. Paul Sharrad, "Wrestling with the Angel: Pacific Criticism and Harry Dansey's *Te Raukura*," in *Inside Out: Literature, Cultural Politics, and Identity in the New Pacific*, ed. Vilsoni Hereniko and Rob Wilson (Lanham, Md.: Rowman & Littlefield, 1999), 322 (hereafter cited as *Inside Out*).

10. Selina Tusitala Marsh, "Theory 'versus' Pacific Islands Writing: Toward a *Tama'ita'i* Criticism in the Works of Three Pacific Islands Woman Poets," in *Inside Out*, 338.

11. Epeli Hau'ofa, "Our Sea of Islands" in *A New Oceania: Rediscovering Our Sea of Islands*, ed. Eric Wadell, Vijay Naidu, and Epeli Hau'ofa (Suva, Fiji: University of the South Pacific, Beake House, 1993), 16.

12. Jacques Lacan, *The Four Fundamental Concepts of Psycho-analysis*, ed. Jacques-Alain Miller, trans. Alan Sheridan (New York: Norton, 1978) (hereafter cited as *Psycho-analysis*).

13. Albert Wendt, "Tatauing the Post-Colonial Body," *SPAN* 42–43 (1996): 16 (hereafter cited as "Tatauing").

14. Augustin Krämer, *The Samoa Islands*, trans. Theodore Verhaaren (Honolulu: University of Hawai'i Press, 1995) (hereafter cited as *Samoa*).

15. Mead notes, "The high chief's son is circumcised and tattooed with ceremony, the sons of talking chiefs being called in to share his pain." Margaret Mead, *Coming of Age in Samoa* (New York: Morrow, 1973), 13.

16. Carl Marquardt, *The Tattooing of Both Sexes in Samoa*, trans. Sibyl Ferner (Papakura: McMillan, 1984), 21 (hereafter cited as *Both Sexes*).

17. In Samoa, giving and receiving *tatau* continued unabated throughout colonial administrations. "Tattooing," a United States anthropologist reported in 1924, a time when conventional history suggests that other Pacific tattoo had declined, "is practiced today in Samoa in the old native fashion, and far more generally; for, with the relaxation of ancient rigid laws of class distinction, designs which were once the exclusive possession of the chiefly class may now be worn by any man capable of paying for them." Willowdean Chatterson Handy, "Samoan Tattooing,"

in E. S. Craighill Handy and W. C. Handy, *Samoan House Building, Cooking, and Tattooing* (Honolulu: Bishop Museum, 1924), 21 (hereafter cited as "Samoan"). Payment included building a special structure for the *tatau* work, housing and feeding the artist and the artist's family during the entire operation (sometimes lasting six months), and giving the artist fine mats and other treasured articles ("Samoan," 22). In 1899 Marquardt reports the tattoo as taking up to three months (*Both Sexes*, 10).

18. "Tatauing," 23; see also Malama Meleisea et al., "German Samoa 1900–1914," in *Lagaga: A Short History of Western Samoa*, ed. Malama Meleisea and Penelope Schoeffel Meleisea (Suva, Fiji: University of the South Pacific Press, 1987), 119. The word *mau* means "opinion" and invokes in the first instance the opinion of Pule and in the second Samoan public opinion. Before achieving political independence in 1962, the islands known as Western Samoa were governed by, in addition to chiefs and traditional councils, a New Zealand administration under a League of Nations mandate. Before World War I these islands were claimed by Germany. A United States naval administration governed the islands still known as American Samoa and now termed an unincorporated and unorganized territory of the United States. In 1997, Western Samoa officially changed its name to Samoa. See Malama Meleisea, *The Making of Modern Samoa* (Suva, Fiji: Institute of Pacific Studies of the University of the South Pacific, 1987), 142.

19. In this way, the tattoos discussed here contradict Blanchard's contention that tattoos "are the mark of the colonized other: the difference between the colonizer and the colonized is in the texture of the skin"; quoted in Margo DeMello, *Bodies of Inscription: A Cultural History of the Modern Tattoo Community* (Durham, N.C.: Duke University Press, 2000), 44. In the Pacific, the skin's texture changes dramatically in Māori *moko*: a traditional chisel carves the design into the skin, forming grooves deep enough to lay a pin in them (Yates quoted in Linda Waimarie Nikora, Mohi Rua, and Ngahuia Te Awekotuku, "Wearing Moko: Maori Facial Marking in Today's World," in *Tattoo: Bodies, Art, and Exchange in the Pacific and the West*, ed. Nicholas Thomas et al. [Durham, N.C.: Duke University Press, 2005], 192 [hereafter cited as *Tattoo*]). In Wendt's and Figiel's works, *tatau* function as a mark not of the colonized other but of Samoan authority.

20. Jane Caplan, *Written on the Body: The Tattoo in European and American History* (Princeton, N.J.: Princeton University Press, 2000), hereafter cited as *Written*.

21. Tagi is well named: *tagi* means, when used as a verb, "to cry" and, as a noun, "a claim." At the first sight of Tagi, the boy sees that he has been crying; and, as the boy understands it, Tagi's tattoo gift makes a claim on the boy. In his 1899 study of Samoan tattooing, Marquardt suggests that the term *toluse* ("Cross"), but not the pattern it designates, is new (*Both Sexes*, 30).

22. One anthropologist studying colonial-era accounts deems that *tatau* "was explicitly seen as the culmination, or finalization, of the separation of birth" (*Wrapping*, 73). This statement must be revised to account for the collective subject and ongoing subject formation that tattoo inaugurates. Further, the anthropologist does not treat tattooing as a living art; he suggests that it was practiced historically in Polynesian

societies because "these are societies which are dominated by criminals, soldiers, and prostitutes, not societies which repress them" (*Wrapping*, 19).

23. Tattooing as penalty has a long history. For the ancient Greeks and Romans, Jones notes, tattooing was utilitarian and signaled degradation; C. P. Jones, "*Stigma*: Tattooing and Branding in Graeco-Roman Antiquity," *Journal of Roman Studies* 77 (1987): 143. As a counterpractice, prisoners have tattooed themselves. The association between tattooing and criminality has long been studied by social scientists, some of whom perceive a causal or predictive link between the two practices. After Pope Hadrian's legates to Britain officially discouraged tattoo among Christians in 786 CE, tattooing on the European continent declined, until people in the Crusades began tattooing to commemorate the trip to the Holy Land.

24. Franz Kafka, "In the Penal Colony," in *The Penal Colony*, trans. Willa Muir and Edwin Muir (New York: Schocken, 1948).

25. Michel Foucault, *Discipline and Punish: The Birth of the Prison*, trans. Alan Sheridan (New York: Vintage, 1979), 15.

26. Though it is not his focus, Sharrad notes the importance, in Wendt's thinking, of "tattoo—sign of belonging, identity, textuality, sexuality, performance, cultural renovation." Paul Sharrad, *Circling the Void: Albert Wendt and Pacific Literature* (Auckland: Auckland University Press, 2003), 19.

27. Gayatri Chakravorty Spivak, "The Burden of English," in *Orientalism and the Postcolonial Predicament*, ed. Carol A. Breckenridge and Peter van der Veer (Philadelphia: University of Pennsylvania Press, 1993), 149.

28. Vilsoni Hereniko, *Art in the New Pacific* (Suva, Fiji: Institute of Pacific Studies, 1980), 71.

29. In an interview with Subramani, Figiel notes that her first two books, *Where We Once Belonged* and *The Girl in the Moon Circle*, "were written as performance pieces." Subramani, "Interview [with Sia Figiel]," in Sia Figiel, *The Girl in the Moon Circle* (Suva, Fiji: Mana Publications, 1996), 121 (hereafter cited as *Moon Circle*). Figiel observes, further, "The oral and written traditions exist in many ways on pluralistic planes. However, as a performance poet who has access to writing, I've tried as much as possible in my work to merge the two so that they become one" (123). *The Girl in the Moon Circle* in particular presents speech that breaks into writing. See also Sina Vaʻai, *Literary Representations in Western Polynesia* (Apia: National University of Samoa, 1999), 137.

30. G. B. Milner, *Samoan Dictionary* (Auckland: Polynesian Press, 1993), 223.

31. Juniper Ellis, "Moving the Centre: An Interview with Sia Figiel," *World Literature Written in English* 37, nos. 1–2 (1998): 141–42.

32. Lynch's and Hunkin's works confirm this grammatical principle. To describe the close relation between possessor and possessed conveyed in the personal-noun form, Lynch uses the terms "close," "subordinate," and "inalienable"; to describe the impersonal-noun relation to the possessor, he uses "remote," "dominant," and "alienable." John Lynch, *Pacific Languages: An Introduction* (Honolulu: University of Hawaiʻi Press, 1998), 122–23; Galumalemana Afeleti L. Hunkin, *Gagana Samoa: A Samoan Language Coursebook* (Auckland: Polynesian Press, 1992).

33. *Psycho-analysis*, 141. Lacan offers his definition to distinguish his idea of the subject from the Cartesian one. Here the *cogito* becomes almost ridiculous, presented as the "monster or homunculus," and "the celebrated little fellow who governs [the subject], who is the driver" (ibid.).

34. As has been noted elsewhere, particularly in reference to his discussion of the phallus (see, for example, Judith Butler, *Bodies That Matter: On the Discursive Limits of "Sex"* [New York: Routledge, 1993], 73–84), Lacan uses a topographic figure that is both metaphoric and material. As Fleming notes, Lacan also presents an imaginary tattooed penis, which stands in for "the gaze as such." Juliet Fleming, "The Renaissance Tattoo," in *Written*; see the notes on page 272. Figures that describe tattooing are also metaphoric and material. See Gell's treatment of tattooing as a "dermatological complaint" or "somatic illness" that warrants an "epidemiological" study (*Wrapping*, 18–20).

35. Sia Figiel, *Where We Once Belonged* (Auckland: Pasifika, 1996), 138 (hereafter cited as *Where*).

36. Using the terms "sociocentric" and "egocentric," Mageo makes a related point in her psychological ethnography; Jeannette Marie Mageo, *Theorizing Self in Samoa* (Ann Arbor: University of Michigan Press, 1998), 19.

37. Captain David Porter, *Journal of a Cruise* (Annapolis, Md.: Naval Institute Press, 1986), 294.

38. Greg Dening, *Islands and Beaches: Discourse on a Silent Land, Marquesas, 1774–1880* (Chicago: Dorsey, 1980), 160.

39. Herman Melville, *Typee: A Peep at Polynesian Life* (Evanston, Ill.: Northwestern University Press, 1968).

40. James F. O'Connell, *A Residence of Eleven Years in New Holland and the Caroline Islands*, ed. Saul H. Riesenberg (Honolulu: University of Hawai'i Press, 1972), 109–10 (hereafter cited as *Residence*).

41. Steve Gilbert, *Tattoo History: A Sourcebook* (New York: Juno, 2000), 136.

42. O'Connell's tattoos seem to substantiate the suggestion that "Western tattoos in particular literalize this vision of the body as a surface or ground onto which patterns of significance can be inscribed"; Frances E. Mascia-Lees and Patricia Sharpe, "The Marked and the Un(re)marked: Tattoo and Gender in Theory and Narrative," in *Tattoo, Torture, Mutilation, and Adornment: The Denaturalization of the Body in Culture and Text* (Albany: SUNY Press, 1992), 147. In his account, though, tattoos mean more in the performances they inspire than in their original inscription.

43. *Residence*, 43.

NOTES TO CHAPTER 2

1. Herman Melville, *Moby-Dick*, ed. Hershel Parker, Harrison Hayford, and G. Thomas Tanselle (Evanston, Ill.: Northwestern University Press, 1988).

2. George Lillie Craik, *The New Zealanders* (London: Charles Knight, 1830), hereafter cited as *New Zealanders*.

3. Herman Melville, *Moby-Dick*, ed. Hershel Parker and Harrison Hayford (New York: Norton, 2002), hereafter cited as *Critical Edition*.

4. Claude Lévi-Strauss, *Structural Anthropology*, trans. Claire Jacobson and Brooke Grundfest Schoepf (New York: Basic Books, 1963).

5. It is even possible, given extensive Māori genealogical knowledge, that the *Tohunga tā moko* who created Te Pehi Kupe's tattoo will one day have his or her name attached to this design.

6. H. W. Williams, *Dictionary of the Maori Language* (Wellington: Government Printer, 1992), 427, 407 (hereafter cited as *Maori Language*). I cite specific quotations in my discussion, but I want to acknowledge also that works by Hamilton and Roth collate earlier accounts to form the basis of a genealogy of design, which I draw upon extensively here. Hamilton and Roth in turn follow in the tracks of Taylor (1855), Shortland (1851), and William Marsh Te Rangikaheke (before 1853).

7. Ray quoted in H. Ling Roth, "Maori Tatu and Moko," *Journal of the Anthropological Institute of Great Britain and Ireland* 31 (1901): 64 (hereafter cited as "Maori Tatu").

8. Hans Neleman, *Moko: Maori Tattoo* (Zurich: Edition Stemmle, 1999), 129 (hereafter cited as Neleman).

9. Captain James Cook's naturalist, Joseph Banks, writes of *moko*, "All these finishd [*sic*] with a masterly taste and execution, for of a hundred which at first sight you would judge to be exactly the same, on a close examination no two will prove alike." Joseph Banks, *The* Endeavour *Journal of Joseph Banks, 1768–1771*, ed. J. C. Beaglehole (Sydney: Angus and Robertson, 1963), 2:14 (hereafter cited as *Endeavour Journal*).

10. The circinate coil, a scroll form of the spiral pattern that predominates in Māori design, appears to derive its shape from the *pītau* or *fern frond;* "Maori Tatu" 57; Hirini Moko Mead, *Te Toi Whakairo: The Art of Maori Carving* (Auckland: Reed, 1995), 237 (hereafter cited as *Te Toi*).

11. *Moko* designates both singular and plural forms (the definite article changes to indicate number, as in *te moko*, the tattoo, or *ngā moko*, the tattoos; sometimes the vowel length also changes to indicate the plural). An art historian further clarifies the appropriate terminology: "*Ta moko* is the process; *moko* is the product." Ngahuia Te Awekotuku, "Maori: People and Culture," in *Maori Art and Culture*, ed. D. C. Starzecka (Auckland: David Bateman, 1996), 40.

12. Some contemporary presentations of *moko* continue to separate facial *moko* from the body of Māori culture, and some connect the practice to its living culture. Neleman's *Moko—Maori Tattoo* (1999), for instance, presents stunning photographs of tattoos but separates them from the stories and genealogies that give them meaning (these stories, but for brief excerpts, appear in small print in the book's appendix). Hatfield and Steuer's *Dedicated by Blood / Whakautu ki te toto* (2002), on the other hand, perhaps because one of its coauthors is the well-known *Tohunga tā moko* or "tattoo expert or priest" Gordon Toi Hatfield, connects the practice to the living Māori culture it both reflects and shapes.

13. D. R. Simmons, *Ta Moko: The Art of Maori Tattoo* (Auckland: Reed, 1986), 30 (hereafter cited as *Art of Maori Tattoo*).

14. Hamilton thus declares, "The real patterns on the face are the spaces, not the lines." Augustus Hamilton, *Maori Art* (London: Holland Press, 1972), 308 (hereafter cited as *Maori Art*).

15. Terms such as "anchor koru" and "scroll" pattern are modified versions of Roth's terms, and have entered the lexicon of *moko* scholars, becoming in later works standard names for such patterns.

16. Witi Ihimaera, ed., *Mataora: The Living Face* (Auckland: David Bateman, 1996), 126 (hereafter cited as *Mataora*). Ihimaera's full statement emphasizes the *moko* signature as a form of political power: "Yes, we now reclaim the moko for face and body as mark of mana. But in many respects it never left us. During the mid-nineteenth century Māori used their moko as signature on land deeds of ownership. The moko therefore empowers those documents in ways that may never have been realised. It is an embodiment of the Maori self transferred to paper. Despite the betrayal of the Treaty of Waitangi, moko as signature, continue to confirm our sovereignty on those old documents" (*Mataora*, 126).

17. The song's lyrics are available on the band's official website, at www.moananz.com/popups/lyrics/moko.html.

18. www.moananz.com/music.html# and "Songwriter makes mark with 'moko,'" *New Zealand Herald*, February 5, 2004.

19. The additional statements on the back cover discuss the portrait only in relation to preexisting critical rubrics: "A section on 'Whaling and Whalecraft' again features prose and graphics by John B. Putnam and a sample of contemporary whaling engravings as well as, new to this edition, 'the Original Queequeg'"; "Evoking Melville's fascination with the fluidity of categories like savagery and civilization, the cover image of Tupai Cupa fittingly introduces 'Before *Moby-Dick*: International Controversy over Melville'"; "The image of Tupai Cupa evokes Melville's fascination with the mystery of self-identity and the possibility of knowing another person's 'queenly personality' (Chapter 119). That theme (focused on Melville, Ishmael, and Ahab) is pursued in 'A Handful of Critical Challenges.'" None of these critical rubrics includes discussion of the "Tupai Cupa" portrait. The Preface restates the back cover: "The maps and items in 'Whaling and Whalecraft' have been retained from the 1967 edition, but we have now added to this section a photograph of the engraved self-portrait of the magnificently tattooed face of the real New Zealander on whom Melville modeled Queequeg" (*Critical Edition*, xii–xiii). Parker expands these comments only slightly in volume 2 of his Melville biography: Hershel Parker, *Herman Melville: A Biography*, vol. 2, *1851–1891* (Baltimore: Johns Hopkins University Press, 2002), 40 (hereafter cited as *Biography*).

20. Throughout this chapter, citations are taken from the Northwestern University Press edition of *Moby-Dick*. Historically, the tattooed ancestral heads have most often been termed *moko mōkai*. The phrase means literally "slave heads," and is avoided by many contemporary speakers of Māori, since it is viewed as disrespectful. The term *moko mōkai* may also be inaccurate, since historical accounts record purchases of chiefs' heads.

21. H. G. Robley, *Moko: The Art and History of Maori Tattooing* (London: Chapman and Hall, 1896), 171 (hereafter cited as *Art and History*).

22. The expedition purchased "two preserved heads of New Zealand chiefs" from "a missionary brig, lying at the Bay of Islands," the steward of which seemed primarily

concerned about avoiding the fifty-guinea fine that came if he were caught selling the heads. Charles Wilkes, *Narrative of the United States Exploring Expedition During the Years 1838, 1839, 1840, 1841, 1842* (New York: Putnam, 1856), 400, 399 (hereafter cited as *Narrative*). In the Smithsonian's National Museum of Natural History collection, these heads now form catalogue item numbers E276197 and E276094.

23. Writing in 1928 in a guide for visitors to the American Museum of Natural History, Margaret Mead declares, "The Museum is fortunate in having the magnificent Robley collection of preserved Maori heads, the finest collection of such heads in the world"; Margaret Mead, *The Maoris and Their Arts*, Guide Leaflet Series No. 71 (New York: American Museum of Natural History, 1928): 33. The current museum catalogue lists thirty-four tattooed heads from the Robley collection, donated by Morris K. Jesup in 1907. The museum also holds several pieces of tattooed skin that were donated as part of the Robley collection, as well as tattoo chisels and a magnificent carved wooden funnel used to give liquid food and drink to those who were receiving a *moko*.

24. Because of these attacks, Ngāti Toa migrated from Kawhia to Kapiti and Wellington before Te Pehi Kupe traveled to England (*Art of Maori Tattoo*, 65).

25. The Norton Critical Edition is not the first to find a Māori original for Queequeg. Jaffé proposes "Ko-towatowa" as he appears in Charles Wilke's *Narrative* as "the source of most of the Queequeg material in *Moby-Dick*"; David Jaffé, "Some Origins of *Moby-Dick*: New Finds in an Old Source" *American Literature* 29.3 (1957): 277 (hereafter cited as "Some Origins"). The parallels he establishes are significant but less direct than with Craik.

26. Geoffrey Sanborn, "Whence Come You, Queequeg?" *American Literature* 77, no. 2 (2005): 235 (hereafter cited as "Whence Come You").

27. The book was published with no author's name attached to it, but Craik's authorship was known by the time Robley published his study of *moko* in 1896, and in 1908, Drummond edited and published a version of Rutherford's captivity narrative, first published in Craik's book, which confirmed Craik's authorship.

28. The Society for the Diffusion of Useful Knowledge, active between 1828 and 1846, was founded to help "educate the masses" (Drummond in *New Zealanders*, n.p.). *The New Zealanders* was the second volume published in the Library of Entertaining Knowledge series.

29. Melville uses Craik in the opening chapters of the novel that feature Queequeg, particularly "Biographical" and "Wheelbarrow," before the *Pequod* sails. He does not use Craik in the later chapters where Queequeg appears (primarily "The Mat-Maker," "The Monkey-rope," and "Queequeg in his Coffin"), perhaps supporting Hayford's theory that the opening chapters were written after Queequeg's shipboard appearances (490–91). Other proponents of a multiple-stage composition theory include Barbour, who discerns "three well defined periods in the writing of *Moby-Dick*," following Stewart, who proposes, "*Moby-Dick* is tri-partite." James Barbour, "The Composition of *Moby-Dick*," *American Literature* 47, no. 3 (1975): 345; George R. Stewart, "The Two *Moby-Dicks*," *American Literature* 25, no. 4 (1954): 417. Stewart uses textual evidence internal to *Moby-Dick*; Barbour adds the examination of

external textual evidence. These scholars follow in the tracks of scholars including Olson (1947), Vincent (1949), and Howard (1952). Entirely apart from questions about compositional stages, Te Pehi Kupe and Queequeg are important textual analogues of one another.

30. *Moby-Dick*, 59. Parker also notes this inversion, which "deliberately alter[s] a source so as to upset the unthinking cultural chauvinism of his American and British readers" (*Biography*, 40).

31. *New Zealanders*, 329. While English authorities refused his requests, according to Craik, an English friend did give him "some old muskets and a brass musketoon" (*New Zealanders*, 329). *Contra* Craik, Taylor reports that the "thoughtless kindness" of people in England resulted in Te Pehi Kupe's obtaining "a large collection of guns and ammunition" (*New Zealanders*, 326). After Te Pehi Kupe's return to New Zealand, Reynolds was subsequently reimbursed £200 by the English government to cover his expenses in maintaining his Māori friend during his visit to England. Robert McNab, ed., *Historical Records of New Zealand* (Wellington: Government Printer, 1908–1914), 644 (hereafter cited as *Historical Records*). Reynolds detailed his request for reimbursement in letters to Under-Secretary Hay and Earl Bathurst, explaining that in addition to hosting Te Pehi onboard ship and in England, he had provided Te Pehi with "a considerable quantity of wearing apparel, carpenters' tools, agricultural utensils, with sundry other articles necessary for his passage out and comfort when at New Zealand" (*Historical Records*, 642). In none of his requests for reimbursement does he mention having provided muskets.

32. Melville's presentation of technology, specifically Queequeg's confession that he carried the wheelbarrow over his head the first time he used it, prompts Sanborn to identify Thomas Jefferson Jacobs's *Scenes, Incidents, and Adventures in the Pacific Ocean* as a source; Thomas Jefferson Jacobs, *Scenes, Incidents, and Adventures in the Pacific Ocean* (New York: Harper & Brothers, 1844; hereafter cited as *Scenes*). Jacobs describes Garry-Garry, a "proto-Queequeg": a "wheelbarrow took his fancy" ("Whence Come You," 235). Jaffé, on the other hand, sees the wheelbarrow scene as indebted to Wilkes's *Narrative* ("Some Origins," 277). Sanborn also identifies Jacobs's Pacific Islander character Sunday (his "native name is Telum-by-by Darco" [*Scenes*, 23]) as a Queequeg source. Jacobs presents "Darco" as a spear-thrower with impeccable aim, and a wrestler who is able to "open his arms [to his shipmates], clasp them like a bear, and, with one tender hug, lay them sprawling and discomfited on the deck" (*Scenes*, 24). Jacobs declines to disclose the location of "Nyappa," Darco's home island, where Darco becomes king.

33. *Moby-Dick*, 21. The square elements in Queequeg's tattoos are at odds with the spiral elements that predominate in Māori tattooing, which uses many of the same design motifs as carving, where "surface decoration" is "complementary to form and in harmony with it" (*Te Toi*, 227). The designs thus follow (rather than cross-cut) the contours of the human face and figure.

34. Facial *moko* designs are gender-specific; Te Pehi Kupe's follow patterns reserved almost exclusively for men, while women's tattoos, or *moko kauae*, usually adorn the chin and lips.

35. *Moby-Dick*, 56. In considering "cannibals" and "Christians," Melville thus makes explicit the logic of Craik's account, which has Dr. Traill trying to explain "the Great Spirit in Heaven" to Te Pehi (*New Zealanders*, 330).

36. Hirini Moko Mead, "The Nature of Taonga," in *Taonga Maori Conference*, (Wellington: Cultural Conservation Advisory Council, Department of Internal Affairs, 1992), 166 (hereafter cited as "Taonga").

37. In a Māori context the heads were viewed in one of two ways: in a deeply sacrosanct, respectful way, used to preserve close relationship with a dead loved one or leader; or alternatively, were captured in battle to show one's ascendancy over the enemy. (Even taking an enemy's head was acknowledgment of the enemy's power.) The U.S. and European markets for these heads changed these practices: "They have now (1830) ceased altogether to preserve the heads of their friends, lest by any means they should fall into the hands of others and be sold"; Yates quoted in Augustus Hamilton, *Maori Art* (London: Holland Press, 1972), 309 (hereafter cited as *Maori Art*). Instead, to supply the market, slaves increasingly began to be killed, and their heads preserved. Sometimes the tattoo was applied to these heads after death. In one dramatic account published in 1840, "The chief offered to tattoo a slave and have the head ready in three days, the price being a cask of powder" (*Maori Art*, 310).

38. Robley states that the English Captain Stewart later entered into a bargain to avenge Te Pehi's death: "On the promise of a cargo of flax," he used his ship to help attack the tribe responsible for killing Te Pehi. In the course of this action, "500 baskets of human flesh" were brought on board and "the ship's coppers were used to prepare the cannibal feast. Stewart on returning failed to obtain payment for these services" (*Art and History*, 16–17). Taylor reports that Stewart did receive payment for these services, including "twenty-five tons of flax" and "Divine justice" for his part in the bloodshed (that is Taylor's interpretation of Stewart's ship's vanishing soon thereafter); Richard Taylor, *Te Ika a Maui, or New Zealand and its Inhabitants* (London: Wertheim and MacIntosh, 1855), 329 (hereafter cited as *Te Ika a Maui*).

39. Geoffrey Sanborn, *The Sign of the Cannibal: Melville and the Making of a Postcolonial Reader* (Durham, N.C.: Duke University Press, 1998), 133, 130 (hereafter cited as *Sign of the Cannibal*). Similarly, it is necessary to revise the assessment that "in his punch line—I thought you'd know that anyone carrying a head around would have to be a cannibal—Coffin is assuming, in mockery, a 'greenness' so intense that it outgreens Ishmael" (*Sign of the Cannibal*, 133).

40. Despite the importance of the copy, it is not identical with the original, an assumption implicit in Leiter's claim that "Queequeg, dead, lives on in the form of the coffin." Lois Leiter, "Queequeg's Coffin," *Nineteenth-Century Fiction* 13, no. 3 (1958): 254.

41. Michael Paul Rogin, *Subversive Genealogy: The Politics and Art of Herman Melville* (Berkeley: University of California Press, 1979), 116. In *American Hieroglyphics*, John Irwin suggests that Queequeg's "condition is literally hieroglyphic"; John Irwin, *American Hieroglyphics: The Symbol of the Egyptian Hieroglyphics in the American Renaissance* (New Haven: Yale University Press, 1980), 285 (hereafter cited as

Hieroglyphics). Rather than standing only for the "inherently indecipherable character of the hieroglyph" (ibid.), though, Melville's presentation of tattoo indicates that he does not possess an Oceanic Rosetta stone that will divulge translations.

42. Lévi-Strauss obtains his version of the self-portrait, whose artist he does not name, from Robley, who in turn reproduces the image from Craik, even though Robley cites an edition that could not contain the self-portrait. Robley cites an 1824 edition, which I have been unable to locate. If it exists, it was published before Te Pehi Kupe's 1826 visit to England. Again, problems arise with attributing singularity to any source or original.

43. For another reading of *moko* as mask, see Roussos's discussion of contemporary Māori writer Alan Duff's novel *Both Sides of the Moon*. Timotheos Roussos, "A Man's 'True Face': Concealing / Revealing Masculinities in Novels by Alan Duff and Witi Ihimaera," *Philament* 5 (2005): n.p. (hereafter cited as "True Face"). Roussos suggests that in Duff's novel, Kapi's "*ta moko* remains unchanged, but its function as a mask shifts as it conceals and reveals different aspects of his changing identities" ("True Face"). (As noted previously, *tā moko* actually refers to the process of chiseling the pattern into the face, while *moko* refers to the product.) The traditional *moko* did not function as mask but as face; in other words, it revealed much more than it concealed. If Duff portrays *moko* as mask, it is because he focuses on the way Kapi's facial designs are read in differing situations: by his own *iwi* or tribe, by the community of outcasts, and by the newly arrived Pakeha settlers. As in *Once Were Warriors*, Duff gives meaning to the full facial *moko* only insofar as it represents the past. The character Mihi, who serves as a voice of interpretive authority in the novel, suggests that the *moko* represents superficial adornment—that is, until the settlers arrive, at which point the designs become unique, representing the past; Alan Duff, *Both Sides of the Moon* (Auckland: Vintage, 1998); *Once Were Warriors* (New York: Vintage, 1995).

44. Henriata Nicholas, with Ngahuia Te Awekotuku, "*Uhi Ta Moko*—Designs Carved in Skin," in *Beyond Words: Reading and Writing in a Visual Age*, ed. John Ruszkiewicz, Daniel Anderson, and Christy Friend (New York: Pearson Longman, 2006), 159.

45. Only in treating the designs as pure form can it be said that in split representation "the actor himself is dissociated." (The formulation, indeed, enacts a kind of death of the artist.) The passive voicing of the sentence masks an active intervention on the anthropologist's part: only in Lévi-Strauss's discussion (and book publication) is the actor dissociated.

46. Roger Neich, *Painted Histories: Early Maori Figurative Painting* (Auckland: Auckland University Press, 1993), 90.

47. Steven Oliver, "Te Pehi Kupe" in *Dictionary of New Zealand Biography*, updated 19 July 2002. www.ngatitoa.iwi.nz/te_pehi.htm. Accessed 15 November 2004. Carkeek makes clear that Te Pehi Kupe's death occurred in the context of ongoing wars between rival tribes, but its immediate cause may have been this insult of a Ngāi Tahu chief's *moko*; Wakahuia Carkeek, *The Kapiti Coast: Maori History and Place Names* (Wellington: Reed, 1966), 28. Smith gives Te Pehi Kupe's last words as

"Kaua e hoatu ki te atua, me homai ki te Kaka-kura," or "Do not give it to the god, but the Kaka-Kura," the meaning of which is unclear. S. Percy Smith, *History and Traditions of the Maoris of the West Coast: North Island of New Zealand Prior to 1840* (New Plymouth: Thomas Avery, 1910), 440.

NOTES TO CHAPTER 3

1. Joseph Banks, *The* Endeavour *Journal of Joseph Banks, 1768–1771*, ed. J. C. Beaglehole (Sydney: Angus and Robertson, 1963), 2:24 (hereafter cited as *Endeavour Journal*).

2. The Banks quotations and many of the Duff quotations depart from modern spelling conventions. The quotations in this chapter have been checked carefully against the Banks and Duff narratives; what a modern reader would consider misspellings are not marked with [*sic*], a notation that would occur with such frequency that it would interrupt the discussion.

3. Ngahuia Te Awekotuku, "More Than Skin Deep: *Ta Moko* Today," in *Claiming the Stones, Naming the Bones*, ed. Alazar Barkan and Ronald Bush (Los Angeles: Getty Research Institute, 2002), 251.

4. Michael King, *Moko: Maori Tattooing in the 20th Century* (Auckland: David Bateman, 1999). No page number given; this quotation appears in chapter two.

5. Gordon Toi Hatfield and Patricia Steuer, *Dedicated by Blood/Whakautu ki te toto* (The Hague: Hunter Media, 2002), 5 (hereafter cited as *Dedicated*). The book, created with photographer Patricia Steuer, opens with a *Karakia* or *prayer* in Māori, which protects the images of *moko* as they travel into the world.

6. Ngahuia Te Awekotuku, "Ta Moko: Culture, Body Modification, and the Psychology of Identity," in *Proceedings of the National Māori Graduates of Psychology Symposium 2002*, ed. Linda Waimarie Nikora et al. (Hamilton, New Zealand: University of Waikato, 2003), 123 (hereafter cited as *Māori Graduates*). Summing up the import of tattooing, Gathercole invokes a different register, suggesting that the *moko* represents "the ideal social personality, i.e., the ancestor." Peter Gathercole, "Contexts of Maroi [*sic*] *Moko*" in *Marks of Civilization*, ed. Arnold Rubin (Los Angeles: Museum of Cultural History, UCLA, 1988), 176.

7. Margaret Meklin and Andrew Meklin, "This Magnificent Accident: Interview with Witi Ihimaera," *The Contemporary Pacific* 16, no. 2 (2004): 362.

8. Tame Wairere Iti, "Perspectives," in *Moko: Maori Tattoo*, ed. Hans Neleman, (Zurich: Edition Stemmle, 1999), 8.

9. Te Awekotuku notes that the Māori Arts and Crafts Institute, which, among other things, trains men in carving and women in weaving, meets "the need to continue traditional art forms within a creatively dynamic environment." Ngahuia Te Awekotuku, "Maori Culture and Tourist Income" in *Pacific Tourism as Islanders See It*, ed. Freda Rajotte and Ron Crocombe (Suva, Fiji: Institute of Pacific Studies, University of the South Pacific, 1980), 158. Māori come from around the country to learn at the institute. Even though his novel presents characters who initially have no connection to culture, in an interview, Duff notes that his own relations tutor at

the institute, and cites the institute representatives as his novels' "staunchest supporters": "All my books are compulsory study there." Vilsoni Hereniko, "An Interview with Alan Duff," *The Contemporary Pacific* 7, no. 2 (1995): 334 (hereafter cited as "Interview").

10. Duff does not specify who rapes Grace. She thinks, "Can't tell who it is, only that it's a man," and wonders if it is her father, implicating Jake in her notebook. Alan Duff, *Once Were Warriors* (New York: Vintage, 1995), 84 (hereafter cited as *Warriors*). The film exonerates Jake for the viewer because the rapist is visible as Uncle Bully, one of her father's friends.

11. Carroll Du Chateau, "Aggro Culture," *Quote Unquote* 11 (1994): 15. *Once Were Warriors* continues to sell well in its home market, making the 2004 list of the top twenty bestselling New Zealand books in New Zealand, with more than 81,000 copies sold. "The Top 20 Bestselling New Zealand Books," *Listener* 193 (May 15–21, 2004), www.listener.co.nz/default,1947.sm, accessed 12 January 2005.

12. Peter Beatson, "Review of *Once Were Warriors*," *Landfall* 179 45, no. 3 (1991): 266.

13. Finlay Macdonald, "A Tale of Two Lakes," *Listener* 129 (1991): 31 (hereafter cited as "Two Lakes").

14. To sum up the critiques, a few representative statements from scholars assessing the cultural politics of Duff's novel: "The really interesting—and unremarked—fact about *Once Were Warriors* is that it can seem an ideologically regressive text," one that "refuses to link the demoralization and degradation of the Maori to the effects of an historically evident, ruthless, and continuous process of European colonization"; Bruce Harding, "Wrestling with Caliban: Patterns of Bi-racial Encounter in *Colour Scheme* and *Once Were Warriors*," *Australian & New Zealand Studies in Canada* 7–8 (1992): 137. "No one could be less representative of Maori writing and politics thus far, nor more problematic from almost any perspective"; Christina A. Thompson, "In Whose Face? An Essay on the Work of Alan Duff," *The Contemporary Pacific* 6, no. 2 (1994): 399. "The sheer force of the book's negativity makes the operation of anti-idealization visible, and thus potentially redundant"; Nicholas Thomas, "Gender and the Politics of Tradition: Alan Duff's *Once Were Warriors*," *Kunapipi* 15, no. 2 (1993): 66 (hereafter cited as "Gender").

15. Alan Duff, *Maori: The Crisis and the Challenge* (Auckland: Tandem, 1993), xi.

16. Ed Rampell, "The Angry Warrior," *Pacific Islands Monthly* 64, no. 12 (1994): 47.

17. Brown analyzes the scholarly reception of Duff. Her title, "Pakeha, Maori, and Alan," encapsulates her claim that because of his nonfiction pronouncements, Duff has been deemed an outsider to both Pakeha and Māori literary traditions. Pakeha refers to whites in Aotearoa/New Zealand and is a neutral term used by both Māori and Pakeha. *Pakeha* means *stranger* or *other*, while the term *Māori* means *ordinary* or *real*. The contemporary terms Māori and Pakeha thus come into being in relation to one another. Only with the arrival of the whites, or strangers, did the idea of a single "Māori people" originate. Prior to that time, people knew themselves by their kinship and tribal groupings; some still refer to the concept of a "Māori people" as a strategic fiction—sometimes useful and sometimes problematic.

18. Frantz Fanon, *The Wretched of the Earth*, trans. Constance Farrington (New York: Grove, 1963), 222 (hereafter cited as *Wretched*).

19. *Once Were Warriors*, 144. The novel offers this comment in presenting tattoos worn by Nig's girlfriend Tania, which are in the book not specified as traditional Māori tattoos. Departing from this aspect of the book, the film presents Tania as wearing a *moko kauae*, a woman's chin *moko*. In the film, however, Tania does not speak.

20. John Bright, *Hand-Book for Emigrants, and Others, Being a History of New Zealand* (London: Henry Hooper, 1841), 77.

21. In his later novel *Both Sides of the Moon* (1998), Duff uses almost identical language to describe the *moko* of the past: "These markings were endured without cry," Te Aranui Kapi recalls proudly, "Not one sound of pain, not in the days and days of tohunga tattooist hammering and chiselling them." Alan Duff, *Both Sides of the Moon* (Auckland: Vintage, 1998), 193.

22. The phrase "Māori head" rather than Māori portrait also suggests that the design may be taken from a *toi moko*, or tattooed ancestral head.

23. *Warriors*, 183. In her introduction to her poetry collection, *Tatau*, which honors the culture of Rarotonga, Jean Tekura Mason also emphasizes the deeply etched quality of traditional *tatau*. She notes, "With the *tatau* came *mana*, strength and pride but in the end, beautiful though they may be, for the body they are but a scar." Jean Tekura Mason, *Tatau (Tattoo)* (Suva, Fiji: Mana Publications in association with Institute of Pacific Studies, University of the South Pacific, 2001), v.

24. Peter Jackson's *Lord of the Rings* trilogy was financed by New Line Cinema, a division of Time Warner, while *Once Were Warriors* received backing from the New Zealand Film Commission and New Zealand On Air.

25. It is also worth noting that the book itself, while received as a departure from previous depictions of Māori life, builds upon such works as *Electric City*, Patricia Grace's portrayal of urban Māori children who are materially poor.

26. *What Becomes of the Broken Hearted?* press kit (Sydney: Beyond Films, 1999), 14 (hereafter cited as press kit). East, like Moana and Taylor, filled the same role for the film's sequel, Ian Mune's *What Becomes of the Broken Hearted?* That work is based upon Duff's novel-sequel of the same name. Duff's Heke family trilogy also includes the novel *Jake's Long Shadow*.

27. Sir Peter Buck, *The Coming of the Maori* (Wellington: Maori Purposes Fund Board, Whitcombe and Tombs, 1966), 299 (hereafter cited as *The Coming*).

28. H. W. Williams, *Dictionary of the Maori Language* (Wellington: Government Printer, 1992), 429. In setting the film in Auckland and changing the name of Nig Heke's gang from the Brown Fists to *Toa*, or warriors, Tamahori may associate the gang with Nga Tamatoa, an historical 1970s movement for Māori sovereignty, whose name appears in prominent graffiti at the film's outset. The phrase Nga Tama Toa, or "the young warriors," is emblazoned on a car hulk, next to which Grace reads a story she has written to her younger siblings.

29. Stephen Turner, "Sovereignty, or the Art of Being Native," *Cultural Critique* 51 (2002): 85 (hereafter cited as "Sovereignty").

30. Nicholas Thomas, *Possessions: Indigenous Art/Colonial Culture* (London: Thames & Hudson, 1999), 237.

31. "Security Man." *Massey* 13 (November 2002), http://masseynews.massey.ac.nz/magazine/2002_Nov/stories/security_man.html. Accessed 13 December 2004 (hereafter cited as "Security Man").

32. Puawai Cairns, "He Taonga te Ta Moko ki Tauranga Moana: A Survey of Attitudes, Opinions, Whakāro noa iho, Towards Ta Moko During the Tauranga Moana, Tauranga Tangata Festival," in *Māori Graduates*, 133.

33. "Moko wearer says she was refused job," *New Zealand Herald*, February 16, 2005; Renee Kiriona, "Woman with Moko Wins $3000 for Discrimination," *New Zealand Herald*, September 3, 2003.

34. Julie Middleton, "New Zealanders More Relaxed About Race," *New Zealand Herald*, February 28, 2006.

35. Immanuel Kant, *Critique of Judgment*, trans. Werner S. Pluhar (Indianapolis: Hackett), 77. Unless otherwise noted, all references are to the Pluhar translation of the *Critique of Judgment* (hereafter cited as *Critique*).

36. The aggressively masculine figures depicted in the Duff and Tamahori works would seem to conform with Kant's "determinate concept" of manhood. Even the gang members would meet this definition of the beautiful. Duff, however, makes the lack of warriorhood in the gangs explicit. In Tamahori's film, to the contrary, all of the major characters are warriors—even Grace, who chooses a path of warriorhood that involves writing and sharing stories about her culture. Like Kant's statement, Duff's critique of warriorhood gone awry and Tamahori's expanded definition of the warrior suggest that it is perhaps limiting to see manhood as defined solely by warlike features.

37. Immanuel Kant, *Kritik der Urteilskraft*, ed. Wilhelm Weischedel (Frankfurt am Main: Suhrkamp, 1974).

38. The Latin terms translate literally as "roving beauty" and "adherent beauty." Meredith's translation renders Kant's terms as "free beauty" and "beauty which is merely dependent." Immanuel Kant, *Critique of Judgement*, trans. James Creed Meredith (Oxford: Clarendon Press, 1964), 72.

39. Paul Guyer, *Kant and the Claims of Taste* (Cambridge, Mass.: Harvard University Press, 1979), 247. Emphasis in original. His formulation remains identical in the 1997 second edition of the work. Paul Guyer, *Kant and the Claims of Taste* (Cambridge: Cambridge University Press, 1997), 219.

40. Paul Guyer, "Dependent Beauty Revisited: A Reply to Wicks," *Journal of Aesthetics and Art Criticism* 57, no. 3 (1999): 360.

41. Robert Wicks, "Can Tattooed Faces Be Beautiful? Limits on the Restriction of Forms in Dependent Beauty," *Journal of Aesthetics and Art Criticism* 57, no. 3 (1999): 361–62 (hereafter cited as "Faces").

42. Gayatri Chakravorty Spivak, *A Critique of Postcolonial Reason* (Cambridge, Mass.: Harvard University Press, 1999), 26–27.

43. Thompson quoted in D. R. Simmons, *Ta Moko: The Art of Maori Tattoo* (Auckland: Reed, 1986), 150 (hereafter cited as *Art*).

44. Ngahuia Te Awekotuku, "Ta Moko: Maori Tattoo," in *Goldie*, ed. Roger Blackley (Auckland: Auckland Art Gallery; David Bateman, 1997), 112 (hereafter cited as "Ta Moko").

45. Owen Jones, *Grammar of Ornament* (London: Day and Son, 1856), hereafter cited as *Ornament*. Jones sets forth the principles that govern his design theory, including first, a comment that places his work in the company of Kant: "That whenever any style of ornament commands universal admiration, it will always be found to be in accordance with the laws which regulate the distribution of form in nature" (*Ornament*, 2).

46. The anomaly can be explained: either Jones misidentifies the sex of the *moko* bearer or he presents, without knowing that he was so doing, a rare case of a highborn woman who had no peers equal to her in rank, and was therefore "set aside" as incapable of marriage or mating. Such a woman received the prerogatives of a male chief, and sometimes bore the male facial *moko* (*Art*, 128–29).

47. "Ta Moko," 245; "Maori Heads" ("Maori Heads to be Returned to NZ," *New Zealand Herald*, January 13, 2005; Jon Stokes, "Haunting Welcome brings Ancestors Home at Last," *New Zealand Herald*, November 23, 2005.

48. Ihimaera and Māori artist Robert Jahnke declare, "Yes, we now reclaim the moko for face and body as mark of mana. But in many respects it never left us." Robert Jahnke and Witi Ihimaera, "Ta Te Tiriti o Waitangi" in *Mataora: The Living Face*, ed. Witi Ihimaera (Auckland: David Bateman, 1996), 126.

49. "Ta moko," 123. Parkinson traveled with James Cook and drew copies of the art Banks deemed incomparable; both Parkinson and Banks acquired *arioʻi* tattoos in Tahiti. Anne Salmond, *The Trial of the Cannibal Dog: Captain Cook in the South Seas* (London: Penguin, 2004), 76.

NOTES TO CHAPTER 4

1. No publication date is given in the book, but the author notes that she is recounting the story of the first forty years of the Christian missions in Tahiti, the first of which began in 1796. In the Huntington Library's copy of *The Night of Toil* a curator identifies in a penciled-in note that the book was published in the nineteenth century, but does not specify a date.

2. Mrs. Favell L. B. Mortimer, *The Night of Toil; or, a Familiar Account of the Labors of the First Missionaries in The South Sea Islands* (New York: American Tract Society, 1838), 203 (hereafter cited as *Toil*).

3. Makiko Kuwahara, *Tattoo: An Anthropology* (Oxford: Berg, 2005), 2, 27, 29 (hereafter cited as *Tattoo: An Anthropology*).

4. Parker's dissatisfaction leaves him only when he receives the Byzantine Christ tattoo; he feels called to obtain the tattoo after he endures a near-death experience under a burning tree. O. E. Parker's revelation leads him to accept his given name of Obadiah Elihue, and leaves him "crying like a baby." Flannery O'Connor, "Parker's Back," in *Three by Flannery O'Connor* (New York: Signet, 1983), 442.

5. Translation mine. Karl von den Steinen, *Die Marquesaner und ihre Kunst: Studien über die Entwicklung primitiver Südseeornamentik nach eigenen Reiseergebnissen und*

dem Material der Museen (New York: Hacker, 1969), 1:95 (hereafter cited as *Die Marquesaner*). The script uses differing words to refer to the differing gods: the Marquesan "etua" indicates Marquesan gods, and the Samoan / Polynesian word "atua" designates the Christian God, or Jehovah.

6. Adam J. von Krusenstern, *Voyage Round the World in the Years 1803, 1804, 1805, and 1806*, ed. Richard Belgrave Hoppner (New York: Da Capo, 1968), 1:155–56.

7. Elena Govor, "'Speckled Bodies': Russian Voyagers and Nuku Hivans, 1804," in *Tattoo: Bodies, Art, and Exchange in the Pacific and the West*, ed. Nicholas Thomas, Anna Cole, and Bronwen Douglas (Durham, N.C.: Duke University Press, 2005), 69 (hereafter cited as *Tattoo*).

8. Juniper Ellis, "A New Oceania: An Interview with Epeli Hau'ofa," *Antipodes* 15, no. 1 (2001): 24 (hereafter cited as "Oceania Interview").

9. Epeli Hau'ofa, "Our Sea of Islands," in *A New Oceania: Rediscovering Our Sea of Islands*, ed. Eric Wadell, Vijay Naidu, and Epeli Hau'ofa (Suva, Fiji: University of the South Pacific, Beake House, 1993), 6.

10. *Sic.* Joseph Banks, *The* Endeavour *Journal of Joseph Banks, 1768–1771*, ed. J. C. Beaglehole (Sydney: Angus and Robertson, 1963), 1:335 (hereafter cited as *Endeavour Journal*).

11. It is thus possible to revise the assessment that "tattooing was banished because, as an undecipherable writing system, it threatened the interpretive skills of Europeans and highlighted their limits." Robert Nicole, *The Word, the Pen, and the Pistol: Literature and Power in Tahiti* (Albany: SUNY Press, 2001), 178 (hereafter cited as *The Word*). *Tātau* did threaten the interpretive ability of visitors, but not because it can be reduced to a writing system. Rather, it was a symbolic structure that both anticipated and exceeded the writing systems the missionaries would introduce.

12. James Morrison, *The Journal of James Morrison, Boatswain's Mate of The Bounty describing the Mutiny and subsequent Misfortunes of the Mutineers together with an account of the Island of Tahiti*, ed. Owen Rutter (London: Golden Cockerel Press, 1935), 220–22 (hereafter cited as *Journal of James Morrison*); J. R. Forster, *Observations made During a Voyage Round the World, on Physical Geography, Natural History, and Ethic Philosophy* (London: G. Robinson, 1778), 433–34 (hereafter cited as *Observations*); *Endeavour Journal*, 1:335; Douglas L. Oliver, *Ancient Tahitian Society* (Honolulu: University Press of Hawai'i, 1974), 602 (hereafter cited as *Tahitian Society*).

13. Alfred Gell, *Wrapping in Images: Tattooing in Polynesia* (Oxford: Clarendon Press, 1993), 140 (hereafter cited as *Wrapping*).

14. Sven Wahlroos, *English-Tahitian Tahitian-English Dictionary* (Honolulu: Mā'ohi Heritage Press, 2002), 590.

15. Previous commentators have suggested that Forster may refer here to pubic hair, but is the sole observer to suggest this particular correlation (*Tahitian Society*, 2:607). On the other hand, since pubic hair was often removed, the marks of puberty may be *tātau*. Forster's phrasing suggests that the marks of puberty are indicated by but not identical with tattooing.

16. James Wilson, *A Missionary Voyage to the Southern Pacific Ocean, 1796–1798* (Graz, Austria: Akademische Druck- u. Verlagsanstalt, 1966), 339 (hereafter cited as *Mis-*

sionary Voyage); H. Ling Roth, "Tatu in the Society Islands," *Journal of the Anthropological Institute of Great Britain and Ireland* 35 (1905): 292 (hereafter cited as "Tatu"); *Wrapping*, 141.

17. William Ellis, *Polynesian Researches During a Residence of Nearly Eight Years in the Society and Sandwich Islands* (London: Henry G. Bohn, 1853), 3:217 (hereafter cited as *Polynesian Researches*).

18. The Huahine laws followed the first two legal codes promulgated in the Society Islands: Tahiti's, and Ra'iatea's. Huahine's legal code was founded upon those laws, but it was refined to include points the missionaries considered had been omitted from the preceding codes.

19. Frederick D. Bennett, *Narrative of a Whaling Voyage Round the Globe From the Year 1833–1836* (New York: Da Capo, 1970), 1:117 (hereafter cited as *Whaling Voyage*).

20. Williams and Threlkeld cited in Colin Newbury, *Tahiti Nui: Change and Survival in French Polynesia, 1767–1945* (Honolulu: University of Hawai'i Press, 1980), 62 (hereafter cited as *Tahiti Nui*).

21. Neil Gunson, "An Account of the Mamaia or Visionary Heresy of Tahiti, 1826–1841," *Journal of the Polynesian Society* 71 (1962), hereafter cited as "Mamaia"; *The Word*, 171–72. Prophets were inspired by visions and by scriptures including particularly the Hebrew Bible/Old Testament. Māmaiā was probably a name given to the movement by its critics, as manuscripts at the time recorded the meaning of Māmaiā as "Unripe fruit, or fruit that falls from the tree before it is properly ripe and is considered by the natives good for nothing or not good for anything either for man or beast" ("Mamaia," 210).

22. Even those travelers who were sometimes critical of the way missionaries intervened to reshape Pacific societies could thus hold a contradictory position. Bennett, for instance, acquires tattoo tokens of former times while suggesting simultaneously that the new laws are less vicious than the old ways.

23. Ralph Gardner White, "An Account of the Mamaia: Glossary and Texts," *Journal of the Polynesian Society* 71 (1962): 248.

24. James Wilson, captain of the *Duff* on its 1796–98 missionary voyage, denounces the *ario'i* and equates them specifically with tattooing: "The famous, or rather infamous arreoy society, consisting of noble persons in general, have also different ranks among themselves, like our freemasons, known by the manner of their tattooing" (*Missionary Voyage*, 335).

25. Teuira Henry, *Ancient Tahiti*, Bernice P. Bishop Museum Bulletin 48 (1928): 234 (hereafter cited as *Ancient Tahiti*); *Tahitian Society*, 2:933–34; *Wrapping*, 148–49.

26. *Ancient Tahiti*, 235; see also *Tahitian Society*, 2:934. Another tattoo term noted a marked absence of patterns on *ario'i*; a few were untattooed, and known as *papa tea*, or *plain legs* (*Tahitian Society*, 2:951, *Ancient Tahiti*, 237).

27. Georg Forster, *A Voyage Round the World, in His Brittanic Majesty's Sloop*, Resolution (London: B. White, J. Robson, P. Elmsly, G. Robinson, 1777), 2:129 (hereafter cited as *Resolution*). His source for this statement was Mahine, himself an *ario'i*.

28. *Polynesian Researches*, 1:265, 266; Otto von Kotzebue, *A New Voyage Round the World in the Years 1823, 24, 25, and 26* (New York: Da Capo, 1967), 1:174–75 (hereafter cited as *New Voyage*).

29. John Davies, *The History of the Tahitian Mission, 1799–1830*, ed. C. W. Newbury (Cambridge: Cambridge University Press, 1961), 328.

30. Tricia Allen, interviewed by Steve Gilbert in "Polynesia Today," in *Tattoo History: A Sourcebook*, ed. Steve Gilbert (New York: Juno, 2000), 188 (the interview hereafter cited as "Polynesia Today").

31. Frederick Walpole, *Four Years in the Pacific, in Her Majesty's Ship "Collingwood," from 1844 to 1848* (London: Richard Bentley, 1850), 2:313 (hereafter cited as *Collingwood*).

32. Henri Hiro, *Pehepehe i Taù Nunaa / Message Poétique* (Papeete: Tupuna Productions, 1990), 35, translation mine (hereafter cited as *Pehepehe*).

33. Gotz, "'Each Tattoo is an encounter': Chimé Interview/Moorea," *Tattoo Age* 1 (2000): 16–17.

34. Abraham Fornander, *Fornander Collection of Hawaiian Antiquities and Folk-Lore: The Hawaiian Account of the Formation of Their Islands and Origin of Their Race with the Traditions of Their Migrations, etc., as Gathered from Original Sources, Memoirs of the Bernice Pauahi Bishop Museum* (Honolulu: Bishop Museum Press, 1916), hereafter cited as *Fornander*.

35. Kenneth P. Emory, "Hawaiian Tattooing," in *Occasional Papers of Bernice P. Bishop Museum* 18 (1946): 249 (hereafter cited as "Emory").

36. James Cook, *The Journals of Captain James Cook on His Voyages of Discovery*, ed. J. C. Beaglehole (Cambridge: Cambridge University Press, 1955), vol. 3, part 1, 280 (hereafter cited as *Journals*).

37. Jacques Arago, *Narrative of a Voyage Around the World in the Uranie and Physicienne Corvettes* (New York: Da Capo, 1971), 2:76, 147 (hereafter cited as *Voyage*).

38. Adrienne Kaeppler, "Hawaiian Tattoo: A Conjunction of Genealogy and Aesthetics" (hereafter cited as "Hawaiian Tattoo"), in *Marks of Civilization: Artistic Transformation of the Human Body*, ed. Arnold Rubin (Los Angeles: Museum of Cultural History, UCLA, 1988), 157, see also 169–70.

39. Samuel M. Kamakau, *Ruling Chiefs of Hawaii* (Honolulu: Kamehameha Schools Press, 1961), 149. Kamakau records part of Kalola's genealogy: "Ka-lola Pupuka-o-Hono-ka-wai-lani, daughter of Ke-kaulike and Ke-ku'i-apo-iwa-nui, chiefs of the prostrating tabu (*kapu moe*) on Maui" (118).

40. Jonathan Kay Kamakawiwo'ole Osorio, *Dismembering Lāhui: A History of the Hawaiian Nation to 1887* (Honolulu: University of Hawai'i Press, 2002), 11 (hereafter cited as *Dismembering Lāhui*).

41. *New Voyage*, 2:245; "Hawaiian Tattoo," 160. Ka'ahumanu sought these tattoos despite helping to formulate the prohibitionary or sumptuary laws as regent from 1824 to 1832. The sumptuary laws, passed between 1825 and 1829, would ultimately prohibit cultural activities including 'awa drinking and hula (*Dismembering Lāhui*, 12–13).

42. John Davis Paris, *Fragments of Real Missionary Life*, eds. Mary C. Porter and Ethel M. Damon (Honolulu: The Friend, 1926), 13, 14.

43. Kealalōkahi Losch, "Hoʻōla hou ka Moko a me ka Uhi: The Revival of Cultural Tattooing in Aotearoa and Hawaiʻi" (M.A. thesis, University of Hawaiʻi, 1999), 16 (hereafter cited as "Revival").

44. These terms are used by *kākau* artist P. F. Kwiatkowski in his book, *The Hawaiian Tattoo*. Pukui and Elbert, though, cite both *kākau* and *uhi* as nouns and transitive verbs, which would mean that both words could designate the process as well as the product of tattooing.

45. In the Marquesas Islands, too, the lizard is associated with tattooing and with Etua, the gods. Karl von den Steinen identifies art in which figures of the kakaá (northwest dialect) or nanaá (southeast dialect) are symbiotic with or even substituted for figures of Etua (*Die Marquesaner*, 2:107–9).

46. Jacques Arago, *Souvenirs d'un Avengle, Voyage Autour du Monde* (Paris: Hortet et Ozanne, 1840), 2:102 (cited in "Emory," 244).

47. Ibid., 244.

48. Tricia Allen, *Tattoo Traditions of Hawaiʻi* (Honolulu: Mutual, 2005), 133 (hereafter cited as *Tattoo Traditions*).

49. Carolyn Lei-Lanilau, "*Oli Makahiki*, Chant Composed as a Gift for My Daughter Kalea-Qy-Ana during *Makahiki*, the Rest Period from October through January, 1994," in *Frontiers* 23, no. 2 (2002): 38.

50. Kuʻualoa Hoʻomanawanui, "He Lei Hoʻoheno no nā Kau a Kau: Language, Performance, and Form in Hawaiian Poetry," in *The Contemporary Pacific* 17, no. 1 (2005): 59.

51. P. F. Kwiatkowski, *The Hawaiian Tattoo* (Kohala: Halona, 1996), 35.

52. George Vason, *An Authentic Narrative of Four Years' Residence at Tongataboo, one of the Friendly Islands, in the South-Sea by — Who went thither in the Duff, under Captain Wilson, in 1796. With an appendix, by an eminent writer [Solomon Pigott]* (London: Longman, Hurst, Rees, and Orme, 1810), 223 (hereafter cited as *Tongataboo*). The 1840 version edited by James Orange is hereafter cited as *Tongataboo 1840*.

53. Michelle Elleray, "Crossing the Beach: A Victorian Tale Adrift in the Pacific," *Victorian Studies* 47, no. 2 (2005): 164 (hereafter cited as "Crossing"). Vanessa Smith, too, casts Vason's actions in terms of a conversion to Tongan ways; Vanessa Smith, "George Vason: Falling from Grace," in *Exploration & Exchange: A South Seas Anthology* (Chicago: University of Chicago Press, 2000), 156; Vanessa Smith, *Literary Culture and the Pacific: Nineteenth-Century Textual Encounters* (Cambridge: Cambridge University Press, 1998), 36 (hereafter cited as *Literary*).

54. Edwin N. Ferdon, *Early Tonga as the Explorers Saw It, 1616–1810* (Tucson: University of Arizona Press, 1987), 128.

55. In 1906, Basil Thomson reports, "The office of *Ta Tatu* was not hereditary, as so many of the trades were among the Tongans." Thomson quoted in H. Ling Roth, "Tonga Islanders' Skin-Marking," *Man* 6 (1906): 8 (hereafter cited as "Skin-Marking"). In Samoa, on the other hand, the office was an hereditary privilege (*Wrapping*, 107).

56. The clergyman's name has been variously given as Solomon Pigott and Samuel Piggott.

57. James Ward, *Monumental Inscriptions in the Baptist Burial Ground, Mount Street, Nottingham* (London: Chiswick, 1899), 64.

58. Orange in *Tongataboo 1840*, v. The 1810 narrative calls into question Orange's claim that Vason "had no intention that the facts should be made public during his life" (*Tongataboo 1840*, vi).

59. Vason provides no further information about Broomhall, not even noting his given name. James Wilson, captain of the *Duff*, which delivered to the South Pacific Vason, Broomhall, and twenty-eight other male missionaries, along with six missionary wives and three missionary children, includes in his passenger list "Benjamin Broomhall, 20, buckle and harness maker" (*Missionary Voyage*, 5). Wilson lists Vason's identifying information as "George Veeson, 24, bricklayer" (*Missionary Voyage*, 6).

60. Vason's continuing anxiety about returning home with his tattoo revises Elleray's suggestion that "the permanency of the *tatatau* precludes the recognition of wrongdoing," although it supports her conclusion, "at best one can simply cover it up" ("Crossing," 171). Vason's desires to be set apart on an isolated island suggest that he realizes on the journey away from Tonga that he no longer fits in Tonga or in England. His original 1810 narrative does not express the explicit opprobrium that one might expect in part because it is so early that attitudes toward tattooing have not yet hardened, and the designs' association with criminality and degeneracy has not yet been formulated.

61. John Martin, *An Account of the Natives of the Tonga Islands, in the South Pacific Ocean. With an Original Grammar and Vocabulary of Their Language. Compiled and arranged from the extensive communication of Mr. William Mariner, several years resident in those islands* (Westmead, England: Gregg International, 1972), 265 (hereafter cited as *Tonga Islands*).

62. Thanks to Joseph Walsh for help with the Latin translations in this chapter. The original reads in its entirety, *"rara avis et picta pandat spectacula cauda."*

63. According to John Thomas, when they were promulgated officially most of the laws had already been in effect in Vava'u for at least the previous twelve months. Cited in Sione Lātūkefu, *Church and State in Tonga: The Wesleyan Methodist Missionaries and Political Development, 1822–1875* (Honolulu: University Press of Hawai'i, 1974), 121–22 (hereafter cited as *Church and State*). The laws were printed in 1838.

64. I. C. Campbell, *Island Kingdom: Tonga Ancient and Modern* (Christchurch: Canterbury University Press, 1992), 101 (hereafter cited as *Island Kingdom*).

65. Aisea Toetu'u, "Aisea Toetu'u," in *Tattoo Traditions*, 185. In her book *Tattoo Traditions of Hawai'i*, Allen includes writings about Hawaiian tattoo by contemporary tattoo artists and tattoo wearers. In some cases, the writers discuss not only Hawaiian tattoo but also other Pacific traditions.

66. Rodney (Ni) Powell, "Rodney (Ni) Powell," in *Tattoo Traditions*, 193.

67. Epeli Hau'ofa, *Kisses in the Nederends* (Honolulu: University of Hawai'i Press, 1995), hereafter cited as *Kisses*.

68. Hau'ofa is particularly apt at portraying the way cultures circulate. He was raised in Papua New Guinea by his Tongan parents and has worked as personal secretary to the King of Tonga, as well as head of the school of development at the University of the South Pacific in Fiji. Holding a Ph.D. in anthropology, he is now founding director of the Oceania Centre for Arts and Culture at the University; his writing draws upon the half-dozen Pacific languages he speaks.

69. The only available transplant organ is a "white feminist arsehole" (*Kisses*, 147) which Oilei's body rejects, until Babu heroically inserts his nose into the organ in a prolonged kiss, thereby coaxing Oilei's body to accept the transplanted organ. Griffen suggests that the sequence, while "dubiously worded from a feminist viewpoint, cannot be taken as misogynistic," and indeed helps Hau'ofa achieve an "all-encompassing egalitarian ethos" appropriate to Hau'ofa's "truly polyphonic Pacific novel"; Arlene Griffen, "A Pacific Novel: The Example of Epeli Hau'ofa," *Dreadlocks in Oceania* 1 (1997): 166, 168, 169.

70. The Pai Marire movement (also known as the Hauhau) was inspired by the Taranaki prophet Te Ua Haumene, and in turn helped inspire the Ringatu and Tariao religions.

71. Epeli Hau'ofa, *Tales of the Tikongs* (Honolulu: University of Hawai'i Press, 1994) hereafter cited as *Tikongs*. In an interview, Hau'ofa declares, "the rest of the pieces came from anger. And then I would work and work to get that anger off, and bring out the other side of me, which is poking fun" ("Oceania Interview," 24).

72. Hau'ofa acknowledges Mary Douglas's *Purity and Danger* as an ironic source of his ethnographic allegory of the body in *Kisses;* Michelle Keown, "Freeing the Ancestors: An Interview with Epeli Hau'ofa" *Ariel* 32, no. 1 (2001): 72. Maintaining Hau'ofa's terms, which associate nature with the anus and (degraded) culture with the arse-hole, Edmond examines the novel's geopolitical references: "the South Pacific has become the nuclear arse-hole (not anus) of the world"; Rod Edmond, "'Kiss my arse!' Epeli Hau'ofa and the Politics of Laughter," *The Journal of Commonwealth Literature* 25, no. 1 (1990): 151.

73. Ni Powell, "Historical Observations," http://tongan_tattoo.tripod.com/Tongan-Tattoo/id1.html. Accessed 8 June 2005.

74. Willowdean Chatterson Handy, *Forever the Land of Men: An Account of a Visit to the Marquesas Islands* (New York: Dodd, Mead, 1965), 64.

75. John La Farge, *An American Artist in the South Seas* (London: KPI, 1987), 272.

76. Henry Adams, *The Letters of Henry Adams*, ed. J. C. Levenson et al. (Cambridge, Mass.: Harvard University Press, 1982), 3:420; Adams continues to lament that Tahitian women are clothed; see, for example, 3:422, 424, 431, 478.

77. *Wrapping*, 285. In the Hawaiian islands, a scholar traces the process by which tattoo "evolved from genealogically associated ritual protection, the painful commemoration of genealogically important individuals, and the indication of special status in society, to whimsically decorative motifs of goats and other introduced designs" ("Hawaiian Tattoo," 169). And in the "Friendly Islands," "'Demotic' Tongan tattooing was an imitation of court practice, and in the relative simplicity of the design

recorded by Dumont D'Urville's draughtsman one can perhaps see the effect of vulgarization on the model provided by Samoan design" (*Wrapping*, 107). These statements, too, suggest that a decline has occurred, from genealogically inspired rituals to whimsical decoration, from elaborate Samoan designs to "vulgarized" Tongan ones.

78. Emphasizing the material effects of differing uses of "tradition," Hauʻofa notes, "Increasingly the privileged and the poor observe different traditions, each adhering to those that serve their interest best. The difference is that the poor merely live by their preferred traditions while the privileged often try to force certain other traditions on the poor in order to maintain social stability, that is, in order to secure the privileges that they have gained, not so much from their involvement in traditional activities, as from their privileged access to resources in the regional economy. In such a situation, traditions are used by the ruling classes to enforce the new order"; Epeli Hauʻofa, "The New South Pacific Society: Integration and Independence," in *Class and Culture in the South Pacific*, ed. Antony Hooper et al. (Auckland: Centre for Pacific Studies, University of Auckland Press, 1987), 14.

79. While he does not focus on anthropology's search for cultural purity, in his study of nineteenth-century ethnography Herbert has observed that missionaries and anthropologists exhibit surprising similarities. They adopt an analogous position vis-à-vis their host cultures, "both submerged in and detached from an exotic cultural milieu"; Christopher Herbert, *Culture and Anomie: Ethnographic Imagination in the Nineteenth Century* (Chicago: University of Chicago Press, 1991), 158. In addition, missionary "field" narratives anticipate the founding principles of ethnography, even articulating a similar methodology. Meanwhile, anthropology continues to cast itself as offering a form of salvation, a transformation of the observing self that amounts to a conversion or liberation.

80. Albert Wendt, "Towards a New Oceania," *Mana Review* 1, no. 1 (1976): 52.

NOTES TO CHAPTER 5

1. Herman Melville, *Typee: A Peep at Polynesian Life* (Evanston, Ill.: Northwestern University Press, 1968), hereafter cited as *Typee*.

2. Historically, untattooed men are exceptional in accounts of the islands. Otherwise, "it would appear that this form of body decoration was not confined to certain ranks or classes in the Marquesas," and women's hands had to be tattooed before they could prepare food for or eat from the communal bowl of *popoi*. Willowdean Chatterson Handy, "Samoan Tattooing" in E. S. Craighill Handy and Willowdean Chatterson Handy, *Samoan House Building, Cooking, and Tattooing*, Bernice P. Bishop *Museum Bulletin 15* (Honolulu: Bishop Museum, 1924), 3, 5 (hereafter cited as "Samoan Tattooing").

3. Raymond Williams, *Keywords: A Vocabulary of Culture and Society* (New York: Oxford University Press, 1976), 80 (hereafter cited as *Keywords*).

4. Herman Melville, *Omoo: A Narrative of Adventures in the South Seas* (Evanston, Ill.: Northwestern University Press, 1968), hereafter cited as *Omoo*.

5. Geoffrey M. White and Ty Kawika Tengan, "Disappearing Worlds: Anthropology and Cultural Studies in Hawai'i and the Pacific," *The Contemporary Pacific* 13, no. 2 (2001): 383 (hereafter cited as "Disappearing Worlds").

6. E. B. Tylor, *Primitive Culture* (New York: Harper, 1958).

7. Jack London, *Cruise of the Snark* (New York: Review of Reviews, 1917), 168 (hereafter cited as *Snark*).

8. Willowdean Chatterson Handy, *Forever the Land of Men: An Account of a Visit to the Marquesas Islands* (New York: Dodd, Mead, 1965), 4 (hereafter cited as *Forever*).

9. Margaret Mead, *Coming of Age in Samoa* (New York: Morrow, 1973). Mead conducted her studies under the auspices of the U.S. Naval Administration in those islands, which, she suggests, allowed her to "remain aloof from native feuds and lines of demarcation." To reflect the political realities that shaped her book, it might be more accurately titled *Coming of Age in* American *Samoa*.

10. Greg Dening, *Islands and Beaches: Discourse on a Silent Land: Marquesas, 1774–1880* (Chicago: Dorsey Press, 1980), 160 (hereafter cited as *Islands*).

11. Karl von den Steinen, *Die Marquesaner und ihre Kunst: Studien über die Entwicklung primitiver Südseeornamentik nach eigenen Reiseergebnissen und dem Material der Museen* (New York: Hacker, 1969), 1:102–36. Gell states incorrectly that Steinen began collecting motifs in 1891, and that he identified 174 motifs. Alfred Gell, *Wrapping in Images: Tattooing in Polynesia* (Oxford: Clarendon Press, 1993), 163 (hereafter cited as *Wrapping*). When correcting for Steinen's duplicate examples of motifs, the number is just under 100.

12. Tricia Allen, interviewed by Steve Gilbert, "Polynesia Today" in *Tattoo History: A Sourcebook* (New York: Juno, 2000), 190 (hereafter cited as "Polynesia").

13. Isabelle Genoux, "Tattooing Festival," in *Artok* October 15, 2000 (www.abc.net.au/ arts/artok/bodyart/s199572.htm, accessed 15 February 2001).

14. Carol S. Ivory, "Art, Tourism, and Cultural Revival in the Marquesas Islands," in *Unpacking Culture: Art and Commodity in Colonial and Postcolonial Worlds*, ed. Ruth B. Phillips and Christopher B. Steiner (Berkeley: University of California Press, 1999), 327–31. The revivals date from various periods: in tapa painting from the mid-1950s, in tiki carving from the 1960s, and in pareu painting since the 1990s (Ivory, 327–31). The term tiki carving refers to wooden figures; the term *pahu tiki*, used elsewhere herein, refers to tattoo.

15. Johannes Fabian, *Time and the Other: How Anthropology Makes Its Object* (New York: Columbia University Press, 1983), 31; italics in original.

16. Elizabeth DeLoughrey, "The Spiral Temporality of Patricia Grace's *Potiki*," in *Ariel* 30, no. 1 (1999): 79.

17. Willowdean Chatterson Handy, *Tattooing in the Marquesas*, Bernice P. Bishop Museum Bulletin 1 (1922), 21.

18. Captain David Porter, *Journal of a Cruise* (Annapolis, Md.: Naval Institute Press, 1986), 294 (hereafter cited as *Cruise*).

19. C. S. Stewart, *A Visit to the South Seas, in the U.S. Ship* Vincennes, *During the Years 1829 and 1830* (New York: Sleight & Robinson, 1831), 309 (hereafter cited as *Vincennes*).

20. The difference between Porter's and Stewart's descriptions derives in part from the competing intellectual frameworks their narratives exemplify. T. Walter Herbert suggests in *Marquesan Encounters* that Porter exemplifies Enlightenment rationality, and Stewart a sophisticated Calvinist morality. Herbert identifies Melville's book *Typee* as an exemplar of a third, romantic orientation to the Marquesas; T. Walter Herbert, *Marquesan Encounters: Melville and the Meaning of Civilization* (Cambridge, Mass.: Harvard University Press, 1980; hereafter cited as *Encounters*).

21. Stewart retreats several times from the Nuku Hivans, explaining, "In almost every instance, language and allusions of the most objectionable character—as is the case every day in their ordinary conversation—are introduced: and many are abominable, almost beyond belief." When the conversation becomes licentious, he returns to the ship (*Vincennes*, 261).

22. The commander of the U.S. Exploring Expedition notes, "The Congress of the United States, having in view the important interests of our commerce embarked in the whale-fishers, and other adventures in the great Southern Ocean, by an act of the 18th of May, 1836, authorized an Expedition to be fitted out for the purpose of exploring and surveying that sea, as well to determine the existence of all doubtful islands and shoals, as to discover and accurately fix the position of those which lie in or near the track of our vessels in that quarter." Charles Wilkes, *Narrative of the United States Exploring Expedition During the Years 1838, 1839, 1840, 1841, 1842* (New York: Putnam, 1856), 1:xxv.

23. William Ellis, *Polynesian Researches During a Residence of Nearly Eight Years in the Society and Sandwich Islands* (London: Henry G. Bohn, 1853), 1:248 (hereafter cited as *Researches*). Though he called for and actively supported the sending of U.S. missionaries to the Pacific, however, while in the region Stewart remained a shipboard chaplain, and he holds himself and his account at a greater distance from Pacific life than does William Ellis. Ellis discusses the Marquesas Islands in volume 3 of the *Polynesian Researches*. He bases his account on others' descriptions of the islands, including those provided by several Enata he knew during his time in Hawai'i.

24. Charmian London, Photograph Captions c. 1907–1908, Jack London Papers, JLP 495, Photograph Album 57–12e-g, 57–12l. Her repeated entries calling attention to tattooed people bear repeated exclamation marks. The photographs from the Londons' trip feature many tattooed men and women, especially in the Marquesas Islands, and in Samoa portray a tattooing in process (JLP 500, Photograph Album 62–13a).

25. Leonard Cassuto, "'What an object he would have made of me!': Tattooing and the Racial Freak in Melville's *Typee*," in *Freakery: Cultural Spectacles of the Extraordinary Body*, ed. Rosemarie Garland Thomson (New York: New York University Press, 1996), 235 (hereafter cited as "Racial Freak").

26. As Otter points out, if he is tattooed, "Tommo will be incorporated in native systems in a more enduring sense: not through metabolism but through inscription"; Samuel Otter, *Melville's Anatomies* (Berkeley: University of California Press, 1999), 10.

27. Jay Leyda, *The Melville Log: A Documentary Life of Herman Melville* (New York: Harcourt, Brace, 1951), 1: 175.

28. *Typee*, 8. Elsewhere I have noted the way Melville follows Falstaff in punning on the cat*a*strophe that is thus revealed, a pun anticipated by the reference to the agh*a*st French observers; Juniper Ellis, "Island Queen: Women and Power in Melville's South Pacific," in *Melville and Women*, Elizabeth Schultz and Haskell Springer, eds. (Kent, Ohio: Kent State University Press, 2006), 167 (hereafter cited as "Island Queen").

29. Melville dramatizes the artist's demand to tattoo Tommo's face. The ship's doctor Coulter, who stayed for a brief time in Hiva Oa in the 1830s, dealt with the decree that he be tattooed by requesting that the marks not adorn his face or hands, a request that was immediately granted: "I would submit to be 'tatooed' [*sic*] provided that neither my face nor hands should be touched. They at once said that would do." John Coulter, *Adventures in the Pacific; with observations on the natural productions, manners and customs of the natives of the various islands* (London: Longmans, Brown, 1845), 208.

30. John Wenke, "Melville's *Typee*: A Tale of Two Worlds," in *Critical Essays on Herman Melville's* Typee, ed. Milton R. Stern (Boston: G. K. Hall, 1982), 255, 256. In keeping with his argument that *Typee* links "tattooing and blackness, and blackness and freak shows" ("Racial Freak," 245), Cassuto suggests a related reading: that Tommo presents himself as a slave before he jumps ship, and before he flees the Taipi ("Racial Freak," 243). Cassuto reads *Typee* in terms of U.S. categories based on racial blackness.

31. Gayatri Chakravorty Spivak, *A Critique of Postcolonial Reason* (Cambridge, Mass.: Harvard University Press, 1999), 304 (hereafter cited as *Critique*).

32. In Melville's narrative, Marquesan tattoo is a form of signification in its own right. Melville's narrative does not present a "conflict between the tattoo and the signifier for Tommo," but Tommo's fear of the tattoo as signifier. Daneen Wardrop, "The Signifier and the Tattoo: Inscribing the Uninscribed and the Forces of Colonization in Melville's *Typee*," *ESQ* 47, no. 2 (2001): 136.

33. Alex Calder invokes the mysterious movement of the *tabu* in *Typee*: "your smile at another's smile, your wink at another's wink, is a passing analogy for the culture you sometimes think they have in mind." Alex Calder, "'The Thrice Mysterious Taboo': Melville's *Typee* and the Perception of Culture," *Representations* 67 (1999): 40.

34. Appearing at the beginning of *Omoo* as a warning against going too far into the Pacific, Hardy echoes the "genuine South-Sea vagabond" (*Omoo*, 12) who conducts the ship into the harbor at the opening of *Typee*.

35. Wolfgang Kayser, *The Grotesque in Art and Literature*, trans. Ulrich Weisstein (Gloucester, Mass.: Peter Smith, 1968), 184–85 (hereafter cited as *The Grotesque*).

36. Edgar Allan Poe, *Tales of the Grotesque and Arabesque* (Philadelphia: Lea and Blanchard, 1840). Kayser notes: "In another tale, *The Murders of the Rue Morgue*, Poe characterizes the appearance of the room in which the double murder has taken place by calling it 'a *grotesquerie* in horror absolutely alien from humanity.' Poe thus uses the word 'grotesque' on two different levels of meaning: to describe a concrete situation in which chaos prevails, and to indicate the tenor of entire stories con-

cerned with terrible, incomprehensible, inexplicable, bizarre, fantastic, and noctur-
nal happenings" (*The Grotesque*, 79; italics in original).

37. In her tattooing monograph, Chatterson Handy exhibits a consequence of this
approach to tattoo as visible culture, observed by a visitor separate from that
culture. She presents Vae Kehu's rare tattooed girdle according to anthropologi-
cal conventions that anatomize the designs, presenting each piece of design as
separate from the whole life of the people. The design plate assigns to each motifs
one of the first three letters of the English alphabet, indicating, the "Explanation
of Plates" tells readers, (1) *ka'ake* (literally, underarm curve, elaborated into a
human figure with upraised arms (*Tattooing in the Marquesas*, 20); (2) *mata* (or
eyes); and (3) *fanaua* (or a spirit, represented in tattoo in order to protect the
bearer) (*Tattooing in the Marquesas*, 29). This way of presenting and naming de-
signs is an anthropological convention that presents the relevant information in
separate sections, first the narrative examination of *tiki*, then the translation of
design names, followed by the bibliography, the explanation of plates, and finally
the plates themselves. No statement explains the relationship of the discrete parts:
the overarching narrative connection is assumed. The separate pieces that explain
tiki design allow the viewer to maintain a distance from the art that was formerly
a way of life, rendering the patterns in Chatterson Handy's own words, "pure
design" (*Tattooing in the Marquesas*, 24).

38. *Sic.* Joseph Banks, *The* Endeavour *Journal of Joseph Banks, 1768–1771*, ed. J. C. Bea-
glehole (Sydney: Angus and Robertson, 1963), 336–37 (hereafter cited as *Endeavour
Journal*).

39. Anne Salmond, *The Trial of the Cannibal Dog: Captain Cook in the South Seas* (Lon-
don: Penguin, 2004), 76 (hereafter cited as *Cannibal Dog*). The *ario'i* formed "an
exclusive society of priests, voyagers, warriors, orators and famed lovers dedicated
to 'Oro," the god of war (*Cannibal Dog*, 37).

40. *Endeavour Journal*, 41. Though he may honor Davy's request (it would appear that
no record of his reply survives), in his account of Oceania Banks does not distrib-
ute images of these characters. Despite Banks's narrative silence about these marks,
Davy is nevertheless aware of their existence, and wishes a copy, a reproduction of
the *ario'i* sign that Banks bears.

41. *Cannibal Dog*, 8. Salmond offers this assessment in considering how Cook's crew
could have, in Queen Charlotte Sound, Aotearoa, tried and convicted a dog of can-
nibalism and therefore cooked and eaten it. The reasoning of course extends to situ-
ations where Parkinson, Banks, and others received *ario'i* tattoos.

42. Albert Parry, *Tattoo: Secrets of a Strange Art as Practiced Among the Natives of the
United States* (New York: Simon & Schuster, 1933), 98 (hereafter cited as *Strange
Art*).

43. Clinton Sanders, *Customizing the Body: The Art and Culture of Tattooing* (Philadel-
phia: Temple University Press, 1989), 16.

44. Cesare Lombroso, "The Savage Origin of Tattooing," *Appleton's Popular Science
Monthly* 48 (November 1895–April 1896): 793 (hereafter cited as "Savage Origin").

45. See also "Racial Freak," 240.

46. *"Der moderne mensch, der sich tätowiert, ist ein verbrecher oder ein degenerierter. Es gibt gefängnisse, in denen achtzig prozent der häftilinge tätowierungen aufweisen. Die tätowierten, die nicht in haft sind, sind latente verbrecher oder degenerierte aristokraten. Wenn ein tätowierter in freiheit stirbt, so ist er eben einige jahre, bevor er einen mord verübt hat, gestorben"*; Adolf Loos, "Ornament und Verbrechen," in *Sämtliche Schriften* (Vienna: Verlag Herold, 1962), 1:276; italics added.

47. Joseph Kabris and A. F. Dulys, *Précis Historique et Véritable du Séjour de Joseph Kabris* (Paris: J. G. Dentu, c. 1817), hereafter cited as *Joseph Kabris*.

48. Greg Dening, *Beach Crossings: Voyaging Across Times, Cultures, and Self* (Philadelphia: University of Pennsylvania Press, 2004), 32, 315 (hereafter cited as *Beach Crossings*). Charles Roberts Anderson identifies Kabris's descriptions as a source of Melville's information and "misinformation" about Nuku Hivan tattooing. Charles Roberts Anderson, *Melville in the South Seas* (New York: Columbia University Press, 1939), 154–55.

49. G. H. von Langsdorff, *Voyages and Travels in Various Parts of the World, During the Years 1803, 1804, 1805, 1806, and 1807* (New York: Da Capo, 1968), 1:122. As Govor points out, descriptions of Robarts's tattoos vary; most state, though, that he was adorned minimally with Marquesan designs; Elena Govor, "'Speckled Bodies': Russian Voyagers and Nuku Hivans, 1804," in *Tattoo: Bodies, Art, and Exchange in the Pacific and the West*, ed. Nicholas Thomas, Anna Cole, and Bronwen Douglas (Durham, N.C.: Duke University Press, 2005), 67–68.

50. George Lillie Craik, *The New Zealanders* (London: Charles Knight, 1830), hereafter cited as *New Zealanders*.

51. George Burchett, *Memoirs of a Tattooist* (London: Oldbourne, 1958), 24–25; Robert Bogdan, *Freak Show: Presenting Human Oddities for Amusement and Profit* (Chicago: University of Chicago Press, 1988), 242.

52. Craik also uses other available accounts to corroborate Rutherford's descriptions, something Melville could not do after disclaiming knowledge of most previous accounts, including those he drew upon to create his narrative. In other words, Melville claims that his account is unique, emphasizing novelty over the ability to corroborate truth-claims.

53. Another famous tattooed white man, Barnet Burns, who received a fairly intricate facial *moko* in Aotearoa in about 1832, follows this same pattern. He claims that he received the tattoo to save his life. After he returned to England, he displayed his tattoos in public performances and in a pamphlet, *A Brief Narrative of the Remarkable History of Barnet Burns*. Burns, too, planned to return to Aotearoa.

54. The tattooed white man's difficulty in explaining away the marks after he leaves their place of origin even inspires fantasies in which the tattoo marks can be erased. Frederick O'Brien's travel narrative *Atolls of the Sun* presents an American man who must erase his Marquesan designs by reversing the tattooing; Frederick O'Brien, *Atolls of the Sun* (New York: Century, 1922). He does so by puncturing his skin with "the milk of a woman" (360) in the same places where the pigment had been placed. He will thus be able to claim his inheritance in the United States. O'Brien adapted this story for his screenplay for *White Shadows in the South Seas* (1928),

MGM's first sound film, which received an Oscar for cinematography. In *The Stars My Destination* (1956), Alfred Bester's science-fiction novel, the twenty-fifth-century main character must erase a Māori tattoo by being tattooed again, this time with bleach; Alfred Bester, *The Stars My Destination* (New York: Vintage, 1996). Until he does so, he bears "a hideous tattooed face," namely "a Māori mask. Cheeks, chin, nose, and eyelids were decorated with stripes and swirls" (33). In O'Brien's and in Bester's narratives, after the tattoo is erased, its pattern returns in livid red when the former tattoo bearer feels strong emotion, particularly anger.

NOTES TO CHAPTER 6

1. Albert Parry, *Tattoo: Secrets of a Strange Art as Practiced Among the Natives of the United States* (New York: Simon & Schuster, 1933), 2 (hereafter cited as *Strange Art*).

2. Kobel cited in Christine Braunberger, "Revolting Bodies: The Monster Beauty of Tattooed Women," *NWSA Journal* 12, no. 2 (2000): 20.

3. Walter Bromberg, "Psychologic Motives in Tattooing," *Archives of Neurology and Psychiatry* 33 (1935): 229, 231, 232.

4. Robert F. Raspa and John Cusack, "Psychiatric Implications of Tattoos," *American Family Physician* 41 (1990): 1483, 1481, 1485.

5. Armando Favazza, *Bodies Under Siege: Self-mutilation and Body Modification in Culture and Psychiatry* (Baltimore: Johns Hopkins University Press, 1996), 153. This assessment repeats a refrain familiar in medical and psychoanalytic considerations of tattoo. The physician Briggs, who suggests that tattoo is "valuable in determining the emotional pattern of an individual," proposes, "The types of tattoo may be such that the type of psychoneurosis may be apparent. The homosexual has his form of tattooing. The latent homosexual has his." John F. Briggs, "Tattooing," *Medical Times* 87, no. 8 (1959): 1038–39.

6. Alfred Gell, *Wrapping in Images: Tattooing in Polynesia* (Oxford: Clarendon Press, 1993), hereafter cited as *Wrapping*.

7. Tennessee Williams, *The Rose Tattoo* (New York: New Directions, 1951).

8. Sarah Hall, *The Electric Michelangelo* (London: Faber, 2004), 272 (hereafter cited as *Electric*). Grace is very articulate about the eye and women's bodies in particular. When the tattoo artist asks, "Is it that you want them not to look at you lecherously and won't you still have to take your clothes off, mostly, for these doo-dads to show, and doesn't that defeat the purpose?" Grace declares, "It will always be about body! Always for us! I don't see a time when it won't. I can't say you can't have my body, that's already decided, it's already obtained. If I had fired the first shot it would have been on a different field—in the mind. All I can do is interfere with what they think is theirs, how it is supposed to look, the rules. I can interrupt like a rude person in a conversation" (*Electric*, 274).

9. Grace is aware of the way the tattoo focuses the sexual economy of the gaze. She draws the gaze on and to her body, attempting to define and interfere with its expected workings. In so doing, she becomes the most popular tattooed woman per-

forming in Coney Island, until a man pours acid on her skin, almost killing her and defacing her tattooed eyes as well as her breasts and belly. She retaliates by blinding him. Thus, even in the form her revenge takes, the gaze of the other remains her focus. In not specifying what happens to Grace after she exacts her revenge, however, Hall may offer another attempt to alter this economy, allowing Grace to escape the narrative gaze. In a third example of Hall's focus on the way a woman's body meets the world, Grace becomes the love of the tattoo artist's life, but he penetrates her only with his tattoo needle. Later, he "relives his journey across her body," concluding that "under his unyielding bevelled brush, perhaps those were the times he was making love to her after all" (*Electric*, 282). Even with the tattoo artist, then, Grace both avoids and submits to penetration; with him, she decides which form the contact takes.

10. Elizabeth Stoddard, *The Morgesons*, ed. Lawrence Buell and Sandra A. Zagarell (Philadelphia: University of Pennsylvania Press, 1989).

11. Margot Mifflin, *Bodies of Subversion: A Secret History of Women and Tattoo* (New York: Juno, 1997).

12. Lee Wallace, *Sexual Encounters: Pacific Texts, Modern Sexualities* (Ithaca, N.Y.: Cornell University Press, 2003), 140 (hereafter cited as *Sexual Encounters*).

13. Lisa Kahaleole Chang Hall and J. Kehaulani Kauanui, "Same-Sex Sexuality in Pacific Literature," in *Asian American Sexualities: Dimensions of the Gay and Lesbian Experience*, ed. Russell Leong (New York: Routledge, 1996), 114 (hereafter cited as *Asian American Sexualities*).

14. Niko Besnier, "Polynesian Gender Liminality Through Time and Space," in *Third Sex, Third Gender: Beyond Sexual Dimorphism in Culture and History*, ed. Gilbert Herdt (New York: Zone Books, 1994), 300; italics in original (hereafter cited as "Polynesian Gender").

15. "Polynesian Gender," 327, 316. This fact complicates Wallace's critique of Besnier. She suggests that in Besnier's argument, "So unmarked is the category of the male who has sex with *fa'afafine* that at moments in Besnier's argument, all Samoan and Tongan men except *fa'afafine* and *fakaleitī* are implicated: 'While not all gender-liminal individuals have sex with nonliminal men, they are always perceived as a possible sexual conquest by men in societies like Samoa and Tonga.' All men are categorically entangled in the sexual possibilities figured forth by *fa'afafine* even as they stand outside gender-liminal behaviors or identifications" (*Sexual Encounters*, 142). If men can gain or lose gender-liminal status in adulthood, then regardless of whether they have sex with men, they do not necessarily stand very far outside gender-liminal behaviors or identifications. The need to *create* distance may explain why some men subject gender-liminal individuals to violence. Women (and their sexual and gender practices) remain the absent component in both discussions, which focus on liminal and nonliminal men and their respective, sometimes situational, sexual and gender practices.

16. Jeannette Marie Mageo, *Theorizing Self in Samoa* (Ann Arbor: University of Michigan Press, 1998), 210.

17. Albert Wendt, "Tatauing the Post-Colonial Body," *SPAN* 42–43 (1996): 20 (hereafter cited as "Tatauing").

18. Augustin Krämer, *The Samoa Islands*, trans. Theodore Verhaaren (Honolulu: University of Hawai'i Press, 1995), 2:70 (hereafter cited as *Samoa Islands*).

19. *Wrapping*, 86. In this interpretation, not the *malu* but the traditional public defloration ceremony corresponds to the male *tatau*. Whereas the male *tatau* indicates that a man has been "'stopped up' with fortifying designs, result[ing] in a permanent encasing of the body in a protective shield" (*Wrapping*, 92), the public defloration renders a woman penetrable, open to the passage of "semen, blood, children" (*Wrapping*, 92). Traditionally, a woman is tattooed while she is still a virgin, allowing Gell to suggest that the *malu* is a teasing sign of the woman's sealed hymen. The public defloration ceremony performed on the woman during the marriage ritual thus renders the woman open to penetration, while the man is rendered closed to penetration by the corresponding ritual for men, *tatau*.

20. Sia Figiel, *They Who Do Not Grieve* (Auckland: Vintage, 1999), hereafter cited as *Grieve*.

21. H. G. Robley, *Moko: The Art and History of Maori Tattooing* (London: Chapman and Hall, 1896), 118 (hereafter cited as *Art and History*).

22. Another, more rare form of tattoo reserved for women was "the tara whakairo, or tattooing around the vaginal area"; Wena Harawira, Caleb Maitai, and Lee Umbers, "Tattoos Are Back: Moko—More Than Skin Deep," *Mana: The Maori News Magazine for All New Zealanders 2* (1993): 9 (hereafter cited as "Skin Deep"). Te Awekotuku describes the marks as preparing women "for a special role as the whare tangata, or bearer of children" ("Skin Deep," 9).

23. "Madonna and Child Tekoteko," http://tinyurl.com/3balsb. Two of the Madonna and Child carvings are known to exist; one is held by the Auckland Museum, and the other by the Te Papa museum in Wellington. Patoromu Tamatea has been credited historically with carving the figure held by the Auckland Museum, though Roger Neich has suggested recently that the style of carving would suggest it was created by someone else. Roger Neich, *Carved Histories: Rotorua Ngati Tarawhai Woodcarving* (Auckland: Auckland University Press, 2001), 197.

24. In other words, the carver produced the highest possible tribute to Mary and Jesus, using Māori *moko* and carving traditions to express Catholic doctrine. Perhaps unaware of what these *moko* patterns signified, the church, however, declined to accept the carving, and it currently is held by the Auckland Museum. Thanks to changing appreciations, however, it was used in 1997 to help welcome John Paul II to Aotearoa.

25. D. R. Simmons, *Ta Moko: The Art of Maori Tattoo* (Auckland: Reed, 1986), 153. Michael King, *Moko: Maori Tattooing in the 20th Century* (Auckland: David Bateman, 1999), 2. No page numbers; hereafter cited as *20th Century*, with chapter headings given in lieu of page numbers.

26. Ngahuia Te Awekotuku, "The Future of the Humanities in a Fragmented World," in "Guest Column: Roundtable on the Future of the Humanities in a Fragmented World," *PMLA* 120, no. 3 (2005): 722 (hereafter cited as "Future").

27. Ngahuia Te Awekotuku, "Ta Moko: Maori Tattoo," in *Goldie*, ed. Roger Blackley (Auckland: Auckland Art Gallery and David Bateman, 1997), 110.

28. Huia Tomlins Jahnke, "Māori Women and Education: Historical and Contemporary Perspectives," in *Mai i Rangiātea: Māori Wellbeing and Development*, ed. Pania Te Whāiti, Mārie McCarthy, and Arohia Durie (Auckland: Auckland University Press and Bridget Williams Books, 1997), 96 (hereafter cited as "Māori Women").

29. "Future," 723. *Carte de visite* and postcard images of women bearing *moko kauae* were popular products in the nineteenth and twentieth centuries. These images sometimes eroticize the depicted women, thus placing such photographic images of *kauae* designs within the non-Pacific tradition of sexualized tattoo.

30. Linda Waimarie Nikora, Mohi Rua, and Ngahuia Te Awekotuku, "Wearing Moko: Maori Facial Marking in Today's World," in *Tattoo: Bodies, Art, and Exchange in the Pacific and the West*, ed. Nicholas Thomas, Anna Cole, and Bronwen Douglas, (Durham, N.C.: Duke University Press, 2005), 197 (hereafter cited as *Tattoo*).

31. Ngahuia Te Awekotuku, "More Than Skin Deep: *Ta Moko* Today," in *Claiming the Stones, Naming the Bones*, ed. Alazar Barkan and Ronald Bush (Los Angeles: Getty Research Institute, 2002), 248. Photographs are available at Ron Athey's website and at www.western-project.com/athey/athey.html. See also the young Canadian man who calls himself Tat2dface, pictured at tattoo.about.com/cs/tatart/1/bl-tat2dface.htm.

32. Outside the Pacific, the marks on a woman's chin have been interpreted as highly sexualized: "Evidently we are to read the female mouth / chin-tattoo as a whole as a representation of the phallus probing towards its predestined (open) orifice" (*Wrapping*, 266). In this reading, *moko kauae* indicate a woman's sexual activity, showing that her vagina, which corresponds to her tattooed mouth, is open to the penis. In other words, a woman's power is sexual, residing in the fact that she can be penetrated. While the *moko* chants establish that the designs were no doubt seen as attractive, this interpretation seems very much at odds with other accounts of *moko kauae*.

33. C. Maxwell Churchward, *Tongan Dictionary* (Tonga: Government Printing Press, 1959), 460.

34. Edwin N. Ferdon, *Early Tonga as the Explorers Saw It, 1616–1810* (Tucson: University of Arizona Press, 1987), 128.

35. Anderson quoted in James Cook, *The Journals of Captain James Cook on his Voyages of Discovery*, ed. J. C. Beaglehole (Cambridge: Hakluyt Society at the Cambridge University Press, 1955), vol. 3, part 2, 930 (hereafter cited as *Journals*); King quoted in *Journals*, vol. 3, part 2, 1366. According to William Mariner, "The women are not subjected to it, though a few of them choose to have some marks of it on the inside of their fingers"; John Martin, *An Account of the Natives of the Tonga Islands, in the South Pacific Ocean. With an Original Grammar and Vocabulary of their Language. Compiled and arranged from the extensive communication of Mr. William Mariner, several years resident in those islands* (Westmead, England: Gregg International, 1972), 2:266–267 (hereafter cited as *Mariner*).

36. *Journals*, vol. 3, part 2, 1181. Based on his (apparently incorrect) observation that men do not tattoo their tongues, Samwell speculates that a King who had "a Xan-

tippe for his Queen" may have devised the tongue tattoo to disgrace and punish not only his queen but all women (*Journals*, vol. 3, part 2, 1181). (Socrates' wife Xanthippe is famous as a shrew.) Hawaiians quoted in other descriptions identify the tongue tattoo as a sign of mourning, and William Ellis's account includes male chiefs' explicit declarations that the mark of grief will last forever, as they receive the tattoo on their tongues.

37. Kenneth P. Emory, "Hawaiian Tattooing," in *Occasional Papers of Bernice P. Bishop Museum* 18 (1946): 250.

38. *Wrapping*, 158; Makiko Kuwahara, *Tattoo: An Anthropology* (Oxford and New York: Berg, 2005), 34 (hereafter cited as Kuwahara).

39. Kuwahara, 30; Karen Stevenson, "Polynesian Tattoo: A Shift in Meaning," *Artlink* 16, no. 4 (1996): 32 (hereafter cited as "Polynesian Tattoo").

40. Kuwahara, "Multiple Skins: Space, Time and Tattooing in Tahiti," in *Tattoo*, 172.

41. Tricia Allen interviewed by Steve Gilbert in "Polynesia Today," in *Tattoo History: A Sourcebook*, ed. Steve Gilbert (New York: Juno, 2000), 189 (hereafter cited as *Tattoo History*).

42. Theodor Kleinschmidt, *Notes on the Hill Tribes of Vitilevu, 1877–1878*, ed. Herbert Tischner, trans. Stefanie Vuikaba Waine, *Domodomo* 2, no. 4 (1984): 159 (hereafter cited as *Vitilevu*). Qia is pronounced ngia. The accounts from Fiji, Samoa, and Tonga all suggest that tattooing originates in Fiji and emphasize that differing genders are tattooed in Fiji and in Samoa and Tonga. The Samoan tattooing song cited earlier attributes the origin of the tradition to Fiji, and it places front and center the fact that women are tattooed in Fiji while men are tattooed in Samoa. Similarly, William Mariner presents a Tongan account of two women who travel from Fiji to Tonga, bringing the art of tattoo with them, and due to a traveling accident, reverse the genders of tattoo recipients. Songs and stories in Fiji emphasize the way that women are tattooed in Fiji but men are tattooed in Tonga. Pacific stories and songs about tattooing thus become a way to represent cultural exchange and adaptation.

43. Adolph Brewster, *The Hill Tribes of Fiji: A Record of Forty Years' Intimate Connection with the Tribes of the Mountainous Interior of Fiji* (London: Seeley, Service, 1922), 185 (hereafter cited as *Hill Tribes*).

44. Malakai Navatu, "Tattooing," in *Hill Tribes*, 186 (hereafter cited as Navatu).

45. Basil Thomson, *The Fijians: A Study of the Decay of Custom* (London: William Heinemann, 1908), 217 (hereafter cited as *Decay of Custom*).

46. Navatu, 185–86. One meaning of the word *cala* is "to err," thus providing another reversal from the tattooing practiced in Samoa: in Fiji, women are tattooed, and the name of the design can mean an error, while in Samoa men are tattooed, and one meaning of *tatau* is "right, fitting, or proper." The gender of the tattoo deity and of the tattoo practitioner also differ in Fiji and in Samoa.

47. Thomas Williams, "The Islands and Their Inhabitants," in Thomas Williams and James Calvert, *Fiji and the Fijians*, ed. George Stringer Rowe (New York: Appleton, 1859), 126 (hereafter cited as *Fiji*).

48. Joseva Bembe Tumbi, "Tattooing," in *Hill Tribes*, 187 (hereafter cited as Tumbi).

49. *Fiji*, 126. These sources are the ones Gell states that he has consulted in creating his discussion of Vitian tattooing. Their descriptions of mouth tattooing, cited here, thus do not support his claim that "the custom was to tattoo semicircles around the corners of the mouth. If these marks were small and did not meet up over the upper lip, the girl's tattoo was only half complete; when the tattooed lines around the mouth joined up, that indicated that tattooing had been completed" (*Wrapping*, 79). To note an additional correction, throughout his discussion Gell also uses the term *qia*, meaning *to tattoo*, as a noun.

50. All of these accounts of the patterns contradict Gell's suggestion that tattoo degrades the recipient. Following Nayacakalou, he proposes that rank in Fiji is derived from gender, and that women by definition possess lower rank than do men. He claims that women in Fiji are tattooed to mark their low rank, a thesis that corresponds to his suggestion that tattooing shames the recipient. (To the contrary, tattoo's absence rather than presence is noted repeatedly as a mark of shame.) If this notion were true, it seems impossible that no mention would appear in other accounts. It seems that Gell's framing thesis has led him astray; thus, his claim for a connection between traditional Polynesian tattooing and contemporary European subcultural tattooing leads him to look at tattoo as degrading rather than honorific. Because he believes that tattooing in the West is practiced by "criminals, common soldiers and sailors, lunatics, prostitutes" he concludes that traditional tattooing was widely practiced in the Pacific since "these are societies which are dominated by criminals, soldiers, and prostitutes" (*Wrapping*, 19). These assumptions are highly questionable.

51. Anne E. Becker, *Body, Self, and Society: The View from Fiji* (Philadelphia: University of Pennsylvania Press, 1995), 1.

52. Joseph Veramu, *Moving Through the Streets* (Suva, Fiji: Mana Publications and Institute of Pacific Studies, 1994), hereafter cited as *Moving*.

53. While political and economic power, as well as social standing, are determined by matrilineal clanship, German colonial law (1899–1914) changed the way land was inherited: "Although clanship is passed through the mother, inheritance, usually land, has been determined by the father since German times." Resio S. Moses and Gene Ashby, "Tradition and Democracy on Pohnpei Island," in *Culture and Democracy in the South Pacific*, ed. Ron Crocombe et al. (Suva, Fiji: Institute of Pacific Studies, University of the South Pacific, 1992), 208.

54. In *The Book of Luelen*, Bernart includes *pelipel* in his history of Pohnpei. This book records oral history and mythology and suggests that tattooing starts in the "beginning of the period of the line of the Lords of Teleur," when men "began to tattoo their skin, and pulled out their face hair with the scales of fish from the sea" and "women wore a wrap-around of breadfruit bark cloth, and they were also tattooed on their skins." Luelen Bernart, *The Book of Luelen*, ed. and trans. John L. Fischer, Saul H. Riesenberg, and Marjorie G. Whiting (Honolulu: University Press of Hawai'i, 1977), 72.

55. Paul Hambruch and Anneliese Eilers, *Ponape: Gesellschaft und Geistige Kultur, Wirtschaft und Stoffliche Kultur* (Hamburg: Friederichsen, De Gruyter, 1936), 2:269 (hereafter cited as *Ponape*). See also Saul Riesenberg's note in James O'Connell, *A*

Residence of Eleven Years in New Holland and the Caroline Islands, ed. Saul Riesenberg (Honolulu: University of Hawaiʻi Press, 1972), 116.

56. Gene Ashby, *Pohnpei: An Island Argosy* (Pohnpei, F.S.M., and Eugene, Ore.: Rainy Day Press, 1993), 228 (hereafter cited as *Pohnpei*).

57. *Pohnpei*, 228; David Hanlon, *Upon a Stone Altar: A History of the Island of Pohnpei to 1890* (Honolulu: University of Hawaiʻi Press, 1988), 41.

58. Nān Kătin, "Ko žoi pen uīa intin," in *Ponape*, 269 (hereafter cited as "Ko žoi"), translation mine. Nān Kătin may be a tattoo artist, since *Nahn* is a word used in announcing a person's title, and in the phrase Hambruch records for woman tattoo artist or expert, "*Kătin nting*," *nting* means to tattoo or write, and *Kătin* designates the person's expertise.

59. Because Hambruch died in 1933, his colleague Anneliese Eilers prepared this 1936 volume for publication, and it could be that the author and editor were not able to standardize the orthography. And in any case, only in the late 1970s has Pohnpeian spelling been standardized formally. Even with the formal orthographic standards, today Pohnpeian spelling continues to vary in daily use, on street signs, and in city names. Kenneth Rehg, "Taking the Pulse of Pohnpeian," *Oceanic Linguistics* 37, no. 2 (1998): 325–26.

60. Kenneth L. Regh and Damian G. Sohl, *Ponapean-English Dictionary* (Honolulu: University of Hawaiʻi Press, 1979), 56 (hereafter cited as *Ponapean-English Dictionary*). Sincere thanks are due to Fran Hezel, S.J., for sharing his expertise about Pohnpeian terms. Errors are, of course, my own.

61. As in Samoa and Fiji, in Pohnpei parallels are drawn between tattooing, childbirth, and circumcision or *lekilek*: "boys were trained to be strong and brave, to endure pain, especially for tattooing and the removal of one testicle which was a ritualistic part of initiation into manhood. Girls were also trained to be brave both for tattooing and for the bearing of many children." Nat Colletta, *American Schools for the Natives of Ponape: A Study of Education and Culture Change in Micronesia* (Honolulu: East-West Center, University Press of Hawaiʻi, 1980), 12.

62. Tricia Allen, "European Explorers and Marquesan Tattooing: The Wildest Island Style," *Tattootime* 5 (1991): 87.

63. Quotation from Bronwen Douglas, "'Cureous Figures': European Voyagers and Tatau / Tattoo in Polynesia, 1595–1800," *Tattoo*, 32 (hereafter cited as "Figures").

64. William Dampier, *A New Voyage Round the World*, ed. John Masefield (London: E. Grant Richards, 1906), 1:497 (hereafter cited as *New Voyage*).

65. Anton Gill, *The Devil's Mariner: A Life of William Dampier, Pirate and Explorer, 1651–1715* (London: Michael Joseph, 1997), 217 (hereafter cited as *Devil's Mariner*).

NOTES TO EPILOGUE

1. Petelo Suluʻape, "History of Samoan Tattooing," *Tattootime* 5 (1991): 104–5.

2. Tusiata Avia, "The Patterns on Her Skin," in *Tatau*, ed. Sean Mallon and Roger Blackley (Wellington: Adam Art Gallery, Victoria University of Wellington, 2003), 27.

3. Sean Mallon and Uili Fecteau, "Tatau-ed: Polynesian Tatau in Aotearoa," in *Pacific Art Niu Sila*, ed. Sean Mallon and Pandora Fulimalo Pereira (Wellington: Te Papa Press, 2002), 31.

4. Ngahuia Te Awekotuku, "More Than Skin Deep: *Ta Moko* Today," in *Claiming the Stones, Naming the Bones*, ed. Alazar Barkan and Ronald Bush (Los Angeles: Getty Research Institute, 2002), 248 (hereafter cited as "More Than Skin Deep").

5. Suluʻape, "Samoan Tattooing," 109; Mallon and Fecteau, "Tatau-ed," 28.

6. Gordon Toi Hatfield and Patricia Steuer, *Dedicated by Blood / Whakautu ki te toto* (The Hague: Hunter Media, 2002), 88 (hereafter cited as *Dedicated*).

7. Jim Masilak, "Fighters Warm Up with Mind Game—Different Demeanors Put on Stage During Weigh-In," *Commercial Appeal* (Memphis), February 21, 2003.

8. "Sidelines," *Ottawa Citizen*, February 18, 2003.

9. Tim Dahlberg, "Let the Carnival Begin," Associated Press Sports News, February 20, 2003.

10. Margo DeMello, "Anchors, Hearts and Eagles: From the Literal to the Symbolic in American Tattooing," in *Literacies: Writing Systems and Literate Practices*, ed. David L. Schmidt and Janet S. Smith (Davis: University of California, 1991), 93.

11. Margo DeMello, *Bodies of Inscription: A Cultural History of the Modern Tattoo Community* (Durham, N.C.: Duke University Press, 2000), 137 (hereafter cited as *Bodies*).

12. New Zealand Press Association, "Concern Over Ignorant Use of Moko," February 27, 2003.

13. Deutsche Presse Agentur, "Mike Tyson's Maori Tattoo Not the Real Thing, Expert Says," February 22, 2003.

14. Peter Shand, "Scenes from the Colonial Catwalk: Cultural Appropriation, Intellectual Property Rights, and Fashion," *Cultural Analysis* 3 (2002): 72, 74.

15. H. W. Williams, *Dictionary of the Maori Language* (Wellington: Government Printer, 1992), 282, 486.

16. Michael Neill, "From the Editor," in *Shakespeare Quarterly* 52, no. 4 (2001): iii.

17. Thomas Chambers, "The Head of a Chief of New Zealand, the face curiously tataowed, or mark'd, according to their Manner," in Sydney Parkinson, *A Journal of a Voyage to the South Seas in his Majesty's ship the Endeavour* (London: Stanfield Parkinson, 1773), plate xvi.

18. Neill, "From the Editor," v; Roger Neich, *Painted Histories: Early Maori Figurative Painting* (Auckland: Auckland University Press, 1993), 34.

19. Roger Neich, "Wood Carving," in *Maori Art and Culture*, ed. D. C. Starzecka, (Auckland: David Bateman, 1996), 105; see also Neich, *Painted Histories*, 38.

20. Personal communication, March 21, 2007.

Bibliography

Adams, Henry. *The Letters of Henry Adams*. 6 vols. Ed. J. C. Levenson et al. Cambridge, Mass.: Harvard University Press, 1982.

Allen, Tricia. "European Explorers and Marquesan Tattooing: The Wildest Island Style." *Tattootime* 5 (1991): 86–101.

———, ed. *Tattoo Traditions of Hawai'i*. Honolulu: Mutual, 2005.

Allen, Tricia, and Steve Gilbert. "Polynesia Today." Gilbert 187–95.

Anderson, Charles Roberts. *Melville in the South Seas*. New York: Columbia University Press, 1939.

Arago, Jacques. *Narrative of a Voyage Around the World in the Uranie and Physicienne Corvettes*. 1823. New York: Da Capo, 1971.

———. *Souvenirs d'un Avengle, Voyage Autour du Monde*. 2 vols. Paris: Hortet et Ozanne, 1840.

Ashby, Gene. *Pohnpei, An Island Argosy*. Pohnpei, F.S.M., and Eugene, Ore.: Rainy Day Press, 1993.

———, ed. *Some Things of Value: Micronesian Customs as Seen by Micronesians*. By the Students of the Community College of Micronesia. Eugene, Ore.: Rainy Day Press, 1983.

Avia, Tusiata. "The Patterns on Her Skin." *Tatau*. Ed. Sean Mallon and Roger Blackley. Wellington: Adam Art Gallery, Victoria University of Wellington, 2003. 26–28.

Banks, Joseph. *The* Endeavour *Journal of Joseph Banks, 1768–1771*. 2 vols. Ed. J. C. Beaglehole. Sydney: Angus and Robertson, 1963.

Barbour, James. "The Composition of *Moby-Dick*." *American Literature* 47, no. 3 (1975): 343–60.

Barclay, Barry. *Mana Tuturu: Maori Treasures and Intellectual Property Rights*. Auckland: Auckland University Press, 2005.

Barry, Mabel Fuatino. "Pea." *Mana* 12, no. 1 (1997): 45–49.

Beatson, Peter. "Review of *Once Were Warriors*." *Landfall 179* 45, no. 3 (1991): 365–68.

Becker, Anne E. *Body, Self, and Society: The View from Fiji*. Philadelphia: University of Pennsylvania Press, 1995.

Bennett, Frederick D. *Narrative of a Whaling Voyage Round the Globe From the Year 1833–1836*. 2 vols. 1840. New York: Da Capo, 1970.

Bernart, Luelen. *The Book of Luelen*. Trans. and ed. John L. Fischer, Saul H. Riesenberg, and Marjorie G. Whiting. Honolulu: University Press of Hawai'i, 1977.

Besnier, Niko. "Polynesian Gender Liminality Through Time and Space." *Third Sex, Third Gender: Beyond Sexual Dimorphism in Culture and History*. Ed. Gilbert Herdt. New York: Zone Books, 1994. 285–328.

Bester, Alfred. *The Stars My Destination*. 1956. New York: Vintage, 1996.

Bogdan, Robert. *Freak Show: Presenting Human Oddities for Amusement and Profit*. Chicago: University of Chicago Press, 1988.

Braunberger, Christine. "Revolting Bodies: The Monster Beauty of Tattooed Women." *NWSA Journal* 12, no. 2 (2000): 1–23.

Brewster, Adolph. *The Hill Tribes of Fiji: A Record of Forty Years' Intimate Connection with the Tribes of the Mountainous Interior of Fiji*. London: Seeley, Service, 1922.

Briggs, John F. "Tattooing." *Medical Times* 87, no. 8 (1959): 1030–39.

Bright, John. *Hand-Book for Emigrants, and Others, Being a History of New Zealand*. London: Henry Hooper, 1841.

Bromberg, Walter. "Psychologic Motives in Tattooing." *Archives of Neurology and Psychiatry* 33 (1935): 228–32.

Brown, Danielle. "Pakeha, Maori, and Alan: The Political and Literary Exclusion of Alan Duff." *SPAN* 40 (1995): 72–80.

Buck, Sir Peter. *The Coming of the Maori*. 1949. Wellington: Maori Purposes Fund Board, Whitcombe and Tombs, 1966.

Burchett, George. *Memoirs of a Tattooist*. London: Oldbourne, 1958.

Butler, Judith. *Bodies That Matter: On the Discursive Limits of "Sex."* New York: Routledge, 1993.

Cairns, Puawai. "He Taonga te Ta Moko ki Tauranga Moana: A survey of attitudes, opinions, whakāro noa iho, towards ta moko during the Tauranga Moana, Tauranga Tangata Festival." Nikora 133–39.

Calder, Alex. "'The Thrice Mysterious Taboo': Melville's *Typee* and the Perception of Culture." *Representations* 67 (1999): 27–43.

Campbell, I. C. *Island Kingdom: Tonga Ancient and Modern*. Christchurch: Canterbury University Press, 1992.

Caplan, Jane, ed. *Written on the Body: The Tattoo in European and American History*. Princeton, N.J.: Princeton University Press, 2000.

Carkeek, Wakahuia. *The Kapiti Coast: Maori History and Place Names*. Wellington: Reed, 1966.

Carroll, Lynne, and Roxanne Anderson. "Body Piercing, Tattooing, Self-Esteem, and Body Investment in Adolescent Girls." *Adolescence* 37 (2002): 627–37.

Cassuto, Leonard. "'What an object he would have made of me!': Tattooing and the Racial Freak in Melville's *Typee*." *Freakery: Cultural Spectacles of the Extraordinary*

Body. Ed. Rosemarie Garland Thomson. New York: New York University Press, 1996. 234–47.

Chambers, Thomas. "The Head of a Chief of New Zealand, the face curiously tataowed, or mark'd, according to their Manner." *A Journal of a Voyage to the South Seas in his Majesty's ship the* Endeavour. Sydney Parkinson. London: Stanfield Parkinson, 1773.

Chow, Rey. "How (the) Inscrutable Chinese Led to Globalized Theory." *PMLA* 116, no. 1 (2001): 69–74.

Churchward, C. Maxwell. *Tongan Dictionary*. Tonga: Government Printing Press, 1959.

Colletta, Nat J. *American Schools for the Natives of Ponape: A Study of Education and Culture Change in Micronesia*. Honolulu: East-West Center, University of Hawaiʻi, 1980.

Cook, James. *The Journals of Captain James Cook on his Voyages of Discovery*. 4 vols. Ed. J. C. Beaglehole. Cambridge: Hakluyt Society at the Cambridge University Press, 1955.

Coulter, John, M.D. *Adventures in the Pacific; with Observations on the Natural Productions, Manners and Customs of the Natives of the Various Islands*. London: Longmans, Brown, 1845.

[Craik, George Lillie.] *The New Zealanders*. London: Charles Knight, 1830.

Cubitt, Catherine. *Anglo-Saxon Church Councils c. 650–c. 850*. London: Leicester University Press, 1995.

Dahlberg, Tim. "Let the Carnival Begin." Associated Press, February 20, 2003.

Dampier, William. *A New Voyage Round the World*. 2 vols. Ed. John Masefield. London: E. Grant Richards, 1906.

Davies, John. *The History of the Tahitian Mission, 1799–1830*. Ed. C. W. Newbury. Cambridge: Hakluyt Society, Cambridge University Press, 1961.

DeLoughrey, Elizabeth. "The Spiral Temporality of Patricia Grace's *Potiki*." *Ariel* 30, no. 1 (1999): 59–83.

DeMello, Margo. "Anchors, Hearts and Eagles: From the Literal to the Symbolic in American Tattooing." *Literacies: Writing Systems and Literate Practices*. Ed. David L. Schmidt and Janet S. Smith. Davis: University of California, 1991. 93–110.

———. *Bodies of Inscription: A Cultural History of the Modern Tattoo Community*. Durham, N.C.: Duke University Press, 2000.

Dening, Greg. *Beach Crossings: Voyaging Across Times, Cultures, and Self*. Philadelphia: University of Pennsylvania Press, 2004.

———. *Islands and Beaches: Discourse on a Silent Land, Marquesas, 1774–1880*. Chicago: Dorsey, 1980.

Derrida, Jacques. *Of Grammatology*. 1967. Trans. Gayatri Chakravorty Spivak. Baltimore: Johns Hopkins University Press, 1976.

Deutsche Presse-Agentur. "Mike Tyson's Maori Tattoo Not the Real Thing, Expert Says." February 22, 2003.

Douglas, Bronwen. "'Cureous Figures': European Voyagers and *Tatau*/Tattoo in Polynesia, 1595–1800." Thomas et al. 32–52.

Drummond, James. "Introduction." *John Rutherford, The White Chief.* [George Lillie Craik.] Ed. James Drummond. Christchurch: Whitcombe and Tombs, 1908.

Du Chateau, Carroll. "Aggro Culture." *Quote Unquote* 11 (1994): 12–16.

Duff, Alan. *Both Sides of the Moon.* Auckland: Vintage, 1998.

———. *Maori: The Crisis and the Challenge.* Auckland: Tandem, 1993.

———. *Once Were Warriors.* 1990. New York: Vintage, 1995.

Edmond, Rod. "'Kiss my arse!' Epeli Hau'ofa and the Politics of Laughter." *Journal of Commonwealth Literature* 25, no. 1 (1990): 142–55.

Elleray, Michelle. "Crossing the Beach: A Victorian Tale Adrift in the Pacific." *Victorian Studies* 47, no. 2 (2005): 164–73.

Ellis, Juniper. "Island Queens: Women and Power in Melville's South Pacific." *Melville and Women.* Ed. Elizabeth Schultz and Haskell Springer. Kent, Ohio: Kent State University Press, 2006. 163–80.

———. "Moving the Centre: An Interview with Sia Figiel." *World Literature Written in English* 37, no. 1–2 (1998): 135–43.

———. "A New Oceania: An Interview with Epeli Hau'ofa." *Antipodes* 15, no. 1 (2001): 22–25.

Ellis, William. *Polynesian Researches During a Residence of Nearly Eight Years in the Society and Sandwich Islands.* Rev. ed. 4 vols. London: Henry G. Bohn, 1853.

Emory, Kenneth P. "Hawaiian Tattooing." *Occasional Papers of Bernice P. Bishop Museum* 18 (1946): 235–70.

Fabian, Johannes. *Time and the Other: How Anthropology Makes Its Object.* New York: Columbia University Press, 1983.

Fairchild, Samantha. "Samantha Fairchild." Allen 198–200.

Fanon, Frantz. *The Wretched of the Earth.* 1961. Trans. Constance Farrington. New York: Grove, 1963.

Favazza, Armando. *Bodies Under Siege: Self-mutilation and Body Modification in Culture and Psychiatry.* 2nd ed. Baltimore: Johns Hopkins University Press, 1996.

Ferdon, Edwin N. *Early Tonga as the Explorers Saw It, 1616–1810.* Tucson: University of Arizona Press, 1987.

Figiel, Sia. *The Girl in the Moon Circle.* Suva, Fiji: Mana Publications, 1996.

———. *They Who Do Not Grieve.* Auckland: Vintage, 1999.

———. *Where We Once Belonged.* Auckland: Pasifika, 1996.

Fleming, Juliet. *Graffiti and the Writing Arts of Early Modern England.* Philadelphia: University of Pennsylvania Press, 2001.

———. "The Renaissance Tattoo." Caplan 61–82.

Fornander, Abraham. *Fornander Collection of Hawaiian Antiquities and Folk-Lore: The Hawaiian Account of the Formation of Their Islands and Origin of Their Race with the Traditions of Their Migrations, etc., as Gathered from Original Sources.* 4 vols. Trans. rev. by Thomas G. Thrum. Honolulu: Bishop Museum Press, 1916.

Forster, Georg. *A Voyage Round the World, in His Brittanic Majesty's Sloop, Resolution.* 2 vols. London: B. White, J. Robson, P. Elmsly, G. Robinson, 1777.

Forster, J. R. *Observations Made During a Voyage Round the World, on Physical Geography, Natural History, and Ethic Philosophy.* London: G. Robinson, 1778.

Foucault, Michel. *Discipline and Punish: The Birth of the Prison.* 1975. Trans. Alan Sheridan. New York: Vintage, 1979.

Gathercole, Peter. "Contexts of Maroi [*sic*] Moko." *Marks of Civilization.* Ed. Arnold Rubin. Los Angeles: Museum of Cultural History, UCLA, 1988. 171–77.

Gell, Alfred. *Wrapping in Images: Tattooing in Polynesia.* Oxford: Clarendon Press, 1993.

Genoux, Isabelle. "Tattooing Festival." *Artok,* October 15, 2000. www.abc.net.au/arts/artok/bodyart/s199572.htm. Accessed 15 February 2001.

Gilbert, Steve, ed. *Tattoo History: A Sourcebook.* New York: Juno, 2000.

Gill, Anton. *The Devil's Mariner: A Life of William Dampier, Pirate and Explorer, 1651–1715.* London: Michael Joseph, 1997.

Gon, Sam 'Ohukani'ōhi'a III. "Sam 'Ohukani'ōhi'a Gon III." Allen 176–77.

Gotz. "'Each Tattoo Is an Encounter': Chimé Interview / Moorea." *Tattoo Age* 1 (2000): 16–21.

Govor, Elena. "'Speckled Bodies': Russian Voyagers and Nuku Hivans, 1804." Thomas et al. 53–71.

Griffen, Arlene. "A Pacific Novel: The Example of Epeli Hau'ofa." *Dreadlocks in Oceania* 1 (1997): 149–75.

Gunson, Niel. "An Account of the Mamaia or Visionary Heresy of Tahiti, 1826–1841." *Journal of the Polynesian Society* 71 (1962): 209–43.

Gustafson, Mark. "The Tattoo in the Later Roman Empire and Beyond." Caplan 17–31.

Guyer, Paul. "Dependent Beauty Revisited: A Reply to Wicks." *Journal of Aesthetics and Art Criticism* 57, no. 3 (1999): 357–61.

———. *Kant and the Claims of Taste.* Cambridge, Mass.: Harvard University Press, 1979.

———. *Kant and the Claims of Taste.* 2nd ed. Cambridge: Cambridge University Press, 1997.

Haddan, Arthur West, and William Stubbs, eds. *Councils and Ecclesiastical Documents Relating to Great Britain and Ireland.* 3 vols. Oxford: Clarendon Press, 1871.

Hall, Lisa Kahaleole Chang, and J. Kehaulani Kauanui. "Same-Sex Sexuality in Pacific Literature." *Asian American Sexualities: Dimensions of the Gay and Lesbian Experience.* Ed. Russell Leong. New York and London: Routledge, 1996. 113–18.

Hall, Sarah. *The Electric Michelangelo.* London: Faber, 2004.

Hambruch, Paul, and Anneliese Eilers. *Ponape: Gesellschaft und Geistige Kultur, Wirtschaft und Stoffliche Kultur.* 3 vols. Hamburg: Friederichsen, De Gruyter, 1936.

Hamilton, Augustus. *Maori Art.* 1901. London: Holland, 1972.

Handy, Willowdean Chatterson. *Forever the Land of Men: An Account of a Visit to the Marquesas Islands.* New York: Dodd, Mead, 1965.

———. "Samoan Tattooing." *Samoan House Building, Cooking, and Tattooing. Bernice P. Bishop Museum Bulletin 15.* Honolulu: Bishop Museum, 1924. 21–29.

———. *Tattooing in the Marquesas. Bernice P. Bishop Museum Bulletin* 1 (1922).

Hanlon, David. "Beyond 'the English Method of Tattooing.'" *The Contemporary Pacific* 15, no. 1 (2003): 19–40.

———. *Upon a Stone Altar: A History of the Island of Pohnpei to 1890.* Honolulu: University of Hawai'i Press, 1988.

Harawira, Wena, Caleb Maitai, and Lee Umbers. "Tattoos Are Back: Moko—More Than Skin Deep." *Mana: The Maori News Magazine for All New Zealanders* 2 (1993): 4–8.

Harding, Bruce. "Wrestling with Caliban: Patterns of Bi-racial Encounter in *Colour Scheme* and *Once Were Warriors*." *Australian & New Zealand Studies in Canada* 7–8 (1992): 136–55.

Hatfield, Gordon Toi, and Patricia Steuer. *Dedicated by Blood / Whakautu ki te toto*. The Hague: Hunter Media, 2002.

Hau'ofa, Epeli. "The New South Pacific Society: Integration and Independence." *Class and Culture in the South Pacific*. Ed. Antony Hooper et al. Auckland: Centre for Pacific Studies, University of Auckland Press, 1987. 1–14.

——. *Kisses in the Nederends*. 1987. Honolulu: University of Hawai'i Press, 1995.

——. "Our Sea of Islands." *A New Oceania: Rediscovering Our Sea of Islands*. Ed. Eric Wadell, Vijay Naidu, and Epeli Hau'ofa. Suva, Fiji: University of the South Pacific, Beake House, 1993. 2–16.

——. *Tales of the Tikongs*. 1983. Honolulu: University of Hawai'i Press, 1994.

Hawkesworth, John. *An Account of the Voyages . . . in the Southern Hemisphere*. 3 vols. London: W. Strahan and T. Cadell, 1773.

Hayford, Harrison. "Unnecessary Duplicates: A Key to the Writing of *Moby-Dick*." *Critical Essays on Herman Melville's* Moby-Dick. Ed. Brian Higgins and Hershel Parker. New York: G. K. Hall, 1992. 479–504.

Henry, Teuira. *Ancient Tahiti. Bernice P. Bishop Museum Bulletin* 48 (1928).

Herbert, Christopher. *Culture and Anomie: Ethnographic Imagination in the Nineteenth Century*. Chicago: University of Chicago Press, 1991.

Herbert, T. Walter. *Marquesan Encounters: Melville and the Meaning of Civilization*. Cambridge, Mass.: Harvard University Press, 1980.

——. *Moby-Dick and Calvinism: A World Dismantled*. New Brunswick, N.J.: Rutgers University Press, 1977.

[Hereniko], Vilsoni Tausie. *Art in the New Pacific*. Suva, Fiji: Institute of Pacific Studies, 1980.

Hereniko, Vilsoni. "An Interview with Alan Duff." *The Contemporary Pacific* 7, no. 2 (1995): 328–34.

Hereniko, Vilsoni, and Rob Wilson, eds. *Inside Out: Literature, Cultural Politics, and Identity in the New Pacific*. Lanham, Md.: Rowman & Littlefield, 1999.

Hiro, Henri. *Pehepehe i Taù Nunaa/Message Poétique*. Papeete: Tupuna Productions, 1990.

Ho'omanawanui Ku'ualoa. "He Lei Ho'oheno no nā Kau a Kau: Language, Performance, and Form in Hawaiian Poetry." *The Contemporary Pacific* 17, no. 1 (2005): 29–81.

Howard, Leon. *Herman Melville: A Biography*. Berkeley: University of California Press, 1951.

Hunkin, Galumalemana Afeleti L. *Gagana Samoa: A Samoan Language Coursebook*. Auckland: Polynesian Press, 1992.

Ihimaera, Witi, ed. *Mataora: The Living Face*. Auckland: David Bateman, 1996.

Irwin, John. *American Hieroglyphics: The Symbol of the Egyptian Hieroglyphics in the American Renaissance*. New Haven: Yale University Press, 1980.

Iti, Tame Wairere. "Perspectives." *Moko—Maori Tattoo*. Hans Neleman. Zurich: Edition Stemmle, 1999.

Ivory, Carol S. "Art, Tourism, and Cultural Revival in the Marquesas Islands." *Unpacking Culture: Art and Commodity in Colonial and Postcolonial Worlds*. Ed. Ruth B. Phillips and Christopher B. Steiner. Berkeley: University of California Press, 1999. 316–34.

Jacobs, Thomas Jefferson. *Scenes, Incidents, and Adventures in the Pacific Ocean*. New York: Harper & Brothers, 1844.

Jaffé, David. "Some Origins of *Moby-Dick*: New Finds in an Old Source." *American Literature* 29, no. 3 (1957): 263–77.

Jahnke, Huia Tomlins. "Māori Women and Education: Historical and Contemporary Perspectives." *Mai i Rangiātea: Māori Wellbeing and Development*. Ed. Pania Te Whāiti, Mārie McCarthy, and Arohia Durie. Auckland: Auckland University Press / Bridget Williams, 1997. 96–112.

Jahnke, Robert, and Witi Ihimaera. "Ta Te Tiriti o Waitangi." Ihimaera, *Mataora*. 126–27.

Jones, C. P. "Stigma and Tattoo." Caplan. 1–16.

———. "*Stigma*: Tattooing and Branding in Graeco-Roman Antiquity." *Journal of Roman Studies* 77 (1987): 139–55.

Jones, Owen. *Grammar of Ornament*. London: Day and Son, 1856.

Kabris, Joseph, and A. F. Dulys. *Précis Historique et Véritable du Séjour de Joseph Kabris*. Paris: J. G. Dentu, c. 1817.

Kaeppler, Adrienne. "Hawaiian Tattoo: A Conjunction of Genealogy and Aesthetics." Rubin 157–70.

Kafka, Franz. "In the Penal Colony." *The Penal Colony*. Trans. Willa Muir and Edwin Muir. New York: Schocken, 1948. 191–227.

Kalāhele, ʻĪmaikalani. "H-3: A Series of Questions." *ʻŌiwi: A Native Hawaiian Journal* 1 (1998): 164–65.

Kamakau, Samuel M. *Ruling Chiefs of Hawaii*. Honolulu: Kamehameha Schools Press, 1961.

Kant, Immanuel. *Critique of Judgement*. Trans. James Creed Meredith. Oxford: Clarendon Press, 1964.

———. *Critique of Judgment*. Trans. Werner S. Pluhar. Indianapolis: Hackett, 1987.

———. *Kritik der Urteilskraft*. Ed. Wilhelm Weischedel. Frankfurt am Main: Suhrkamp, 1974.

Kātin, Nān. "Ko žoi pen uia intin." Hambruch and Eilers 2:268–70.

Kayser, Wolfgang. *The Grotesque in Art and Literature*. 1957. Trans. Ulrich Weisstein. Gloucester, Mass.: Peter Smith, 1968.

Keown, Michelle. "Freeing the Ancestors: An Interview with Epeli Hauʻofa." *Ariel* 32, no. 1 (2001): 71–80.

King, Michael. *Moko: Maori Tattooing in the 20th Century*. 1972. Auckland: David Bateman, 1999.

Kleinschmidt, Theodor. *Notes on the Hill Tribes of Vitilevu, 1877–1878.* Ed. Herbert Tischner. Trans. Stefanie Vuikaba Waine. *Domodomo* 2, no. 4 (1984): 138–91.

Kotzebue, Otto von. *A New Voyage Round the World in the Years 1823, 24, 25, and 26.* 2 vols. 1830. New York: Da Capo, 1967.

Krämer, Augustin. *The Samoa Islands.* 2 vols. 1903. Trans. Theodore Verhaaren. Honolulu: University of Hawai'i Press, 1995.

Krusenstern, Adam J. von. *Voyage Round the World in the Years 1803, 1804, 1805, and 1806.* 2 vols. 1813. Trans. Richard Belgrave Hoppner. New York: Da Capo, 1968.

Kuwahara, Makiko. "Multiple Skins: Space, Time and Tattooing in Tahiti." Thomas et al. 171–90.

——. *Tattoo: An Anthropology.* Oxford: Berg, 2005.

Kwiatkowski, P. F. *The Hawaiian Tattoo.* Kohala: Halona, 1996.

Lacan, Jacques. *The Four Fundamental Concepts of Psycho-analysis.* 1973. Ed. Jacques-Alain Miller. Trans. Alan Sheridan. New York: Norton, 1978.

La Farge, John. *An American Artist in the South Seas.* 1914. London: KPI, 1987.

Langsdorff, G. H. von. *Voyages and Travels in Various Parts of the World, During the Years 1803, 1804, 1805, 1806, and 1807.* 2 vols. 1813. New York: Da Capo, 1968.

Lātūkefu, Sione. *Church and State in Tonga: The Wesleyan Methodist Missionaries and Political Development, 1822–1875.* Honolulu: University Press of Hawai'i, 1974.

Lei-Lanilau, Carolyn. "*Oli Makahiki,* Chant Composed as a Gift for My Daughter Kalea-Qy-Ana During *Makahiki,* the Rest Period from October Through January, 1994." *Frontiers* 23, no. 2 (2002): 36–42.

Leiter, Lois. "Queequeg's Coffin." *Nineteenth-Century Fiction* 13, no. 3 (1958): 249–54.

Lévi-Strauss, Claude. *Structural Anthropology.* 1958. Trans. Claire Jacobson and Brooke Grundfest Schoepf. New York: Basic Books, 1963.

Leyda, Jay. *The Melville Log: A Documentary Life of Herman Melville.* 2 vols. New York: Harcourt, Brace, 1951.

Liddell, Henry, and Robert Scott. *Greek-English Lexicon.* 8th ed. American Book Company: New York, 1897.

Lombroso, Cesare. "The Savage Origin of Tattooing." *Appleton's Popular Science Monthly* 48 (November 1895–April 1896): 793–803.

London, Charmian. Photograph Captions. c. 1907–1908. Jack London Papers, JLP 495, Photograph Album 57–12e-g, 57–12l. Huntington Library, San Marino, California.

London, Jack. *Cruise of the Snark.* 1908. New York: Review of Reviews, 1917.

Loos, Adolf. "Ornament und Verbrechen." *Sämtliche Schriften.* Vienna: Verlag Herold, 1962. 1:276–88.

Losch, Kealalōkahi. "Hoʻōla hou ka Moko a me ka Uhi: The Revival of Cultural Tattooing in Aotearoa and Hawaiʻi." M.A. thesis, University of Hawaiʻi, 1999.

Lynch, John. *Pacific Languages: An Introduction.* Honolulu: University of Hawaiʻi Press, 1998.

Macdonald, Finlay. "A Tale of Two Lakes." *Listener* 129 (1991): 30–32.

MacQuarrie, Charles W. "Insular Celtic Tattooing: History, Myth and Metaphor." Caplan 32–45.

"Madonna and Child Tekoteko." Te Papa Museum website. http://tinyurl.com/3balsb.

Mageo, Jeannette Marie. *Theorizing Self in Samoa*. Ann Arbor: University of Michigan Press, 1998.

Mallon, Sean, and Uili Fecteau. "Tatau-ed: Polynesian Tatau in Aotearoa." *Pacific Art Niu Sila*. Ed. Mallon and Pandora Fulimalo Pereira. Wellington: Te Papa Press, 2002. 21–37.

Marquardt, Carl. *The Tattooing of Both Sexes in Samoa*. 1899. Trans. Sibyl Ferner. Papakura: McMillan, 1984.

Marsh, Selina Tusitala. "Theory 'versus' Pacific Islands Writing: Toward a *Tama'ita'i* Criticism in the Works of Three Pacific Islands Woman Poets." Hereniko and Wilson 337–56.

Martin, John. *An Account of the Natives of the Tonga Islands, in the South Pacific Ocean. With an Original Grammar and Vocabulary of their Language. Compiled and arranged from the extensive communication of Mr. William Mariner, several years resident in those islands*. 2 vols. Westmead, England: Gregg, 1817.

Mascia-Lees, Frances E., and Patricia Sharpe. "The Marked and the Un(re)marked: Tattoo and Gender in Theory and Narrative." *Tattoo, Torture, Mutilation, and Adornment: The Denaturalization of the Body in Culture and Text*. Albany: SUNY Press, 1992. 145–69.

Masilak, Jim. "Fighters Warm Up with Mind Game—Different Demeanors Put on Stage During Weigh-In." *Commercial Appeal* (Memphis), February 21, 2003.

Mason, Jean Tekura. *Tatau (Tattoo)*. Suva, Fiji: Mana Publications in Association with the Institute of Pacific Studies, University of the South Pacific, 2001.

Matsuda, Matt K. *Empire of Love: Histories of France and the Pacific*. New York: Oxford University Press, 2005.

McKinney, Chris. *Tattoo*. Honolulu: Mutual Publishing, 1999.

McNab, Robert, ed. *Historical Records of New Zealand*. 2 vols. Wellington: Government Printer, 1908–1914.

Mead, Hirini Moko. *Te Toi Whakairo: The Art of Maori Carving*. 1986. Auckland: Reed, 1995.

Mead, Margaret. *Coming of Age in Samoa*. 1928. New York: Morrow, 1973.

———. *The Maoris and Their Arts*. New York: American Museum of Natural History, 1928.

———. *Social Organization of Manua*. 1930. 2nd ed. Honolulu: Bishop Museum, 1967.

Meklin, Margaret, and Andrew Meklin. "This Magnificent Accident: Interview with Witi Ihimaera." *The Contemporary Pacific* 16, no. 2 (2004): 358–66.

Meleisea, Malama. *The Making of Modern Samoa*. Suva, Fiji: Institute of Pacific Studies of the University of the South Pacific, 1987.

Meleisea, Malama, et al. "German Samoa 1900–1914." *Lagaga: A Short History of Western Samoa*. Ed. Malama Meleisea and Penelope Schoeffel Meleisea. Suva, Fiji: University of the South Pacific, 1987. 108–23.

Melville, Herman. *Moby-Dick*. 2nd ed. Ed. Hershel Parker and Harrison Hayford. New York: Norton, 2002.

———. *Moby-Dick*. 1851. Ed. Hershel Parker, Harrison Hayford, and G. Thomas Tanselle. Evanston, Ill.: Northwestern University Press, 1988.

————. *Omoo: A Narrative of Adventures in the South Seas.* 1847. Evanston, Ill.: Northwestern University Press, 1968.

————. *Typee: A Peep at Polynesian Life.* 1846. Evanston, Ill.: Northwestern University Press, 1968.

Mifflin, Margot. *Bodies of Subversion: A Secret History of Women and Tattoo.* New York: Juno, 1997.

Milner, G. B. *Samoan Dictionary.* Auckland: Polynesian Press, 1993.

Morrison, James. *The Journal of James Morrison, Boatswain's Mate of* The Bounty *describing the Mutiny and subsequent Misfortunes of the Mutineers together with an account of the Island of Tahiti.* Ed. Owen Rutter. London: Golden Cockerel Press, 1935.

Morrison, Toni, Gayatri Chakravorty Spivak, and Ngahuia Te Awekotuku. "Guest Column: Roundtable on the Future of the Humanities in a Fragmented World." *PMLA* 120, no. 3 (2005): 715–23.

Morse, Jedidiah. *American Gazetteer.* Boston: S. Hall, 1797.

[Mortimer, Mrs. Favell L. B.] *The Night of Toil; or, a Familiar Account of the Labors of the First Missionaries in The South Sea Islands.* New York: American Tract Society, 1838.

Moses, Resio S., and Gene Ashby. "Tradition and Democracy on Pohnpei Island." *Culture and Democracy in the South Pacific.* Ed. Ron Crocombe, Uentabo Neemia, Asesela Ravuvu, and Werner vom Busch. Suva, Fiji: Institute of Pacific Studies, University of the South Pacific, 1992. 205–16.

Navatu, Malakai. "Tattooing." Brewster 185–86.

Neich, Roger. *Carved Histories: Rotorua Ngati Tarawhai Woodcarving.* Auckland: Auckland University Press, 2001.

————. *Painted Histories: Early Maori Figurative Painting.* Auckland: Auckland University Press, 1993.

————. "Wood Carving." *Maori Art and Culture.* Ed. D. C. Starzecka. Auckland: David Bateman, 1996. 69–113.

Neill, Michael. "From the Editor." *Shakespeare Quarterly* 52, no. 4 (2001): iii–x.

Neleman, Hans. *Moko: Maori Tattoo.* Zurich: Edition Stemmle, 1999.

Newbury, Colin. *Tahiti Nui: Change and Survival in French Polynesia, 1767–1945.* Honolulu: University of Hawai'i Press, 1980.

New Zealand Press Association. "Concern Over Ignorant Use of Moko." Global News Wire. February 27, 2003.

Nicholas, Henriata, with Ngahuia Te Awekotuku. "*Uhi Ta Moko*—Designs Carved in Skin." *Beyond Words: Reading and Writing in a Visual Age.* Ed. John Ruszkiewicz, Daniel Anderson, and Christy Friend. New York: Pearson Longman, 2006. 154–59.

Nicole, Robert. *The Word, the Pen, and the Pistol: Literature and Power in Tahiti.* Albany: SUNY Press, 2001.

Nikora, Linda Waimarie, et al., eds. *The Proceedings of the National Māori Graduates of Psychology Symposium 2002.* Hamilton, New Zealand: University of Waikato, 2003.

Nikora, Linda Waimarie, Mohi Rua, and Ngahuia Te Awekotuku. "Wearing Moko: Maori Facial Marking in Today's World." Thomas et al. 191–203.

O'Brien, Frederick. *Atolls of the Sun*. New York: Century, 1922.

O'Connell, James F. *A Residence of Eleven Years in New Holland and the Caroline Islands*. 1836. Ed. Saul H. Riesenberg. Honolulu: University Press of Hawai'i, 1972.

O'Connor, Flannery. "Parker's Back." 1956. *Three By Flannery O'Connor*. New York: Signet, 1983. 425–42.

Oliver, Douglas L. *Ancient Tahitian Society*. 4 vols. Honolulu: University Press of Hawai'i, 1974.

Oliver, Steven. "Te Pehi Kupe." *Dictionary of New Zealand Biography*. Updated July 19, 2002. http://www.ngatitoa.iwi.nz/te_pehi.htm. Accessed 15 November 2004.

Olson, Charles. *Call Me Ishmael*. New York: Reynal and Hitchcock, 1947.

Once Were Warriors. Dir. Lee Tamahori. Fine Line, 1994.

Once Were Warriors. New Zealand Film Archive. http://www.filmarchive.org.nz/taonga_maori/taonga_images.html. Accessed 6 December 2004.

Osorio, Jonathan Kay Kamakawiwo'ole. *Dismembering Lāhui: A History of the Hawaiian Nation to 1887*. Honolulu: University of Hawai'i Press, 2002.

Otter, Samuel. *Melville's Anatomies*. Berkeley: University of California Press, 1999.

Paris, John Davis. *Fragments of Real Missionary Life*. Ed. Mary C. Porter and Ethel M. Damon. Honolulu: The Friend, 1926.

Parker, Hershel. *Herman Melville: A Biography*. 2 vols. Baltimore: Johns Hopkins University Press, 2002.

Parkinson, Sydney. "Portrait of a New Zeland [*sic*] Man, 1769." British Library, London. Additional Manuscripts 23920, f. 55.

Parry, Albert. *Tattoo: Secrets of a Strange Art as Practiced Among the Natives of the United States*. New York: Simon & Schuster, 1933.

Poe, Edgar Allan. *Tales of the Grotesque and Arabesque*. 2 vols. Philadelphia: Lea and Blanchard, 1840.

Porter, Captain David. *Journal of a Cruise*. 1815. Annapolis: Naval Institute Press, 1986.

Powell, Ni. "Historical Observations." http://tongan_tattoo.tripod.com/ TonganTattoo/id1.html. Accessed 8 June 2005.

Powell, Rodney (Ni). "Rodney (Ni) Powell." Allen 193–95.

Pukui, Mary Kawena, and Samuel H. Elbert. *Hawaiian Dictionary*. Rev. ed. Honolulu: University of Hawai'i Press, 1986.

Rampell, Ed. "The Angry Warrior." *Pacific Islands Monthly* 64, no. 12 (1994): 46–47.

Raspa, Robert F., and John Cusack. "Psychiatric Implications of Tattoos." *American Family Physician* 41 (1990): 1481–86.

Regh, Kenneth. "Taking the Pulse of Pohnpeian." *Oceanic Linguistics* 3, no. 2 (1998): 323–45.

Regh, Kenneth L., and Damian G. Sohl. *Ponapean-English Dictionary*. Honolulu: University of Hawai'i Press, 1979.

Riesenberg, Saul H. *The Native Polity of Ponape*. Washington, D.C.: Smithsonian Institution Press, 1968.

Roberts, Timothy A., and Sheryl A. Ryan. "Tattooing and High-Risk Behavior in Adolescents." *Pediatrics* 110, no. 6 (2002): 1058–63.

Robinson, Roger. "Albert Wendt: An Assessment." *Readings in Pacific Literature*. Ed. Paul Sharrad. Wollongong, Australia: New Literatures Research Centre, University of Wollongong, 1993. 161–72.

Robley, H. G. *Moko: The Art and History of Maori Tattooing*. London: Chapman and Hall, 1896.

Rogin, Michael Paul. *Subversive Genealogy: The Politics and Art of Herman Melville*. Berkeley: University of California Press, 1979.

Roth, H. Ling. "Maori Tatu and Moko." *Journal of the Anthropological Institute of Great Britain and Ireland* 31 (1901): 29–64.

———. "Tatu in the Society Islands." *Journal of the Anthropological Institute of Great Britain and Ireland* 35 (1905): 283–94.

———. "Tonga Islanders' Skin-Marking." *Man* 6 (1906): 6–9.

Roussos, Timotheos. "A Man's 'True Face': Concealing/Revealing Masculinities in Novels by Alan Duff and Witi Ihimaera." *Philament* 5 (2005). http://www.arts.usyd.edu.au/publications/philament/issue5_Critique_Roussos.htm. Accessed 15 April 2005.

Rubin, Arnold, ed. *Marks of Civilization: Artistic Transformation of the Human Body*. Los Angeles: Museum of Cultural History, UCLA, 1988.

Salmond, Anne. *The Trial of the Cannibal Dog: Captain Cook in the South Seas*. London: Penguin, 2004.

Sanborn, Geoffrey. *The Sign of the Cannibal: Melville and the Making of a Postcolonial Reader*. Durham, N.C.: Duke University Press, 1998.

———. "Whence Come You, Queequeg?" *American Literature* 77, no. 2 (2005): 227–57.

Sanders, Clinton. *Customizing the Body: The Art and Culture of Tattooing*. Philadelphia: Temple University Press, 1989.

"Security Man." *Massey* 13 (November 2002). http://masseynews.massey.ac.nz/magazine/2002_Nov/stories/security_man.html. Accessed 13 December 2004.

Sellers, Audra Marie. "Audra Marie Sellers." Allen 133.

Shand, Peter. "Scenes from the Colonial Catwalk: Cultural Appropriation, Intellectual Property Rights, and Fashion." *Cultural Analysis* 3 (2002): 47–88.

Sharrad, Paul. *Circling the Void: Albert Wendt and Pacific Literature*. Auckland: Auckland University Press, 2003.

———. "Wrestling with the Angel: Pacific Criticism and Harry Dansey's *Te Raukura*." Hereniko and Wilson 319–36.

Shortland, Edward. *The Southern Districts of New Zealand*. London: Longman, Brown, Green, and Longmans, 1851.

"Sidelines." *Ottawa Citizen*, February 18, 2003.

Simmons, D. R. *Ta Moko: The Art of Maori Tattoo*. Auckland: Reed, 1986.

Smith, Linda Tuhiwai. *Decolonizing Methodologies: Research and Indigenous Peoples*. London: Zed Books, 1999.

Smith, S. Percy. *History and Traditions of the Maoris of the West Coast: North Island of New Zealand Prior to 1840*. New Plymouth: Thomas Avery, 1910.

Smith, Vanessa. "George Vason: Falling from Grace." *Exploration & Exchange: A South Seas Anthology*. Chicago: University of Chicago Press, 2000. 156–60.

———. *Literary Culture and the Pacific: Nineteenth-Century Textual Encounters*. Cambridge: Cambridge University Press, 1998.

Spivak, Gayatri Chakravorty. "The Burden of English." *Orientalism and the Postcolonial Predicament*. Ed. Carol A. Breckenridge and Peter van der Veer. Philadelphia: University of Pennsylvania Press, 1993. 134–57.

———. *A Critique of Postcolonial Reason*. Cambridge, Mass.: Harvard University Press, 1999.

Steinen, Karl von den. *Die Marquesaner und ihre Kunst: Studien über die Entwicklung primitiver Südseeornamentik nach eigenen Reiseergebnissen und dem Material der Museen*. 1925–1928. New York: Hacker, 1969.

Stevenson, Karen. "Polynesian Tattoo: A Shift in Meaning." *Artlink* 16, no. 4 (1996): 32–33.

Stewart, C. S. *A Visit to the South Seas, in the U.S. Ship* Vincennes, *During the Years 1829 and 1830*. New York: Sleight & Robinson, 1831.

Stewart, George R. "The Two *Moby-Dicks*." *American Literature* 25, no. 4 (1954): 417–48.

Stoddard, Elizabeth. *The Morgesons*. 1862. Ed. Lawrence Buell and Sandra A. Zagarell. Philadelphia: University of Pennsylvania Press, 1989.

Subramani. "Interview [with Sia Figiel]." *The Girl in the Moon Circle*. Suva, Fiji: Mana, 1996. 121–32.

———. "A Promise of Renewal: An Interview with Epeli Hau'ofa." Hau'ofa, *Kisses* 155–75.

Sullivan, Nikki. *Tattooed Bodies: Subjectivity, Textuality, Ethics, and Pleasure*. Westport, Conn.: Praeger, 2001.

Sulu'ape, Petelo. "History of Samoan Tattooing." *Tattootime* 5 (1991): 102–9.

Taylor, Richard. *Te Ika a Maui, or New Zealand and Its Inhabitants*. London: Wertheim and MacIntosh, 1855.

Te Awekotuku, Ngahuia. "The Future of the Humanities in a Fragmented World." Morrison et al. 721–23.

———. "Maori Culture and Tourist Income." *Pacific Tourism as Islanders See It*. Ed. Freda Rajotte and Ron Crocombe. Suva, Fiji: Institute of Pacific Studies, University of the South Pacific, 1980. 153–62.

———. "Maori: People and Culture." *Maori Art and Culture*. Ed. D. C. Starzecka. Auckland: David Bateman, 1996. 26–49.

———. "Mata Ora: Chiseling the Living Face." *Sensible Objects: Colonialism, Museums and Material Culture*. Ed. Elizabeth Edwards, Chris Gosden, and Ruth B. Phillips. New York: Berg, 2006. 121–40.

———. "More Than Skin Deep: *Ta Moko* Today." *Claiming the Stones, Naming the Bones*. Ed. Alazar Barkan and Ronald Bush. Los Angeles: Getty Research Institute, 2002. 243–54.

———. "Ta Moko: Culture, Body Modification, and the Psychology of Identity." Nikora 123–27.

———. "Ta Moko: Maori Tattoo." *Goldie*. Ed. Roger Blackley. Auckland: Auckland Art Gallery / David Bateman, 1997: 109–14.

Te Rangikaheke, William Marsh. "Sir George Grey NZ Maori Manuscript 89." Simmons 159–71.

Te Riria, Ko. "The Maori Moko System." Te Riria and Simmons 29–90.

———. "Te Tuhi Moko." Simmons 129–43.

Te Riria, Ko, and David Simmons. *Maori Tattoo*. Auckland: Bush Press, 1989.

Teaiwa, Teresia. "Reading Paul Gauguin's *Noa Noa* with Epeli Hau'ofa's *Kisses in the Nederends*: Militourism, Feminism, and the 'Polynesian' Body." Hereniko and Wilson 249–63.

Thomas, Nicholas. "Gender and the Politics of Tradition: Alan Duff's *Once Were Warriors*." *Kunapipi* 15, no. 2 (1993): 57–67.

———. *Possessions: Indigenous Art/Colonial Culture*. London: Thames & Hudson, 1999.

Thomas, Nicholas, Anna Cole, and Bronwen Douglas, eds. *Tattoo: Bodies, Art, and Exchange in the Pacific and the West*. Durham, N.C.: Duke University Press, 2005.

Thompson, Christina A. "In Whose Face? An Essay on the Work of Alan Duff." *The Contemporary Pacific* 6, no. 2 (1994): 398–413.

Thomson, Basil. *The Fijians: A Study of the Decay of Custom*. London: William Heinemann, 1908.

Toetu'u, Aisea. "Aisea Toetu'u." Allen 185–87.

"The Top 20 Bestselling New Zealand Books." *Listener* 193 (May 15–21, 2004) http://www.listener.co.nz/default,1947.sm. Accessed 12 January 2005.

Tumbi, Joseva Bembe. "Tattooing." Brewster 186–87.

Turner, Stephen. "Sovereignty, or The Art of Being Native." *Cultural Critique* 51 (2002): 74–100.

Tylor, E. B. *Primitive Culture*. 2 vols. 1870. New York: Harper, 1958.

Va'ai, Emma Kruse. "Ta Tatau." *Nuanua: Pacific Writing in English Since 1980*. Ed. Albert Wendt. Auckland: Auckland University Press, 1995. 291–94.

Va'ai, Sina. *Literary Representations in Western Polynesia*. Apia: National University of Samoa, 1999.

[Vason, George.] *An Authentic Narrative of Four Years' Residence at Tongataboo, one of the Friendly Islands, in the South-Sea by —— Who went thither in the Duff, under Captain Wilson, in 1796. With an appendix, by an eminent writer*. London: Longman, Hurst, Rees, and Orme, 1810.

Veramu, Joseph. *Moving Through the Streets*. Suva, Fiji: Mana, 1994.

Vincent, Howard. *The Trying-Out of* Moby-Dick. Cambridge, Mass.: Riverside, 1949.

Wahlroos, Sven. *English-Tahitian Tahitian-English Dictionary*. Honolulu: Māʻohi Heritage Press, 2002.

Wallace, Lee. *Sexual Encounters: Pacific Texts, Modern Sexualities*. Ithaca, N.Y.: Cornell University Press, 2003.

Walpole, Frederick. *Four Years in the Pacific, in Her Majesty's Ship "Collingwood," from 1844 to 1848*. 2nd ed. 2 vols. London: Richard Bentley, 1850.

Ward, James. *Monumental Inscriptions in the Baptist Burial Ground, Mount Street, Nottingham.* London: Chiswick, 1899.

Wardrop, Daneen. "The Signifier and the Tattoo: Inscribing the Uninscribed and the Forces of Colonization in Melville's *Typee.*" *ESQ* 47, no. 2 (2001): 135–61.

Wendt, Albert. "The Cross of Soot." *Flying Fox in a Freedom Tree and Other Stories.* Auckland: Penguin, 1988. 7–20.

———. *The Mango's Kiss.* Auckland: Random House, 2003.

———. "Tatauing the Post-Colonial Body." *SPAN* 42–43 (1996): 15–29.

———. "Towards a New Oceania." *Mana Review* 1, no. 1 (1976): 49–60.

Wenke, John. "Melville's *Typee*: A Tale of Two Worlds." *Critical Essays on Herman Melville's* Typee. Ed. Milton R. Stern. Boston: G. K. Hall, 1982. 250–58.

What Becomes of the Broken Hearted? Dir. Ian Mune. Polygram, 1999.

White, Geoffrey M., and Ty Kawika Tengan. "Disappearing Worlds: Anthropology and Cultural Studies in Hawai'i and the Pacific." *The Contemporary Pacific* 13, no. 2 (2001): 381–416.

White, Ralph Gardner. "An Account of the Mamaia: Glossary and Texts." *Journal of the Polynesian Society* 71 (1962): 244–53.

Wicks, Robert. "Can Tattooed Faces Be Beautiful? Limits on the Restriction of Forms in Dependent Beauty." *Journal of Aesthetics and Art Criticism* 57, no. 3 (1999): 361–63.

Wilkes, Charles. *Narrative of the United States Exploring Expedition During the Years 1838, 1839, 1840, 1841, 1842.* 5 vols. New York: Putnam, 1856.

Williams, H. W. *Dictionary of the Maori Language.* 7th ed. Wellington: Government Printer, 1992.

Williams, Raymond. *Keywords: A Vocabulary of Culture and Society.* New York: Oxford University Press, 1976.

Williams, Tennessee. *The Rose Tattoo.* New York: New Directions, 1951.

Williams, Thomas. *The Islands and Their Inhabitants.* Thomas Williams and James Calvert. *Fiji and the Fijians.* Ed. George Stringer Rowe. New York: Appleton, 1859. 1–209.

Wilson, James. *A Missionary Voyage to the Southern Pacific Ocean 1796–1798.* 1799. Graz, Austria: Akademische Druck- u. Verlagsanstalt, 1966.

Wordsworth, William. "Ode: Intimations of Immortality from Recollections in Early Childhood." *Poems, in Two Volumes, and Other Poems, 1800–1807.* Ed. Jared Curtis. Ithaca, N.Y.: Cornell University Press, 1983. 271–72.

Index